IN SEASON

I N

A Natural History of

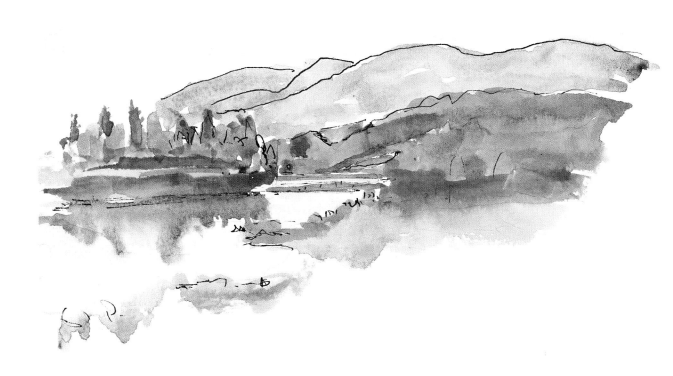

University Press of New England *Hanover and London*

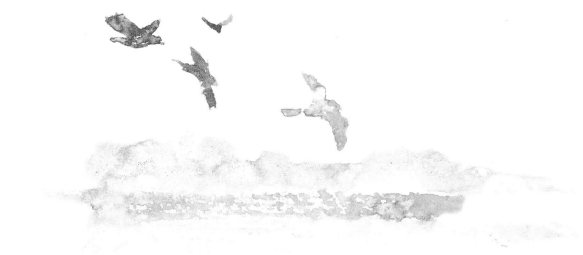

SEASON

the New England Year

Field Illustrations and Notes by

Nona Bell Estrin

Nona Bell Estrin

*after meeting
Judy in the
woods of
Vermont
in 2012*

Essays by

Charles W. Johnson

Charles W. Johnson

University Press of New England, Hanover, NH 03755

Printed in China

5 4 3 2 1

LIBRARY OF CONGRESS CATALOGING-IN-PUBLICATION DATA

Estrin, Nona Bell.

In season : a natural history of the New England year / field
illustrations and notes by Nona Bell Estrin ; essays by Charles W.
Johnson.

 p. cm.

ISBN 1–58465–127–X (cloth : alk. paper)

1. Natural history—New England. 2. Seasons—New England.

I. Johnson, Charles W., 1943– II. Title.

QH104.5.N4 E88 2002

508.74—dc21 2001004769

Contents

Acknowledgments

Many people helped us immensely in putting this book together—and most probably weren't even aware they were helping.

Landowners kindly allowed us to experience changes in a particular locale over the course of the year: Ollie and Ruth Brazier (Massachusetts), Tom Brazier and family (Vermont), the Butlers, Diana Chace, T. and Helen Clark, the Hawkinses, Fred and Lisa Levine, Marty and Edie Miller, Chris Pratt, Jeb Spaulding, Tom and Sheila Thomson, Mario and Phil Trabulsy, and others.

Fellow naturalists and field biologists shared their knowledge, enthusiasm, and time outdoors. Among them were Jim Andrews, Lori Barg, Chip Darmstadt, Mark DesMeules, Trish Hanson, David Govatski, Jerry Jenkins, Sue Morse, Dennis Murley, Steve Parren, Bryan Pfeiffer, Mark Rahill, Annie Reed, Chris Rimmer, Susan Sawyer, and Jackie Sones.

Several people often alerted us to natural events they observed: Geoff Beyer, Sara Brock, Jo Chickering, Katie Feldman, Ellen David Friedman, Julie Halpert, Kim Kendall, Jennifer Myka, Lucy Patti, Pam Pollock, Anna Saxman, Jamie Shanely, Lochlin Smith, and others.

Family and friends provided various kinds of advice and support: Michael Cicalese, Hans Estrin, Karen Kitzmiller, Gale Lawrence, Bill Manning, Zoë Parker, Delia Robinson, Anna Saxman, Stephan Syz, Adelaide Murphy Tryol, and Hub Vogelmann.

John Busby, Clare Walker Leslie, David Measures, and Greg Poole brought us into a community of extraordinary field artists, thereby giving us the confidence to move ahead with this project.

Thanks to Dave Houghton, Stephen Long, Bill Manning, and Patrick Noonan for the support, participation, and encouragement they and their organizations have given throughout.

Finally, Phil Pochoda and the editors and production staff at the University Press of New England—especially Mike Burton—had a vision for this project and the ability to make it happen. They even made it fun.

N.B.E.

C.W.J.

The following organizations have given generous financial and programmatic support for the publication of this book:

The Conservation Fund
The Trust for Public Land
The Friendship Fund
The Vermont Leadership Center
Northern Woodlands Magazine

IN SEASON

Introduction

Whether out of desire for order or due to assumptions inherited as children, we live with a myth about New England: that we have four distinct seasons here—spring, summer, fall, and winter. One follows the other in predictable order. We've seen it portrayed on calendars: spring is the time of woodland wildflowers and new leaves unfurling; summer of still ponds rippled by the dip of dragonflies, the nearby farm fields tall with grass and daisies; fall the blaze of color, first upon the trees, then spread upon the ground; winter's cold sharp upon the face and hands, a hardened landscape, yet softened in white, a cloak for our reflections.

The seasons match well an analogy to life—birth, growth, maturity, and death. It is an easy classification, neat, tidy. It may serve to reinforce our self-image or promote our expectations, perhaps even buffer our disappointments. But it is paradoxically both an overdrawn and a meager characterization of what actually happens in New England's nature.

Granted, New Englanders do make reference to other seasons—sometimes in jest, sometimes trying to make the best of unpredictability, and mostly in the context of recreational interests or our (sometimes pleasant, sometimes less so) interaction with natural events: mud season ("New England's fifth season"), black fly season, hurricane season, sugaring season, deer season (or its subseasons: bow, rifle, and muzzle-loading), ski season, trout season, bluefish season . . . and, heaven help us, even a "shopping season," the voracious weeks before Christmas, which seem to gnaw further and further back into the year.

In reality, of course, there are as many seasons as one wants to make of them, innumerable happenings that run into each other, blend with one another,

transition slowly or quickly, smoothly or abruptly. The time of wood frogs and spring peepers. Migrations of salamanders, warblers, shorebirds, hawks, whales. The mating of horseshoe crabs at the sandy shoreline. The blooming of goldenrods and asters. The emergence of mushrooms. The hibernation of woodchucks and frogs and insects. And on and on. In fact, there are so many seasons that we quickly see that "season" is but an artifice for our convenience, a way to organize a terrific jumble of events or summarize a bewildering array of detail.

While we all recognize certain repeating events in nature, we may not see the actual sequences or patterns, may not know how they are connected, or may overlook them due to distractions or other businesses of our living. This may lead us to a feeling of dissociation from the natural world, even that it is something outside ourselves.

We hope this book, through everyday observations expressed simply and spontaneously in sketches, notes, and narrative, can help lead people—*guide*, in the most encouraging and inclusive way—into a new or renewed relationship with nature. Part field guide, part journal, part text, part art, this book may seem at first an unusual amalgam, but it is intentionally so. It is not an encyclopedia or almanac, but rather a way of looking and knowing, one glimpse among many possible at our world outside, an example and, perhaps, a stimulation to others to seek their own discoveries and explore their own creativity.

By alloying art, science, and personal participation in the presentation, we are suggesting that intimacy with nature is far more than accumulated knowledge about it. It is also about familiarity, over a long time, with its moods and gestures, its easy times and hard times, reinforced again and again and again. We believe that through intimacy we reveal our deepest caring, express our most ardent passion, have our most complete understanding, and are willing to devote our greatest efforts to protect. And we believe this true in all our relationships, not just among humans.

We have another, related reason for writing this. Each year field guides of ever greater variety and number appear on bookstore shelves. More organizations offer field trips and workshops on a slew of natural history topics. Ecotourism is growing in popularity worldwide. It seems from this that people want to see and learn more about the natural world (perhaps because they are losing contact with it). They are moving away from what may be a more tradi-

tional relationship with it—consumption, exploitation, domestication—but there are risks, too, unseen consequences of such a boom in information and specialization.

One risk is that in our desire to discover the new bird, the new flower, the new ecosystem, we go ever farther afield, ignoring, or perhaps damning as ordinary, the nature in our own local communities, bit of backwoods, or narrow stretch of coastline, however small it is. Another risk is, as we learn more about various components or elements of nature, we may see less of the interrelationships among them or understand less of their confluences and connections. Yet another, that as we use our brains more and more, we may use our hearts less and less; our desire for knowledge overwhelms that for participation.

As a foil to these risks, this book is about "being right where we are." Nature is indeed as wondrous and complex outside our doors as it is a continent away, just as grand, changing, and mysterious within a few familiar acres as in a distant wilderness of thousands. Our simple overriding goal is to offer ways to rekindle what we all, every one of us, had as children—open wonder and insatiable curiosity about the natural world, unabashed love for it, the feeling we belonged. That little flame, smoldering perhaps, or sputtering sometimes, never really goes out. It just needs a gentle breath now and then, the slightest puff, to help it burn brightly, warmly, into life once again.

The Abenaki elder Rick Two Bears tells how his people, when going out hunting, say instead they are going for a walk. "For," he explains, "when we go for a walk, we have no expectations or disappointments; anything that happens is okay."

So that is what we suggest, just going for a walk—or even sitting—outside, any day you can, keeping eyes, ears, nose, and heart as open as can be. Then, you cannot help but see, hear, or feel something happen. Everything will be okay.

ABOUT THE FIELD SKETCHBOOK AND JOURNAL ENTRIES
(NONA ESTRIN)

Like so many others, I keep field notes of natural events. I've done this off and on since childhood. And like others, I often couldn't find my own references to an event when I needed it. So I began to do more field sketches in pen and ink or pencil as an easy visual indexing method (to locate records of turtle egg-laying, for example, I'd flip through the sketchbooks for the turtle pictures.) Over time I added quick watercolor sketches to better capture an event or mood. So, eventually the process of observing and recording—being

secretary for the day—took on a range of emotional color, from meditative to passionate. It also strengthened my interest in the sequence of events and taught me patience, to enjoy just watching when nothing much seems to be going on.

Although I put a date on my illustrations, it is sequence that really tells what else is happening at the time, what took place just before and what to expect next. Sequence, in fact, is a more realistic measure of natural events than calendar dates and is an accurate characterization of what seasons really contain. The subjects I have chosen are indicators—the memorable clues that can quickly lead into one sequence or another. For example, when the maples and wild apples put forth their blooms, it's time to hunt for morels, watch wood frog eggs transform into tadpoles, and listen for the first buzzy call of scarlet tanagers.

With all the innumerable things going on outside—and things are happening all the time—what we choose as indicators and what sequences we trace are, of course, selective and highly personal. Each of us has a special time, special place, and a special interpretation of what is going on. These are some of mine.

Except where noted, all my work is done outside, usually on walks or skis from the house, in affordable spiral watercolor and multimedia sketchbooks. I use a waterproof ink pen and a small field watercolor set with eight colors, which get mixed a lot. These are rather quick and spontaneous records of observations, impressions, and fleeting events, often done in hurried or difficult situations. I use them to compare what was seen last year with the present year, and most important, as a reminder of upcoming subtle or ephemeral activities, often forgotten in the intervening year. For publication in this book, I have edited daily field notes from two years or so and transcribed them into type; associated field watercolors and sketches have been included. The journal color pages were chosen for content, not artistic merit, and reproduced as they are, with all the smudges, extraneous information, and terrible spelling. The field notes on these color pages in most cases do not appear elsewhere in the book, and may be difficult to decipher. Sorry!

Finally, in my journals I focus on that which I can see, or sniff, or hear—the things I feel though my senses. This is how I "remember." I've also included some material about how we celebrate seasonal events, including local and wild foods we look forward to and gather for the table. Just a glance at our plates can often tell us where we are and what time of year it is. This, to me, reinforces the concept of "home," a simple way to connect daily rambles with domestic routines, as peoples of all times have done.

As a complement to Nona's illustrations and observations—as stories behind her scenes—most of my essays are about big themes in New England's seasonal cycles, such as migration, winter survival, breeding, and so forth. But rather than describing that which categorizes, segregates, or separates life here into traditional components (often for identification purposes)—such as plants, animals, terrestrial or aquatic, warm-blooded or cold, and so on—I wanted to explore that which unites us as living beings (humans included) in this one particular, highly variable, climatically mercurial, yet oddly cohesive region of the continent we all inhabit. I do so because I wish to convey my belief that what unites us as living creatures is far more important than what distinguishes us as individuals.

A few of the essays are on topics (e.g., eating, communicating, biological clocks) not especially related to a particular season but common to all seasons. To set the stage, the first essay compresses the venerable ecological history of New England into a few pages (for more on the present landscape, see "Natural Communities" at the back of the book). And the concluding essay and poem are purely personal views of our human relationship to nature, a relationship that is innate, essential, yet of increasing quandary in a world ever more dominated by our kind.

Old New England

A History of Histories

This place we call New England—six adjoining states perched at the eastern edge of North America—is but a tiny piece of the world, a mere .00034 of its total area. Yet it is a remarkable place for its size, rich in natural history, complex in geology, and diverse in landscapes and seascapes. It is also anything but "new." It has been a near eternity in the making.

Situated where it is, it has experienced, not just once but several times, the momentous coming together and drifting apart of the continents of North America, Africa, and Eurasia. The collisions have heaved this land from plains into cloud-piercing mountains; the pulling apart has let oceans, most recently our Atlantic, flow between. Over this great span of time, the mountains, grain by grain, inch by inch, have worn down time and again, the eroded silts, sands, and gravels piling into great swaths of continental shelf, beaches, shoals, and islands.

Time beyond imagining, really, during which plants and animals appeared on planet Earth for the first time and evolved into their countless forms, some falling to extinction, others coming into the beings we recognize today. Climates have shifted from tropic to arctic, rainforest humid to desert dry. Glaciers, some more than a mile high, have ridden over this ancient landscape many times, transforming it with their weight and abrasive power, wiping out animals, plants, even soils and bedrock, leaving barrenness to be recolonized slowly, by centuries, over and over again.

With the disappearance of the last glacier, we humans have come to take our place, however recent and brief our stay may be by comparison. In our time we have had the privilege of witnessing such a universe and discovering such

history, always recognizing that what we see is not the final configuration but only one glimpse, a moment of an infinite, inexorable unfolding.

This time gone by, though we try to convey a sense of it by description or analogous measurement, is simply incomprehensible in its enormity. The rocks have another language to convey their stories.

When our world was much newer it turned faster on its axis than it does now. Like a spinning top, it has been slowing down the longer it goes. We know because the fossils of ancient, extinct corals embedded in limestone along Lake Champlain tell us so. Corals, now as then, add a microscopically thin layer of calcium carbonate to their structure every day of the year—each day's layer is thicker in summer when growth is fast, thinner in winter when slowed. Thus a researcher, when looking at a section of coral under a microscope, can count the number of days per year. Today's corals of the Caribbean show 365 of these increments per year, 365 days and nights in our circle of the sun. The fossil corals of Lake Champlain, alive those 450 million years ago, record over 400.

The Champlain corals, and reef-dwelling trilobites, cephalopods, crinoids, brachiopods, and other fossils locked in limestone tell us another thing. The broad valley, framed by mountains on either side, subjected to the swings and lurches of northern seasons, was once the bottom of a shallow sea, bathed in tropical light and warmth. On land, no plant or animal had yet evolved.

Just to the west of Lake Champlain, today's Adirondack Mountains, rugged as they are today, are a nubbin of what they were over a billion years ago when

first formed. Back then, called by us the Grenville Mountains, they were perhaps as high as the Himalayas, more than 20,000 feet of granite spread over a much larger region than today, situated not far from the earth's equator.

For half a billion years they remained relatively unchanged but for relentless weathering and erosion. Then, almost 600 million years ago, the crust east of today's Adirondacks began to spread apart, thin, and subside (a process called "rifting"). Sand and other materials eroding from the Grenville Mountains worked their way down into the newly formed, ever widening Iapetus Ocean, as we have named it, an ocean predating our present Atlantic.

The spreading and subsiding continued for another 100 million years, as the Iapetus grew, with an immense coral reef building in the shallow, warm waters at its margins. However, around 440 million years ago, this spreading ceased, and the widely separated landmasses began to converge. Seafloor plunged eastward beneath the high-riding continental plate into the molten magma below (the whole process called "subduction"), creating a long string of submarine volcanoes. The convergence continued over 10 million years, with the Iapetus shrinking and the leading edge of the easternmost continental mass scraping and bulldozing great wedges of ocean bottom (sediments, coral reefs, and oceanic crust) before it. Finally, as the continents collided, these now gigantic wedges smashed up against the Adirondacks, rising out of the sea and turning under pressure and heat into the present-day Taconic Mountains of Vermont and Massachusetts. Following closely behind, the string of volcanoes came to rest and solidified as bedrock in the region we call New Hampshire.

Beginning around 360 million years ago (the Taconic Mountains had been building for 80 million years, new rifting occurred aligned with today's Connecticut River Valley, a long ribbon all the way to Canada's Gaspé Peninsula. The continents began drifting apart again but then soon resumed their convergence. The old subduction zone ceased to be active; a new one developed, with the Eurasian and African plates plunging westward under the North American plate. This convergence continued until, after another 15 million years, the continents piled into each other and buckled upward once more, giving birth to Vermont's Green Mountains and Massachusetts' Berkshires (part of the same formation) just east of the older Taconics. Below the surface, rock melting and volcanic activity, associated with subduction, created the gigantic granite deposits quarried now in Barre, Vermont, and elsewhere. The Iapetus Ocean by then had been squeezed out of existence.

So it stayed for another 145 million years, as the Green Mountains continued to build. In fact, the continents of today's world were all amassed then in one huge continent called Pangaea, surrounded by an even more immense

global ocean called Panthalassa, with the region of New England still positioned near the equator.

But beginning about 200 million years ago, this giant continent broke into the smaller, major continents we identify in atlases today. The Americas, in particular, drifted apart from Africa and Eurasia as molten basalt oozed into the spreading seafloor between them, with the new Atlantic Ocean filling in the growing gap between spreading continental plates. The North American plate, as it pulled away from Africa and Eurasia, rifted and fractured east of the former boundary of the previous plate—Maine and a goodly portion of New Hampshire were, prior to the formation of Pangaea, a chunk of Africa.

North America thus began a voyage it is still on today. Creeping north and west an inch or two a year, New England has gone some 3,000 miles from its once tropical setting. Meanwhile the Green and Berkshire Mountains have worn down, bit by bit, to possibly half their peak heights. The huge granitic domes of the White Mountains of New Hampshire and Maine, and the Granite Hills of Vermont's Northeast Kingdom—former great subsurface caverns (plutons) of magma associated with the subduction zone—have emerged as the softer surrounding rock eroded away. Birds, then mammals, appeared on Earth, and have evolved into their present forms. Dinosaurs spent most of their 120-million-year history drifting along on this great continental breakup and then became extinct, as we know from the rocks—former sands and muds—in Connecticut, Massachusetts, and Maine, which hold their fossilized bones and passing footprints. Giant extinct tree ferns and other plants of humid tropical swamps are likewise set as fossils in Vermont and Maine.

The Age of Ice

At least four, likely many more, times within the past two to three million years—the "Ice Age" or, in geologic terms, Pleistocene epoch, just a recent tick in the geologic clock of Earth—widespread and massively thick glaciers have descended upon and retreated from North America in response to changes in climate. In the process, and by their weight and movement, they reworked the landscape in monumental ways.

The most recent episode in our region lasted about 10,000 years, from the glacier's maximum extent 18,000 years ago to its exit 10,000 years later. It covered everything in its advance, including all the highest peaks, under one to two miles of ice. At its greatest extent, this (Laurentian) ice sheet lay in a huge frozen ocean from the Arctic as far south as present New York City and west-

ward to the Rocky Mountains. As it moved down New England, it bulldozed the land, scouring bedrock and carrying away great quantities of material: large boulders plucked from mountains, sands, gravels, and finer silts ground like flour. As it rode over the mountains, it smoothed them on the north-facing slopes and summits, then plucked rocks from the leeward slopes while descending the southern flanks, often making them steeper and more jagged on that side. It "flowed" through river valleys and lake basins and, like a giant rasp, rounded their sides and excavated their depths.

The weight of ice must have been incredible. It crushed the land below it, compressing and pushing it down 700 feet in places. Yet even with that, the ocean pulled back. So much ice was tied up in the continental glaciers worldwide that sea level was as much as 400 feet lower than today, with the Atlantic seacoast 75 miles east of where it is now.

But as the climate slowly began warming around 18,000 years ago, the glacier retreated, leaving huge mounds of sand and gravel rubble as visible testimony to its farthest advance south. These so-called moraines are exposed most strikingly as the arc of islands sweeping southwest from Cape Cod to New York: Nantucket, Martha's Vineyard, Block Island, and Long Island.

Water poured in torrents from the melting glacier, carving new or reshaping old channels in the freshly exposed and barren landscape, turning basins into lakes. Materials eroded and carried by the glacier—silts, sands, gravels, even boulders—were laid down across the land's surface or in its waters. Here and there great chunks of ice broke off and rested in the sands and gravels to become kettle ponds, the smallish, circular water bodies so prevalent in New England, many of which later developed into bogs.

All the while, the seas worldwide kept rising from water released by melting glaciers. In Maine, the Atlantic Ocean moved inland over the glacially depressed landscape well into the central and northern parts of the state, up rivers, against steep granite walls of their valleys. However, the land, increasingly relieved of the pressures from glacial ice, began to rise, or "rebound." In fact, it eventually rebounded faster than the ocean rose, so the formerly inundated coastline of Maine reappeared.

By 13,000 years ago the ice remained only in northern Maine and just north of New Hampshire and Vermont. Lakes, ponds, and rivers of all sizes covered the terrain. Lake Vermont, a larger predecessor of modern Lake Champlain, lapped at the foothills of the Green Mountains, its exit to the ocean via the present St. Lawrence blocked by the impenetrable wall of ice. Due to a similar blockage in what is now present-day Connecticut, long and skinny Lake Hitchcock occupied most of what is now the Connecticut River Valley.

As the land continued to rise faster than the ocean, a sizable portion of the submerged continental shelf off New England was exposed about 9,000 years ago. The rivers coursed their way down mountains and into new, more eastern coastal shallows.

Eventually, land rebounding slowed while seas kept rising. By 7,000 years ago, the Atlantic reached its approximate modern-day level. Eastern segments of major river valleys such as the Penobscot, Sheepscot, Androscoggin, and Kennebec were "drowned" by the incursive sea, changing them into the many and intricate series of rocky embayments so characteristic of the Maine coast today. Drowned also were the former coastal plains and associated dunes, to become today's Grand Banks, Georges Bank, and other shallows off the eastern coast. (Stellwagen Bank, an important breeding ground for marine life north of Provincetown, Massachusetts, is a submerged glacial moraine.) The tides and currents have sifted and sculpted and smoothed the remaining coastal sands into the great arm of Cape Cod and beaches to the south.

Farther west, the ice retreated north and cleared the St. Lawrence River Valley, as rising ocean waters found their way around the glacial fringe and into Lake Vermont, the big basin between the Green Mountains and Adirondacks. These marine waters mixed with the fresh, eventually transforming Lake Vermont into the saltier Champlain Sea. However, the land, freed of its ice burden, rebounded in the north of Vermont enough that by 12,000 years ago it barred the sea from entering. The marine environment slowly changed back to freshwater, and modern, smaller Lake Champlain was born.

The Ice Age legacy is everywhere around us. Roughly smoothed peaks and U-shaped valleys whose bedrock shows deep scratches from boulders dragged over. Bowl-shaped gulfs against mountains, carved by smaller, isolated glaciers after the main sheet left. Broad cradles of river valleys. Rock-infested soil, the bane of every farmer since farming began here, spread and scattered everywhere. Sinuous sand and gravel terraces next to rivers that once spanned

the distances between ice edge and upland wall. Lakes, ponds, bogs, and other wetlands by the thousands, occupants of quiet impounded waters.

Coming Back to Life

Into places left vacant by the waning and ultimately extinct Laurentian ice sheet came other invaders—plants and animals, most of which had been killed or displaced by the ice. Some, however, were new.

Earliest to colonize the barren landscape as it became exposed (first the mountaintops, then the slopes, then the valleys) were low-lying and hardy species of willows, sedges, mosses, and others able to cope with the harsh terrain and climate. The land became steppe tundra, appearing like that of much of the Arctic or high mountaintops today. With the plants came an array of animals capable of surviving these conditions: caribou, elk, wolves, and even the extinct mammoth whose bones were discovered in 1848 in western Vermont. In coastal waters lived walruses, seals, and whales. Birds such as snowy owls and ravens preyed on lemmings, arctic hares, and others smaller mammals. Arctic char, a species of salmon, was probably the most common fish.

Among the new arrivals were people, the original Native Americans, who migrated in from the west, along the glacier's melting fringe. These Paleo-Indians, as archaeologists have termed them, were Inuit (Eskimo)–like hunter-gatherers, whose way of life revolved largely around big game, thus shifted with the herds. But they also took advantage of other foods in season—plants, birds, smaller game.

As the climate warmed and soils painstakingly accumulated, trees such as red spruce, balsam fir, paper birch, and quaking aspen displaced tundra progressively uphill. Eventually, by 9,000 years ago, this forest had reclaimed much of our area.

The climate continued to moderate, accompanied by northward migration of new trees and associated plants and animals. By 8,500 years ago, New England had taken on today's appearance, predominantly forested with a mixture of softwoods (spruce, fir, white pine, eastern hemlock) and northern hardwoods (sugar maple, yellow birch, beech), depending on site. Tundra, reduced greatly in size and extent, persisted on only the higher, colder, more exposed peaks. The sandy coastal plain was colonized with beach and dune plants, with the more stable backlands supporting pitch pine and scrub oak.

Over this extensive region, gradual but great changes took place in the Native American culture, as well. It adapted to a changing environment, particularly

in response to available food. The seminomadic Paleo-Indians, who ranged widely in search of the larger migratory mammals, evolved into the so-called Archaic Indians, whose territories, though still large, were more defined by the availability of local game (fish, deer, bear, etc.) and vegetation that could be eaten in season or stored for winter use. They seem to have had a culture more designed around settlements, albeit settlements that shifted with the seasons: spring and summer in the valleys near rivers and lakes for fish and plant foraging, fall and winter in the forests for game and the protection of trees.

With yet further warming to a postglacial maximum between 8,500 to 5,000 years ago (the "hypsithermal interval"), the climate turned similar to that of modern-day Pennsylvania or New Jersey, and trees of even more southerly origin moved in—oaks, hickories, American chestnut, tulip poplar, black gum, sassafras, and others.

Since then and up to our present era, the climate has cooled again, into what is known as the Little Ice Age. The northern hardwoods have reclaimed most of their former territory across the region. Spruce and fir have increased, especially in the northern reaches of the states and at higher elevations. The more southerly species have retreated to the relatively warmer areas in the southern parts of New England, in milder coastal stretches, and in the broader valleys of Lake Champlain and the Connecticut River. The coastal plain vegetation has remained much in composition as it was during the warmer interval. Tundra, either a leftover of the Arctic or newly appearing with the cooling trend, sits atop the highest peaks such as Katahdin in Maine, the Presidential Range in New Hampshire, and Vermont's Mount Mansfield and Camel's Hump. The cold, moist climate of northern and coastal Maine has bred the region's most extensive and elaborate peatlands (bogs), thousands of acres mounding into great plateaus or climbing up and over the mildly hilly terrain.

From 3,000 to just 300 or 400 years ago, the Native American culture was more and more influenced by social changes associated with the rise of agriculture to the south and west, particularly a shift away from territorial hunting-gathering and toward settlements and social orders. This "Woodland Period" is reconstructed primarily through evidence of pottery, agricultural implements, and cultivated grains at well-established sites, especially near major waterways and water bodies.

In the latter stages of this long prehistory, the Native Americans apparently became more distinctly divided into five regional language groups. The

"Eastern Algonquian" consisted of many tribes extending along the Atlantic seaboard from the Gaspé and Nova Scotia in the north to Maryland and Delaware in the south, then west to Lake Champlain and the Adirondacks. At their western interface, and sometimes in conflict with the Algonquians, was the more warlike "Iroquoian" group. The names of rivers, mountains, towns, and other features of New England carry the Algonquian imprint deeply. To cite just a few: Mount Katahdin, Mount Sunapee, Kancamagus Highway, Piscataqua River, Pemigewasset Wilderness, Missisquoi Bay, Winooski River, Nickwackett Cave, Narragansett Bay, Connecticut River, Lake Winnipesaukee, Quabbin Reservoir, Monhegan Island, Nantucket Island, Ogunquit, Pocasset, Woonsocket, Naugatuck, and the states of Massachusetts and Connecticut.

Arrival of White People

The New England encountered by the first white explorers, trappers, and settlers in the early 1600s surely was a land rich in resources and beautiful to behold, yet daunting in its wildness, deep forests, and trackless mountains. Except for perhaps the 5% or less of the landscape in treeless mountaintops, lakes, ponds, rivers, wetlands, or the relatively small area disturbed by the Native Americans for agriculture or game production, it was all forested—the northern half of Maine and northern third of New Hampshire and Vermont in mixed coniferous (spruce-fir) boreal and northern hardwood (maple-beech-birch-hemlock) forest, the rest in northern hardwoods or transitional hardwoods (oak-hickory-chestnut-pine).

Within this vast wilderness lived trees hundreds of years old and animals that still illuminate our own legends and imaginations: mountain lions, timber wolves, wolverines, even caribou and elk. Passenger pigeons, now extinct but once the most abundant bird species on Earth, often saturated the woods and sky: one early observer described a flock of a billion birds or more, making a swath in the sky a mile wide and 240 miles long. Bald eagles nested along the coast and countless lakes. Wild turkeys grew fat on acorns and chestnuts in southern New England. And indigenous peoples lived in sparse, sustaining numbers here.

But it soon changed. The coming and settlement of white people, expanding mostly from southern New England in the eighteenth century, and the supplanting of Native American ways by Western attitudes toward the land and its resources, was utterly transforming. Though it all happened within a blink of the historic eye, it was of geologic proportions and impact.

The forests in the southern half of New England fell in waves to the axes and saws of settlers clearing the land for crops and pastures, for firewood and tools of their trade, for sun to light the shaded forest recesses, for safety from wild animals and Natives. The tall, grand, ancient white pines were cut wholesale for masts for British ships and lumber. Later, before coal or oil became the fuel of choice, the new railroad trains gobbled up vast quantities of hardwoods to feed their ravenous steam engines.

Within 150 years of the first settlements, from say 1700 to 1850, this section of New England had gone from virtually 100% forested to almost completely forestless. It was also a period when many of the native, woodland-dependent wildlife species were severely depleted or eliminated altogether, victims of loss of the old forests, conversion of their habitats to fields and pastures, relentless attempts to exterminate, uncontrolled hunting, or all these. Many large mammals—mountain lion, moose, wolves, even deer and beaver—were all but gone by the last quarter of the nineteenth century. So were several birds, particularly passenger pigeons, never to return, and wild turkeys. Streams and rivers, their watersheds no longer protected by an upland covering of trees, ran brown with silts and muds rain-washed down from the hills. The native trout were literally choked to death, while dams for waterpower on most rivers barred salmon, shad, lake sturgeon, and others from access to spawning grounds upstream.

Fortunately, the vast northern coniferous forest, some 26 million acres across three states, lay beyond the reach, means, or interest of new settlers. Through this period it remained a wilderness, mostly untouched by the agricultural hand that had so changed the area immediately to the south. And the logging that proved so heavy elsewhere was yet to come.

From 1850 to the late 1800s, a constellation of events and forces halted, then reversed, what had been happening over the previous century and a half in the region.

Newly constructed railroads provided relatively easy access to homestead range and croplands in the Midwest, whose deep, rich prairie soils and lush grasses must have seemed like heaven to farmers used to fighting the scrub and gnarly hillside soils of the Northeast. The Civil War called men from the fields into battle. Later, cities to the south and west, hubs of the Industrial Revolution, lured many in hopeful search for easier and better-paying jobs.

In consequence, farms were abandoned by the score, and the fallow fields and meadows soon were thick with shrubs, then seedlings of trees—most notably white pines that throve in full exposure to the sun. They grew quickly; within 25 years of abandonment, new forests, though patchy across the landscape, stood where once was open land.

Into the vast northern coniferous forests, meanwhile, had moved timbering operations, now grown and developed into a large-scale and significant enterprise. Huge quantities of spruce and pine were floated to mills down major rivers such as the Connecticut, Piscataqua, Kennebec, and Penobscot, clogging them from bank to bank for miles during the spring log drives.

Within 50 years, the wild north woods, once seemingly so endless as to swallow all traces of human activity, went from wilderness to logged-over land —a stark reminder of how quickly, pervasively, and deeply humans can alter a landscape, even with primitive hand tools, once they set their minds and muscles to it. By the turn of the century, almost all the big trees had gone, and the emerging paper industry turned to smaller trees left over or regrowing.

But significantly from a historical perspective, the heavy impacts and undeniable abuses of land clearing for farms and logs had not gone unnoticed. As the forests were being cut over, the roots of concern were growing. The Vermont statesman, author, and intellect George Perkins Marsh, in his landmark 1864 book *Man and Nature,* was one of the first to write at length on the interconnections between humans and nature, to warn of the consequences of misuse and overuse of natural resources, and to call for proper stewardship of the earth. His contribution, according to Stewart Udall in his book *The Quiet Crisis,* was "the beginning of land wisdom in this country." It was the dawning of conservation and forestry.

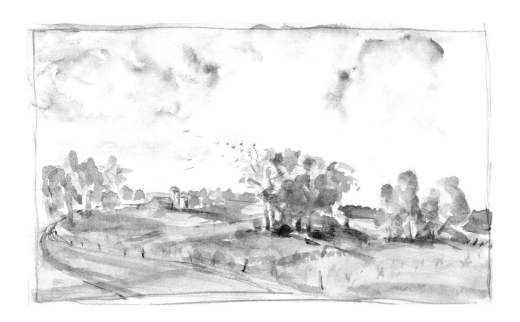

Today and Tomorrow

Today, as farming shrinks and consolidates in the more fertile valleys, forests are taking back the lands once gained so arduously for fields and pasture. These forests have returned to a composition, total acreage, and outward appearance similar to the presettlement forests of four centuries ago. But they are different. All but tiny fragments of the original vanished forests, preserved as old growth natural areas, are gone.

The rest have been replaced by younger forests, most of which have come through one, maybe two, perhaps as many as three more cycles of cutting, clearing, and regrowth since 1900. Their trees are of less grandeur and dimension; they also conceal more houses and roads. Their owners are many more than they used to be, holding smaller tracts. More people want to use them, for more and different reasons: wood, living space, recreation, escape, watershed protection, development. The list keeps growing, as do the changes to both landscape and its native inhabitants.

The land will always change, of course, as will our relationship to it. But which way will go the New England of tomorrow? How much will our hopes and visions become that reality?

We should stop sometimes and consider what we've inherited. It is an ancient, venerable landscape, hiding much of its antiquity under relatively new cloaks of trees and waters, its former youthful ruggedness tempered smoother and softer with age. The massive sequence of mountain building, from the colliding of continents over unfathomable stretches of time, has left an indelible north–south stamp upon the land, an orientation that has influenced profoundly all that has followed: the mile-thick glaciers that crept down from the north; the climates of different epochs; the changing communities of plants and animals; the lives and ways of peoples who have lived here for over 10,000 years.

In this corner of the continent I often take short walks through its long history. One time I walked across a field, newly plowed beside a river, and found an arrowhead sticking out of turned-over soil. I ran my finger over the sharp edge of this stone, the same edge made by a Native hunter who perhaps searched or waited here for passing caribou or moose. Other times I have walked around great boulders strewn along the riverbanks, having spewed out of the waning

glacier 10,000 years ago. I envision its ice and cloudy waters and tumbling rocks crashing by.

Often in forests I come across laid-up walls of these very rocks, and know I've entered an old pasture abandoned last century, now given to trees instead of sheep or cattle. I wonder about the families who struggled against the land I find so picturesque. I wonder what their hopes and heartaches were.

When I climb our mountains, up slopes made by colliding continents millions, maybe hundreds of millions of years ago, I'm aware of setting my boots down solidly on outcrops of ancient seafloor, long ago crumpled into wavy rocks. While resting I might pick up a pebble half a billion years old, transformed and transported by the glacier, rounded to a marble by the tumbling, churning waters. I can only look at it, roll it around in my fingers, and toss it aside, something so small yet too much to grasp.

Along these ways I may sit and rest and just look about, at the span of time I have walked across or touched—time of nearly immeasurable duration leading to this very place and moment. Then marvel at this convergence and, for a fleeting moment, if I'm lucky, feel an inseparable part of its unending future.

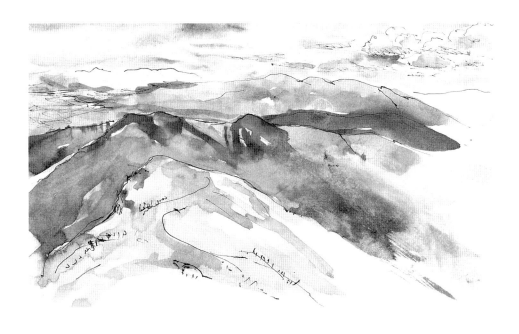

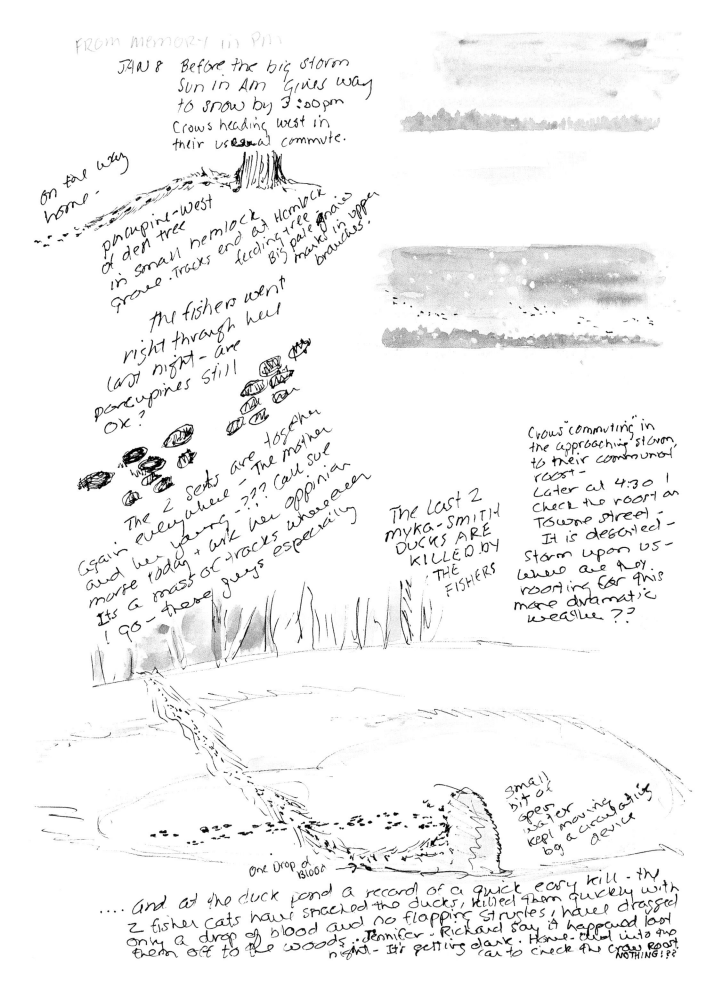

JAN 8 Before the big storm
Sun in Am gives way
to snow by 3:00pm
Crows heading west in
their useal commute.

On the way
home.

Porcupine-West
of den tree
in small hemlock
grove. Tracks end at Hemlock
feeding tree
Big pale gnaw
marks in upper
branches!

The fishers went
right through here
last night - are
porcupines still
Ok?

The 2 sets are together
again everywhere - The mother
and her young -??? Call Sue
morse today + ask her oppinion
Its a mass of tracks whereever
I go - these guys especially

The Last 2
myka-smith
DUCKS ARE
KILLED by
THE
FISHERS

Crows "commuting" in
the approaching storm,
to their communal
roost -
Later at 4:30 I
check the roost on
Towne Street -
It is deserted -
storm upon us -
where are they
roosting for this
more dramatic
weather ??

small
bit of
open
water
kept moving
by a circulating
device

One Drop of
BLOOD

.... And at the duck pond a record of a quick easy kill - the
2 fisher cats have snacked the ducks, killed them quickly with
only a drop of blood and no flapping struggles, have dragged
them off to the woods. Jennifer, Richard say it happened last
night - It's getting dark. Home-child into the
car to check the crow roost.
NOTHING!??

JANUARY

Jan 1 ('99). Early, before 8:00, I see a fox in full winter coat slowly and attentively crossing the snowy field at Murray Hill, just behind the houses. 5 degrees by 10:00 AM.

Jan 2 ('99). −10, clear, cold. Full moon on the snow last night. Tracked on skis to Clark's. Can't stop to sketch but saw so many wonderful things: crows, which have never wintered here before, patches of snow crust being lifted and blown off by the wind, shrew tunnel elevations in snow, great leaping deer tracks across the snow—2 together. Fox tracks everywhere this year. I look for paired tracks.

3:30 PM. Crows flying over again, heading W. At 4:00 PM I finally just get in the car and follow them along. They are going 25 mph, one group after another. I lose a few groups as they come over the last hill before the valley where the Winooski and the North Branch create the "container" that is our town of Montpelier. After awhile I find a big pre-roosting site of 300. By now—4:30— they are loading the branches, quiet and not afraid of me in my car. A small quiet road goes right through the middle of the roost. I'm excited as big crow flocks have never wintered in central Vermont before—these birds are secretive in rural areas and hard to observe at close range.

Jan 3 ('98). 3:00 PM. Now, big flakes again, some the size of quarters! Time to put the Christmas tree out—a balsam top from one of the trees W of the vegetable garden. It is covered with cones this year, still in some stage of seed dispersal—a graphic example of why we have found the small aromatic seeds

JAN 9 BIG STORM ALL DAY.
 WOMEN IN CONSERVATION
 MEETING AT OUR HOUSE
 FROM 11:00 · 3:00 ·
 we ski 2 times - before,
 (wet + sticky - sleeting to
 freezing rain) and after;
 Heavenly - both snow like
 a dreamy garment pelted
 up around snug + fitting.

The coopers,
waiting for
an hour
for a dove.
misses - keeps
my eyes wandering
out the windows -
finally get out the
scope + everyone has a
look.

Around 3⁰ the crows start
commuting in a terribly
blostery squally wind,
from the W. They take an
entirely new route up the
Bowman wetland, swooping
up + down - mostly flying low,
between here + Merrilees toward
6·32. We head out after them,
lose them in a squall Hill/Clark
field, but have a memorable ski
at dusk through dramatic swirling
squalls, alternating suddenly
with quiet still flakes floating
down around us - stitching us
to the landscape. We glide on,
as if by magic up and impervious +
powerful. It is a wonderful feeling
to ski in a storm, evening coming
on + a warm home and dinner
at the end of the trail.

Charles + Zephyr
going
home in the
near
dark.
wind + snow
swirling around
us
8 to 10 inches
of snow by
morning.

FROM MEMORY (4 PM)

SKIJOURING INFO

Jan 10 '99
Our Ski Party stopping
on Hawkins Hill to watch
the Red Tailed Hawk
soaring above the east
Side of the slope down
to the Winooski River
Valley. Dogs, Zeph + Bud
(on harness)
11 years old, happy - once
we get the hard·pack
of the snow·mobile trail
under their paws -
10°· perfect skiing
day. Beautiful
light, sun, snow.
A few tracks.
Another
A new house
on the
old pasture.

A foot of New
snow. Beautiful
Skiing. Zephyr and Bud
(husky mixe's) still
enjoy skijouring on
harness after all
these years.

SUNNY DAY 10°
TERRITORY DRUMMING cont.
10:30· Out to track down
the "snoring" of woodpeckers
which has started again.
This time FINALLY (at 10°
in sun) I locate him - A
male Hairy - very hard to
find - A female pecking
nearby Rat tat, tat tat... tat
to his sn·n·n·n·n·n·n·nowOOOR
noise - this is the closest I came
approximate this rapid·fine
drumming. He drums, she taps
for 10 min. then up higher into
tree + I dash for house to warm
my hands!
This is the coldest temp. at which
I have heard this, AND THE SOUND,
which we can hear through the
window, was absent during the
overcast + snowy days.

From armory in PM
after attending voluntary
Simplicity meeting c neighbors
and others interested.

SNOW HEAPED AROUND THE TREES

JAN 11; 10:00 AM; 10°, Sun.
Snow comming in tonight
and tomorrow. Today is
the window for tracks
from last night - before they
are covered over -
Birds this AM around feeder -
· house finches· one male
· Siskins - 1 or 2
· Goldfinches - a bunch
· nuthatches - both
· woodpeckers - D + H
· Coopers hawk· one
· Doves· mourning
· Chickadees.
·

The finches
and doves
sitting together
on the little elm.
wanted to sketch it
but the doggies made
a move to go out +
off they flew.

Opps - there HAS been snow in
the night - enough to erase the
track record or obscure it -

and scales since August, and even today some scales have fallen/blown down onto the new snow. Dispersal takes place mostly in Aug. but continues at a slower pace these 5 months longer.

Jan 3 ('99). Big snow and ice storm underway when we wake. Huge flakes give way to hard small ice pellets; then to brief freezing rain and back to a fine, softly falling snow. Every kind of snow seems represented—a diversity of snows. The sounds on the window keep changing, too. The skiing is fast and soft—we are out for an hour. See and hear a lone robin down on Clark's. Stop for hot chocolate at Jennifer and Richard's, where only 2 of their 12 ducks are still alive after coyote and fisher predation. No one is driving today. The crows are playing in the wind, which has "warmed" to +27 from −10 in 24 hours.

Jan 4 ('99). 8:00 AM, 24 degrees. A glaze of "boilerplate" on everything, but with a soft mat finish. That's the final snow, which came down with the last moisture to stick to and dapple the surface of the freezing rain as it hardened.

The shadows in the woods are bluish on a warm yellow to white snow surface. The sun is glistening up the world quite nicely. Doggies breaking through the crust. Hard conditions for wildlife, except for mice, voles, tunneling *under* glaze.

Our woods are full of birds now. Downies, hairies, nuthatches, chickadees . . . so many! It can only be because of the ice and our generous feeding this morning. Woodpecker snore-like drumming (downy or hairy? male or female?). Quiets right down as soon as I come out to see. Hands too cold to stay long.

11 AM. Quiet in woods now. DD reports a late robin at her house, pecking at the apples which are frozen but beginning to disintegrate—seem to be after the seeds. I wonder that they never use feeders.

Jan 5 ('98). Raspberry patch and wetland. 5 degrees, 11:00 AM, sun, no clouds or wind. Light new snow (yesterday PM). Extraordinary tracking conditions on crust, with good light and shadows even at noon due to low winter sun. Every grain of snow shows up, blue shadows on golden snow. Golden-crowned kinglet singing.

Crow schedule—we can set our clocks by this: 7:00 AM. Small groups of crows flying E, commuting to their day's work at the big farms N of here; 3:30–4:30 PM back W to roost together in Montpelier.

Jan 7 ('98). Another beautiful day, not as cold but all the tracks covered by last night's snow showers. This morning I ski out—much better temperatures

for stopping to look at things (20 degrees ±) but the only tracks are from a few snowshoe hare at dawn, and red squirrels which are active during the day.

I begin to appreciate the colors and texture of the snow more. Today it is a dappled texture and blue on gold with many small subtle light refractions from very fine crystals. Looking forward to tomorrow with one full night of track accumulation and temps in the upper 20s, with sun (for shadow definition).

Jan 8 ('98). Grouse tracks everywhere, total walk-about as all animals seem to be out stoking up in advance of the big storm coming tonight: porcupine, the 2 fishers (mom and young—these guys are everywhere over a several mile, 2-hour ski on Clark's and this side), coyote, fox, scores of snowshoe hare, etc., etc.

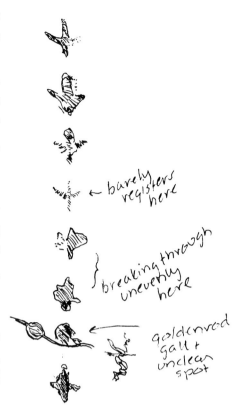

Jan 12 ('99). Another 10-degree day, but no sun inside or out to warm things. The coldest night, −25 degrees. Length of day = 9 hours, 21 min, pulling out of its solstice "stall" of 3 weeks ago. Today a full 15 min longer and gathering momentum.

Jan 13 ('99). Fine bullet-type snow pouring down all morning. Roads horrible. Then, SUN (suddenly as an arctic cold front comes through) for most of the afternoon and into early evening. None of the snow crystals are symmetrical, but a light fluffy snow, consisting of conglomerate clusterings of small, varied ice crystals, each crystal reflecting light and with darker holdings where the light seems "drawn out."

At 9:00 PM, temp at −12 degrees and dropping. A very cold night, expected to be −25. We scurry around, open all interior doors so rooms won't freeze, load woodstove to top, fill bath tub with hot solar/wood-heated water as a heat sink, etc. Where do all the creatures go? Do they do special things on −10 degree and colder nights?

Jan 14 ('99). −25 degrees in AM. Sun warms the house by 9:30 or so. At 10:00 I hear the hairy woodpecker's territorial drumming in the woods. And it's −17 degrees! Earlier we hear the chickadee's territorial call, *phee bee,* at −22!

4:30. The crows are now leaving the roost and heading southwest around the flank of Hubbard Park hill. We follow them by car, Charles driving and me scouting out the open window at −5 degrees. They're getting amazing wind chill up there, maybe why they stop here and there, like at our yard, to warm up.

BUTLERS FIELD · 1·21·99 Hard cRUST / light dusting
Edge at top

Many small holes in field — 5 in 30 ft
these contain urine stains and squar
stat - 1½" X 1", with large cavern
inside → from 7 to 26 feet apart.

These two holes open to larger chamber + tunnel.

firm icy walls inside.

1" x 1"

1½ inch to 3"
mostly 3".

1½ "straddle

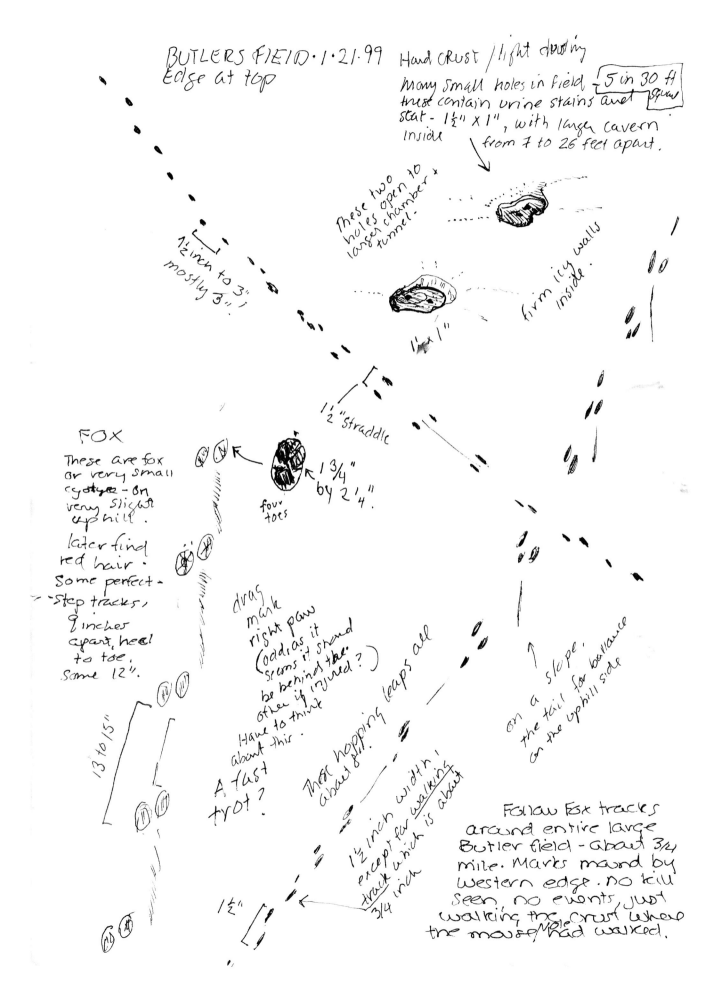

FOX
These are fox
or very small
coyote - On
very slight
uphill.
later find
red hair.
Some perfect -
step tracks,
9 inches
apart, heel
to toe.
Some 12".

1 3/4 "
by 2' 4".

four
toes

13 to 15"

drag
mark
right paw
(odd as it should
seems it should
be behind the
other if injured?
Have to think
about this.

A fast
trot?

These hopping leaps all
about 8".

1½ inch width,
except for walking
track which is about
3/4 inch

on a slope.
the tail for ballance
on the uphill side

1½"

Follow Fox tracks
around entire large
Butler field - about 3/4
mile. Marks mound by
western edge. no kill
seen. no events, just
walking the crust where
the mouse/had walked.

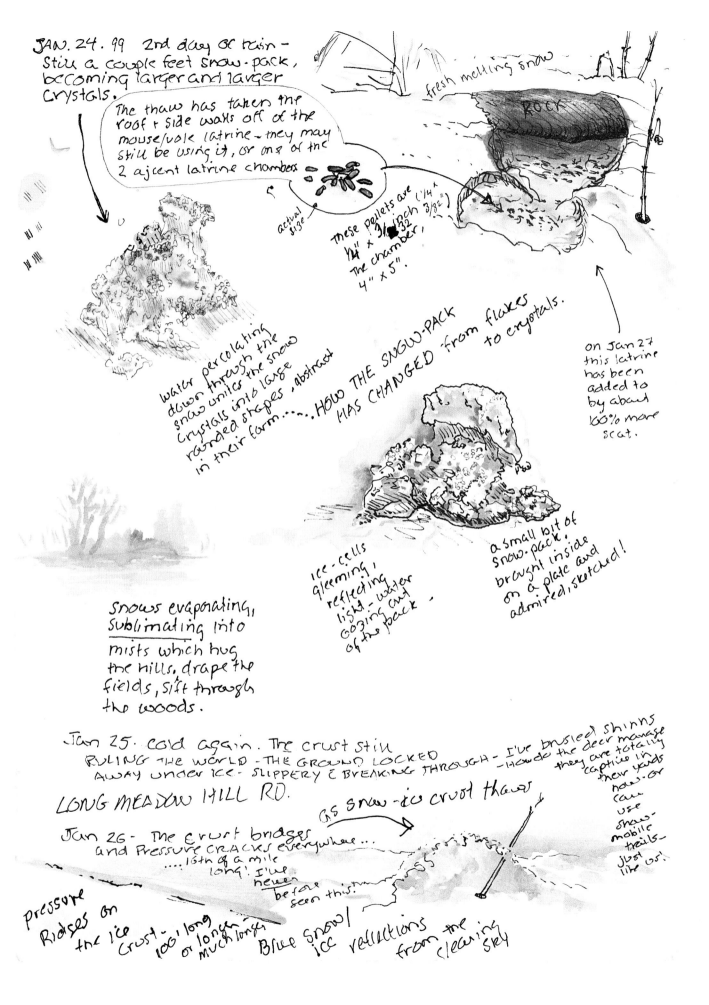

JAN. 24. 99 2nd day of rain – Still a couple feet snow-pack, becoming larger and larger crystals.

fresh melting snow

ROCK

The thaw has taken the roof + side walls off of the mouse/vole latrine – they may still be using it, or one of the 2 adjacent latrine chambers

actual size

These pellets are (1/4") 1/4" x 3/32" (1/8 inch 3/32) The chamber, 4" x 5".

water percolating down through the snow unites the snow crystals into large rounded shapes, abstract in their form.....HOW THE SNOW-PACK HAS CHANGED from flakes to crystals.

on Jan 27 this latrine has been added to by about 100% more scat.

ice-cells gleaming, reflecting light – water oozing out of the pack

a small bit of snow-pack brought inside on a plate and admired, sketched!

snows evaporating, sublimating into mists which hug the hills, drape the fields, sift through the woods.

Jan 25. cold again. The crust still RULING THE WORLD - THE GROUND LOCKED AWAY UNDER ICE - SLIPPERY & BREAKING THROUGH - I've bruised shinns - How do the deer manage they are totally captive in their yards now - or can use snow-mobile trails - just like us!

LONG MEADOW HILL RD.

Jan 26 - The crust bridges and pressure CRACKS everywhere...15th of a mile long! I've never before seen this.

As snow-ice crust thaws

Pressure Ridges on the ice crust - 100' long or longer, much longer

Blue snow/ ice reflections from the clearing sky

They peel around to the red pine groves on the hill high above the state capitol building where, as dark falls, we see great swirls of them boiling up from time to time. Then we head home to a warm house, and a voice mail message with crow questions from several people in Montpelier.

More snow crystals. Snow tonight has long spikes all jumbled and broken in their fall. Some others, feather-like. I see this by freezing a black bowl outside, snow falls in, bring bowl inside, look quickly with hand lens as it begins to melt almost right away. Such a totally different kind of snow from yesterday's.

Jan 15 ('99). Big storm with many inches of snow upon us. Still o degrees. Sleet now as warmer air pushes in above us but does not reach us here on the ground. We know it's up there, though, from the frozen raindrops clicking down all morning. The thermometer inching gradually up.

I'm sick in bed, propped up next to the window, with books and binoculars, and a hot water bottle on my feet, drinking ginger tea and honey. Ginger tea recipe: Slice up some whole fresh ginger root. Simmer in a few cups of water for about ½ hour. Dilute or drink full strength (honey optional) for stomach upset or mix with punch or black tea (iced) or peppermint or other juice or tea for refreshment.

Jan 16 ('99). Tracks over back field found on short walk after dark, by flashlight. A carnage of pilfered goldenrod galls. Crows tracks all around them and in our back yard by the compost. Also a fisher came through last night on top of the crust, bounding without breaking through, one of the young ones, alone.

Jan 17 ('99). Colchester, Vt. A beautiful, sunny, 40-degree day. Flock of pine grosbeaks in woods near the lake. Heard but only seen out of the corner of our eyes. Two note or a rich warble, unexpected at this time of year.

Later, sledding on the hill by the big field where the ground is crisscrossed with fox tracks, some double. There will be a den again this year, with any luck. Many of these are older tracks, but none from before last week's ice storm. The children are delighted with the tracks, the crust, which they can walk on and we can't, the "little balls"—goldenrod galls—and the sun. Sledding seems secondary to them.

Return home to find huge hawk tracks on porch where a dove has been caught and picked clean and eaten, all right on the deck! Astounding. Nothing remains but thousands of feathers, a gall bladder type of organ, and one or two bones. The Cooper's hawk which we so often see is a prime suspect.

Jan 18 ('99). Rain! Shoveling the deck, snow-raking roof, brief ski at dusk, an indoor workday. Cooper's hawk back, in the woods next to the house.

Jan 19 ('99). A day of snow settling into snow pack. The air is right around freezing but there is water oozing out from under the snow onto roads and sidewalks, and as the soft fluffy snow re-forms into larger and larger crystals, the pack gets denser and less deep. As it shrinks, holes open up around the base of trees.

Jan 20 ('99). Colder. Heard the coyotes calling last night. Mating should start soon. The big fields at Clark's are altogether locked up in a layer of thick ice crust, even harder to break than in the woods. There is absolutely no sign of tracks of any kind. The mice and voles and shrews are safely under the ice with all the food and warmth they could need. It is hard going now for all the animals who build their diet around them, and on the deer who cannot move around or avoid the larger predators. How do the foxes and owls manage? Snowshoe hare are up this year, but are there really that many? They must be terribly difficult to catch, compared to voles.

Lori Barg did see a fox carrying a snowshoe hare yesterday, in Plainfield.

Jan 20 ('99). Gray, 35 degrees. Very little breaking through, except for the deer, which must be confined now to the trodden down "yards" until the crust softens more. This heavy white crust, a full inch and a half thick, is molded to every contour of land, a couple more ice layers underneath. It's settling gradually into what, after enough of these freeze-thaw cycles, becomes drifts of heavy, large diamond like crystals — snow pack transforming.

Jan 21 ('99). Very light snow in night. Sun and in the 40s, mid-day. Feels like spring! Today, tracks are everywhere. Mice and even voles are making their way up and onto the crust. Fox and hare and of course squirrels, grouse. All are hard to follow far because they become lost on the sections where the light snow is swept away.

Jan 30 ('99). Cold moonlit night. 0 degrees by morning. Home late for a moonlit ski. 10 degrees, blue shadows, sky blue-black, the moon a soft golden hue, and all the moon glow patches on the snow have this same warmth, as does the snow on the dark trees.

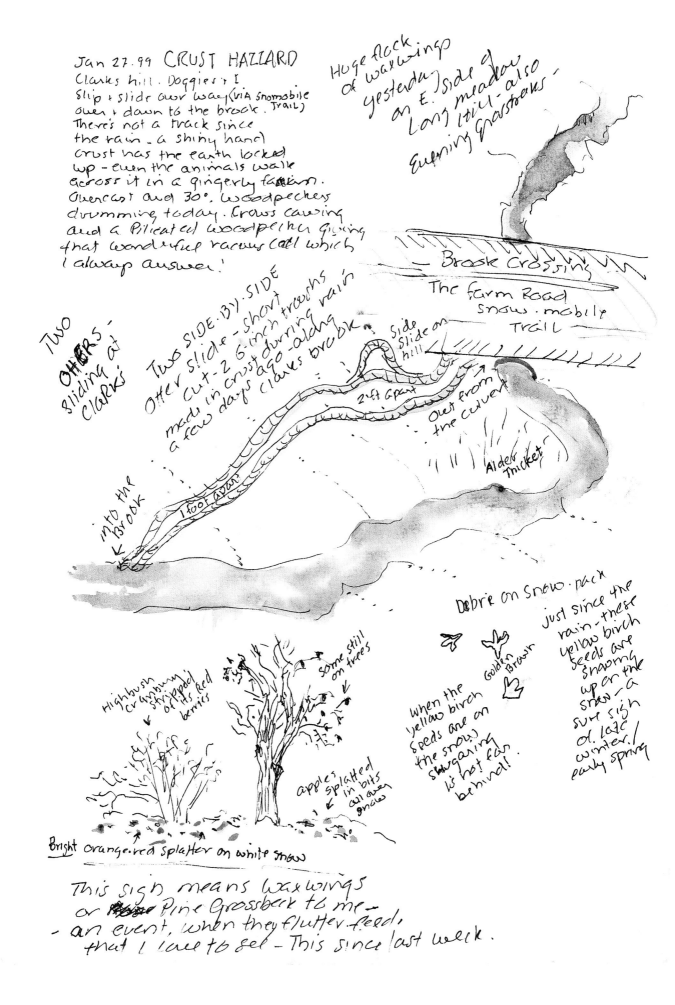

Jan 27.99 CRUST HAZZARD
Clarks hill. Doggies + I
slip + slide our way (via snomobile trail)
over + down to the brook.
There's not a track since
the rain - a shiny hard
crust has the earth locked
up - even the animals walk
across it in a gingerly fashion.
Overcast and 30°. Woodpeckers
drumming today. Crows cawing
and a Pileated woodpecker giving
that wonderful raucus call which
I always answer!

Huge flock
of waxwings
yesterday
on E. side of
Long Hill - also
Evening grossbeaks

Brook Crossing

The farm Road
snow-mobile
Trail

TWO
OTHERS.
sliding at
Clarks

TWO SIDE-BY-SIDE
Otter slide - short streaks
cut - 2·6 inch treads
made in crust during rain
a few days ago - along Clarks brook

Side
slide on
hill

2 ft apart

Out from
the culvert

Alder
Thicket

into the
brook

1 foot apart

Debre on snow-pack

Golden Brown

When the
yellow birch
seeds are on
the snow
skiegoing
is not far
behind!

Just since the
rain - these
yellow birch
seeds are
showing
up on the
snow - a
sure sign
of late
winter /
early spring

Highbush cranbury
stripped of its Red
berries

Some still
on trees

apples
splatted
in bits
all over
snow

Bright orange-red splatter on white snow

This sign means waxwings
or Pine Grossbeak to me -
- an event, when they flutter-feed,
that I love to see - This since last week.

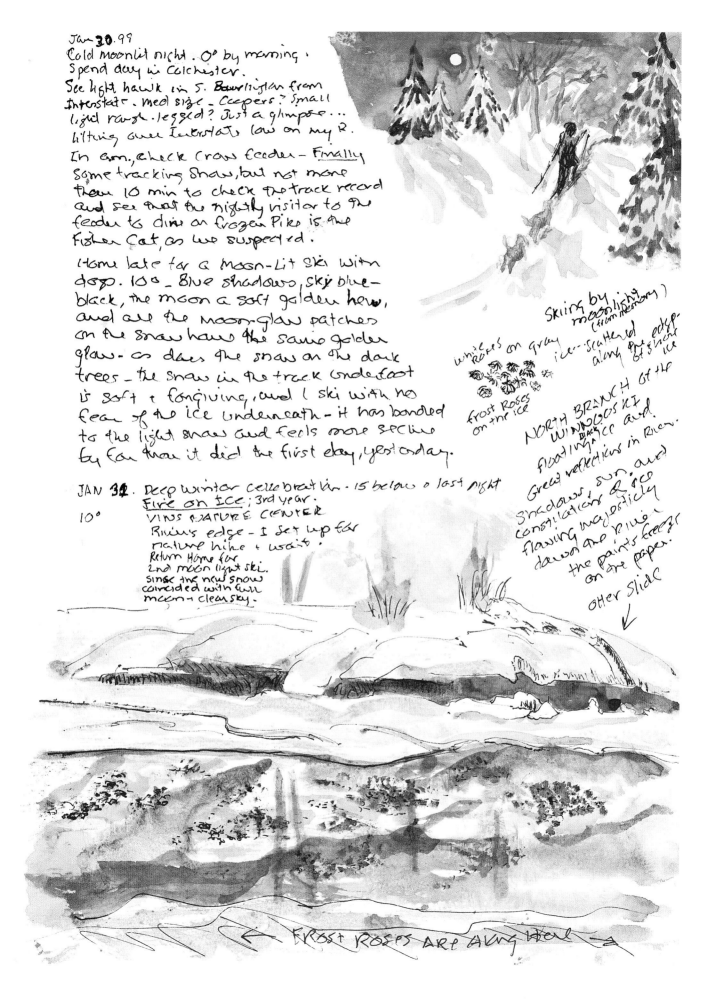

Jan 30. 99
Cold moonlit night. 0° by morning.
Spend day in Colchester.
See light hawk in S. Burlington from
Interstate. Med size - Coopers? Small
light rough-legged? Just a glimpse...
lifting over Interstate low on my R.

In a.m., check crow feeder - Finally
some tracking snow, but not more
than 10 min to check the track record
and see that the nightly visitor to the
feeder to dine on frozen Pike is the
Fisher Cat, as we suspected.

Home late for a moon-lit ski with
dogs. 10° - Blue shadows, sky blue-
black, the moon a soft golden hew,
and all the moon-glow patches
on the snow have the same golden
glow - as does the snow on the dark
trees - the snow in the track underfoot
is soft + forgiving, and I ski with no
fear of the ice underneath - it has bonded
to the light snow and feels more secure
by far than it did the first day, yesterday.

JAN 31. Deep winter celebration - 15 below 0 last night
Fire on ice; 3rd year.
10° VINS NATURE CENTER
 River's edge - I set up for
 nature hike + wait.
 Return Home for
 2nd moon light ski.
 Since the new snow
 coincided with full
 moon + clear sky.

Skiing by moonlight
(from memory)
whites & reds on gray
ice - scattered edge
along the edge of shore
ice
frost roses
on the ice

NORTH BRANCH of the
WINOOSKI
BLACK ICE and
floating ice and
Great reflections in River.
Shadows, sun, and
constellations & ice
flowing majestically
down the River -
the paints freeze
on the paper.
OTHER SLIDE

← FROST ROSES ARE ALONG HERE →

Surviving Winter

A Matter of Style, a Question of Degrees

When we humans encounter a threatening person or face a troublesome time, we have a variety of responses. We may stand our ground, unyielding, puffing up, prepared to fight. We may charge forward, trying to gain control and seize the advantage. We may hang back, measuring the opposition, trying to find openings in the armor, a way into the softer areas. We may also look for quick alliances with others who might be nearby or in similar danger, building force by numbers. And then we often turn and flee, choosing to abandon any claim of territory for a more pacific or hospitable environment elsewhere, or seek a safe, out-of-the-way spot, curl up, and hope the trouble will miraculously disappear.

As individuals, we may react consistently in just one of these ways, or all of them at various times, depending on the situation, our mood, our disposition, cultural conditioning, or what's at stake. At least we have this range of options available to us—we think, or hope—when times get tough.

But consider if you are not a human, but any other animal. Or any plant, for that matter. Nature has endowed you, too, with at least one of these ways for dealing with a threatening, troublesome, and implacable adversary: the epochal New England event called winter. All the plants and animals here collectively display this same range of options for survival.

Birds in the hundreds of species, some mammals (a few bats, whales, and seals), fish, and insects, blessed with wings or fins and the wherewithal to travel long distances, in the fall simply depart for other places more suitably benign, mostly southern and coastal United States, Mexico, or Central America, where they can continue living their lives pretty much as they have other times of the

year. ("Southern" and "benign" are relative, of course. Several arctic-breeding species such as snow buntings or beluga whales may move south for winter into "balmy" New England.)

Some birds, especially northern species such as pine siskins, redpolls, snow buntings, evening grosbeaks, and snowy owls, while still freely mobile and with migratory tendencies, seem rather to be wanderers (maybe opportunists is the better term), as their presence, arrivals, or departures are less predictable; some years they may be here—or show up—in sizable numbers all winter, others intermittently, sporadically, meagerly, or not at all. Northern species exhibit this wandering most, probably because their food supply, whether rodents, fruits, or seeds, is so erratic from year to year, flush in some, scarce in others. Some New England summer residents will also delay or dispense with migration, too, if conditions permit, such as some dabbling ducks where water remains unfrozen and robins near human habitation.

Then there are the animals (and plants) that, whether limited by body architecture, physiology, habits, available sources of food, or reasons yet to be discovered by scientific digging (could it be that some just like New England winters?), remain here the year round. They are adapted to, or adapt to, the seasons as they come and go, to these very limitations, or at least to the limitations most imperiling their existence.

Many continue much as they do the rest of the year, active and searching through the cold days or nights, trying to find what they can of their traditional foods—prey or vegetation—though they might be scarcer: foods such as active small mammals (eaten by, for example, barred owls and fishers); birds (eaten by sharp-shinned hawks, northern shrikes); fish (by puffins, gray seals); dormant insects (by pileated woodpeckers, brown creepers); leftover seeds and fruits (chickadees, goldfinches, meadow voles); buds, bark, and twigs (deer, moose, snowshoe hares); carrion (green crabs, herring gulls); or any of these, depending on what the winter-active animals find or are able to scavenge (coyote, crow).

Many such animals change physical appearance or physiology to deal with the new demands of the season. Mammals often grow new coats of fur whose hairs are hollow and thus better insulators; they also may store white fat as an energy reserve. Birds shiver to produce more body heat when needed,

and some, like the partridge, grow feathers over their bills and feet to protect those more exposed areas. Most have special circulatory systems that can pre-heat cool blood coming from the feet, an area of great energy loss and vulnerability.

Others change behavior. Through summer and fall, chipmunks store up great quantities of seeds, a larder they can draw upon when necessary in winter. Chickadees and shorttail shrews in spring, summer, and fall are rather solitary, or at least independent, but in winter they come together with others of their kind, pooling body heat at night or during especially cold spells by bunching up in tight common spaces—chickadees in tree cavities, shrews in underground chambers—from which they venture forth in their daily, daytime forays for food. (Garter and other snakes "ball up" underground in winter, too, but, unlike chickadees and shrews, remain in hibernation throughout.)

For many of these species, making it through usually means making do with less. They lose weight, experience degrees or modes of starvation; indeed, starvation may even be their means of survival, ironic as it sounds. Wildlife biologists in the Arctic, studying how caribou can survive the long, harsh winters on a high-fiber, low-protein diet of mostly lichens, found that the animals actually "downsize," losing mass and reducing caloric requirements as they adjust to the available quality and quantity of food. In other words, caribou spend less energy doing with less than they would spend trying to find more. In New England, biologists also record that white-tailed deer regularly lose 25 to 30% of their weight each winter, even if they are fed artificially—perhaps a comparable strategy to their cousin, the caribou.

It may even be true of us humans. Of Native Americans, William Cronon wrote, "Northern Indians accepted as a matter of course that the months of February and March, when the animals they hunted were lean and relatively scarce, would be times of little food." The ability to withstand, even to the point of starvation, under this interpretation is not a liability but an asset, not for the individual, of course, but for the group as a whole.

Over the eons of continuous biological experimentation we call evolution many creatures have arrived at other means that seem to work as well as resisting or persisting. Instead, they either roll with the punches or avoid them altogether: taking advantage of better times, places, or situations, lying low during especially difficult periods, or simply waiting—patiently or asleep—for more bountiful times to return.

The sleep is light or short for some. Red squirrels may only do so for the duration of a storm or deep freeze. Striped skunks and raccoons can go for weeks or months in slumber, living off built-up fat, arousing only occasionally

during milder spells. Chipmunks seem to have not made up their minds: sometimes they remain active underground all winter, living off food they have hoarded, but sometimes they fall into semihibernation, probably due to the lack of such storage.

Others' sleep is longer and deeper, a form or modification of hibernation. Beneath the root ball of an upturned tree or within a shallow cave of cliff-fallen rocks the black bear spends winter, its body temperature lowered markedly, its breathing slowed to a few inhalations per minute, its heart pumping blood weakly, infrequently, through the torpid body. Even so, being so, it does not hibernate, but rouses occasionally during the darkest, coldest months—mothers even give birth and suckle their newborns then.

Still others hibernate in the truest, strictest sense of the term—their breathing practically stops, their heartbeat becomes so infrequent as to be undetectable, and their body temperature falls to near freezing. That of some insects, reptiles, and amphibians actually goes below freezing; their blood is protected from crystallizing by the presence of glycol—literally antifreeze. In the Northeast, jumping mice, woodchucks, and some species of bats are the only mammals that truly hibernate, while most reptiles and amphibians do so, buried in mud or deep soils below the frost line, as do many insects, either as larvae (e.g., the woolly bear caterpillar), adults (the mourning cloak butterfly), or somewhere in between (pupae, such as chrysalises of the cecropia moth).

Then there are those that go even a step beyond hibernation, closer to the appearance of death. Suspended animation, we used to call it. Imagine a being with no pulse, no breathing, no detectable sign of life—until we see it miraculously come to life again. This may be, in a way of thinking, the most perfect way to spend the winter: frozen solid, for all intents devoid of life, therefore seeming to need little or nothing of what life requires for its continuation—air, food, water. Many insects so transform, expelling water from their tissues and becoming dry as old bone, therefore making themselves freeze-proof no matter how cold it gets. Some frogs and fish are able to enter this state if trapped in suddenly freezing water, though it is not their usual mode.

Tardigrades, commonly called "water bears" for their appearance and shambling manner of movement when seen under the microscope, are minute, cosmopolitan arthropod inhabitants of mosses, lichens, seaweeds, and many other places. They are perhaps the champions of suspended animation. In a dormant state ("tun") they are able to withstand temperatures as low as −270 degrees Celsius (−454 degrees Fahrenheit) or as high as 145 degrees Celsius (293 degrees Fahrenheit). For protracted periods they can be immersed in acid, placed in an oxygen-free atmosphere, even subjected to total vacuum, and still

revive. They can pass a hundred winters, a century or more, in such a state, mimicking stone, then suddenly return to life with the simple addition of a little water.

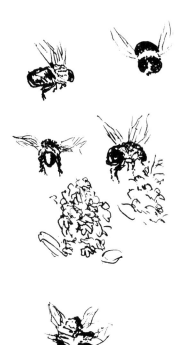

So comes the question, apparently absurd on the surface: is it possible that dying actually could be considered a way of making it through the winter? Obviously, the life-form "making it through" in this case would not be the individual but the species. Bumblebees, for example. All the individuals except the pregnant queen die in the fall, leaving to her alone the future of all her generations to come. The wholesale die-off may be essential in this group of bees, which, unlike honeybees (who do survive the winter), stores little food for the masses emerging in early spring.

Certainly the drive for survival in many animals goes far beyond the welfare of a single individual. The pooling of body heat, for example, confers benefits to the whole, not just one bird or mammal taking part. We humans regularly sacrifice ourselves for others out of love or duty or principle. Surely such acts are not wanton but demonstrate there is something more important in life than ourselves. Does not all death make room for younger lives, even provide the sustenance by which life itself is nourished?

We find in plants, too, all the same strategies at work as in animals, though we have arbitrarily given the functions different names. Some mosses, lichens, algae, and coniferous trees are active all winter, though perhaps at greatly reduced rates. Maples and oaks, hobblebush and dogwoods, all "hibernate." Seeds and spores of most plants freeze solidly, entering "suspended animation" until a propitious spring, decade, or, sometimes, century arrives; some seeds even require freezing for germination. All annuals, and the above-ground parts of many biennials and perennials, die—while their seeds survive winter and carry on the

species. Whether for plant or animal the concepts are the same, if not the particular designs or our verbal assignations.

The boundaries blur in other areas as well. It was once believed that of warm-blooded animals, only mammals hibernated. But in the American West, a species of swallow was discovered that spends the winters in full hibernation,

clinging like bats to canyon walls, plastered in the crevices. It was also believed that humans of all times and places stayed active all winter by hunting animals, by living off their agriculture (either fresh or stored), or by engineering solutions (transporting goods, creating artificial environments). But aside from ever more complex technology, which seems to be the main human strategy for surviving winter, many peoples—just like plants and animals—have adapted with their bodies. They can tolerate temperatures much lower than we New Englanders think possible, let alone comfortable, such as the Nepalese who walk barefoot in winter in the Himalayas or sleep uncovered and exposed to its nights; the Patagonians who swim naked in near-antarctic waters, sharing the space with icebergs; the Inuits whose very life is geared to cold. At the extreme, a race of Greenland Inuits was discovered whose members spend much of their long winters in extended sleep or slumber, their body temperatures and breathing rates dropping far below the normal. Is this a form of hibernation?

Winter is not just a time for passing, a long period of wait for some awakening, any more than is sleep for the 24-hour cycle of our day. Rather, it is a vital, necessary part of life, maybe even when life reveals itself most. Who knows? Maybe even bears, bumblebees, and tardigrades dream. Or, possibly, elms, viburnums, and goldenrods.

Winter, when measured opposite summer, as is often done, is like the unfilled space in a painting or piece of sculpture, the quiet spell in music, the unspoken in speech, the unwritten in writing. Each allows the other to be known, gives it definition and dimension. Makes it possible, even. Winter, whether spent in struggle, rest, oblivion, or death, brings essential restoration, meaning beyond consciousness.

IMBOLC · ½ way from Solstice to Equinox

Feb 1 · Sun - Fresh Snow - 30's°
tracks are "off the charts" track
and hard to follow. Take alot of pictures.
Fisher Cat everywhere - no
sign of the porcupine - related,
possibly! Out for 2 hours on
Clarkes enjoying it. Follow the
fox tracks for awhile - marks the
white stone in the big field again.
Feb 2. Even though I've been all over
there.

↳ GROUNDHOG DAY SNOW
Snow flakes 1 inch across -
actually amalgamations of
many flakes - these fall
slowly. Two Two Crows
have been eating corn
out by the coooptsl +
are now sitting together
at the edge of the clearing.
Last night! followed the flock
(several hundred) at 4:00 - 5:00
to a pre roosting spot S. of town
hill below the end of _____ St.
Then after 45 min to their roost
in the softwoods behind College
St. in the ravine just S of Cameron's
house. At dark, with my ears cupped
I can hear a thousand soft gargelled
"Caws" and as many pairs of wings
adjusting + fidgets - flapping as they
settle in for the night.

11:00 AM Outside on dark blue plate,
MANY 6 sided left out to
flakes - some whole cool. With 10
many melting or power, $4.00
melted partially handlens from
already. Also U. of vt · store.
long spikes in
the flakes masses.
Saw these before
where a freezing
rain was forcast, & it is today.
Still 25°.

(left margin, rotated text:)
Everyone stops + is interested. One
woman with a baby they
told me that she had
heard.. when the
crows return to
Vt.. it's time for
Spring.. But
suddenly they are
NOT leaving for
the winter.. and they vary
their roosts
over the week
- perhaps
related
to bird
temp.
Still,
Always
return
to montpelier
environs at
night to roost,
returning from
the E. Mautelier
farms + woods.

(bottom rotated text:)
Feb 3.
By 10:30, Hot sun!
Cold wind! the snow become gullies
on Clarkes hill has
a "bad-lands" of snow-
running down the hill.

Feb 2. 1st sign of the
Crow flock beginning to
turn attention to pairing
up. two lone crows acting
in unison. They have
just been eating the
Sprinkled corn below -
no signs of the rest of
the flock. It's 25° and
9:30 Am. from window
using that anitas frisket stuff.

Feb 3. Rain all night Light
Soft fog lifting in am.
Snow still very much intact

(right margin, rotated text:)
1st day the
Grotton hills
look
red
Spring
color!

The wind picks my page
up + slings paints into
snow 3x!

FEBRUARY

Feb 13 ('99). Mass. Audubon Sanctuary, Wellfleet, Cape Cod. Visiting the coast in winter. Bluebirds wintering in the coastal heathlands at Marconi Station. Oldsquaws, eiders, buffleheads, dovekies off Provincetown wharf.

Feb 14 ('99). Low 30s, wind and snow. Take small boat to Billingsgate Shoals to see harbor and gray seals in a dramatic—and stormy—setting.

Feb 18 ('99). A soft gray day. The snow pack sagging into solid mass before it degrades into honeycombs of "rotten" snow. Right now it holds me up and skiing is possible anywhere in fields or woods.

The paths cut into the snow by deer in their primary "yard"—these paths are about a foot below surrounding snow and about 18–24" wide, and are criss-crossed over many acres of hemlock and fir.

The porcupine is in the maple again—surprised to see it in its den on such a mild day. It moves further inside as the dogs approach the tree and never shows its face, only the soft long fur and quills of an ample backside.

Feb 19 ('99). PM. Two red squirrels actively rushing about the garage rafters and fussing at dusk. Then at 7:30 PM we hear them overhead in their loud and protracted mating squabbles. Racing and scuffling overhead, with a constant torrent of chattering.

Cedar waxwings! Come across a flock of 30 or so in the raspberry patch, after finding the buckthorns stripped of berries and blue stains beneath them. Many winters it's Bohemian waxwings that do this, but this year the yellow

- When crows first sit quietly together away from the flock, and the snow-pack is sagging, it's Imbolc—halfway between the winter solstice and spring equinox.
- When the days get longer sugar makers are ready for the first sap flow, juncos are trilling, and someone reports hearing the first redwing blackbird.

39

tummies and under tail coverts prove not. I've never seen buckthorn or high-bush cranberry here eaten by any but pine grosbeaks and waxwings. Some years there are so many flocks that their purple droppings are everywhere on cars and walks.

Feb 24 ('99). Wetland at DD's and Stuffy's. 3 degrees in the sun. The beavers are home. Warm, moist air from their breath and bodies, exiting the lodge through a vent like smoke from a chimney, tells me they are in residence.

The sun has melted snow on the S side of the lodge. There are several spots where moist air from the beavers' warmth has left big "hoar" frost type crystals. All this, along with a woolly smell I can just detect, say "inhabited."

Sketching in the sun. Too cold to stay out long without moving. The muskrat hole is still open, and very faint tracks lead to lower ponds.

Feb 25 ('99). Last week in February. Creatures getting hungry, food supplies for many dwindling or inaccessible under the icy crust. Cloudy, snow, 1" accumulation. 10 degrees all day.

Kim and Jamie report turkeys eating apples—only a few apples left, but 2 birds in tree. They must be very hungry as there are no oaks here and the beech crop mostly failed last year. I bring the remainder of our cracked corn over and see the many tracks under the tree. I hear later that they returned for the corn.

The turkeys in the tree, as Kim described, were very ungainly, awkwardly stretching their necks way out to peck at apples which then fell to the ground. The turkeys on the ground all rushed upon them for any bit of nourishment, eating not the flesh but the tiny seeds.

Deer eating birdseed under a bird feeder on Towne Hill Rd. I've seen them here several times in the afternoon well before dark. Their winter coats make a thick concealing hide—they look healthy and fat though this can't be.

Feb 27 ('99). Signs of spring! 30s, blazing sun. Ski over to Sibley Farm where we see half the community out enjoying the day, and the perfectly groomed snowmobile trails, and where the snow is peppered with snow fleas—springtails. Later in the day I ski down to Clark's field where the small stoneflies are out, all over the snow, in the big field above the brook.

Feb 28 ('99). Weather coming in, wind, strange clouds—warm—then snow! 1½" by dark. Length of day = 11 hrs, 8 min. Sun rising this week almost on flanks of Spruce Mt.

Eat and Be Eaten

Through stories, often with animals as characters, fairy tales try to warn about the vices and virtues in the human condition — the pitfalls to avoid, the bitterness of greed, the goodness of honesty, the rewards of patience, the need for being careful in strange environments, the folly of vanity. They tell us lessons, put us on the right track in life. But they also make us take sides and play our favorites. Who of us, for example, did not first learn to fear the wolf in Little Red Riding Hood:

> "Why, grandmother, what great big ears you have!"
> "All the better to hear you with, my dear."
> "Why, grandmother, what big eyes you have!"
> "All the better to see you with, my dear."
> "Why, grandmother, what long, sharp teeth you have!"
> "All the better to EAT you with, my dear!"

The message here is clear: evil people are out there, waiting to take advantage of you, maybe even kill you, and they are often disguised or lying in wait. You must be aware and be careful. The analogy of the wolf is apt and timeless, the image vivid even though that particular animal no longer shadows our steps in the wilderness, no longer poses a danger to most every one of us. The legends long outlive the wolves, fanning fears not yet extinguished.

Another message of this story lies subtly under the surface, like a current felt rather than seen, also inherited from more primal times of our existence. Predators — those animals that prey upon and eat other animals — are

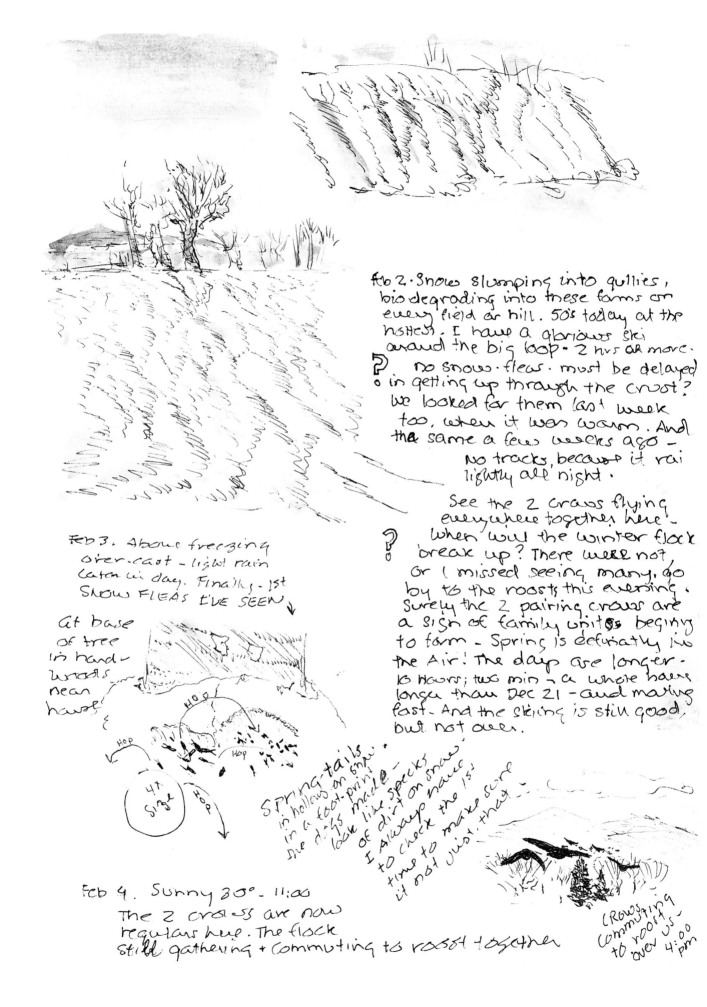

Feb 2. Snow slumping into gullies, bio degrading into these forms on every field or hill. 50's today at the hottest. I have a glorious ski around the big loop - 2 hrs or more.

? No snow-fleas. must be delayed in getting up through the crust? We looked for them last week too, when it was warm. And the same a few weeks ago - No tracks, because it rai lightly all night.

See the 2 crows flying everywhere together here.

? When will the winter flock break up? There were not, or I missed seeing many, go by to the roosts this evening. Surely the 2 pairing crows are a sign of family units begiing to form - Spring is definatly in the Air! The days are longer - 10 hours; two min - a whole hour longer than Dec 21 - and moving fast. And the skiing is still good, but not over.

Feb 3. Above freezing over-cast - light rain later in day. Finally - 1st SNOW FLEAS I'VE SEEN ↓

At base of tree in hard-woods near house

Hop
Hop
Hop
HOP
4x size

Spring-tails in hollows on snow, in a foot-print the dogs made - look like specks of dirt on snow. I always have to check the 1st time to make sure it not just that -

CROWSING commuting to roost, to over 4:00 pm

Feb 4. Sunny 30° - 11:00
The 2 crows are now regulars here. The flock still gathering + commuting to roost together

Feb 9 and 10 (25 Robins at
marios in Colchester)
Two dramatic weather days
from leaden unvaried gray
yesterday to a breakout of
sun + color + wind in pm.
Today under-nourished see-
through clouds are being
whipped out of here from
the west, the pale blue sky
behind them. They have
just ~~scudded~~ dumping a
few inches of snow in
squalls, and are finished,
as dry air + weak sun
tone up our newly fallen
snow into the dazzle zone.

Feb 11 and 12

Two beautiful spring
skiing days - today the
warmest. we have glorious
skis from the house out
over fields + through woods.
This, between work + other
commitments, ~~much~~ colors
the day with ecstatic, mindless
joy. ~~~~ which is, for me,
specific to February & country
skiing. now, we can with
Chas, heading to the cape for
a few days of seal watching,
and winter ocean.
 some parts of the
Shannon ^ White River still
clogged with ice. Ice-out
may happen today, with
temps in the 50s _

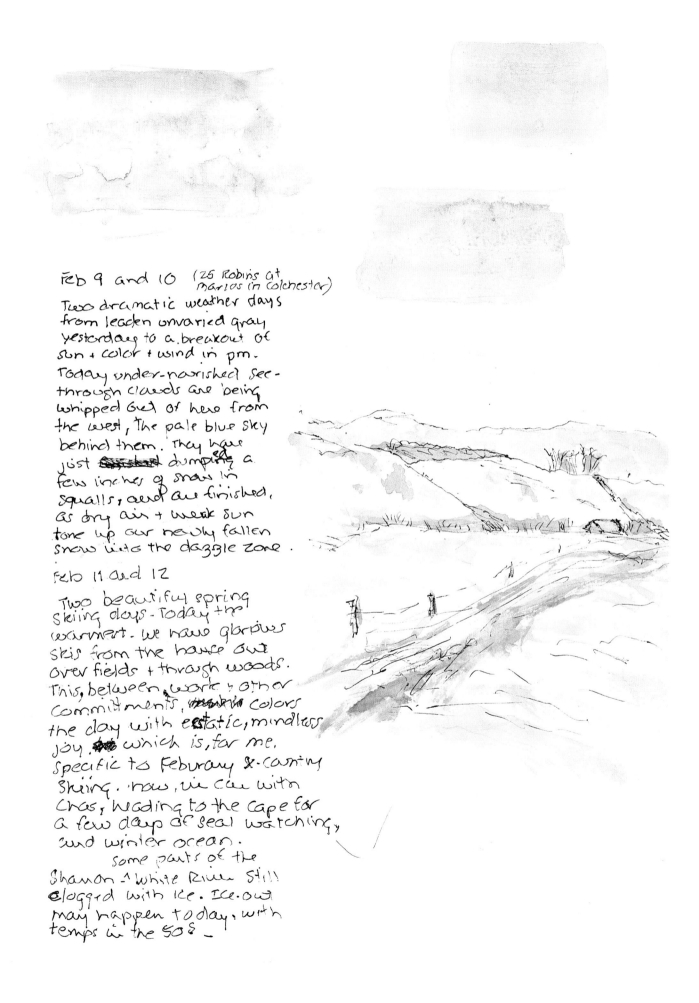

inherently wicked. They take advantage of the less powerful and intend to inflict harm. Predators should be, indeed deserve to be, eliminated. The world would be a safer place without them. So the hunter comes with his gun, dispatches the wolf, rescues Little Red Riding Hood, and we are relieved. Now we can go to sleep in peace.

This attitude has long been locked into a stereotypical view of nature, and dates mostly from a time when predators were a direct threat to people's lives or livelihoods, or their sense of security. In New England, white settlers eliminated the mountain lion and timber wolf since they posed a real or imagined threat to themselves, domestic or more desired wild animals, or even woodland travelers (settlers also eliminated the forests where these animals dwelled partly for that very reason). We see old photographs of men displaying dead hawks like murderers rightly paying the price for their plundering. Even today this attitude persists, in one form or another. Proposals to reintroduce the wolf to its native New England region have been countered with alarm and protest. Coyotes get the blame for killing sheep, an act more often due to roaming domestic dogs. Fishers have been cast as monsters capable of snatching little children from their doorsteps. The feelings and reactions may be vestigial, brought to the surface when we try to save a chickadee from a sharp-shinned hawk at the backyard feeder or a frog from becoming a slow meal for a snake. We still play favorites.

We assign both eaters and eaten to a hierarchy of power. The predator is stronger, on top, has control; the prey is weaker, underneath, is controlled. Some would almost wish the roles reversed, now and then, to make the balance right, to make it seem more fair. But everything alive gets hungry and must eat to stay alive itself. What is dined upon is not a choice from menus but a matter of old design: rabbits are meant for twigs and grasses, wolves for rabbits. The teeth are different, the jaws, the stomachs, the habits and habitats, all defining who the animals are and how they live. Their evolution has come so far without prejudice, moral, or bestowing of virtue—those are concepts of our invention and, undoubtedly, our need.

It comes down to this: no matter what brand of creature we may be, we all must find food while keeping from being food ourselves. Life and death are inseparable companions; the one defines the other. Our preferences and desires have no influence on that relationship, any more than wishing will undo that which has long since been done.

Since "eating" is a universal activity among living things, we often categorize organisms according to how and what they eat. Those that manufacture all their own food out of elements in the soils and molecules in the air are "auto-

trophs." These are mostly the green, photosynthesizing plants all around us, though some bacteria and fungi are able to make their own food without oxygen or sunlight. All the others cannot make their own food but must obtain it already prepared in some form or other. These are collectively "heterotrophs."

(Autotrophs and heterotrophs often, maybe always, live in close association with other organisms, a relationship called symbiosis: "a permanent or long-lasting association between two or more species of organisms," where one or all members derive some degree of protection, nutrition, or both. Three kinds of symbiosis are recognized: parasitism, mutualism, and commensalism. In parasitism, one species lives at the expense of the other, often to its detriment or, in extreme cases, its demise. Examples are ticks on deer and birds, wood-rotting fungi on living trees. In mutualism, both symbionts benefit and neither is harmed. In lichens, for example, a fungus provides the home for an alga that, in turn, supplies nutrients to the fungus. Ants often tend aphids—the ant offers protection while the aphid supplies food in the form of honeydew. In commensalism, one symbiont benefits while the other is neither helped nor harmed, such as many vines on trees.)

What animal heterotrophs eat further defines them. An herbivore consumes living vegetable matter, entire plants or their parts; a carnivore eats animals; an insectivore eats insects (or other invertebrates); and an omnivore eats it all—plant, animal, alive or dead.

The classification sifts down even finer with how herbivore, carnivore, or omnivore gathers its food. An herbivore grazes on herbaceous material, browses twigs and other woody plant parts, or does both, depending on the season or availability of food. The cottontail and white-tailed deer are two of these. Most carnivores and insectivores are predators, whether they be invertebrate (e.g., praying mantis, spider), fish (northern pike, brook trout), amphibian (toad, salamander), reptile (timber rattlesnake, spiny softshell turtle), bird (gannet, flycatcher), or mammal (shrew, bobcat). Some carnivores, such as carrion beetles, fly maggots, and turkey vultures, are scavengers, eating the flesh only of those animals that have already died.

Of course, these generalities are never so clear-cut in nature as in our organized minds. A black bear or red fox, for instance, at times can be a carnivore, omnivore, herbivore, or even scavenger depending on what's in season and most available to eat. Adaptability and opportunism are often the means to survival in times of scarcity.

In fact, the organizational systems we devise often seem arbitrary, reinforcing stereotypes or preconceptions. Wood-rotting fungi such as honeymushroom and horse's-hoof might just as well be called parasites or even

LAST WEEK IN FEB.
CREATURES GETTING
HUNGRY. FOOD SUPPLYS
FOR MANY DWINDLING
OR INACCESSABLE UNDER
THE ICY CRUST.

Deer eating Birdseed

Browsing under a
bird-feeder on Favre
Hill Rd. I've seen them
here several times
in the afternoon
well before dark.
Their winter coats
make a thick
concealing hide.
- they look
healthy + fat
though this
can't be .

The turkeys in the
tree, as Kim described,
were very ungainly and
awkwardly stretching out
their necks ... way out,
to peck at apples, which
then fell to the ground -
turkeys, who all RUSHED
upon them for any bit of
nourishment.

TURKEYS EATING APPLES ...
only a few apples left, but 2
birds in tree, knocking down
apples when they attempt to
peck at them, and several
birds on ground rushing up
to where the apples roll
on the slope, eating not
the flesh, but the tiny seeds.
they must be very hungry
as there are no oaks near
and the beech crop mostly
failed last year. I bring
corn over, after hearing this
story from Kim + Jamie, and
seeing the many tracks under
the tree. I hear they have
returned later for the corn.

Drawn at home. pm,
not field drawings.
Feb 25
Cloudy. Snow.
16° all day
1 inch
accum.

Feb 26. Clouds breaking by end
of day. At 4:15 pm the
crows come through
for their stop on way
to roost in Montpelier.
20° all day today.
Also at 4:15, 10 or so
Cedar waxwings stop
to look around.

Skiing at 61.32.
View of Camel's Hump
to west, and of sky
breaking up into
varied blues, each
such a different shade
[of blue] we all
keep stopping to savor
the jolt of color.
[Sara, Betty + I]

SIGNS OF SPRING!

Feb 27 · 30's; Blazing sun. Ski
over to Sibley Farm
where we see half the
community out enjoying
the day, and the perfectly
groomed snow.mobile trails,
and where the snow is
peppered with snow-fleas.
Springtails. Later in the
day, I ski down to Clark's
fields where the small
STONE → stone.flys are out, all
over the snow, in the
big field above the brook.

1st Stone flys -
Tiny wings, legs
(6) and both
antennae and
"tails" (?)

about
actual
size in
these
guys

Foot-print
dark with
snow-fleas

"SNOW FLEA" SPRING-TAILS
On the snow as if someone
sprinkled pounds of black
pepper, but with special
attention to the many foot
prints or depressions in the
snow. There are zillions there.
Impossible to count or estimate.
They darken every hollow in
the snow - at least here near
the hardwoods- right next to
the trees. There are never any
in the fields

Feb 28. weather comming
in - wind, strange
clouds - warm -
then snow! 1½
inches by dark.

| Length of day |
| 11 hrs, 8 min |

Sun rise this week
almost to flanks of
Spruce mt!

predators, since they actually attack and over time may kill living trees. Bog-dwelling pitcher plants, sundews, and bladderworts all are at times carnivorous, or at least insectivorous, when in their own peculiar ways they entice insects or other organisms to supplement their diets. Saprophytic fungi and the flowering plants Indian pipe and beechdrops are scavengers of sorts, though they remain rooted to their substrate.

Might not, indeed, all our terms be interchangeable between animals and plants? A deer could just as well be called a predator of the plants it browses. Certain aphids a parasite on alders. A bald eagle a parasite of osprey, by stealing a fish it has caught. Goldenrods scavengers of the minerals in the soil, and dung beetles saprophytes of the balls of manure they feed upon.

For predators and insectivores, capturing their quarry is most of the battle. If they are mobile and wide-ranging, such as bobcats, bluefish, or rough-legged hawks, they may hunt, relying on a combination of stealth, surprise, speed, and/or strength to overpower prey. Those less far-ranging might instead let the prey come to them, setting traps and snares. The ant-lion buries itself at the base of a funnel-shaped depression in the sand and when a victim falls in grabs it with its giant pincers. An orb-weaving spider spins its sticky, near-invisible web for its prey.

Deception sometimes plays an important part in the capturing, and might be considered a manner of trap or snare. An intriguing example is found among fireflies. Most people are familiar with their phosphorescent flashes spangling a warm midsummer night. These are the males, each species emitting as it flies a different pattern of flashes intended for the flightless females waiting in the grass below. The females, seeing them, flash back; the males drop down toward the beckoning signals. Each species has its own code of flashes, a way to ensure that males and females of the same species find each other for mating. But there is a trick one species plays, taking advantage of the system. Most fireflies are herbivorous, but the female of one carnivorous species has deciphered the code of other species in her area and, siren-like, lures those eager males down, then kills and eats them!

If nature has devised these many ways for plants and animals to obtain their food, it has spent an equal energy devising means for them to keep from being eaten. It has done so in the design of bodies, in physiologies, in certain habits and manners.

Often that which allows an organism to catch or harvest its food also is the very means it uses to avoid being eaten itself. Teeth and claws and beaks turn from food-gathering tools to weapons of defense. Modified parts protect:

quills in porcupines, spines in fish, thorns in blackberries, stinging hairs in caterpillars, biting jaws in ants and spiders, stingers in bees and wasps.

Others simply try to get away and avoid confrontation altogether, whether the deer by running, the squirrel by climbing, the duck by flying, a mackerel by swimming, a whale by sounding, or a turtle by pulling into its shell. Some try to hide, such as rabbits within the density of shrubs or woodchucks in tunnels underground or birds in the thick obscurity of leaves.

Another way to hide is by camouflage, blending with the background, making yourself invisible. The oddly constructed flounder, both eyes atop a flattened body, takes on the color and texture of the ocean bottom where it lies in wait for an unsuspecting fish to swim by. Treefrogs can change color from green to gray to brown, depending upon the background of the vegetation they cling to. Snowshoe hare and weasels are white in the white of winter, brown in the earthy summer. Some caterpillars look like the leaves on which they feed, or like thorns against twigs, or twigs against branches. Butterflies and moths assume the form of the leaves or flower petals of the plants on which they alight.

Many have somewhat the inverse ruse: pretending to be what they're not, even advertising the pretense. Many caterpillars, for instance, look like distasteful bird droppings, and are left alone. Others have markings that look like big eyes on their posterior ends, either to frighten off some would-be attackers or to direct a bird peck away from vital areas, or possibly both. (The large "eyes" on the hind wings of hairstreak butterflies or on the giant silkworm moths serve the same purpose.) Harmless and vulnerable species of syrphid flies, katydids, and moths, by looking like bees and wasps, take advantage of their model's reputation.

The pretending may be in behavior as well as body form. The mother ruffed grouse or killdeer draws attention away from her babies and toward herself by flopping around as if wounded (the "broken wing" routine). Many animals play dead when they realize trying to escape is hopeless. Puffer fish, hognose snakes, toads, and some insects when threatened often inflate themselves with air to look bigger, or fiercer, than they really are. Birds will stiffen and fluff up their feathers. Mammals will erect their hairs ("raising hackles" in dogs), turn a lip in snarl, growl, or make other aggressive or alarming noises.

It also helps to be distasteful, toxic, or downright deadly poisonous. Knowledge somehow passes from parent to child, generation to generation, about what is good to eat and what is not (one biologist has discovered that a bear cub will put its nose to the mouth of its mother as she eats, apparently to smell what kind of food is acceptable). Few predators can stomach the monarch butterfly, or the spines of tussock moths, or the warty toxins in the

bumps of toads, or the burning slime of slugs. In fact, it serves these animals well to bring attention to themselves by flaunting their toxicity with striking and unmistakable colors (warning coloration) or obvious, unforgettable structures. There is also mimicry here, with relatively harmless animals resembling their more harmful look-alikes—viceroy butterflies looking like monarchs, for example.

Sacrificing parts of oneself can be a way of self-preservation. Five-lined skinks and some salamanders have easily detached, regenerative tails, which remain in the mouths of predators while the animal slips away. Earthworms can make do with only half of themselves. Even in cases where animals might not so easily give up their body parts, adapting and adjusting are ways to survival: coyotes still hunting successfully with paws, jaws, or legs missing, bacteria developing resistance to antibiotics, birds flying without a full complement of feathers, and so forth.

We have been talking about animals mostly, but plants have their equivalent ways of self-perpetuation. To keep from being eaten, many are toxic or unpalatable to those that would consume, such as willows, heaths, mushrooms, cherry leaves, and many more. Others are equipped with defenses—thorns, stinging hairs, thick bark, sticky leaves. Plants, too, have their versions of survival through loss: sprouting when a branch is cut, producing huge numbers of spores or seeds most of which face certain failure.

And what about us? Where do we humans fit in? How would we classify, categorize, and define ourselves? We are carnivores of the flesh of most every animal and bird. We are herbivores of all the parts of plants—fruits, nuts, leaves, stems, branches, roots—turning them into food or drink. We cultivate and domesticate to make it easier for our masses to gather and dine at designated hours.

In fact, we humans have been supremely successful, not only at eating just about everything, but also at avoiding being eaten by anything (except microbes, and we're working on eliminating them). But it goes further. We consume in many more ways than simply by eating: we wrap fur, feathers, and skin around ourselves to keep warm or be fashionable; we cut plants into wood for homes or fuel, weave them into clothes and paper; we devour our water, our air, the very rocks and substance of our foundation. We are predator, browser, grazer, parasite all in one, of all the world, all at once. But we are also that even of ourselves. In a world grown too full of us and our appetites, we seem to turn upon each other in a different, more rapacious kind of hunger.

In Darwin's scheme, only the fittest survive. But in the greater scheme, the fittest too must die. In every game there must be losers if winners are to be;

both are necessary for there to be a game at all. By which standard, then, do we measure success on Earth—number of victories, numbers of those vanquished, longevity, durability, memorability? Or is it none of these, but something else? No victor, no victim, no comparison of spans of life or toughness or strength. Maybe just being is enough, simply knowing that we were here for whatever time was ours to stay.

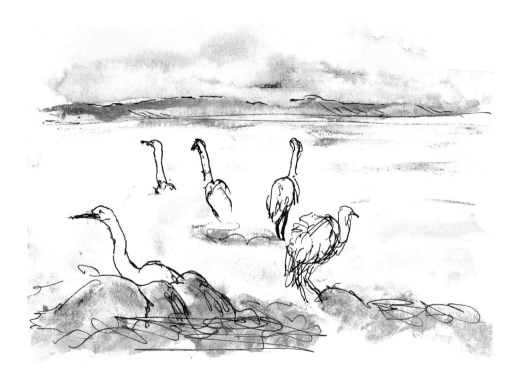

MARCH

March 1 ('99). Noon, 35 degrees, 5" of wet new snow, clearing. Otters (not fishers) by Clark's brook, their trail right down into the water. Snow too deep to track on skis or on foot, so I ski beside the brook on the single-track snowmobile trail enjoying the sounds of the water—wonderful deep, low, and resonant by the bridge, with the higher notes of splashes and trickles.

Brook ice breaking up by the alders near the bridge. Sky clearing. The snow pack is solid and heavy with recent snow and rain, more coming. Tonight is full moon but clouds moving in again.

March 2 ('99). Town Meeting Day. Sap buckets up on Towne Hill Road. Full moon ski just after dark. Coyotes calling. Saw-whet owl *toot-toot-tooting* in pines off School House Road, close to our house again—this while I was skiing out at dusk. Great night for sounds and light. Moon is bright on the snow.

I locate the saw-whet owl by sound, then slowly approach for a quick glimpse as it flies a few feet, adjusting its perch. A male courting, with the endless same-tone note, a magical late winter/spring sound. Not too cold to open the window and enjoy it later from inside.

March 5 ('99). Butternut flats. High 20s or low 30s. Wind from the west, then south, then west again. Blazing noon sun. I have taken my skis off and settled down in a "hot spot" on the S side of a white pine, where all is warm and peaceful.

The rain has soaked into the snow, frozen, and left a dense firm surface. Deer, dogs, coyotes, humans, all can walk easily on top with no breaking through.

However, the distance from the snowpack to tree twigs has increased, hard on deer who had already browsed most of the branches (cedar) they could reach. There are huge track marks and holes where, when warmer (night before last), the crust gave way for practically any creature, then these holes filled with rain water and stretched.

Dusk. Hundreds of crows diving and performing aerial maneuvers on the north side of Main Street hill, in the softwoods. It's clear they haven't altogether given up their winter roost. We still see them passing through most mornings and evenings, and they are here many nights now, according to Theresa. Mixing it up with mating behavior added to the excitement and spectacle.

9:45 PM. Downtown Montpelier. Driving home along Main Street I see a huge waning moon rising in the notch above East State Street, to the left of the handsome brick building. This is a March event to be looked for just after full moon, as at other times of the year (except Oct.) the moon would be too far north or south to rise into the little notch provided by E. State Street.

March 6 ('99). A March snowstorm. Low pressure. Snow all day, starting very fine at 6:30 AM and never letting up. 15 degrees. The flakes are so small that I can't make out much, even with the hand lens and my black coat. A jumble of ice cylinders and fragments, some with rounded edges. How this can be, in such a cold air mass, I don't know.

Mid-afternoon, a pileated woodpecker is in the big black cherry in the woods, quietly tapping. Later I take a look and note an old nest-size hole about 15' up or more, facing away from the house. About 6" diameter so far.

4:30 PM. Soft grays and dark, almost black, balsam and hardwood trunks. The color spectrum snapped shut in the heavy snow. How does that happen? The reds and purples are not at all heightened or even visible except close up. Dark now. Still snowing. Still 15 degrees.

Sketch a winter bouquet of dried flower/seed heads of vervain, turtle-head, milkweed, picked in the fall. A reminder of the Baltimore (butterfly) turtle-head fen in bloom. They sit in the kitchen window and always please my eye.

9:00 PM. A foot of new snow outside. Our world is full of snow.

March 7 ('99). Sun! Tons of snow! 14", fresh, dry, and light. 15 degrees.
Wind is blowing this light snow everywhere but huge globs stay with twig and limb junctures and on horizontal surfaces.

The sun is hot and changes the snow in just a few hours. We sunbathe in a protected doorway at noon.

2:00 PM. Ski the big loop around the Center alone, stopping at a neighbor's

14"

8:00 AM before sun hits

10"

1:00 pm same day! blazing sun

Weather changes
over the Widnooski
Valley to the East in
1 hour of march
squalls. Cold front
Comming through
after 12 hrs of RAIN.

March 4·99
8:30 am.
Rain! Squally
Gales comming
through since last
night. The snow still
holding on. I expect
Red Wing Blackbirds any
day now. All this from
the South-East.

9:00 Am
Wind, and
dramatic
clouds + low
racing fogs
over the mts.
to the East.
A wild mom-
ent of sun!

9:20 a quick
view of Spruce
mt. as a heavy
mass of clouds
moves in above.
A deep blue, suddenly.
dark

BIG WIND
COMES THROUGH
HERE. AS SUN
IS SHINING.
WIND STILL FROM
EAST. IS THE
COLD FRONT
COMMING FROM
THE EAST?

9:30 Sun in +
out of the clouds
Different aspects of
the hills + mountians
across the Winooski
showing themselves
every few minutes.
Wind howling at
9:35 am. A tree
goes down in the
woods.

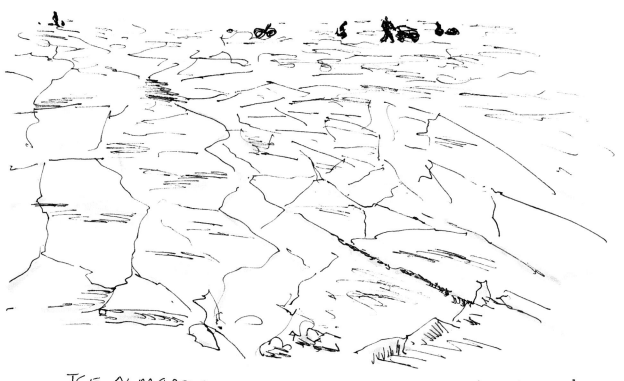

ICE ALMOST OUT...

These jagged chunks move about with the wind, Like in the arctic, and can be blown out, leaving open water if the wind changes.

Kingsland Bay — 5:00 Sun.

broom handle →
long nail →

* We've heard the ice is not safe this year. Many cars + other equipment lost.

Here the home-made hand ice pick one old-timer showed me. Used if he falls in. In leather sheath on belt. To pull self up onto ice from water.

The ice is breaking up into huge geometric plates & standing water on top of them. Out further, ice fisherman* and a few, 3 or 4 wheelers. The open water + birds are a half mile this way →

4:30 Button Bay

2 Eagles on the ice, one in tree, one flying AND a zillion ducks.

Couple of Grackles + blackbirds about —

Waxwings in the apple trees — our barnyard — only a few apples left —

Heat wells in the snow pack around the trees →

MARCH 19.
Drip! Drip!

E. Montpelier. Some old-style tapping under way in East Montpelier center; near Hudson's Trees

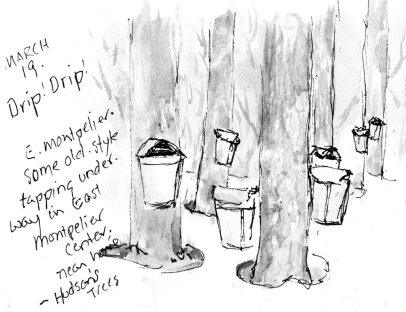

house-warming when I'm almost home. It is beautiful, and very cold, 10 to 15 degrees with a sharp wind from the north. The open, north-facing fields are brutal and I come close to frost-biting my left ear.

On Brazier Road I see a hard to explain snow/wind phenomenon. Blue shadows on golden tinged, rose tinged white white snow. Swirls of snow, "snow devils" with every gust, as the balsam unload their clouds of white powder in squalls of glitter dust.

Seventy-five cedar waxwings on hill on Pratt's land. All warming in 3:30 PM sun. Their breasts all yellow. They are quiet, then some lisping calls and a bit of position readjustment in the tree. A 0 degree night coming.

wind building wave patterns on snow

Hard snows pack on top- undercut from wind.

Suddenly wind gets in under snow undercuts and...

In a second these pieces (plate-like) are torn off and hurled 10-12 feet!

March 9 ('99). Long ski again, around the big loop, 2½ easy hours. Conditions memorable—powder most everywhere, clear, warm light, with deep blue shadows. Blazing beach-like fields. See 3 very sad looking turkeys on top at Brazier's, about to leave the manure pile where they pick seed and trot single file across the field to escape our intrusion. Is this all that's left of the 18 or so from last fall? They are matted with burdock burs and don't look healthy. It's been a terrible year for them, with all the crust for weeks on end.

March 10 ('99). AM. Pileated woodpecker still/again, working on the same (nest?) hole as March 6. Quiet tapping for at least an hour. When I check in PM I find hole has lengthened a fraction more than what seems right for nest. No sign of a mate nearby.

Wind snow wave patterns softening into sugar icing swirls. Sounds: finches and tree sparrows singing, twittering; mud-splash sounds from School House Rd as car goes by in the thawing roadbed.

Skunk out! PM, after dark. A skunk over by Codling Road has sprayed Otto (neighbor dog).

March 12 ('99). Overcast, wind from N, but sheltered here. Heavy sky with odd yellow look. 20s. 7:00 AM. We are running out of wood!

The 15 doves are still roosting in the trees, in separate groups of 3–4 each. By 7:30 they have moved in closer to the feeder but have not started feeding.

A redwing? I hear a high whistle over and over. Not the *konk-le-reee* but the call note. A first sign of spring coming from the hill.

March 13 ('99). Craftsbury, Vt. 32 degrees. Overcast with a light, mild, hazy cloud cover. Occasional flakes or mist as temperatures hover right at 32. Feels warm. Friends and I on our annual ski, two days at Craftsbury. Beautiful skiing,

lots of tracks. Fisher, fox, coyote, shrew, vole, mouse, many snowshoe hare. The field/woods edges are loaded with hare highways.

March 14 ('99). Craftsbury, Vt. 32 degrees. Ski to village along river and return on 15K loop. Many otter tracks and slides along the Black River. We ski through dense flurry zones on top of every hill. No wind. River, a large brook really, flowing in silver and inky black loops through new snow cover.

PM — return to E. Montpelier. One redwing, one grackle, one rough-legged hawk. Many snow fleas. Stoneflies everywhere along rivers and small streams.

March 15 ('99). E. Montpelier. Light snow. 9:30 AM. The yard is full of blue jays in a pre-mating flock. Twice as many as our usual winter '98–'99 flock of 7 or so. All hopped up and displaying, chasing, and every kind of call. Then there is a taking-up of their *tooo-lee* musical flutelike call, with 5 or more birds giving the call, all in tune with each other and singing fifths. Also a lot of "rattle" calls. It's like being in the tropics. I get Charles and we stop working to listen for 15 minutes until they drop into other calls.

March 16 ('99). The doves have been cooing now for about 2 weeks. Blue jays en masse today as I leave the house at 9:30 AM.

March 17 ('99). Bryan and Lori take us to see eagles on the lake as ice breaks up. Lake Champlain at Long Point near Ferrisburgh. Lake still frozen but some open water out where we see a few eagles: a second-year immature in tree on island, others sitting on ice here and there, the distant ones looking like half-full black garbage bags. Mature bird (with white tail) flying, comes in close, attempting to take fish from 2 ringbill gulls.

Charlotte Beach — buffleheads and goldeneyes, several hundred in open water with hundreds of tiny icebergs. About 100 other ducks, horned grebes, mergansers, too many Canada geese to count.

March 19 ('99). 9:30 AM. Light snow falling and suddenly the bird feeders are very popular again. Blue jay note coordination going on all morning. Why have I never noticed this before? I keep going to the windows, with pitch pipe to check notes, binoculars, and sketchbook. With windows open to catch the "songs," I'm fooled by a blue jay making a perfect red-shouldered hawk *keer keer keer*.

Goldfinches still not turning yellow here. Grackle and redwings making appearances.

Clark Rd., clay 1

Clark Rd. 2, mud 2

Clark Rd. 3

MUD SEASON!
THE OLD COOLING
RD. IS RUTTED + FULL
OF MUD AND PUDDLES,
RUNNING DOWN HILL,
REFLECTING BLUE SKY.
BIRDS ARRIVING - RED
WINGS + GRACKELS.(3.25)
(SNOW STILL MELTING and
LOTS OF IT LEFT. SKI WITH
DOGS DOWN TO CLARK'S BROOK)
 (FROM MEMORY)
 (Frisket for puddles)

Brazier Rd.
flats mud 3.26
Green clay + yellowish
mud on top: none of
these soak into the paper
or hold pigments much.
These were strong grey to
Olive colors on the road.
Saw a Red-tailed hawk
low over Butler's field and
25 robins in the sumac at
Flanders. Buds on Red
maple noticable - bigger?
Redder! Turkey Flocks breaking
 up.

Bitter wind, 33°
snow. holding
Brazier field; south

FIRST REALLY WARM DAY

INSECTS OUT
CRAWLING on snow at top
of Clark's field. 1 inch long; 3/8" wide

black head

honey golden
10 segmented body
which is black under
the lighter hairs.

SNOW PACK SHRINKING
This is how the snow pack shrinks:

Everywhere! hemlock twigs

God knows what

birch seed

covered with debris. which is melting, burns, in melting snow.

① Bare ground at tree bases gets BIGGER + BIGGER

3.27. Shimmering clear 50° +.
Snow degraded into snow diamonds.
Big ones. Bare ground on S. and W.
facing hills. Chas + Dogs + I ski out
clomping happily over any bare
ground. The skiing is Red klister
or fish-scales (waxless). We are
one the latter, for ability to clomp
over mud/grass etc. Stone flys
all crawling "uphill" (South) away from
brook. Also leaf hoppers (tiny) in an
oasis of bare ground by a log.

② Bare ground at
tree bases gets BIGGER + BIGGER

3.28 Good sugaring. Below freezing
last night, nice crisp, clean start
today. Then rain all afternoon
and evening. We have Sandy (Sister)
from Maine, Marlo + family to
meet English cousins here for
a visit. Sugar on snow at
Marges in pm,
followed by big (17!)
family dinner at
our house — My
grand boys win all hearts.

Blue jay
pre-mating
flock over on
Clark's at 8:35
Am on our
outing 2 cousins

③ Seeps are
warmer + they
melt. because
the H2O is 32°,
at coldest.

Today
we saw tiny
marsh marigold
leaves un-curling
in a seep on
Clark's.

3.29 Rain last
night. Cleaner
today, but
the snow
is GOING
FAST. More
Redwings ♂
and Grackles
in. Vast Am
bird choruses
of finches.
(Gold and
House, Tree
Sparrows
and Juncos
still here all
twittering along
with resident
population + the
new arrivals —
Sweet to hear!

④ The SUN + AIR
just evaporates
it! maybe called
sublimation? OR
just melting

Now there is water
running UNDER the
Snow; you can hear
it trickling along, often
through old vole tunnels
—WHERE DO THE VOLES GO
TO STAY DRY? EVERYTHING
SEEMS SODDEN.

⑤ Just
plain old
RAIN + FOG

Today the top
layers of snow pack
were gone + we're down
to the ice-storm pressure-
ridge cracks—These we
haven't seen since
end of JAN!

Snow squall over Spruce Mt. 32 degrees, wind out of the NW and suddenly there are a bunch of crows flying W toward their roost. But mostly they have quit the flock to pair up.

March 20 ('99). VERNAL EQUINOX. 12 hours day, 12 hours night. Beautiful sunny day, 40s; sap flowing. Redwing blackbirds singing. Big-toothed aspen bark noticeably green/yellow or olive compared to the gray-green of quaking aspen.

March 21 ('99). Butternut buds fatter and gray-green. We take our walk on the top of the crust very early before it softens, down to Butternut Flats, where we see the above, and pick a huge bunch of willows for forcing indoors—a spring ritual. They have not even started to make "pussies" yet.

Tracks sharp and clear, in a dusting of snow on hard pack. Last night, notice and admire the Big Dipper high in the sky now as spring approaches. Birds: first turkey vulture seen today over Butternut Flats. Also juncos trilling in the yard at home.

Visit the deer kill of March 14 down on Butternut Flats. Picked clean in one week by coyotes, fishers, foxes, crows, even tiny shrews! (Good track record.)

March 22 ('99). Wild weather day, with high winds, driving rain out of the east, then heavy snow horizontally sweeping in from the west, and finally rain clearing out by 7:00 PM. Many trees down on our ski trail. First chipmunk report, from Bryan and Lori in Plainfield.

March 23 ('99). Kestrels are in! Three, on way to kid's sketching group. Seems yesterday's wind has brought them and a blue, blue sky. Sun and turkey tracks, snow fleas, and heat waves off the snowpack. Every small dark piece of debris on the snow has caught and held heat from the sun, melting down through the snow in lace-like patterns, the biggest pieces (leaf, bark, etc.) have burned into the snow about an inch deep.

March 24 ('99). Sun and snowpack shrinking and birds singing. Redwings, the males, are arriving—*konk-lee-reee;* grackles, our "tuxedo boys," clucking and strutting their beautiful black shiny plumage; juncos trilling high and sweet as they do at this time of year.

Pussy willows on the kitchen table have just put out a couple fuzzy "kittens" since the twigs were cut two days ago. Ready to pop.

March 25 ('99). Yesterday planted spinach, lettuce in the cold frame, where

ground is thawed, even though the frame is surrounded by snow! The small spinach plants from last fall are already putting out new leaves.

Today we see our first chipmunk and hear a report of a bear track up Brazier Road.

March 27 ('98). Snow on the ground and warm weather—60s!! The snowpack is shrinking. Cut hobblebush on Mt. Mansfield for forcing.

March 27 ('99). Shimmering, clear 50+. The skiing is red klister or fish scales (waxless). We are on the latter, for ability to clomp over mud, grass, etc. Stoneflies all crawling "uphill" (south) away from brook. Also leaf hoppers (tiny) in an oasis of bare ground near a log.

March 28 ('98). 80s! Geese flying over in Colchester (Mallett's Bay, Lake Champlain). Grackle and robin flocks back.

March 29 ('98). AM. All quiet, 60s. Listening for fox sparrows which have not yet appeared. We do hear a fox sparrow–like call, but higher, less sure. Tree sparrow? A half dozen snow geese fly over, going east, out of formation. Snow still good, but shrinking.

A flock of juncos have arrived and are trilling, feeding, resting during their migration. Still heading north, but will stay a week or two. I like to listen to the din of their many collective sounds. The ground is alive with quiet scuffling and pecking, amongst the debris of the last many months (seeds, etc.) on the old snowpack.

And finally, a fox sparrow. Just a glimpse, but unmistakable, under the balsam ground feeder. Now there are three.

Chipmunk sitting at the edge of burrow for 10 min. at a time. A small figure in a field of snow near the woods. Into his burrow at the slightest provocation.

Grasses start to poke out of snowpack in tufts.

Wild leeks just showing on the cobble below the house. Whiffs of the lovely onion smell—we are so ready for fresh greens and here they come!

March 29 ('99). Rain last night. Now there is water running under the snow; you can hear it trickling along, often through old vole tunnels. Where do the voles go to stay dry? Everything is sodden.

Round domes of vole nests exposed today all over the field. This round hole in snow is 7"; nest about 5" across. Heat from the nest has melted snow earlier in winter, when nest was occupied.

Sun coming out. Home by porcupine tree, up through deer yard, I have to take off skis and walk. I put them back on and ski through a most heavily browsed area with not a twig left unsnipped, up to about 6' in the cedars.

Beech leaves have started to show up on the ground, most still holding to the young trees but not for much longer. A warm brown color, with light coming through. They still make a dry rattling with any air movement.

March 30–31 ('98). In Colchester overnight. Lake a vast plain of melting ice. Blast of record heat—80s! Should be in the 40s and 50s.

Snow geese flying over early, then, as it gets rapidly hotter, they stop. I guess it's too hot for them, too, but have never heard anything about what reaction birds have to an unseasonable heat wave. Last weekend, the first days of the heat wave, they flew over by the thousands, my daughter reports. A few Canada geese later.

Small holes in the snow/ice pack, that bit remaining, where rodents and shrews came and went all winter.

March 31 ('99). Last day of March, last ski? Half through running water, half on my old narrow tracks of packed snow/ice. Beautiful, 60s day. Geese (snow and Canada) going over all day.

The snow is now like so many diamonds—huge, many-faceted crystals reflecting color. It's impossible not to pick them up and sift them through my hands with admiration.

No gloves for skiing or drawing.

Woodcock last night at DD's. This section of back field has had a pair in the past. We're waiting for them but haven't heard the familiar *peent . . . peent*, or the fluttering, sputtering *churps*.

All evening and throughout the whole night the geese are flying over, flock after flock, under the full moon. The window is open and we wake just long enough to hear them. Mostly snow geese, a higher yelping than the Canada goose. Spring!

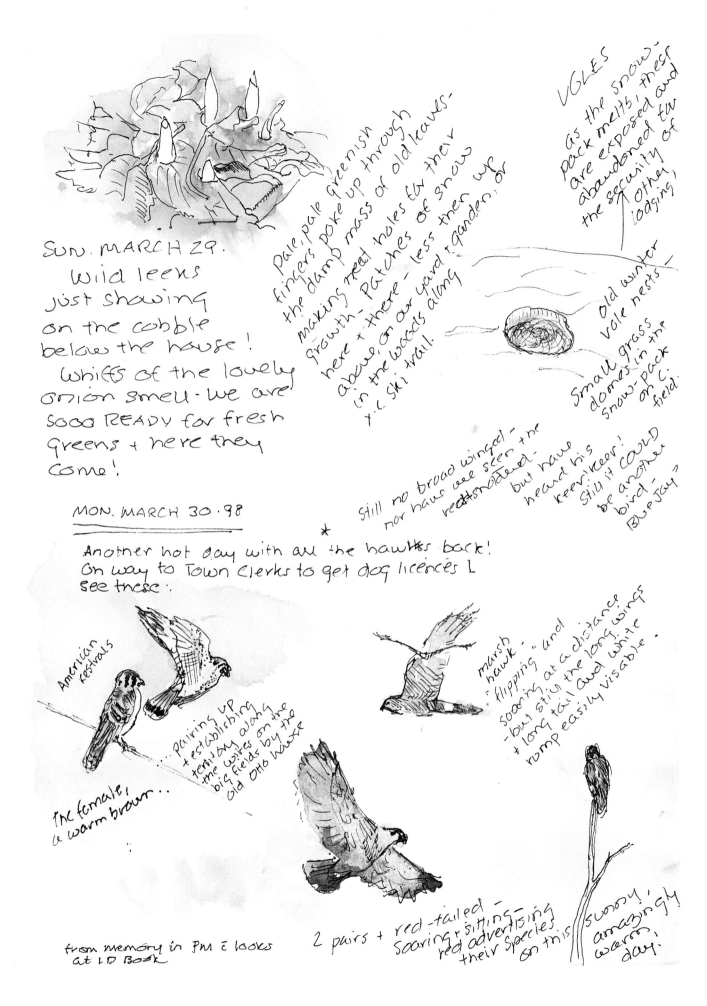

SUN. MARCH 29.
Wild leeks
just showing
on the cobble
below the house!
Whiffs of the lovely
onion smell - we are
sooo READY for fresh
Greens + here they
come!

Pale, pale greenish
fingers poke up through
the damp mass of old leaves-
making neat holes for their
growth - patches of snow
here + there - less then up
above, on our yard + garden, or
in the woods along
Y.C. ski trail.

UGLES
As the snow-
pack melts, these
are exposed and
abandoned for
the security of
other,
lodging,

Old winter
vole nests -
Small grass
domes in the
snow-pack
on C.
field

Still no broad winged -
nor have we seen the
red shouldered -
but have
heard his
'keer, keer!'
still it could
be another
bird -
Blue Jay?

MON. MARCH 30·98

*

Another hot day with all the hawks back!
On way to Town Clerks to get dog licences L
see these:

American
Kestrals

...pairing up
+ establishing
territory along
the wires on the
big fields by the
old Otto house

The female,
a warm brown..

marsh
hawk...
"flipping" and
soaring at a distance
- but still the long wings
+ long tail and white
rump easily visable.

2 pairs + red-tailed -
soaring + sitting
red advertising
their species
on this sunny,
amazingly
warm
day.

from memory in PM ± looks
at LD Book

Keeping Appointments
Biological Clocks and Earth's Calendars

*E*very spring to early summer, horseshoe crabs swim from open ocean into protected beaches and estuaries, crowding by the hundreds into the shallows, shoving against each other as they crawl along the bottom toward shore. The males arrive first, and clamp themselves to the backs of the later-arriving, larger females. Joined, they await the highest tide, which happens at the full or new moons, then swim and crawl to the utmost reaches of the tide, where the females plow their rounded "horseshoe" carapaces into the bottom, carving out rudimentary nests in the sand. Then they deposit enormous quantities of eggs, often several thousand at a time, in each nest. When done they withdraw, and the males detach, release sperm over the masses, and leave, allowing the water to wash sand over the nests and the eggs to develop on their own within their scant concealment.

Horseshoe crabs have been performing this annual procreative ritual for a very long time, unimaginably long, seemingly forever. As a group (not true crabs), they are one of the most ancient lineages on Earth. Their long-extinct ancestors, the trilobites, to whom they bear a strong resemblance, lived on ocean floors over 500 million years ago. Only four species of horseshoe crabs exist in the world today, virtually identical to those that lived 200 million years ago. The one species found on the eastern coast of North America, *Limulus polyphemus*, has been around unchanged for at least the last 20 million.

Over those millions, each year their migration ashore and egg laying has occurred, and must continue to occur, at the specific time when the tides will be their highest. Subsequent high tides, not so high as those on the full or new moons, will not quite reach the nests, allowing the new eggs to develop over the

next few weeks in a somewhat warmer, drier setting. Timing has to be precise, for such tides occur only a few times, for a few hours, over just a couple of propitious months. The horseshoe crabs must anticipate future conditions, biologically speaking, and they must be ready regardless of what awaits them at the meeting of land and sea. Their continuance and continuity depend upon this narrow strip of shore during a tiny slice of the year.

The predictability of the horseshoe crabs' landfall each year over eons has become incorporated into the lives of another entirely different group of animals. Shorebirds, notable among them sanderlings and red knots, migrate along the East Coast in spring, often in great flocks, dropping onto beaches and estuaries to refuel for the long trek north. (One of the most important such staging areas in North America is Delaware Bay, where up to a million birds may stop down annually.) To feed such an arriving army requires an unusually large food supply, which just happens to come in the form of the untold millions of horseshoe crab eggs. Without the horseshoe crabs spawning at exactly the right time in the right place, the huge flocks of shorebirds would soon dwindle, and the species perish.

Sustained by the seaside bounty, the sanderlings and knots continue their journey north along the coast, then move inland, into the tundra breeding grounds of arctic Canada, where they often come into a snow-swept, still-winter environment. Their timing may seem to be off to us, mortally premature even, but collective, ancestral memory, preserved in their genes, is a more dependable judge. With a startling suddenness typical of the tundra spring, the sun soon burns away the snow; the land warms. Insects — buried and protected

over the long winter within the thin layer of peat that is the arctic soil — emerge quickly, becoming in their great numbers a critical source of food for the hungry shorebirds.

It is apparent why the birds come so soon, struggling against the season, risking everything: the raising of their young must take place within the perilously narrow slot of arctic spring and summer, when food is available for the incubating parents and their newly hatched and developing young. Within the

few weeks of the frost-free season, the bird babies must grow from embryo to independence. Unless the parents begin their rearing at the earliest possible moment, the young will not have time to mature to flying ability and move south on their own, before the insects disappear into the cold of the early fall.

Incidentally, arctic insects and other invertebrates, too, have to be poised to take advantage of the fleeting spring-summer. At or even below freezing temperatures outside their places of shelter, many species produce bodily antifreeze fluids (among them ethylene glycol, the actual automotive antifreeze), thereby enabling them to become active when otherwise they would be torpid. Many are also flightless, remaining within the warming confines of soil and low-lying plants. Some shift their activities to take advantage of the sun's heating. For example, brooding mother wolf spiders carry their eggs to the surface entrance of their burrows where they have woven domed "sun rooms" and hold them in the warmth; butterflies and bumblebees bask at the center of flowers where the sun's rays concentrate. Many species, which in more temperate climates complete their life cycle in a single season, may take two or more to do so here. The tiger moth species in New England lives only one season as a caterpillar (the so-called woolly bear) before metamorphosing into the adult moth, while its arctic counterpart spends up to fourteen years in that larval form. Conversely, other groups, such as bumblebees, speed up the process, completing their life's business more quickly in the abbreviated season.

Seaward at this same time, as the sun moves higher in the arctic sky its rays of light strike the pack ice at an ever increasing angle. The ice, acting like a prism, channels the light through the pack, concentrating it on the ice under-surface. There, "pack-ice algae" begin to grow profusely under the influence of the increasing light and nutrients welling up from the ocean depths at this time of year. These algal blooms—a preciously thin layer of life forming at an exact place in a brief time of opportunity—become the food base for much of the arctic life at its oceanic margins. Grazing on them, and multiplying to vast numbers, are various marine invertebrates, especially tiny crustacean amphipods, which in turn are food for larger predators, the fish, birds, and mammals of the region. It is no exaggeration to say that virtually all life in the arctic coastal environment (a huge area of the earth) is supported by this single annual event, the greening of the underside of floe ice.

But the algal blooms alone do not spawn such profusion and proliferation of life in this rigorous environment. It also takes the convergence of other favorable, predictable events. The pack ice must break up enough to form channels (leads) or open areas (polynyas) where birds and marine mammals can gain access to the food while being able to surface for air. Yet at the same time the

pack cannot fragment too much or disperse too widely, as seals, walruses, and polar bears need large, intact platforms for resting, feeding, giving birth to their young, and rearing them. Migrants, such as whales and pelagic and coastal birds, must arrive late enough when the food supply is abundant and available to feed their numbers, yet early enough to allow completion of various life stages on time. The growing of tiny algal cells in the high Arctic does, without too great a stretch of imagination, control the movement of great whales near the equator.

Horseshoe crabs and sanderlings, algae and whales, are among the many creatures that have worked out ways over millions of years to bring their lives together in the right place, at the right time, over vast—seemingly unconnected—distances, despite all their vulnerabilities. They have discovered where predictability hides within so much unpredictability. They have done so by merging and meshing their own internal rhythms with those of the world in which they live, for example, waking/sleeping with the tides or mating with the seasons.

These internal rhythms—as for most plants and animals, even their individual cells—have or are governed by so-called biological clocks, mysterious mechanisms that somehow set and keep track of the timing of such periodic functions as sleep, dormancy, migration, foraging, and so on. In New England, where length of day and night change so dramatically over the year, the ratio (or changing ratio) of light to dark (photoperiod) is a dominant controlling agent, the mainspring, of many biological clocks. Such gauging makes sense, after all, since there are few things more regular and dependable in this world than circling the sun from year to year. Where daily and seasonal periodicities are pro-

nounced, most plants and animals have daily (circadian, literally meaning "about a day") and/or seasonal (infradian, "more than a day") rhythms.

But day length is not the only standard. For dwellers of coastal intertidal zones, internal clocks are often in phase with the tides (circatidal), the dominant environmental force. Crabs, barnacles, clams, even rock-clinging seaweeds and

sand-dwelling diatoms exhibit such rhythms in their times of feeding, molting, reproduction, or other activities. For many nocturnal animals, such as some worms, crustaceans, insects, salamanders, and even mammals, the moon controls many clocks (circalunar) through its phases. Still other clocks are set to what one scientist calls "tides of the atmosphere," major influences other than planetary, solar, or lunar. Honeybees and carpenter bees, for example, may fly only during a brief time of day when their primary host flowers secrete their nectar (and the flowers have their own clocks, too, set to release the nectar at a certain time of day).

Many, if not most, plants and animals, in fact, have more than one clock operating at the same time, reflecting the multifaceted environments in which they must live or through which they must pass in the course of their lives. A few examples: shorebirds' annual migration, feather molts, and intertidal feeding; day lilies' diurnal flowering and winter dormancy; black bears' spring mating, nocturnal feeding, and winter hibernation.

Ironically, once a clock is keyed, or actually locked, into an environmental standard such as day length, phases of the moon, rainy season, or tides, it keeps running according to that standard, regardless of where the animals goes or is taken. Fiddler crabs in their natural, sandy coastal environment become active in the day at low tide, when they come out of their burrows and forage on the exposed flats. If they are taken out of that environment and put into a lab where the lighting (or darkness) is constant, they continue to be active when, outside, it is daytime low tide. (Another example perhaps familiar to most people is jet lag. Our day/night clocks are set to where we live; when jets transport us to radically different time zones, we bring the old schedule with us, and thus feel sleepy or hungry when we used to, not when the new environs tell us we should be.)

Yet biological clocks, like mechanical ones, do not go on forever unless occasionally rewound or somehow reenergized and reset when run down. And, perhaps not surprisingly, it is the environment that both rewinds and resets. If kept in controlled-environment labs for a long time, fiddler crabs begin to lose the precision and regularity of their activity. But when taken back to their home, or a new one with an entirely different tidal calendar, they quickly adapt to the familiar or the new rhythms, whichever the case may be. Human airplane travelers within a day or two comfortably adopt the schedules of their new locale.

The environmental cues that animals and plants use to accomplish this scientists call "zeitgebers," a German word meaning literally "time setters." Photoperiod is only one zeitgeber; others, depending on region, are precipitation (especially in tropical regions, where the daylight-dark ratio is rather con-

stant and the seasons are defined by rainy and dry periods), ocean currents, temperature, sound, social stimuli, possibly even magnetic fields.

While zeitgebers can set, reset, and adjust clocks, they cannot create them or change what nature (i.e., genetics) has already given. An animal with a circadian rhythm cannot be forced, no matter how hard, into a tidal one, or vice versa. Fiddler crabs will always behave in ways that track with the tides, even if raised from eggs in tideless laboratories. Certain cave crickets, though blind and never exposed to light, maintain the day-night schedule of their distant terrestrial ancestors. A long-day plant (that is, one that flowers when the duration of light exceeds that of dark) cannot be made into a short-day one. So in their evolution, organisms have built their clocks according to the dictates of their particular environments, but once acquired, the clocks become part and parcel of their bearers, inseparable. The organisms always carry these imprints, no matter where they go or how far they're taken away. Home is inherent to identity, forged into a being's makeup, driving its actions.

Again like their machine counterparts, and making good ecological sense, biological clocks (at least those not set to temperature) run without being unduly affected by outside temperature—"temperature compensated," in the lingo. A neat trick, considering that temperature strongly influences most physiological functions (a rule of thumb, in fact, is that rates of most physiological processes at least double with every 10-degree Celsius rise in temperature.) In biological clocks, however, temperature change can subdue the intensity of the activity, knock off its peaks and fill its valleys, but not alter the function itself.

So where do these amazing clocks reside within the organism, and how do they work? Researchers have found that, in animals, the exact location varies. In birds it is in the tiny pineal gland deep within the brain, in mammals the hypothalamus at the brain's base, in insects the brain itself, in gastropods (snails) the eyes, in some crustaceans (crabs, lobsters) the eyestalks. In all cases, the clock or clocks control physiological processes through the secretion of hormones from the endocrine system, directed toward regulating the function in question, whether sleep, reproduction, hibernation, or other. Plants have no such central location for their clocks; rather, they seem to be embedded generally throughout living plant tissue, within the cells. The clocks connect to the outside world —allowing an organism's zeitgebers to influence it ("entrain," the fancy word) —through receptors, which also vary according to species. In animals, receptors may be in eyes, tails (as in the horseshoe crab), skin, or other organs. In plants, phytochromes, a group of molecular proteins in the cells, sense light and transmit the appropriate signals to targets—flowers, growing tips, seeds, and so forth—via various chemicals transported in the sap.

Rhythms and routines, then, are not just arbitrary acquisitions of habit to make life easier or more enjoyable but the way a being fits into its world. They are the result of a long and close collaboration between environment and creature, functions that cannot be teased out or away from the life evolved. (I fancy that human routines—or at least the strong desire for them—are vestigial indicators of a once more intimate connection to nature, when we needed to attune ourselves closely to the surroundings in which we lived. And various kinds of music are possibly the echoes of our alignment with natural synchronies, felt so immediately, so within the gut, such as rhythms of heartbeat, sexual arousal, aggression, or serenity.)

As mentioned, if we remove a fiddler crab from its beach and put it into the constant, artificial environment of a lab, its clock keeps running as if it were still on the beach. But what about when we take its beach away, or turn the beach into another kind of place? When happens when home is no longer the familiar place it was?

A crab has neither means nor luxury to pack up and look for another suitable home. If home disappears, or changes in ways beyond the crab's wherewithal to cope, it dies. Bulldoze it to make way for a human house, the crab loses, plain and simple. So it does also if a beach is buttressed against storms, or an estuary channeled and drained, so that the tides no longer wash over or through them day and night. The loss is certain, not hard to see, when the home is altered or destroyed so blatantly.

But what about another kind of destruction, one less stark but perhaps more insidious for the subtle, pervasive, and irreparable manner of its waging? I mean global climate change. Once debated even within the scientific community, now beyond debate, the phenomenon is a threefold certainty. The first certainty: the carbon dioxide content of the atmosphere will double from today's level by about the middle of this century. It will do so even if we could magically stop all human-created carbon dioxide emissions today. The elevated concentrations, through the greenhouse effect, will cause a rise in average global temperatures and a battery of associated problems. The second certainty: we humans are the cause, through combusting fossil fuels, stripping tropical regions of their forests, and starting monumental fires afterward to clear the land for agriculture. And the third certainty: uncertainty. As one leading authority put it, "expect the unexpected; surprises are in store"—greater extremes of temperature, more weird weather in unaccustomed places (even colder than usual in some), more catastrophic events, rising sea levels due to melting glaciers, shifts in ocean currents, ocean temperatures, and nutrient-bearing upwellings, and so on. The uncertainty extends to unanticipated effects on both

biological systems and the ever more teeming numbers of people living in vulnerable areas.

Climatologists project that, with atmospheric carbon dioxide doubling in the next 50 years, average global temperatures will rise 3–5 degrees Celsius (about 5–9 degrees Fahrenheit) over that period. This may not seem like much, but the last glaciation, covering half of North America, Europe, and Asia, occurred when the world's average annual temperature was lower than now by about that same amount. The rate of change, not just the magnitude of it, is the killer—this new rate is over 40 times the natural warming after the most recent glaciation.

For individual organisms the impacts could be direct, such as overheating or flooding out, or indirect, such as forcing shifts of range. Their responses could be simple or complex, predictable or totally unexpected.

Plants, for example, generally grow bigger and faster with more carbon dioxide ("carbon-dioxide fertilization"), but in the process the nutrient content of their tissues drops proportionately. Plant-eating organisms must consume the necessary amount of green matter to supply their nutrient requirements. If, under a doubled carbon dioxide atmosphere, a caterpillar needs to eat twice as much to gain the same amount of nutrition, it will take twice as long to eat. In doing so, would it extend its working hours beyond those long established and coded in its clock, thus exposing itself to unaccustomed predators, temperatures, or other dangers, and upsetting the timing sequence of subsequent metamorphosis?

Temperature, not genetics, determines the sex of some reptiles—the temperature of the environment in which their eggs incubate and develop. In New England, for instance, map turtle eggs will yield all males when the soil temperature is between 23 and 28 degrees Celsius (73 to 82 degrees Fahrenheit), a mix of males and females between 28 and 30 (82 to 86 degrees Fahrenheit), and only

females above 30 (86 degrees Fahrenheit). The species' clock is set to take advantage of these critical temperature swing-points, so that both sexes will come forth in the right proportions in a single season. What will be the consequences when sex ratios become skewed because these reptiles lay their eggs too soon or too late? (There is speculation that this may have contributed to dinosaur extinction: when a giant meteorite crashed into Earth and raised enormous clouds of dust, enough to shield the planet from sunlight and cool it, the animals were forced toward single sexedness and therefore ultimate doom.)

American shad spend most of their adult life in the ocean, but in the spring move into and up rivers where they spawn, arriving at the river mouths when their internal clocks tell them, following the ancestral paths to headwaters thereafter. However, they actually begin their migration upriver when the temperature of the outflowing freshwater reaches 15 degrees Celsius (59 degrees Fahrenheit)—or drops to 15 in warmer southern states. So with the water heating up sooner, but the fish arriving at their traditional times, what happens? Do they go ahead anyway, despite the possibility that conditions at the spawning site are not favorable for egg development or the growth of fry? Or do they simply stay put, not moving upstream? Or, if moving upstream, do they not spawn?

Complicated enough, considering all the shadowy possibilities and unsettling questions. But where things get really messy is in the interactions of organisms, within compounding dimensions of time and space. And at the center of many of these interactions is, of course, the simultaneous gearing of so many biological clocks. Imagine the not-so-implausible biological consequences, the ecological what-ifs, just in the sagas of shorebirds, horseshoe crabs, and whales described at the beginning of this essay, projected 50 years hence.

With their biological clocks running independently of temperature, the sanderlings and knots would still leave their South American wintering grounds about the same time in early spring, arriving at the critical feeding areas, like Delaware Bay, on schedule. However, the areas might not be the same. The low-gradient beaches and tidal mudflats might be greatly reduced in size, having been flooded out by the sea level rising as much as 100 centimeters (about 40 inches). They also might not be the great feeding areas they once were— horseshoe crabs, facing diminished suitable habitat for egg laying, would have deposited far fewer of the staple diet the birds depend upon.

Those surviving would continue north to the tundra breeding grounds. But the tundra might be far different, too, for the effects of warming are greatest in the higher latitudes. The underlying permafrost might have melted some,

with a subsequent drying and draining of peat soils at the tundra surface. The peat might be decomposing, literally rotting in its release from the ice and cold. (The rotting would contribute more carbon dioxide to the atmosphere, as well.) Under such conditions, the big hatches of insects—food for the arriving birds and their young to come—might already have happened, since their emergence is so closely tied to soil temperature. So the birds might miss out again. Moreover, the new conditions might favor winged, flying insects over the former flightless kind. But the flightless, not the winged, are the ones the newborn birds can capture during their early, critical developmental stages. So the young, too, might face starvation. And each succeeding year, there would be fewer birds to make the return journey south.

Along the arctic coast the elevated temperatures might cause the pack ice to break up early and the reduced fragments to melt faster. The under-ice algal blooms might not have had the time, space, or stability to form as they once did. Their diminishment would ripple through the food chain, all the way from grazing amphipods to the mighty migratory whales.

These projections are speculative, of course, the questions yet without answers. But such rapid, profound environmental change is all too possible, even likely, given what we know already. There might be reason for optimism for creatures that can keep pace, adapt, adjust, as many certainly have over the great reaches of time on Earth (even radically changing their clocks, as some animals have done by becoming nocturnal under intolerable daytime threats). But for most, especially the bigger, the slower growing, the longer to develop, the less fecund, the less flexible, accommodation will not be possible. Too much change, too fast, all at once. The world, I fear, is leaving them behind.

In the course of gathering information and ideas for this essay, I asked a biologist friend of mine what he knew about biological clocks. He thought for a while, then said wryly, "They don't tick."

I might not have given his offhand comment a second thought, once. But now I'm not so sure. Maybe some do tick, are ticking. Like alarm clocks as we sleep. Or time bombs as we wait and wonder.

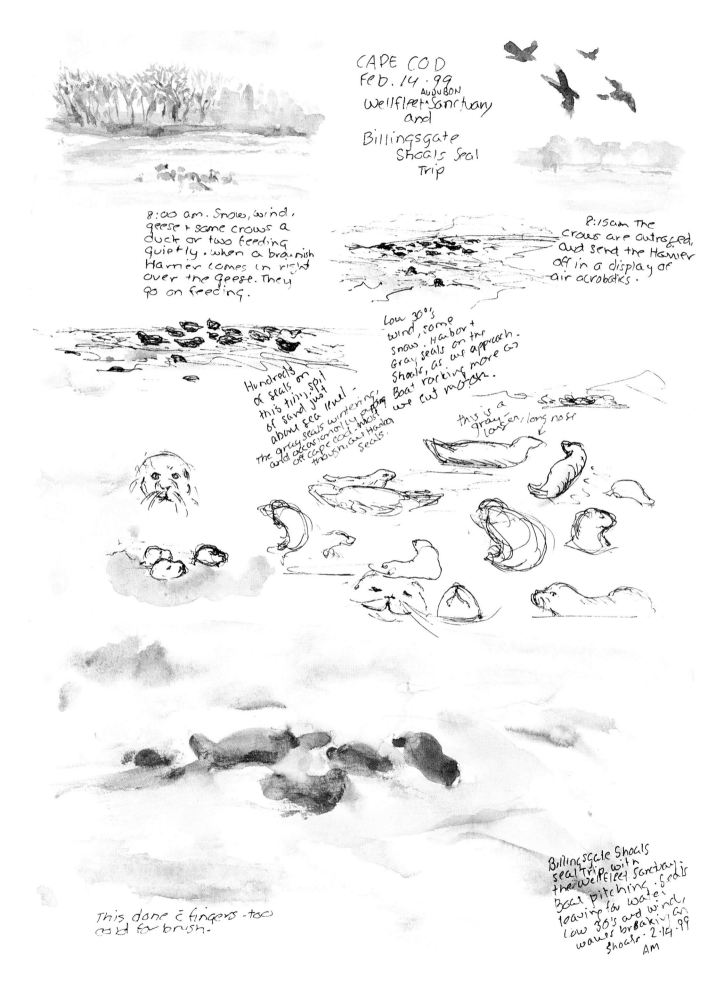

CAPE COD
Feb. 14 · 99
Wellfleet Sanctuary AUDUBON
and
Billingsgate
Shoals Seal
Trip

8:00 am. Snow, wind,
geese + some crows a
duck or two feeding
quietly. when a brownish
Harrier comes in right
over the geese. They
go on feeding.

8:15am The
crows are outraged,
and send the Harrier
off in a display of
air acrobatics.

Low 30's
wind, some
snow. Harbor +
Gray seals on the
Shoals, as we approach.
Boat rocking more so
we cut motor.

Hundreds
of seals on
this tiny spit
of sand just
above sea level -
The gray seals wintering
and occasionally pupping
off Cape Cod - most
though, are Harbor
seals.

this is a
gray - larger, long nose

This done c̄ fingers - too
cold for brush.

Billingsgate Shoals
seal Trip with
the Wellfleet Sanctuary
Boat pitching. Seals
leaving for water,
Low 30's and wind,
waves breaking on
shoals. 2·14·99
AM

APRIL

April 1 ('98). Cooler, rain. Snow melt puddles, snow on one side, matted leaves and grass on the other. On the surface, tiny snow-melt snow fleas, or water types of springtails. They are randomly distributed, hop if picked up on the end of the finger, and some seem just "hatched" or molted or whatever the word is for their transitions. They are transparent, with big eyes.

Ruffed grouse drumming on the Canine Express, a 2½-mile walking circuit from the house. 1st time this year.

Small retreating edge of snow-pack. Like miniature glaciers. I've always been fascinated with these. Today they do not sparkle and dance with light like they do on sunny days.

April 1 ('99). Sun, 60s. Many water sounds. Water running off a melting lawn, down a bank, and into a ditch.

The melting remains of the snow-pack in Hawkins' field remind me of Baffin Island in July, the Arctic sea still full of melting and breaking-up ice. The brooks are tumbling along with all this contributed water.

Out on walk by Butler's gate on Brazier Rd. Two mourning cloak butterflies, one up from a sunny post-top, the other sitting on the snow-pack. When they fly together I can hear their wings, lovely, in unison, up and down, then off, and now they are both back resting in this same area, one returning to the post. Our first butterflies, just out of hibernation.

Konk klur REEE! New flocks of blackbirds in the maple and poplar tops. This morning, grackles and redwings.

- When bulbs first poke through the ground, it's time to look for leeks and hazelnut red flower tips starting.
- When the maples flower and the first daffodils bloom fiddleheads are ready to be picked.
- Mark DesMeules (Alna, Maine): "When the ospreys and eagles return, the alewives are running."
- When the alewives (herring) run, the striped bass come in to eat them.

Red elderberry buds swelling. Smell of earth. Spider webs in back field, single strands about 9–10" high.

April 2 ('98). Canine Express, 1:30 PM. Cold rain, then sun, then clouds. Grouse droppings, the yellow brown color of winter birch buds, in snow right next to the snowmobile/ski trail . . . evidence that a ruffed grouse spent at least one or 2 nights buried in snow here. We so easily could have skied within 2 feet of it on our evening ski runs.

Put up American kestrel nesting box on hill by corner. Chas hears wood-cock and snipe.

Sun coming and going. Not a bit of snow left on Clark's big field.

April 3 ('98). Kestrel on wing and then to Weiss' television antenna. It's considering our kestrel nesting box just put up. Can't tell if it's a male or female —bad light and no binoculars.

Hobblebush, cut March 24, is starting to bloom. First wild onions (leeks) to eat—our first fresh local vegetables.

April 3 ('99). 50s, rain early, cloud, then clearing. There's a phoebe about— *screee-beee!* A cross sort of call—and very welcome.

Down in the little wetland on School House Road the marsh marigolds are showing more leaf (the wild leeks too, up here on the hill) and the willows are offering one or two furry bud-pussies. The robins were singing at 4:30 this AM.

Beaked hazelnut just starting to show red at the tips of its female (pistil-late) flowers. This is easy to miss, but the red, once seen in this season—where everything else is brown—is memorable. Lori B. calls this "the firecracker."

April 4 ('99). Easter. Cold, 30s. Morning walk on railroad bed in Berlin, along the river with Charles and dogs. We pick big bunch of lustrous pussy wil-lows and see a couple dozen wood ducks. Migrating? They are flying up through the flooded willows and silver maple, making that strange *weeeek! weeeek!* kind of noise. Everything stands still as they fly, even the dogs!

Also see 7 killdeer on the driving range. They are all together, very noisy. Later in the air, same. Some sort of mating behavior, but it's too cold and windy to stop for long at all. Bud digs a big hole—woodchuck under the rail bed.

April 5 ('99). 8:00 AM. See many robin flocks on way to town forest to check on logging in area of one of our town trail easements. The cut is heavy but the ground is untouched—all moss and ground cover intact. Sun coming

in through the open spaces. Birds singing: brown creeper (their warbler-like high, sweet spring song), winter wren (first time this year), purple finch, kinglet (golden-crowned), chickadees. Also heard: chain saws (Paul cleaning up with his crew from the logging), tractor sounds, occasional wind in softwoods overhead, tree coming down now and then as they complete stand improvement.

Back home, upper field. Noon, blue sky. One robin has settled down, keeps hopping up on the pasture-ant mounds.

There is no snow here today except N side of white pines, and the vegetable garden is bare but sodden. The song sparrows are back in the yard singing today. Light wind from the N and cooler. From the upper field here I see no snow, though there is still plenty in the woods. A small brown and orange-yellow butterfly, half the size of a mourning cloak, just went by—an over-wintering Milbert's tortoise shell? What else could be out at this time of year? It's bigger than the "l'enfant" and has the yellow of MT. Flies are out. It's nice to sit and watch—very quiet now at noon. The grass is as yellow and matted down as it will ever be. Crocus blooming out by big rock.

April 6 ('98). E. Montpelier. After 2 years' absence, a huge flock of mixed redwings, cowbirds, and grackles has alit in the balsams. They feed by the scores on the seed we throw on the ground. In the trees, they are very melodiously noisy, but hidden altogether by the evergreen's dense branching. When they alight to feed, the ground is teeming with them! Lots of contested eating, clucks, displays and chortling. An occasional fox sparrow and others (tree sparrow, house sparrow, etc.). Then in a *whoosh* they fly up at some movement or sound.

April 7 ('98). Sun and breeze out of the south will take us into the 50s +. Long Meadow Hill. Looking for wood turtles but it may be too early, water still feels very cold—needs to be 40 degrees +, according to Steve Parren who studies them in the field.

April 7 ('99). Fresh food! Lunch today is dandelions from the cold frame, in salad with a few spinach leaves from same. Also steamed leeks. From now on we'll be having them daily for about a month.

A great wind in the afternoon, after rain in the morning. Spring brook temperatures, E. Montpelier: Mallery Brook, at Cherry Tree Hill culvert = 42–45 degrees. Colt's-foot blooming.

I'm so delighted to see a real honeybee that I spill my paints! The minor bulbs are blooming, surrounded by bare soil and last year's various debris. This

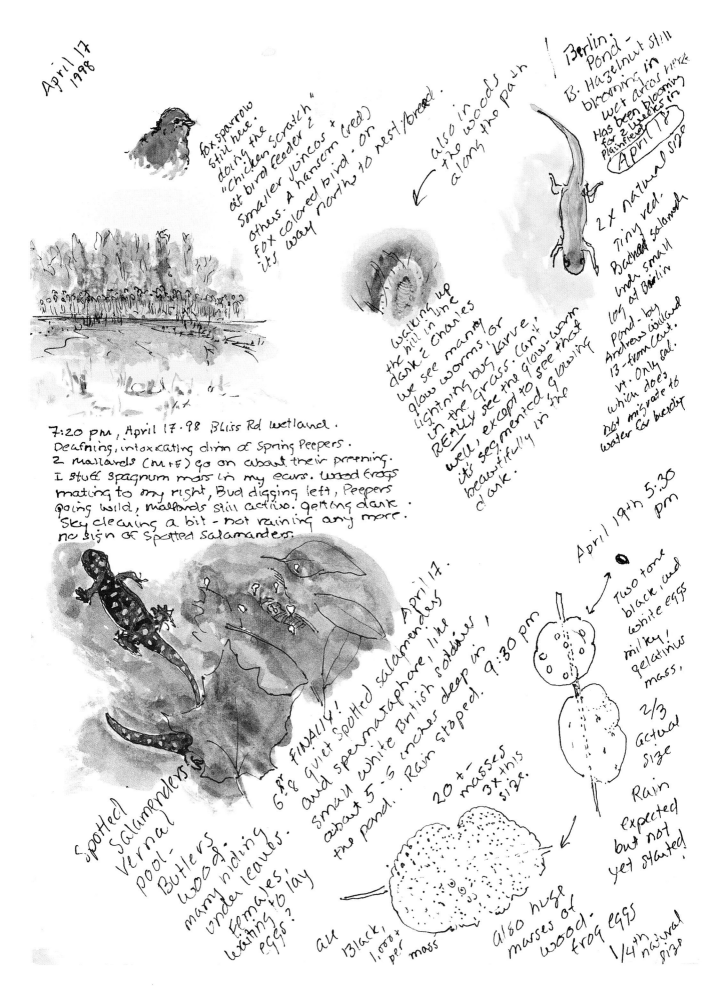

April 17
1998

fox sparrow
still here.
doing the
"chicken scratch"
at bird feeder ?
smaller Juncos +
others. A hansom (red)
Fox colored bird - on
its way north to nest/breed.

← also in
the woods
along the path

Berlin
Pond -
B. Hazelnut still
blooming in
wet areas here.
Has been blooming
for 2 weeks in
Plainfield TP.
April 18

2 x natural size

tiny red-
Backed salamander
under small
log at Berlin
Pond. by
Andrews Willard
13-from Cont.
vt. Only sal.
which does
not migrate to
water for breeding

walking up
the hill in the
dark - Charles
+ we see many
glow worms or
lightning bug larvae
in the grass. Can't
REALLY see the glow-worm
well, except to see that
it's segmented glowing
beautifully in the
dark.

7:20 pm, April 17.98 Bliss Rd wetland.
Deafning, intoxicating dirim of Spring Peepers.
2 mallards (M + F) go on about their preening.
I stuff spagnum moss in my ears. wood frogs
mating to my right, Bud digging left, Peepers
going wild, mallards still active. getting dark.
Sky clearing a bit - not raining any more.
No sign of Spotted salamanders.

April 17.
6-8 quiet Spotted Salamanders.
and spermataphore, like
small white British soldiers !
about 5-5 inches deep in
the pond. Rain stoped. 9:30 pm

Spotted
Salamanders
vernal
pool.
Butlers
woods -
many hiding
under leaves.
females
waiting to lay
eggs.?

20+
masses
3x this
size.

all
Black,
1,000+
per mass

also huge
masses of
wood-
frog eggs

1/4th natural
size

April 19th 5:30
pm

Two tone
black and
white eggs
milky!
gelatinus
mass.

2/3
actual
size

Rain
expected
but not
yet started.

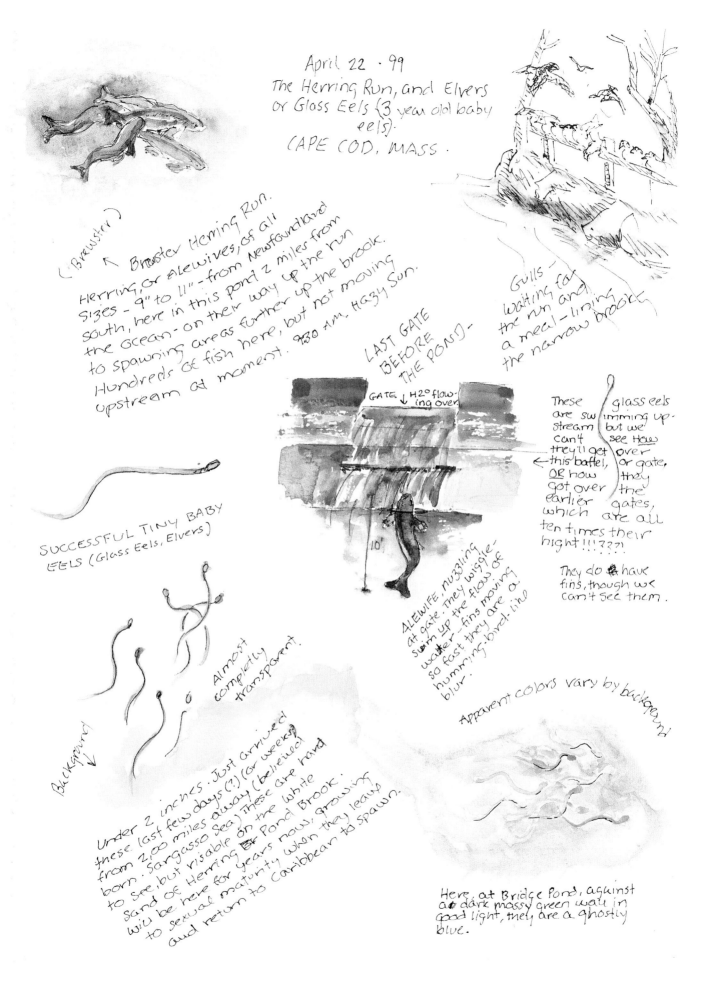

April 22 · 99
The Herring Run, and Elvers
or Glass Eels (3 year old baby
eels).
CAPE COD, MASS.

(Brewster)

← Brewster Herring Run.
Herring, or Alewives, of all
sizes – 9" to 11" – from Newfoundland
south, here in this pond 2 miles from
the ocean – on their way up the run
to spawning areas further up the brook.
Hundreds of fish here, but not moving
upstream at moment. 9:30 AM, HAZY SUN.

Gulls –
waiting for
the run and
a meal – lining
the narrow brook.

LAST GATE
BEFORE
THE POND)–

GATE ↓ H2O flow-
ing over.

These | glass eels
are sw|imming up-
stream | but we
can't | see HOW
they'll get | over
←this baffel, | or gate,
OR how | they
got over | the
earlier | gates,
which | are all
ten times their
hight !!!????!

They do 有 have
fins, though we
can't see them.

10

SUCCESSFUL TINY BABY
EELS (Glass Eels, Elvers)

ALEWIFE, nuzzling
at gate. They wiggle
swim up the flow of
water – fins moving
so fast they are a
humming-bird-like
blur.

Almost
completely
transparent.

Background ↓

Under 2 inches. Just arrived
these. (last few days (?) (or weeks)
from 2,00 miles away (believed
born. Sargasso Sea) These are hard
to see, but visable on the white
sand of Herring or Pond Brook.
will be here for years now, growing
to sexual maturity when they leave
and return to Caribbean to spawn.

Apparent colors vary by background

Here, at Bridge Pond, against
a dark massy green wall in
good light, they are a ghostly
blue.

one bee has found these dozen or so flowers, orange pollen on its back legs, down by the "feet."

Bluebirds! *Chory! Chorr! Chorr!* Will they stay?

April 9 ('99). Bluebirds are in and out of the "swallows'" box!

Phoebe flitting about at top of hill, now down by our wood shed. A tiny auburn-colored spider crosses my page.

Yesterday, a crow with nesting material.

A few minutes later. *Chitter Chitter* . . . swallows are back. Competition for the nest box is on.

A big light hawk . . . too light, really, but the shape, size, and the white rump, black tipped wings, no dihedral, low to ground on Rice's field, then gone. A fine male adult harrier?

Today the leaf-mat is dry and wild leeks are coming up through, bringing dry leaves with them. 3½" high.

April 10 ('99). Middlesex Notch. Light spits of snow, around 32 degrees. Water temps: both beaver ponds = 40 degrees. Is it winter or spring? Pussy willows out and false hellebore up here.

April 11 ('99). Sun. Last night in 20s. Juncos trilling, tree sparrows singing that sound which is so like the expected-any-day fox sparrows. Hepatica blooming last couple of days in woods here in the warmest spots.

PM. Walk up Brazier Road at dusk. Spotted salamander pool still covered with ice; the wood frogs are "quacking" up in Kievit-Kyler's little pond and we hear snipe over the Hawkins fields. At home, the goldfinches are really turning gold and the bluebirds still holding firm at the nest box. We erect a second box 20 paces away. Colors are changing, but no budding, no grass; just light making this color?

April 12 ('99). Later in day I return to spotted salamander pool with Susan Sawyer who confirms eggs of the Jefferson/blue-spotted hybrid. This is only thawed at edges! Earlier than spotted yellows. Grouse drumming in woods.

April 13 ('99). While hanging up laundry on line (a great drying day) I hear first white-throated sparrow in yard. Desk work indoors till 2:00. Out to Butler's.

Sun. Very cold. 2:00 PM. Reptiles out, first snake of the year, Butler's woods by old maples. Garter snake less than 2' long on the move, stops and doesn't make much more progress after I arrive. Beautifully camouflaged among

the dried, matted leaves, pine needles, and twigs. A round, intelligent-looking eye. Kinglets (golden-crowned) singing. Wind blowing. My hands are cold, even with gloves. How can a snake take this weather?

Stop and sit by the little swamp. Sheltered, sunny, warm, a dry hummock of matted-down ferns. The snow is almost all gone and the water gleams and shimmers next to the islands of sphagnum moss. Completely unsketchable.

At Salamander Pond the whole W bottom of pond seems covered with eggs today, some white. I could have just missed this yesterday, as it has not rained since then.

April 14 ('99). Grim 38 degrees, windy. Cloudy. But outside in the woods I find all these—leeks and cowslips for sustenance—*lunch!* And the hepatica, blue cohosh, spring beauties, toothwort, and trout lily (these two in leaf only) for inspiration!

April 15 ('98). 10 AM, on hill by house. Swallows back, a pair here, rather quiet, not nesting yet as none have approached the birdhouse. I hear a bluebird nearby, over by Touchettes'. Grackles have all settled down to rather vocal nesting or pairing, some cowbirds mixed in. Phoebes are mating, two pair in our neighborhood.

No sign of the kestrel. Guess they decided against our kestrel box, but a starling seems to be impressed with it!

Some tiny flying insects have hatched, a small cloud moves by me at 2" off ground.

The snipe is winnowing *woo woo woo woo woo woo woo* above the wet meadows. I look, trying to see or remember exact shape. Only the vaguest recall of a wedge shape, going very fast.

April 16 ('98). Young moose in yard this AM! Yearling comes in on path; out by woods. Careful, slow, and stops for a long time to look at our house. Many young dispersing now.

Beaver, evidently second year young, seen on road. Diana saw a young muskrat walking the road ditch by her house, at Sparrow Farm. This is the time of year many reports of animals in unusual places occur.

Hobblebush viburnum branches, cut and brought in March 27, in bloom, since April 4 when the first white blossoms opened. Outside, hazelnut and poplar are flowering or "tasselling" as I like to think of it.

The leeks are up and in full leaf. We've been eating them daily—sweet, tender fresh cooked greens—dandelions too. Bloodroot is just about to open.

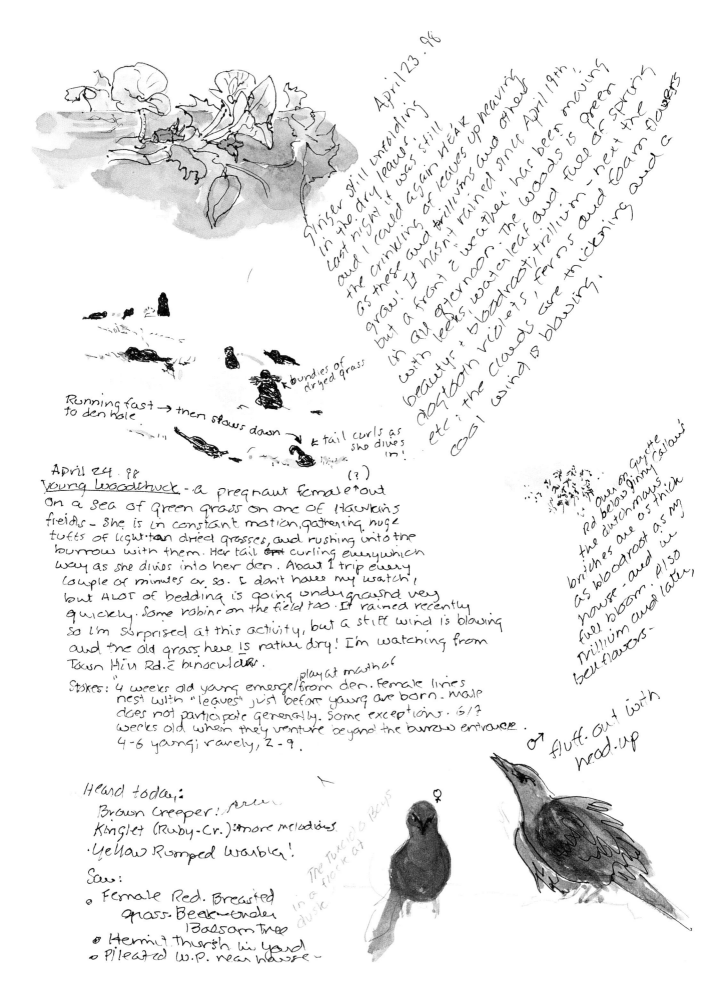

April 23. 96

Ginger still unfolding in the dry leaves . . . in the dry leaves. Last night it was still, and I could again hear heaving the crinkling of leaves up as these and trillium and others grow. It hasn't rained since April 19th, but a front & weather has been moving in all afternoon. The woods is green with leaves, watercleaf and full of spring beauty + bloodroot, trillium - next the dogtooth violets, ferns and foam flowers etc; the clouds are thickening and a cool wind is blowing.

Running fast → then slows down to den hole.

← bundles of dried grass

← tail curls as she dives in!

April 24. 98
Young Woodchuck - a pregnant female? out (?)
on a sea of green grass on one of Hawkins
fields - She is in constant motion, gathering huge
tufts of light-tan dried grasses, and rushing into the
burrow with them. Her tail curling everywhich
way as she dives into her den. About 1 trip every
couple of minutes or so. I don't have my watch,
but ALOT of bedding is going underground very
quickly. Some robins on the field too. It rained recently
so I'm surprised at this activity, but a stiff wind is blowing
and the old grass here is rather dry! I'm watching from
Town Hill Rd. & binoculars.

Stokes: "4 weeks old young emerge/from den. Female lines play at mouth of
nest with "leaves" just before young are born. Male
does not participate generally. Some exceptions. 6/7
weeks old when they venture beyond the burrow entrance.
4-6 young; rarely, 2 - 9.

Over on Guyette
Rd below Ginny Calais'
the dutchmans
britches are as thick
as bloodroot as my
house - and in
full bloom. Also
Trillium and later,
bell flowers-

♂ fluff out with
head up

Heard today:
Brown Creeper!
Kinglet (Ruby-Cr.) more melodious
• Yellow Rumped Warbler!

Saw:
o Female Red-Breasted
grass-Beak-onder
Balsam Tree
o Hermit Thrush in yard
o Pileated W.P. near house-

The Tuxedo Boys in a flock at dusk

♀

CRANBURY meadow Bog Rd. 4·24·99

TRAILING
ARBUTUS
everything
from brown.
frost nipped buds,
to buds ready
to flower to
to glorious, fragrant,
in-bloom flowers* - depending
on micro-climates in this small area.

In bud here
facing the
west wind

garter snake with
a bright coral toungue,
on the bank with the
arbutus - a protected
spot in the sun on this
cold windy day.

In the pond behind us,
scaup and hooded
mergansers. we
feel lucky to have
found such a haven
on a cold day.
* most in bud

BROAD·WING
HAWKS back.
2 Reports. Chas.
and Brian.

protected here
and in full bloom.

Poplar tassling
(flowering) on the
hillsides. (calais)

4·25·99 Still dry - resulting
in intense early spring
colors, as maple flowers
(red-maple) have never
fallen from trees Gradually.
Its so red that it looks like
fall. TO Burlington for Abe's
1st birthday. one year old!

Am - Lead spring wild-flower walk
for VT. Bird Tours & Brian. Leather-
Bush in bloom and because of
the lack of rain, the most spectacle
hepatica on the banks at
water Smith's Sugar woods.

4·26·99. Bluebirds - No sign of
them this Am and the swallow
are back, playing in the air
together, flying up to +
alighting upon both boxes to
peek in - there have been
some dramatic territorial
shifts in our absence - still
hoping they will settle for
some sort of coexsitance.

Bloodroot in bloom -
looks like snow in
the woods here.

This section-along I·89, in
just the right light - Red maple
flowers and a few flowering
poplar - really a lighter color
look almost line shad
which is FAR from
blooming here.

Ginger still folded up just under leaf surface. Lacy Virginia waterleaf leaves up everywhere. Trillium folded up under leaves, almost not recognizable. We've had frosts every night—will they recover as it warms?

Birds heard while sketching: snipe, redwing blackbirds, juncos, jays, cardinal, chickadee, white-throated sparrow, a mystery bird *peep peep peeping*, fox sparrow with its liquid alto song, passing through on way north.

Also, hepatica blooming, with last year's leaves purple, the new leaves curled and very furry. A favorite of my childhood. And blue cohosh—an amazing lavender, soft and smooth.

Brae Loch, Colchester. Out on the lake, 2 female bufflehead ducks.

7:00 PM. Home in time to pick leeks, dandelions, and steam up a spring dinner!

Rain coming in finally after 2 weeks (almost) of sunny but cool spring weather.

7:30. Rain has not started yet. We're expecting tonight to be spotted salamander night, but we need several hours of rain. I'll be up all night at this rate!

April 16 ('99). Frosty start to a sunny day in the 50s–low 60s. 12:00 noon. Siskins still here or passing through on way N. Sun doing its job heating the mat of organic material and the earth underneath. Moaning cawing noise last night at Marc McEathron's. Porcupines?

Ground just thawing from last night's frost. Small patches of ice left in woods here at 900'. Day lilies 3" high in Montpelier. Charles heard first hermit thrush last PM on Canine Express.

Screeee! alerts me to this pair (broad-winged hawks) directly overhead. Big loops away, then back, gradually climbing higher. Sometimes almost touching.

April 17 ('98). 7:20 PM. Bliss Rd wetland. Deafening, intoxicating din of spring peepers. 2 mallards (male and female) go on about their preening. I stuff sphagnum moss in my ears. Wood frogs mating to my right, peepers going wild. Mallards still active. Getting dark. Sky clearing a bit, not raining anymore. No sign of spotted salamanders.

Finally, in semipermanent pool in Butler's woods, 6 or 8 quiet spotted salamanders, many hiding under leaves, and spermatophores, like small white British soldiers lichen, about 5–6" deep in the pond. Rain stopped, 9:30 PM.

April 17 ('99). 9:30 AM. Salamander pond. Full of wood frogs. Sun and the woods wet and lush with moss. Still, only brief showers, no real steady rain. Singing: red-shouldered hawk or a blue jay mimic, nuthatches, phoebe, crows,

wood frogs possibly at a distance, brown creeper, one spring peeper, propeller airplane drones overhead.

Wood frogs resting on surface of water. They dive at the slightest movement and I must wait for them to re-surface. All males so far, and attempting amplexus with one another. In nuptial "garb," females a reddish color, males a rich dark brown. Swim up from the bottom one leg at a time, NOT "frog kick," front legs held close to body; "elbows" out "frog kick" used for fast horizontal movement.

A spotted salamander comes up for air, later a Jefferson complex surfaces on other side of pond.

7:30 PM. Later, much needed rain, and temperature drops from mid-50s to high 30s. The pond is still, and seemingly abandoned, though full of eggs when I checked it with neighbors after supper.

April 18 ('98). Berlin Pond. Out with Jim Andrews and group looking for amphibians. Redback salamander under small log—only salamander here which does not migrate to water for breeding. Beaked hazelnut still blooming in wet areas here.

April 18 ('99). Sunny, clouds, 50s. To Colchester and Burlington. Willows, box-elder changing color. Red maple buds in Richmond. Some quaking aspen in full "tassel." Colt's-foot near blooming.

Jewett Brook, Harvey's Lake, Barnet, Vt. With Tom Willard and Syzs to see smelt run at night. We search the brook with boots and flashlight, but see only a few sparkling white eggs, like white sand encrusted on dark rocks in the brook. Only just started, only 1 or 2 smelt. In full run they can fill the brook, edge to edge!

April 19 ('98). Sand Bar State Park, Lake Champlain, with baby Quinn, AM. Ice-damaged trees, great blue heron and a pair of wood ducks. Also goldeneye pair. Ospreys *peep-peep-peeping* overhead, back and forth. Gray day. No green here yet, the ice storm having destroyed much of the canopy.

Salamander watch continued in E. Montpelier in PM. Raining hard last 45 minutes to hour. Out to check ponds at 5:30 PM and again at 10:30 PM. See a few spotted and 2 lighter "Jefferson complex" types.

April 19 ('99). Sprinkles of rain, some blue sky. Mild, calm, sweet day. An indoor day for me till this 15 minute "sit" upon the hill. 2:30 PM. Snipe working the air over territory. Can't pick them out from the many cloud forms but hear

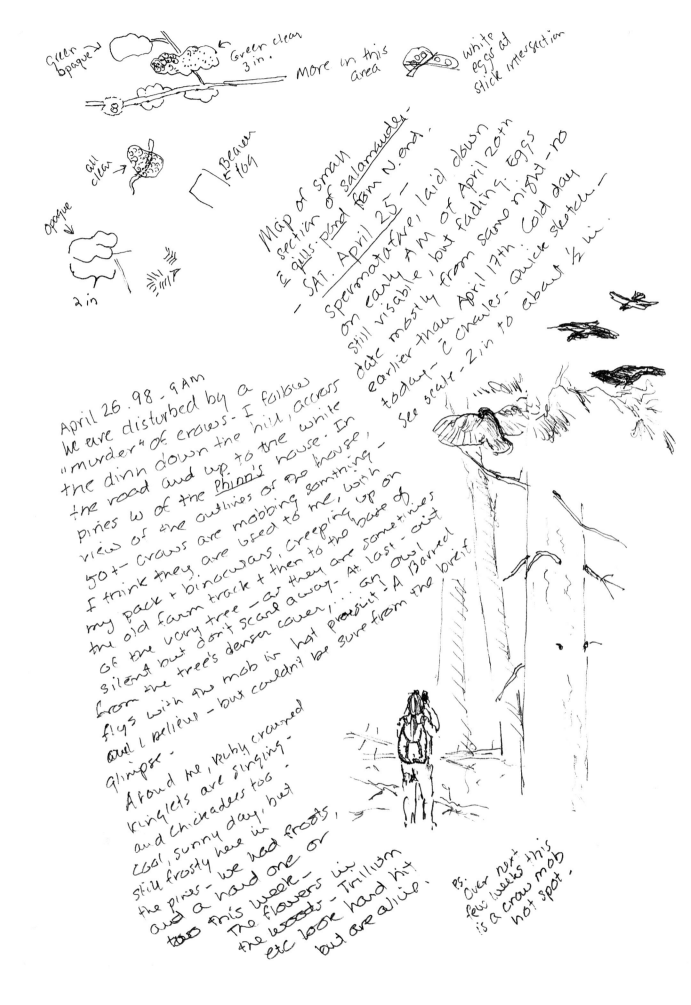

Green
opaque →

← Green clear
3 in.

More in this area

white eggs at stick intersection

all clear →

Beaver log

Opaque →

2 in

Map of small section of salamander E gulls pond from N. end.

— SAT. April 25 —

Spermatophore laid down on early AM of April 20th, still visible but fading. Eggs date mostly from same night — no earlier than April 17th. Cold day today — C Charles - Quick sketch. See scale - 2 in to about ½ in.

April 26. 98 - 9AM
We are disturbed by a "murder" of crows - I follow the dinn down the hill, across the road and up to the white pines W of the Phinn's house. In view of the outlines of Do house, 50+ crows are mobbing something - I think they are used to me, both my pack + binoculars creeping up on the old farm track + then to the base of of the very tree — or they are sometimes silent but don't scare away. At last - out from the tree's denser cover... an owl flys with the mob in hot pursuit! A Barred owl I believe - but couldn't be sure from the brief glimpse.

Around me, ruby crowned kinglets are singing - and chickadees too. cool, sunny day, but still frosty here in the pines - we had frosts, and a hard one or too this week — The flowers in the woods - Trillium etc look hard hit but are alive.

P.S. Over next this few weeks this is a crow mob hot spot.

SUDDEN HEAT - Cool nights but 70† Days + Sunny.

1:30 · Rasbury Tangle - Clarks.
April 31 - Wave of Warblers
Is in - Sunny, Hot! Looking for
fiddleheads - Yellow Rumps -
Beautiful glimpse of male
singing + another flitting -
female Kinglet too. The
tangle is full of little birds
and the 1st warbler songs.

"weet-weet-
weet-weet"
weet-weet-
weet-weet
in high
quick succesion

Blue azure

floats
by

Kinglets making
that chitter -
rattle noise
Red elderbery poped
into tiny leaves

Otto catches some
little bird - like
a grouse -!
can't see it -
a _____ wood-
cock or _____?

or snipe?
Already?
It squeeks
+ he releases
it.

These BOXELDERS
are
IN FLOWER -
NO LEAVES YET

April
30

My home woods are
now a riot of early
spring bloom, and
crawded with leeks,
ginger, Trout Lilly, blood-
root + Virginia water-leaf;
leaves; all shown above
and the air above these
plants is moving with
various pollinators, all too
skidish to stay if you
approach - I watch through
binoculars + enjoy seeing
their activity. Trillium is out
now everywhere, but not in this
small 8 inch square above.

DAFFODIL / FIDDLE-
HEAD CONNECTION
MAY 1 · COLCHESTER
Fiddleheads at vt.
last - in Colchester
at Mario's, and
yes, the daffodils
are blooming their
heads off... Fiddle-
heads JUST starting
to come - some
have apparently
been up for a few
days, about since

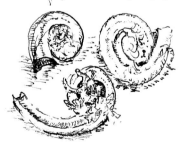

the daffodils first
started to show one
or two blooms. Ours
at home in E. mont. any day now.

5:00 PM
Pittsborg Airport

MAY 1 - On way to Colchester →
Airport → B'oomington, Indiana.
Home for visit to my mum, sister,
their familys, and my old home
woods! 1st shad blooming in Rich-
mond, along with a 5 day heat-
wave in on us since yesterday -
(the wave the above warblers
came in on). This is the moment for
FLOWERING TREES. I enjoy the
Boxelder along the river - The flowering
♀'s more green ; the ♂'s more brown/
 RUST
 COLOR →

constant, soothing "winnowing," the *woo woo woo* sound. No sign of bluebirds; are they looking at other real estate?

April 20 ('98). With Annie Reed and Lori Barg, visiting "their" spotted salamander pool in Plainfield. As we leave, the sky is lifting and clearing, and on a hill across the Winooski River the red maple flowers and new poplar leaves are putting on a display! I believe this is what J. Jenkins calls "red and green day"— the female red maple are still flowering when the poplar leaves break their buds.

April 20 ('99). 50s, breezy, sun and shade. Plant beets, chard, and lettuce in the cold frame. Two beautiful singers, just before the warblers arrive, sound a bit like warblers: the brown creeper and the ruby-crowned kinglet singing from hardwoods and balsams.

April 21 ('98). Looking at elms. Our most graceful tree, yet it has such angular twigs. These have been flowering for about 10 days or longer here, while I was away. Using binoculars to look at the elm "tassels" (flowers). Leaf scars with bud above; buds at top of stem. Globs of flowers along lower stem. Elm flowers pale green and purple-pink. Colors change and intensify as you get closer.

April 21 ('99). Cape Cod. Herring Brook, Eastham. Site of herring (alewife) runs at this time of year. Moon overhead at 5:15, waxing. Tide just about to go out, into the sea.

Flora sequence: daffodils, cherries (domestic), magnolias, forsythia in full bloom; down in bogs leatherleaf the only thing blooming; shad about to bloom, buds developed and ready; balsam poplar, honeysuckle—only leaves fully out; inkberry has leaves, but these apparently evergreen; bear oak buds first to break out, other oaks behind; red maple buds showy.

Bumblebees flying around low in oak woods; these are large over-wintered queens, scouting for nest sites.

Successful tiny baby eels (they are 3 years old before entering rivers), called elvers or glass eels, just arrived from 3,000 miles away (born in Sargasso Sea). Easy to see in the white sand of Herring Pond Brook as they complete their long journey. Will live here for years until sexually mature, when they return to Caribbean to spawn. They are swimming upstream but we can't see how they'll ever get over this baffle or gate, or how they got over the earlier gates, 10 times their height. In the water they are very hard to see, being almost completely transparent. At Bridge Pond they are against a dark mossy green wall and appear blue!

Brewster River. Herring of all sizes, most 9–11", from Newfoundland south spawning here in this pond, 2 miles from the ocean.

Paine Creek or Stony Brook. We are on the banks of the brook leading into the pond. Many small rock chutes and jumps between pools. The cranberry bog is below us. Hundreds of fish in this small pond, not moving upstream at the moment (9:30 AM, low tide at ocean.)

Things we heard about the herring runs:

- "So crowded they push each other up out of the banks."
- "So thick with herring you could walk on them."
- "The water was black with herring; you couldn't see the bottom."
- "They come in at high tide."
- "It doesn't matter what the tide is."
- "Better when it's sunny."
- "Better at night."
- "Runs are down the last few years."
- "Best run we ever had last year."
- "The run is late this year."
- "They haven't really started yet this year."
- "Next week." (About the time shad blooms.)

April 22 ('99). Duck Harbor, Cape Cod. On Great Beach a right whale carcass and parts—many people dissecting and viewing. Horned larks on beach (I thought they were pipits). Bearberry blooming, sand cherry in bud. Further out on beach a small dead pilot whale, recently washed up. We're hearing bobwhites everywhere. Male and female kingfishers on phone lines over Herring Brook. The coastal heathlands now with bear oak budding, a rose pink and gray-green from the lichens.

April 23 ('99). Cape Cod, Wellfleet Audubon Center. Blooming: domestic cherries (wild in bud), blueberries, bearberry, red maple. Sweet gale catkins turn wetland rusty, rugosa roses all have new leaves everywhere, shad in fullest bud (off the Cape shad is blooming).

Birds in salt marsh and waters off coast: brant, Canada geese, red-breasted mergansers, black ducks, eiders, black scoters, etc. At dusk Charles sees a short-eared owl flying low and bat-like over the marsh.

April 24 ('99). Back home from Cape Cod. COLD! Vermont is in a very cold high pressure. 20s last night. 10:00 AM, sunny and freezing. Hands cold.

April 30 - Home to E. Montpelier - 7:00pm

A flower mystery... Still early spring here - Evening. Shads just begining to bloom, maple still in early tassel. no leaves at all - But cold - the Bloodroot + hepatica are way past. How to explain it ?!!! They are still in full swing under the leafless oaks by the lake at Mario's in Colchester!

?

next am I see the wild Am. plum is covered with blossoms. I've never see it like this in 17 years.

Tiny pink bud - Blossom actually white. petiol + stalk red - .

SPRING SOUNDS: ALMOST DARK - SITTING OUTSIDE	• phoebe • peepers - a huge chorus distant - fewer up close. • Robins • hermit thrushes • cars on the road with an occasional motorcycle - will hear it less when leaves are out. • The dogs pacing about as they smell + hear things outside - • white throated sparrow

MISSING: NOT YET category

No mosquitos; yet
NO woodcock; yet
No woodthrushes; yet
NO Toads; yet, trilling

Today, MAY 1, the shad blossoms are opening before my return to the house from a walk to Clarks hill! They were not open as I left! The branches most in sun and against the house are 1st to unfurl their 5 lovely white petles. Today too, I see the maple do have leaves. Tiny umbrellas formed over the tassels -

watching around tree clump of old Basswood trees

Drumming on Basswood tree a few left away! mostly hidden from view but perting in several different spots.

Red crest stunningly bright! Breeding Best?!!

Neck fits big but redder!

twists up into head up into crevice

lovely black back!

A quiet tap-tap on the white, gives away his location. after initial drumming

Pollinators: Two insects: could the one right be an carrion fly - long legs / carrus body high.

1:00 - while watching P. woodpecker I hear another a saw what owl or a truck backing up!! And I have good ears! we have S.W.'s here so?

Watching the bluebird boxes to see what happened in our absence. The male is on the telephone wire, singing. I assume the female is in one of the boxes—which? No swallows in sight.

Ruby-crowned kinglet. I hear fragments of that gorgeous song as we leave the yard to go look at wood frog eggs at Jennifer and Richard's. Returning by the back path, we watch a male kinglet sing and forage for insects. Watching it, I feel it's my "favorite" bird—where do they winter? This one has just arrived. Such a plain little round bird, until it flashes that red crown and lets loose its song!

April 26 ('98). 9 AM. We are disturbed by a "murder" of crows. I follow the din down the hill, across the road and up to the white pines W of the Phinn's house. In view of the outlines of the houses, 50± crows are mobbing something. At last, out from the tree's denser cover, an owl flies with the mob in hot pursuit! A barred owl, I believe, but couldn't be sure from the brief glimpse.

Around me, ruby-crowned kinglets are singing, and chickadees too. Cool, sunny day, but still frosty here in the pines. We had frosts, and a hard one or two, this week. The flowers in the woods—trillium, etc.—look hit but are alive.

To Lord's Hill old growth forest to admire the spring beauties just about to open and the huge old basswood and ash before leaves come out. The basswood's mature shape is quite different than that of its new growth, as is often the case in trees.

April 26 ('99). Bluebirds and swallows are back, the swallows playing in the air together, flying up to and alighting upon both boxes to peek in. There have been some dramatic territorial shifts in our absence. Still hoping they will settle for some sort of coexistence.

Bloodroot in bloom, looks like snow in the woods here. Blue cohosh flowering now. Pistil matures and is pollinated before the stamens mature.

Beech leaves still hanging on.

A huge queen bumblebee making an efficient search of the ground for potential nest site—an abandoned mouse or chipmunk hole? She flies low on a serpentine route, stopping for only a second to investigate a hopeful-looking recess under an occasional dry leaf. I really get only the general impression of a bright orange saddle and that soft deep black and, of course, the sound. And she's gone.

April 27 ('99). E. Montpelier. Warm day and suddenly lawns are green, early daffodils just blooming, and cherry is breaking bud.

Fresh bear scat near the wetland, composed entirely of plant fiber.

Willows flowering. Pussy willows going wild! My hands are covered with yellow pollen, from looking at these, down below the house in the cattail swamp. The "bushes" are very attractive right now, and little bees think so too.

April 28 ('98). Colchester. Dove all puffed up, watching me. Woodpeckers pounding, squirrels scolding, cowbird pair mating a few feet away.

Fiddleheads just coming up on Duck Blind Road, a lot wiped out by trees falling during ice storm. Quinn and I pick many of these for supper— "Yummy!" he says. Dutchman's-breeches blooming.

An early saxifrage growing profusely by the rock puddle on mossy ground.

Male black flies have hatched! They dive into my face periodically, but don't bite. The warblers cannot be far behind.

Maple tree flowers here next to the lake, only a week ahead of E. Montpelier. But generally spring here is 2 weeks, at least, ahead—fiddleheads already up, grass green, dandelions blooming.

7:30 AM. A beautiful fresh morning. Chickadee excavating a hole, his tiny head lost in the cavity. Swallows doing swoop dives of mating on field. A grouse, well camouflaged, scurries away in the brush.

April 29 ('98). Mallett's Bay, Colchester. Hear osprey down on W side of Duck Blind Road.

Sarsaparilla about to flower, leaves just unfurling on a dry bank. Oak overstory.

Vernal pools near Mario & Phil's house full of mosquito larvae and tiny tadpoles. The tads lie on the leaves just submerged in the sunny warm top water. The mosquito larvae line up on the surface mostly, head down. They scramble for the bottom if approached. Tads are less fearful.

I believe tadpoles are predated by mosquito larvae, but not sure. They are by caddisflies—I only see one here.

Inconsistencies and microclimates of spring. These delicate and almost shocking blue-violet hepatica, just starting to bloom on the hill behind Mario & Phil's in Colchester, within sight of the lake, and well behind those lower down. These are so lovely among all the dead leaves.

April 30 ('98). Mallett's Bay, Colchester. Trees in flower! The birches in full golden-copper tassel (yellow birch); the maples a lovely yellow green against a blue, blue sky. Black flies are more numerous today, still not really biting. Time for warbler waves.

The lake is a pale silver blue this AM, with weird patterns in a couple of places. Camel's Hump in the distance.

Using binoculars to see the trees in flower. I see the maple leaves popping out from above each tassel and from buds with no tassel. In a couple of days there will be less sun on the woodland floor.

And the white oaks, just starting to break the buds with leaves and catkins. The leaves become a lovely pink at this stage, just a few more days and the catkins will be 5 inches long.

Back porch, 4:00 PM. Whole flock of white-throated sparrows picking at seed below me. Migration still in progress, at least for many birds—most!

A beautiful fox. Walking with new baby Abe in the snuggly on Duck Blind Road, we flush a fine fox on the other side of the blown-out beaver pond. They den in this area every year. There is a likely sandy bank near. We leave discreetly but not before two barred owls start a loud and varied racket. My attention was attracted, as it so often is, by a crow giving warning and scolding (the fox?).

April 30 ('99). Montpelier. With Sara Brock, see a raven's nest in the old slate quarry on the Zorzi property. Been nesting here for years, within a shout of the Vermont College campus. Two young visible, noisy when calling *GROOK! GROOK!* The parents swoop in periodically. Use scope.

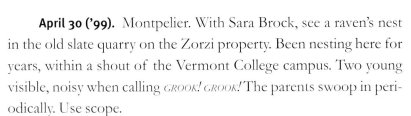

On the way home a small gathering of green frogs, eight all together, facing the water. What are they doing so close together? They are well camouflaged amongst the grasses and twigs. I assume they are females, as males are territorial.

At this time of year, colors of sky and earth reflect one another, the bare hardwoods and cloud edges, the same soft rose. Wind blowing hard. Just after this, a lenticular cloud breezed through. Soft edges. Perfect.

1:30, raspberry tangle, Clark's. Wave of warblers is in—yellow-rumps, Nashvilles, chestnut-sideds. Female kinglet, too. The tangle is full of little birds and the first warbler songs.

Red elderberry popped into tiny leaves and flower buds.

Mating

Is It Love, or Just for Sex?

According to one ancient mythology, the human being was once neither male nor female but whole, complete, genderless, and contented. Sometime along, however, it split into opposite sexes, and the two became separated from one another, and lost. Ever since, the one half has been looking for the missing other, in an endless quest to become whole again. The search is relentless and never ending, the goal tantalizingly close but never fully consummated.

This is surely first and foremost a metaphor about the human interpersonal dilemma, which has perhaps appeared at other times, after being modified or adapted by other cultures (the fall from grace in the Garden of Eden, for example, or as author Willa Cather put it, "human relationships are the tragic necessity of human life"). But, from the biological view, it is also revealing about the nature of mating, among not just the human species but virtually all species, the inexorable drive toward union with another of one's kind.

In trying to pin down the ultimate reason for such behavior, some scientists assert the urge is fundamentally toward procreation, its power commensurate with ensuring perpetuation of the species. Others say the urge is its own desire, a selfish craving for sensual gratification, which, fortunately for the species, whether intended or not, results in offspring. One of the latter, Richard Dawkins, has written a book about the "selfish gene," the premise of which is that the overriding force is DNA making sure it gets itself replicated and passed on from generation to generation, with individual plants and animals merely the vehicles.

So which is it: the bridge between generations, the single most wondrous and sacred symbol of life's seamless continuity; or the most basic biological

urge after self-protection, eating, and sleeping? Or is it merely a means devised by nature to ensure its own perpetuation through its living members? Does it have to be one exclusive of the others, or could it possibly be all simultaneously, inseparably, the most selfish of acts for the individual also being the most self-less for the species, or for life itself? We know such paradoxes. For example, that which gives us the greatest pleasure is also capable of inflicting the deepest pain.

Without trying to confirm one theory or another, or discern "intention" behind this or that behavior, we can simply marvel at the phenomenon in all its diversity. Our brain, regardless of size and degree of development, is no more useful than a fly's when questions have no answers, or when questions are super-fluous. There's no fixed rule, no absolute, about how this relationship works in nature, no single facile combination that aligns the tumblers quickly and lets hidden mystery fall open. Accepting the wonder must be enough sometimes.

Most organisms—species as a whole, not necessarily all individuals within them—mate in some way, if not periodically and regularly, then at some time in their life. Most organisms, too, plant or animal, do so during rather sharply defined seasons, a brief period when males and females are physiologically primed, through elevated levels of hormones (auxins in plants).

Most mammals, birds, reptiles, amphibians, fish, and insects mate in "tra-ditional" ways, pairing in their appropriate season, separating until pairing with other individuals the next season. The "season," triggered by length of daylight, is a product of the intricate interactions of organism and environment. Its tim-ing has evolved to factor in the reproductive charac-teristics of the parent (e.g., gestation period), the developmental characteristics of the offspring (e.g., growth rate), and environmental characteristics (e.g., food availability; the young must achieve some man-ner and measure of self-reliance by winter).

So, large, nonhibernating land mammals such as moose and white-tailed deer, whose gestation periods are long (eight months for moose, nearly seven for deer) and whose young develop slowly over months, mate in the fall, with calves and fawns born early the following spring and growing to strength over summer and fall.

Medium-size mammals—coyotes, foxes, bea-vers, and the like—usually have much shorter ges-tation periods, only several weeks to a few months, and give birth to young in early spring. Yet smaller

mammals such as hares, rabbits, chipmunks, and squirrels may have more than one litter a year, and their young grow rapidly. Cottontails, for example, are weaned and independent in 28 days, red squirrels in a month, though they often remain with the family group until fall. The smallest mammals in New England—mice, voles, and shrews—may breed at any time during the year, out of sight and, in winter, under the snow, within protection of their grassy or earthen nests and tunnels.

Of course, there are exceptions to all these generalities, but for very understandable reasons. Female black bears, whose gestation period is comparable to that of moose, mate in early summer and give birth in the middle of winter, their newborns nursed within protection of underground shelter and maternal warmth. Marine mammals, with gestation periods often a year or more, are not so constrained due to their more mobile and migratory habits. Several members of the weasel family—fishers, martens, long-tailed weasels, and ermines—mate in late winter but do not give birth until the following spring; the fertilized egg, "implanted" in the uterus, grows as an embryo only a few weeks prior to birth (their "gestation," therefore, is still only a few weeks). Though small, jumping mice and bats of several species do not breed in winter, as they hibernate then.

The pattern is similar in birds. Most pair only for the season; some, notably the big waterbirds—geese, swans, and some ducks—remain with the same mate for as long as they live; perhaps this comes closest to our concept of "marriage." And some may have two or more partners in the same season, whether they are polygynous (one male mates with two or more females, such as winter wrens), polyandrous (one female and two or more males, as spotted sandpipers), or promiscuous (e.g., woodcocks).

Of those pairing for the season, the larger birds, especially the raptors

(hawks and owls), generally mate early in the year, have small clutches, and tend their young well into summer. Smaller, shorter-lived birds may have two or more clutches of larger size, most breeding in the spring when insects are available as protein-rich food for their young. A few mate rather late, timed to other natural clocks: for example, cedar waxwings feed extensively on the berries, fruits, and flying insects of late summer, while goldfinches dine on the flush of seeds that ripen then, and line their nests with thistledown that fluffs up white in August.

Courtship—the wooing and winning of a mate through vocal, visual, olfactory, and/or tactile display, usually performed by the male for the female—is an important phase of mating. Often it is a prerequisite to it; in many species, females simply will not or cannot mate unless adequately primed to do so through this process (it is not an unrequited activity, however; females indicate receptiveness by responding through the same, though often less ostentatious, means.) That which attracts also repels: courtship behavior that is intended to secure the affection of the female usually also serves to exclude other males seeking the same, for example, the spiral flights of sulphur butterflies, the ear-splitting peeps and chin sac inflation of spring peepers, the song and ruffled red shoulder feathers of redwing black-birds, the great lunges of breaching whales, the huffing and antler rattling of white-tailed deer. (How about the deafening music and tire-squealing cars of youthful human males?)

Whether in dense tree canopies, a broad field, the deep ocean, or at night, such displays are appropriate to the characteristics and dimensions of the animal's habitat. Bobolinks rise above meadow grasses, then drop out of sight, letting fall as they go the metallic tinkling of their song, almost like broken glass. Spirited, sweet melodies and flecks of color give glimpses of warblers flitting in the shades and leaves of forests. Foxes bark and yip into the February night. The chirps of spring peepers amass into a mighty, head-ringing chorus in the night marshland. Common snipes speed through the evening sky, accompanied by the strange whistling of their wings. Whales, we know through electronic eavesdropping, emit low-frequency submarine calls to others of their kind, often over great distances.

It's not just voices or sounds. It might be striking colors, such as with many birds. Or changes in posture, such as the stiff-legged strutting of dogs. Or activity, such as male cottontails and snowshoe hare leaping over their prospective mates, or humpback whales flinging their bodies thunderously against the ocean as they breach. Or scents. Many insects, for example, emit powerful pheromones, undetectable by us but in minute quantities able to draw mates

over many miles. (At an office picnic, I once saw male gypsy moths fluttering about the pants of one, and only one, of the 35 participants. He, a forest entomologist, said this always happened since he had worn these pants when setting pheromone traps for the species. What was remarkable, though, was that the last trap he set had been four years prior, and he had washed the pants innumerable times since then!)

The displays of colonial breeding species become elaborate, some verging on hyperbole, as if individuals in such colonies need to make extra efforts to announce themselves among the hundreds or thousands of look-alikes of their kind. Also, demonstration of individuality yet adherence to a more structured social order are both critical when space is scarce. This is as true for humans aboard ships or in cities as it is for these colonial animals. The bugling of congregated gannets can be deafening, the amassed voices of spring peepers in ponds or periodical cicadas in treetops head-splitting, the chirps of cave wall-hanging bats like a million densely packed insects. Even if the species members are silent as they go about their business, their courtship movements are comparably extravagant. Spotted salamanders in vernal pools and Atlantic salmon in certain stretches of streams roil the water with their frenzy, horseshoe crabs push the sands of tidal estuaries into bumpy mounds as they bulldoze in, and garter snakes entwine themselves into sometimes huge mating balls.

Though most people may not think of it in these terms, plants also "mate." But, being stationary and unable to come together in the literal manner of animals, they usually do so via intermediaries—other agents do the moving for them. For most terrestrial flowering plants, insects, wind, sometimes birds (e.g., hummingbirds), and even small mammals carry pollen (the male sperm) to the stigma (leading to the female egg[s]). In aquatic flowering plants, such as pondweeds and water lilies, water performs this function, acting as a medium for pollen to float from plant to plant, with either currents or wind providing the movement. Even rain has a role. In the hairycap mosses, cups atop the stems hold the sperm, and splashing raindrops carry it to other, neighboring plants. (Could it be said that viruses mate with cells, to produce more of their own kind?)

The showy, often perfumed blossoms of flowering plants, attractive to us, appeal to other, more useful, sensibilities. They are the plant's advertisement to its intermediaries that food—pollen and/or nectar—awaits as a reward for

facilitating pollination. But beauty and scent are only two means to that end. Deception, sometimes of great elaborateness, is another way.

One type of deception is mimicry, pretending to be what you're not. The putrid odor of the aptly named carrion flower, or even the less obnoxious one of the purple trillium, attracts certain flies that deposit their eggs in rotting flesh; in their mistake, the flies become the unwitting pollinators. The bog orchid grass-pink leads carpenter bees toward a promise of nectar at the bottom of filamentous "anthers" in the base of its top petal. But the anthers are fake, merely filaments, and the petal is hinged, so that the weight of the bee causes it to bend. The back of the bee falls into the ladle-shaped lower petal, where the real pollen sticks to its back. When the bee releases the top petal, struggles out, and flies away, it falls for the same trick at another flower, this time plastering the pollen against the stigma at the far end of the receiving petal.

Trapping is another deception. The odd-structured flower of milkweeds often snares the legs of bees and moths crawling over them; if the creature is able to pull away, its trapped foot yanks out an apparatus full of pollen, which it transports to the next flower. The moccasin flower (pink lady's-slipper) blossom lures bees into its interior through a slit in the sac; however, the bee must exit a different way, during which the sticky pollen sacs adhere to the bee's back. Upon its entrance to the next flower, it deposits the sac on the stigma.

Whether a flower by luring accomplices or victims, a bird by fanning its tail feathers or singing pertly, a mammal by dancing or bellowing, the mission —if we can assign a destination to these attributes—is the same: to allow the sexes to get together at the appropriate time.

However chancy the venture, whatever risks encountered along the way, reproduction is either the by-product of such unions or the goal, depending on your interpretation, or your faith.

MAY

May 1 ('99). Colchester. Daffodil/fiddlehead connection. Yes, the daffodils are blooming their heads off, and fiddleheads just starting to come, some have apparently been up for a few days. Ours at home in E. Montpelier any day now.

This is the moment for flowering trees. I enjoy the box-elder along the river, the flowering females more green; the males more brown/rust color.

May 2 ('98). Rain in the night and showers today. At the salamander pond in the rain, all egg cases growing, even the white ones. My sketch book getting wet, but I don't mind after a long dry period!

The wood frog eggs have already started hatching. About ¼ of the eggs producing these lively guys, not much difference between the body and tail. Hundreds stay with old egg masses, darkening them, while others swim free. Many eggs still unhatched—thousands! The wood frog egg masses have all turned mossy green, as have a few of the salamanders. Some still clear, others cloudy.

New oak ferns, 3–7" high, near old farm dump pool, deep mixed woods with beech. Very live lime green.

May 5 ('99). East Montpelier. Back home for a couple of days where the black flies haven't started.

Wild plum, to me the lightest, airiest, and most ethereal of all the spring bloom, particularly on a gray day.

Nashville warbler singing in area by road.

Clumps of interrupted fern with white to tanish "wool" still adhering to the fiddleheads emerging from last year's dead stalks.

May 7 ('98). Snipe unison paired flight 1 hour, with continuous *chip-a-chip-a-chip-a.* (This is the mystery bird of April 16.)

May 8 ('97). Still more snow-melt snow fleas! So velvety-looking. After snowy night the water in woodland puddles on the Canine Express is full of floating rafts of charcoal blue-gray, very active insects, thousands!

Trout lilies open on May 5 are now closed against the cold of the last few days. It's sunny and warm here in the woods but a 50 degree breeze is blowing out in the open.

As I head up the hill a robin is nestled down into one of our large pasture ant hills, preening away. Stops and eyes me suspiciously, then resumes a few minutes before hopping down. I'm always startled by the largeness of the robin's bill—helps with worm-work?

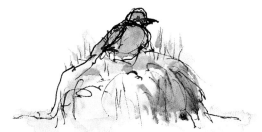

Up close, the left side of the hill has been dug in slightly and has mud (packed) "terraces." A few ants are making the rounds. Has this robin been anting here?

May 8 ('98). Evening, returning home to E. Montpelier, driving rain. Toads on the road migrating to their ponds to lay eggs—many killed. Dead moose on I-89 which I and many others run over. Much car damage and slaughter trauma. Finally home at 10:00 PM.

May 9 ('98). E. Montpelier. Overcast, mild. 7:00 AM. Warbler wave in overnight in E. Montpelier! Yellow-rumps, black-and-white in close to trunk, looking around, singing.

Pick a bag of fiddleheads over on Clark's. Self and sketch book totally covered with mud from shaking dog. Several toads trilling at night in R & J's new pond, the tones in harmony with one another. To sleep, windows open.

May 9 ('99). 5:00 PM. Snipe mating. Sustained unison *chip-a-chip-a-chip* flight loops often at tree top level all over our neighborhood (about 10 acres on ground.)

May 10 ('98). 9:00 AM. E. Montpelier. Solid, slow overcast with imperceptible showers that last a few seconds only. No bugs, and few warblers singing—a yellow-rump, a yellow, and a first chestnut-sided. Now, suddenly, many more.

Trees with still bare limbs here in E. Montpelier. Late leafing big-tooth aspen, bark more yellow or yellow-green than other aspen, and the leaves, coming a couple of weeks after other aspen, are a pale bluish, gray-green at first.

T corner. Sound like woodpecker, answered from over by my house, but shorter *tock tock tock tock tock!* A crow in the crown of a bare ash (still they have not budded) is *tock tocking,* head back, beak open for the entire phrase. Grouse in full swing with drumming every few minutes.

Ash and oaks have not yet flowered (in the case of ashes) or leafed out. Oaks, yellow birch still in lovely golden tassel. Basswood with tiny green leaves, mostly in bud.

See black-and-white warbler with nesting material right at the corner, and singing from exposed perches—the "nuthatch" of the warbler family (in behavior).

May 11 ('98). E. Montpelier. After several days of rain, time to look for morels. Every few years I'm lucky.

May 11 ('99). North Branch Park, Montpelier. Wood anemone, also known as windflower (buttercup family) growing in far western section of the park. Baneberry just blooming. Small, pretty foamflower—white clouds. Maidenhair, many of them, all overlapping, the impression of a circular, delicate lace from above, blue-black stem. Tiny miterwort's white blossoms on 6–10" spires —stunning with the magnification of hand lens. Bloodroot leaves huge now. Toothwort blooming white and intermediate woodfern uncurling.

Warblers everywhere.

May 13 ('98). Pond full of wood frog tads (no predators—caddisflies, mosquitoes, etc.) swimming lazily about in the sunny spots. Salamander eggs mostly unchanged but larvae thinner and longer. Occasionally I think I see a wiggle, but not sure. No sign of spent egg cases of wood frogs. Where did they go? On NW side of pond a mass of tadpoles seem to be predating the salamander eggs. Are they eating the gel or the larvae or both? Or just the algae on the egg cases?

Balsam, spring smell—when the wild apples are blooming, the balsam tips are new and have fragrance of strawberries! We pick a small container to dry in the entry window because it smells so wonderful.

Clumps of royal fern coming up purple-red with goldenish fiddleheads, green interrupted fern all around it.

Bees and flies and other pollinators of the wild crabapple in back yard. Seem to work in pulses: a lot for awhile, then suddenly none at all, quiet.

May 13 ('99). 10:00. Marsh marigolds are in full bloom. Bobolinks singing occasionally from shrubs and small trees, not yet in territories on the ground. Male redwings down in the marsh with females, singing, active. Now snipe flying up and down again, behind some alders. Call like flicker, *chip-a-chip-a-chip-a,* from the ground, not seen.

Turtlehead Fen. Wet field of marsh marigolds. Hard to pick up on: a swarm of solitary bees, mostly silent to my ears, pollinating, so many different kinds. All our native bees before 1700? Or some solitary bees imported along with honey bees? How would anyone know?

I pick a bunch more fiddleheads. Many fronds and fiddleheads hit by frost.

I'm sitting here in the wet meadow on my foam pad, dry and peaceful. A hummingbird motors through. Sun is warming my back. The wind is cool.

Acres of wet meadow with cowslips blooming. "Poor man's gold," I've heard cowslips called.

Turtlehead just 3–6" high now. When will the Baltimore checkerspot caterpillars emerge? This is their nursery!

May 14 ('98). E. Montpelier. Big seed year for yellow birch, elm, but not, it seems, for maple or ash—unless I've missed something in my trips to Colchester.

Dandelions. The beautiful lawn is a productive lawn! (food, drink, etc.) The dandelions are gold and scattered over the lawn in a pattern of random exuberance.

Drawing bees: If, like me, you don't kill them, you have a problem. They are very small. They are all different, and they never stay in one place long. If you happen to find a dead one to draw, you don't know, unless it's a bumblebee or one you are familiar with, whether or not it's a pollinator of the plant you were interested in—in this case apple. Also, it is dead, so you lose all the interesting behavior and positional information, all the empathetical beingness (no pun intended) which makes it impossible to kill them in the first place.

May 15 ('99). Everywhere now: Spring azure butterflies on Schoolhouse Road in damp dirt. Gray with wings folded, pale blue—azure blue—when they pop up. Under an inch when flying. Heavy, funny thorax; long, hard to see abdomen. Also mustard whites flying now.

2 ½ ˣ

smaller

longer

Also, has lower buzz. White pattern on tail

TRILLIAM Polinater Search - THE CARRION FLY
MAY 1 .98

I'm sitting in my woods, in a mass of,
acres of, purple trillium (or Stinking Benjimin, or Nose Bleed
as vt. school children used to call it) looking
all around for possible polinators - I know heard a
carrion fly of some sort is the one - but
aside from a single long legged fly on my
trillium leaf below - no one shows up (he's here
for a half

① wrong time of day? minute)
② The deed has been accomplished?
③ Too early?

I've been in Colchester for a week
so I'm plopped dawn with no sequential
frame or reference for this question -

I do know THIS

- The petals have yellow pollen
 all over them -
- The Carrilian "blood" smell is
 in the air -
- Those Trillium have looked
 a bit beat since a frost
 hit them hard April 26th
- SHADE is begining to form under Load
 of the swollen buds, tassels and
 the newly unwrinkling unbrellas
 of maple leaves. Light shade today
 but more every hour!

- Tonight were expecting RAIN for 2
 days. we are dry + need it, but the
 pollen had better be dispersed to all
 the ova or it will be washed dawn
 by drops onto the mat of last years
 leaves to become soil with the rest of
 whatever is on the ground!

USING BINOCULARS to find pollinators!

Finally using the binoculars + looking at flowers with no
obvious pollen on them, I notice flying insects around
the flowers, but they fly away if I make closer. This is the
large long-legged light tan fly of my picture, above. On
the flowers not in them. Or resting on leaves, as I saw. (?)

4:00 wood-
Pilated wood-
pecker calling
in the woods
below.

< Spruce fir
Softwoods- mixed +HARDWOODS
Pine →
Wet Area
2 Red maple →
field →
Spruce/fir
white pine +
Balsam
Dry grasses
+ new grass
→ with
late sun on it
And Aspen

4:00 pm
The crows
are starting
up over by the
owl roost. I
sit down to
watch - with
a perfect
view, thro
the still
rather
leafless
trees.

End day with a small mess of cowslip
greens - a clean snappy flavor - and
color to match! A couple of fiddle -
heads from Colchester - Here, they are
not at all up yet except in woods, where I refrain.

A spring supper!

MAY 5 Rain →

At last evenings meeting of
My Toxic Materials Management
Plan committee, Judy say there are
Companys killing mosquittos in
wetlands all over the Adirondacks -
this being done for tourists, but may
be rip-off due to loss of mosquitto
preditors - Amphibians, birds, etc.
Need more info -

At Home, Clean, plant lettuce, chard,
spinich; weed asparagas, pick lettuce +
spinich in cold frame, pick, wash, cook
+ eat delicious last of dandilions -

MAY 6 - CHAS' MOTHERS 90TH BIRTHDAY
9:30 I BRING HER WILD APPLE BOUGHS
 WITH TINY PINK BUDS -
· SWALLOWS PLAYING IN THE AIR
 ABOVE THEIR BOX
· POLLEN RINGS - YELLOW - ON
 THE PUDDLES - Its still showery.
· TROUT LILLY'S FILLING THE
 WOODS HERE AT HOME WITH
 PATCHES OF YELLOW EXCITEMENT.
 · Toads trilling in
 New pond

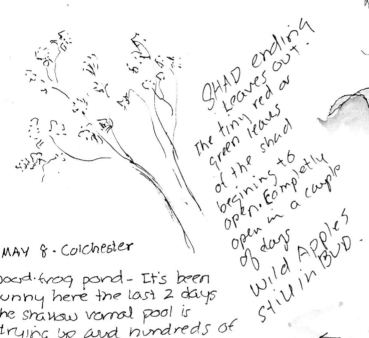

SHAD ending
Leaves out.
The tiny red or
green leaves
of the shad
begining to
open. Completly
open in a couple
of days
Wild APPLES
still in BUD.

from top
the three
inner petels
are longer,
since top (outer)
darker
ones are
curled

MAY 8 · Colchester

Wood-frog pond - It's been
sunny here the last 2 days
The shallow vernal pool is
drying up and hundreds of
woodfrog tadpolls are going
to die if it doesn't rain -
I bring some to deeper water
in a plastic bag but it's actually
pretty hopeless.' How many years
out of 10 do the make it from this
pond - enough that they come back
every year to lay their eggs need.
 flowering tree
SPRING ᴧ BLOOM COMPARISONS

These three blooming together
with the last of the shad on a
few streches of I-89. Shad- graceful;
fire Cherry - orderly; wild apple- hansome;
and wild plum - brushy form with light
airy bloom.

MAY 7 - Much work to do -
· SHADS around house in
 final show - petals all
 over the ground + deck

· Zeph lying amidst a
 shower of petels -

· OFF AGAIN TO
 COLCHESTER AND
 Grandmotherly pursuits!

shad ↗ pin ↗ fire Cherry wild apple wild plum
 fire cherry

Tree frogs singing in colchester, and on I-89 fire cherry blooming
and Large-toothed Aspen, last aspen to leaf out is pale grey-green

Redwing blackbird males displaying and chasing females who come to their territory. They seem to have divided it up pretty clearly.

May 16 ('99). Warblers passing through! Hot! Dry! Still another sunny day. North to Albany, Vermont. Warblers everywhere! No snipe winnowing. Everyone has a pond here. Are all the marshy, wet, open places gone? Barred owls (2) singing.

Dandelions are suddenly in full bloom in E. Montpelier. Several cars and lots of people at fairground field on Rt. 2 below house, picking bags of blossoms—for wine? It's dry and the blossoms are at their height of abundance.

Crows fussing every night, last 3 nights, down by fisher area. Owl? Fisher again? Generally they and the blue jays are quiet as nesting starts.

Warblers seen and heard here so far this spring: parula, black-throated green, b-t blue, black-and-white, yellow-rump, Nashville, common yellow-throat, redstart, chestnut-sided. Still not seen or heard for sure: Canada, palm, blackburnian, mourning, magnolia, yellow. Still no flycatchers, tanagers, indigo buntings, hummingbirds, or orioles.

Black flies thick. Rhubarb ready.

May 17 ('98). First hummingbird—male ruby throat whizzes by. Balsam cones turning a darker color than the deep red purple of a few weeks ago. These can be seen only with binoculars, as they are at top of tree.

Composition of "weed" leaves below the deck here: dame's rocket, jewel-weed, goldenrods, wild asters, agrimony, dandelions, burdock.

Maine report (from Mark and Alison): Toads trilling again (also during warm spell 3–8 May), lilacs blooming. Apples just starting to bloom in central coastal Maine, shad gone, dandelions blooming, and alewives are running "gang-busters" up the rivers.

Steve Parren's wood turtles in Vermont: female still by brook, males moving into upland.

E. Montpelier, on walk to new beaver dam, 3:00 PM. Tree leaves are almost fully out, apple bloom is ending; toothwort still blooming; wild strawberries blooming; most ferns completely unfurled, except New York which is still opening; big-tooth aspen still gray-green, new-leaved look. Briar Patch Road: blackberry flower buds appear; first crickets in dry hot areas singing; tiny baby crickets in same area.

May 18 ('98). AM. Sunny, dry, but not too hot today. I wake to hear the scarlet tanager doing the buzzy vireo-type call, not the *chip-burr,* all up and down the

edge just off deck. Also, glimpses of rose-breasted grosbeak and n. oriole as they fly by.

PM. Many, many fireflies low in grass on hill behind Town Hall at 9:00 PM. None in air.

Two nice morel mushrooms for supper and last of the leeks (tough and just putting up buds).

May 18 ('99). Hot, dry. Hummingbird battles. A second male has arrived. Today is the day poised between spring and summer. Blue and white butterflies. Hot! Hot! Birds silent. Fields yellow with mustard, lawns shimmer with dandelions. Suddenly maple leaves full sized and blowing in the wind. Big-tooth aspen still gray, ash etc. still a bit too yellow-green for summer. Some ash still in flower.

Vetch uncurling, wild strawberry setting fruit. Bedstraw 8–10 in. high, cattail leaves 18 in. high, choke cherry blooming just begun.

Rain coming at last—overcast.

PM. Toads trilling.

May 19 ('98). Sunny, dry, nice breeze. A few apple blossoms begin to be carried off. 9:00 AM. Leaf mat in woods decaying fast, especially under maples in the near cobble. Over to Omie Brook with the dogs and a picnic breakfast. A few warblers, kinglets. Black-throated green singing, veery scolding. A Canada warbler—I like its explosive song.

May 19 ('99). Rain at last! Sounds of wind, rain hissing all around us, and falling on the new broccoli and tomato plants in the garden. Smell of summer rain. Before it rained, blue jays in the maples set up an unusual group quiet-talk amongst themselves, while I finished planting. Very high, continuous, and quiet, fast rhythmed, short phrases or notes, some excitement—sustained but not anxious—the rain coming? Snipe winnowed overhead for a while too. A beautiful day for our sun-scorched and parched souls. Our 1st real rain since the leaves all out. Two in. in 12 hours. Blossom petals in the air mingled with rain.

May 20 ('98). 9:00 AM, my hill. The swallows have quieted down, no more fluttering together in the air; swoops and dives for show and pairing are way down. Doves sitting quietly, preening in the sun. This about the time for their brood shift over—the male just finished 8 hours, the female about to begin the longer day shift.

Bobolinks are back on Butler's hill. They fly over my yard singing. Haven't seen or heard a meadowlark here for 4 years.

May 11. Dandilions + Apples starting to bloom this last few days. Orioles + kingbirds back since last Wed., in Mont. at VINS down by the river. (a few days ahead of us.

11. MAY
Kingbirds inspecting same location as last summers nest! - (the dead butter- nut over the river). Lots of loud rattle -calling attracts my attention and there they are. Later see them or another pair in a willow near River E. VINS field

MAY 12. Male hummingbird is at the feeder and Bobolinks are singing from the air over the fields - a few males, getting 1st pick of location - Teresa's baby expected any moment. The blue birds seem to have vacated, although there is a nest in box #2. Mostly grass, with one pinkish?, believe mottled, smallish egg! (Also a large white feather in the nest.) The sky is summer blue with innocent looking small white clouds lurking around the horizon. Windy. Machine noise from the woods below Herseys - a chipper?

My Hill
3:30
↓
4:00

A flash of BLUE, as an Indigo Bunting flys off from the bird feeder. (which is empty) this at 5:00 pm May 12. I fill it quickly, but don't see this apparition again!

The week I was away was hot and amazing progress toward spring took place - Holding some- what now as 2 night with frost have intervened. High pressure with cooler weather + almost no cloud cover. A male Robin (almost black head) flys by singing a fragment of song.

DANDILIONS SMELL
LIKE HONEY

JUST FLEW BY SINGING
5.12

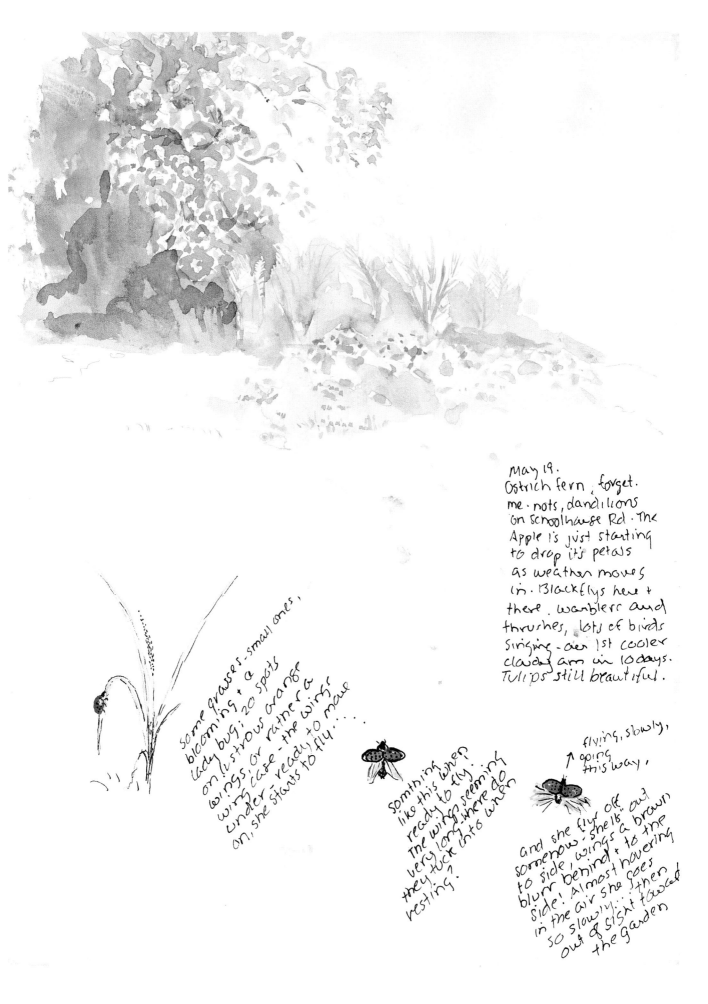

May 19.
Ostrich fern, forget.
me·nots, dandilions
on Schoolhouse Rd. The
Apple is just starting
to drop it's petals
as weather moves
in. Blackflys here +
there. warblers and
thrushes, lots of birds
Singing - our 1st cooler
cloudy am in 10 days.
Tulips still beautiful.

Some grasses-small ones,
blooming + a
lady bug: 20 spots
on lustrous orange
wings, or rather a
wing case - the wings
under - ready to move
on, she starts to fly....

Something
like this when
ready to fly.
The wings seeming
very long-where do
they tuck into when
resting?

flying, slowly,
going
this way,

and she flys off,
somehow-shelb, out
to side! wings a brown
blurr behind + to the
side! almost hovering
in the air she goes
so slowly...then
out of sight toward
the garden

Pair of grackles flying together, their amazing tails, so agile and useful as movable rudders.

10:00 AM. Kingbird pair arrive and investigate many nesting potentials, around the telephone wires and poles above my driveway.

Noon. I'm outside without any sketching materials and a pair of broad-winged hawks appear. They circle in unison, then a third bird, same species, joins them before they soar out of view behind trees to the north. The dark tips and edges of wings and their stately progress through the unison circling leaves me lying on my back on the path in the vegetable garden for a better view.

May 20 ('99). Clear by 10:00 AM. Apples still in full bloom, but now with a carpet of petals under each one, in the air, and here and there where they have blown.

May 21 ('98). Colchester. Most tadpoles dried up but some survive on left side of vernal pool. Cherry, both choke and pin (bird, fire), and apple bloom are over, but black cherry, only visible up close, is still blooming. Nannyberry and highbush cranberry blooming.

Along I-89, big-tooth aspen are no longer pale, except for a touch near Waterbury. Ravens quiet—fledged? See kingbirds again as I leave in AM.

May 21 ('99). Heady, spicy apple blossom smell on Schoolhouse Road today. Some of the old apples are blooming late. A rich sweet feeling to the air. Sun in a pale blue sky, not too hot and a breeze now at noon. The morning was brilliant. We walked early 7:30–8:30 to Braziers' 1st field. Clintonia blooming thickly on top of the hill, a female harrier low over the E meadow. Interrupted fern's fertile fronds or leaflets apparent now, as are Christmas fern's. Two swallowtail butterflies last ½ hour. Ash still that pale spring green, some just budding out now. The mountains haven't leafed out yet much above 2000 ft. Spring wildflowers at about that altitude now.

May 22 ('98). My hill, 4:00 PM. What's happening when nothing is happening. My hill. Mind is blank. Gradually the place unfolds for me to see. Bird or fire cherry has set seed. Hawthorn, still blooming down by house, is setting fruit. Black cherry blooming inconspicuously at tops of trees—the wind is blowing! Milkweed just about 8 inches high, by my knuckle measurement. An inch worm, ½" and nearly transparent, works my pack over. Can see the food digesting in its track. No activity at all at the bird box—unused or just secretive brooding. Shad has set fruit heavily around the house. No sign of the kingbirds

today—hope to see them tomorrow before we leave. The neighbor's robins are still upset—a good sign—how do they ever survive in a yard with cats? Common yellowthroat in full vocal defense of this area. Redwings (male) still advertising and flying about up here away from nesting area. Doves around, sitting and one lovely swoop-flight which I mistake for a hawk. A dove mating flight-display, I believe.

May 23 ('98). Basswood finally in leaf, not in their customary "sulk" today. Veery alarm call. My woods: Some foamflower just finishing. White wood aster about 10 in. tall. Leeks turning yellow and flat on ground, their flower buds standing up. And early lilacs at their glory! Road-cut rescued barren strawberry blooming.

Charles in Pondicherry Wildlife Refuge, NH. Black chokeberry, rhodora, bog laurel all in bloom; Labrador tea, clintonia, tussock sedge, cotton grass, nannyberry just starting. He also saw snipe, bald eagle, rusty blackbird, Virginia rail. Dragonflies emerging from larval stage—saw one two weeks ago.

Check salamander pool on Butler's. Many salamander egg cases are gone, one empty and about one third to one fourth remain. Tadpoles (frog) on bottom on this cold AM, (mostly) not yet awake, I think. Cases have green algae and are hard to see into. (Not moving this AM and no "predation" activity by wood frog tadpoles.)

Driving to Rangeley Lakes, to Kitzmillers' on Toothaker Island, Maine. Sunny, cool, windy. NH Route 110: wind accents balsam poplar's "rusty" look, as we see undersides of leaves. Big-tooth aspen still pale green here. Bluets still blooming. Swallowtails flying.

Lunch stop at bog/fen on 110 on Bell Hill Rd. Blooming: chokeberry, rhodora, fleabane, mt. holly, wild calla. Viburnums about to bloom together (nannyberry, witherod, and arrowwood). Mother duck and ducklings rafting on Androscoggin River.

May 23 ('99). Home. Lilacs at peak, dandelions poofing. A few days ago bobolinks in mad mating chases on Butler's field. Males and females.

Spruce Mt. Follow spring up the mountain, from 1,000' where clintonia, foamflower, and goldthread are blooming, to the boreal zone (2,300', granite rocks, no schist here) where most don't even have buds.

Also: spring azure butterflies still mating; a glade full of (white) azures. Warblers: Cape May and Nashville singing, Canada, mourning, black-throated-blue, ovenbird, Blackburnian, redstart, black-throated green, blackpolls up high —they seem to be everywhere.

Black flies! A comma butterfly.

Shad just about to bloom on summit! Swarms of black flies! Later in PM, first veery singing, then hear them everywhere.

May 24 ('99). Chickering pond and beaver dams. Overcast. This AM a strong moist flow of air from the SE smelled of ocean, hundreds of miles away.

Female hummer reported at Chickering's, but we don't have any females yet.

A beaver makes its way across the pond. Green frogs start *glukkk glucking* as a few rain drops fall. 3:45 PM. Black flies after me here, too. Grouse drumming in the woods behind.

Lilacs at their voluptuous peak of form and fragrance. Now: Saw the first red eft today in Butler's woods. Celandine and swamp buttercup beginning to bloom—Guyette Road cobble base. Tiger swallowtail butterflies floating in and out of clearings and gardens. Apple blossom ended. Dame's rocket blooming in low wet places with ostrich fern. These are quite special together—drifts of glowing purple and a most complementary green.

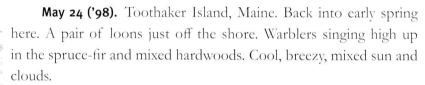

May 24 ('98). Toothaker Island, Maine. Back into early spring here. A pair of loons just off the shore. Warblers singing high up in the spruce-fir and mixed hardwoods. Cool, breezy, mixed sun and clouds.

4:30 PM. Afternoon sun and warm. We walk the trails where a sweet fragrance is blowing across the island. I guess that it's from the acres of rhodora and chokeberry blooming on the mainland to our W and upwind.

Moccasin flower, 14 in this clump, blooming.

May 25 ('98). Toothaker Island, Maine. Warbler flats on perimeter trail. Impressions of immature redstart with rusty apricot hints at neck and tail. Much fancy flitting amongst the greenery; much singing *trill trill trill zippp,* less than 2 seconds call, four times a minute. Fast whip of a call. Somewhat similar warbler songs: redstart, magnolia, chestnut-sided, yellow.

Spruce and balsam fir growing in understory. Balsam's fragrant new growth is bright light green, spruce has not yet shown new growth, buds still tightly undetectable at tip of bough.

Stop near a rhodora bog on the way out, to sniff the air. Yes, this is the fragrance we have been smelling since yesterday. Sweet floral essence of rhodora and chokeberry blown across the water to the island.

May 25 ('99). Phoebe eggs hatch at Jennifer and Rich-
ard's. Hedgerow "flat flowers" starting to bloom on I-89.
Red osier dogwood blooming at home. Bird egg fragments
everywhere—blue, white especially. Air smells sweet.

Bridalwreath spirea starting to bloom. Cold front in
60s, windy. Apples finished, nannyberry just starting. Haw-
thorn just budding and blooming along with fire cherry, at
home in E. Montpelier.

Colchester, PM. 4 baby robins on beam at Trabulsy's.
Nice view from window.

Driving these last few days, wind and rain turning over the leaves. Balsam
poplar the most mystifying color of rose/rust/green/gold; visible, identifiable
by car on color alone.

May 27 ('98). Blueberry flowers. These are our own Norlands, a small
highbush, about 15 years old. Bumblebees with heavy pollen loads (haven't
seen the other kind, without the pollen rakes), and other smaller bees, some
tiny, some actually nectar-eating flies, are active about them.

The bees and pollinators are like birds—you frighten them away when
you come to look at them; gradually, if you are still, they return, but not always.
Sometimes I watch with binoculars, to get relative size, behavior, etc.

May 27 ('99). Great horned owl swamp, 1:00 PM. Cattails bleaching in sun,
new plants emerging and about 2' or more high. Cinnamon fern coming up in
wetland too. Parula warbler sings *zzzzzipp,* but can't see him.

Last year's cattail head fibers softening and sagging into amazing varied
shapes, some starting to let go. Is the seed viable now? After how long? Are
some of these 2 years old?

May 28 ('98). Hedgerow on Brazier Road, across from Grossman's. One
of a few good hedgerows remaining in our town. Farmers take them out for
efficiency; homeowners clear and "gentrify" them; road crews remove them for
right-of-way management. This hedgerow has not been mowed—dates back
to the building of Brazier Road and the clearing of the big field behind. It's
packed with native flowering shrubs which produce loads of wildlife food and
shelter, none taller than 15 ft.

Native flowering shrubs in full bloom: wild (American) plum, grape, Vir-
ginia creeper, highbush cranberry, pin cherry, nannybush, hawthorn, red osier
dogwood. These plants' roots are anchored and protected by big rocks hauled
here by oxen, I imagine, when field was first cleared.

May 28 ('99). Sun, warm. 3:00. My hill. Things are slowing down, as spring pulls its last flags in and summer settles over us. Baby birds have not yet left the nests, which creates bird havoc of June (though I saw a young robin last week on Brazier Road when walking with Sarah). Yes, spring has moved on up the mountains and is about to evaporate until next year. Everywhere, now, young are being nurtured as quietly and unobtrusively as possible by their parents. Sulphurs and mustard whites flutter over fields and openings. Insects of every sort abound. I'm waiting for the birth of the baby grasshoppers—still some days or weeks (?) off. I'm much too busy and haven't had enough time for long sits and unstructured rambles, the way I like.

PM. Garden lupine blooming. Toads and peepers trilling and peeping from Hawkins little fen across the road. Moon waxing.

May 29 ('98). E. Montpelier. The shads are full of green berries. Only one in a hundred are turning red this soon, yet already these trees around the house are attracting a little troupe of cedar waxwings, who make the rounds every year before the fruit is ripe. They are always here when the first berries ripen, by this method of avian vigilance. How many places do they visit in their rounds? Are the shads the first fruit to ripen? I can't think of an earlier one. How anxious they must be for the first fresh fruit of the season, after a winter of dried stuff, and insects, I suppose, to tide them over through the spring. I hear their high *squeeeeee squeeeee,* wheezing song and know to look in the direction of sound for their sleek shapes and soft colors.

A summer feeling to the week. The new leaves are full and lush, shrubs blooming, meadow flowers starting to bloom, and butterflies are everywhere. The days are hot and long and sunny, and clouds billow up in the north toward late afternoon. With any breeze or wind it's finally again the time of familiar leaf noises—not rustling, which is the word we have for this, but a full orchestra of hundreds of thousands of rustlings together—sometimes forte, sometimes pianissimo, and many ranges in between. I step outside to listen several times during the afternoon.

May 29 ('99). Champlain Valley, Vt., to see wood turtles studied and monitored by Steve Parren of Vermont Nongame & Natural Heritage Program. He started serious turtle monitoring as a hobby in '91. Nesting sites, found only last 2 years since began radio-tagging. Linear one-mile territory along brook, with moderate gradient. Many travel 1,000' from water. Hibernacula in backwater behind big log, where moving water apparently stays at 32 degrees in coldest weather. Now, with water at 71 degrees, they're moving away from water.

We see a female wood turtle, an indistinct dark shape, almost hidden in the vegetation. Very hard to see without much twisting and bending from several yards away. Not far upstream a big male in thick vegetation 35' from brook. We stay back and I sketch like mad for a few minutes, then leave quietly.

Used to see them in E. Montpelier more often, a creature often collected illegally and whose habitat is disappearing through mowing, clearing, and development.

E. Montpelier. Predation of nestlings and eggs. 8:00 AM: Robin eggs and yolks broken under white pine at schoolhouse. PM: Sharp-shinned hawk grabs fledgling grackle (amidst heroic effort of adults to protect young) from side of Brazier Road as we walk up to see the orchids. The fledgling is calling piteously as the hungry sharpie carries it off. This only 20 feet in front of us. Sharpie nesting nearby?

Floodplain forests stand out with white to purple dame's rocket and that extraordinary green of ostrich fern.

Yellow lady's-slipper, showy orchis, and moccasin flower all in bloom here. Garden lupine has been blooming for one week. Today our first female hummingbird showed up. Male here today, too. Tadpoles at Jennifer and Richard's, no legs yet; watching their movement in the pond—sometimes in unison, as when I approach all face deep water for quick escape.

Today also, kingbird female brooding on N. Branch butternut site, same exact spot on tree limb as last year. Returnees from last brood or even the parents? The air is absolutely sweet with various scents—flowering grass, sweet vernal grass? Around the house is lilac, everywhere in the air.

"Flat" flowers blooming: hawthorn, dogwoods, nannyberry; later will come elderberry, arrowwood, and cow parsnip.

PM. Craneflies mating on porch and june bugs bumbling. White flowers in woods: starflower, Canada mayflower, etc.

Full moon tonight. Butterflies all day: new skippers, tiger swallowtails yellow and white, and tonight, moths galore, toads trilling, heady scents, moon shining on alternate-leaved dogwood blossoms—little white puffs in the moonlight.

May 30 ('99). Groton State Forest, Vt., Kettle Pond. 20+ tiger swallowtails on wet sand of parking lot, abdomens curved down to the ground. Feeding avidly on clintonia, too. Bullfrogs—yellow-throated males—singing, and tadpoles.

Blooming today on Owl's Head: clintonia, bunchberry, starflower, striped maple, wild sarsaparilla.

May 30 ('00). 9:00 AM. Walking with Lucy in Butler woods. We startle a mother bear and 2 small cubs. She heads for higher ground while the babies gallop up adjacent maples. We leave immediately. Could this be our young bear from last year?

May 31 ('99). Charles finds our annual Baltimore checkerspot caterpillar hatch in Clark's turtlehead fen. Spiny, black with orange skin showing through.

PM. Fireflies on Shapiro's meadow.

Geoff Beyer calls to report 2 baby barred owls fledged in Hubbard Park, Montpelier, and on ground yesterday and today—placed in trees. Can't fly but great, fluffy climbers. Parents on duty.

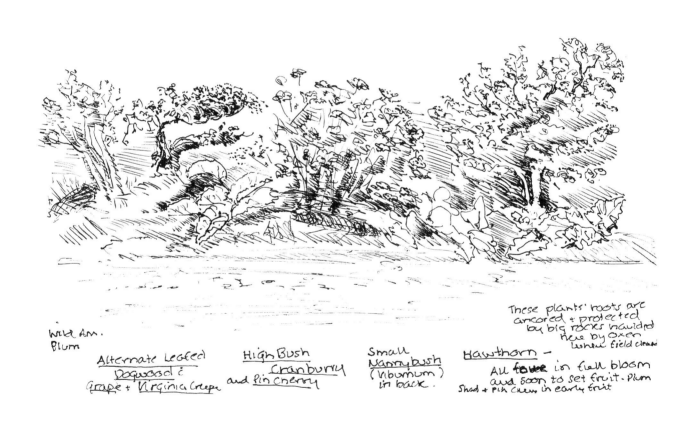

Wild Am. Plum

Alternate Leafed Dogwood ë Grape + Virginia Creeper

High Bush Cranberry and Pin cherry

Small Nannybush (Viburnum) in back.

Hawthorn — All four in full bloom and soon to set fruit. Plum Shad + Pin Cherry in early fruit

These plants' roots are ancored + protected by big rocks hauled here by oxen when field cleared

Home

*T*he world is too big, too unfamiliar, too scary for most of us to feel comfortable in all of it. So we claim, or delineate, smaller territories within which we move around with more ease, in more awareness of where to go and how to do things. We do not really live in the world; we live in homes of various sorts, according to our accustomed or habituated ways.

The structural and functional "home" is for most animals by necessity a well-defined and confined shelter, either discovered or fabricated, a defensible and protected place where the animal can live, secure or store food, and, often, produce (and sometimes raise) offspring. At various times in a creature's life, or throughout its entire span, home may also serve as a place to escape from enemies, as protection against the environment (bad weather, extremes in temperature, excessive wetness or dryness, etc.), and even as a facilitator of communication.

Every creature, from the largest on Earth to those too small to be seen with the naked eye, has a home of sorts. A humpback whale has defined geographical areas of the sea, a grouse its seasonal coverts, a bacterium the cells of living or dead tissue. Take those creatures living on and inside us, for example. Head lice inhabit only the hair atop our heads, while two species of tiny mites live only on our foreheads—one in the hair follicles, another in sebaceous (oil) glands. Distinct bacteria and fungi take up residence in our guts, helping us digest whatever we pass their way. Many parasites similarly inhabit specific locales in animals, brainworm in the brain, botfly maggots in the flesh under the skin, flukes in livers, and so on.

Among plants, home for the maples and ashes is their hardwood forests,

for pitcher plants their bogs, water lilies their ponds, mosses their rocks. They would all be alien elsewhere and would likely die outside those known territories. And like other creatures, plants grow in faithful symbiotic associations—for instance, certain mosses, liverworts, and fungi on specific trees, certain algae within the fungal filaments of lichens, dwarf mistletoe only on conifers.

"Habitat" I suppose is the proper term, the one that science, justifying or demanding, prefers in its sense of impartiality. But habitat and home really amount to the same thing, for any of us, and the latter word carries with it more compassion and feeling. "Habitat" sounds so well defined, discrete, a chunk of real estate that satisfies a creature's needs. But is it really so? The habitat of a warbler is not just its breeding or wintering grounds but everything in between where it stops to rest and feed. Even the air in which it flies is part of its habitat, even the sun by which it measures its days, even the stars it uses to navigate its migration at night.

For most, the first home is the place of birth, and many animals go to great lengths to find their way back when their time comes to be parents. Atlantic salmon and alewives, born in the headwaters of many rivers (salmon) or

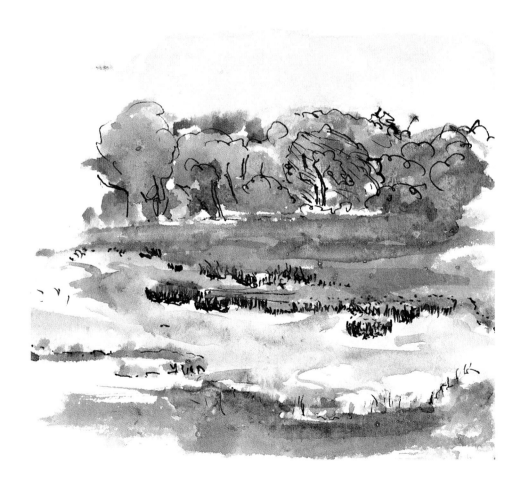

sea-connected ponds (alewives) in New England and spending their early years there, migrate to sea for their adult years, but come back to their place of origin for spawning, finding their way by a combination of navigation (by sun, stars, and/or moon), sense of smell keyed into home waters, and plain old instinct (our way of not having to explain a lot of mysteries). Hundreds of species of birds head north in spring to the wetlands, forests, rocks, or meadows where they were born. The champion traveler, the arctic tern, passes our way twice in its 25,000-mile annual trek from arctic nesting ground to western Africa to Antarctica and back again. Whales calve and seals pup year after year in the same ocean waters as their ancestors. Bats return to the same caves, spotted salamanders to the same pools, timber rattlesnakes to the same ledges. Homing is an ancient, urgent fidelity we surely can feel deeply in ourselves.

Some homes are simply found, occupied, and hardly modified. Hermit crabs sequester shells of dead mollusks, switching to bigger models as they themselves grow bigger (the crabs' soft bodies are precurved to accommodate the twists of the adopted homes). Garter snakes ball up for winter in the sub- terranean chambers dug by chipmunks, moles, or other burrowing animals. Dusky and two-lined salamanders tuck themselves out of the way under stream- side flat rocks. Timber rattlesnakes hide and hibernate among rocky ledges. Deer bed down among the forest's fallen leaves.

Others are more industrious, fabricating a home of nearby materials. Some hardly deserve the term "home," being the scantiest of structures, yet they still serve the purposes of home. Many are temporary, offering protection for a while during a vulnerable stage of life, acting as a receptacle for depositing and protecting eggs, and/or serving as a nursery in which to care for the young.

Aquatic larvae of caddisflies build camouflaged and often ornate encase- ments of nearby materials—tiny pebbles in streams, woody twigs and leaves in vernal pools—cementing them together with saliva. Within these camouflaged encasements the larvae live and develop, and from them they hunt. Terrestrial larvae of some moths turn plant leaves into various homes: leafrollers curl them into cocoons, bound tight with silk they produce; leafminers stay within the thickness of the leaf, eating their way as they go; leafcutters slice out small circular patches they sew together around them; bagworm larvae make their "bags" of clipped small twigs or leaves.

Sometimes one being will cause another to do the work of making its home. Fly and wasp species stimulate goldenrods to form ball- or spindle- shaped galls, within which the larvae develop. A wasp causes similar formations of golf ball–size galls on oak leaves. Certain caterpillars serve as mobile homes for some ichneumon wasps: the adult wasp injects her egg into the caterpillar,

and the larval wasp then slowly consumes the caterpillar flesh; when it is ready to pupate, it kills the caterpillar and fashions the skin into a cocoon, within which the wasp passes the winter.

The simplest homes are practically undefined space, a place where the creature happens to be, something scraped up or thrown together or quickly made of at-hand material. Spittlebugs, the soft-bodied larvae of froghoppers, envelop themselves in a sticky froth they produce as they suck the juices of plants. Trout use their strong tails to round out hollows in streambeds, then pick up stones and pebbles in their mouths to line the nests (called "redds") where spawning occurs. The redback salamander, the only salamander in New England to lay its eggs on land, does so in scooped-out places under logs; the female then incubates them with her own body curled around. Many ground-nesting birds—killdeers, turkeys, grouse—whose precocial young are away as soon as they hatch, make the most rudimentary of nests. So do many North Atlantic oceanic birds, which come ashore on rocky islands to reproduce and raise their young. There, with space at a premium, nesting sites precarious and bare, and nesting material scant, a tiny shelf of rock ledge, adorned with a bit of seaweed or an occasional feather, might be all there is for nests of murres, gannets, razorbills, or guillemots. Often living cheek by jowl with their neighbors, the birds compensate for the crowding by strict adherence to social order, such as remaining within a zone prescribed by pecking distance.

These homes are all built upon a surface of some sort, or within a pre-formed cavity. But many homes are beneath the surface, actively dug into another host, whether living or dead, animate or inanimate substrate. Chambers and tunnels may be excavated from the ground (worms, tiger beetles, crabs, moles, turtles, kingfishers, swallows, puffins, foxes), bored or chiseled into the bark or wood of trees (carpenter ants, bark beetles, woodpeckers, nuthatches), within a fruit or seed (many grubs of insects), or even underwater (the bubble of a fishing spider).

Others are more elaborate or elegant constructions, often equal to a skilled architect's design. The hives of honeybees, the nests of birds, the lodges of beavers. Of our insects, colonial species make the most complex homes. Nests of birds have many variations: neatly woven, sloppy sticks, those that hang (orioles), those domed over (ovenbirds), those of mud, of saliva, of spider silk.

A home may also play the auxiliary role of a trap. The intricately woven webs of orb-weaving spiders are also their homes, where the adults live, set traps for prey, reproduce, and bring forth tiny spiderlings that will eventually be lifted by the wind and borne away on slender threads of their own. The predaceous larva of the ant-lion lies concealed at the bottom of the sandy funnel-pit

it has dug, waiting for a victim to misstep into it and slide down to its jaws. Within the tiny reservoir inside a pitcher plant lives the maggot of a fly, *Sarcophaga*, eating the remains of other insects that have drowned there.

Homes may be separate from one another, well spaced, even isolated, or they may be packed next to, or even atop, each other in communal proximity. Those of the former kind depend on separation from their own species members to ensure adequate defense, allocate available food, escape detection by predators, and avoid contagion by pests. Colonial species, however, rely on strict social hierarchies and protocols, division of labor, and force of numbers to achieve the same ends.

Among insects, for example, the hives of bees, the hills of ants, the paper globes of hornets are necessary structures for raising enormous numbers of young and storing great quantities of food for them. The various duties of these homes are parceled out and performed by different castes: males (drones) mate with the queen, the queen lays eggs, nurse females take care of the larvae, some workers (sterile females) build the nest or hive and others defend it, while still others gather food outside.

Many creatures have more than one home during their lifetime. Adult insects often occupy far different environments than their larvae. Young fish, redback salamanders, many birds, and some mammals spend their earliest days within a more protected "nest" (den for mammals, redd for fish, etc.), and later move out and away into larger habitats. Migratory species establish seasonal homes in vastly different geographical regions.

And we humans, too, in all our times and ways, have built homes of every sort. From those clawed out of cliffs a thousand years ago to those shaped each winter of arctic ice and left to thaw in summer. From apartments piled hundreds high in cities to cabins miles and mountains away. From mansions sprawling over acres to sheets of cardboard thrown down upon a square meter of cold concrete. We have literally staked our claims everywhere.

Home is a powerful magnet, and its attraction among the most powerful of emotions. I heard a story once of an American woman of Puerto Rican ancestry who had participated in a movement for Puerto Rican independence. She had been jailed for alleged violent demonstrations of her patriotism, but curiously she had lived in Chicago all her life and had never been to Puerto Rico until years after her release from prison. It was not a matter for the brain to solve, but of the heart to know. She said that when she finally went there and stepped off the plane, she knew she had come home. You could smell it in the air, she recalled. It had a scent like your mother, when you were a small child snuggling into her.

I also heard, another time, a woman relating how she had been born in a jail cell and lived there in her infant years with her incarcerated mother. Many years later, as an adult, she returned to that jail, on a visit driven by curiosity. She, too, said she had the vague feeling of going home—even the cold clank of steel doors being shut had a comforting familiarity about it, a sense of security.

We all have had such inexplicable, deep feelings called forth, I'm sure, from places in our past. I have had them, certainly, from more than one. I have them when I return to the New England island where I spent the first twenty-three summers of my life. I have them when I go to the Illinois and Indiana prairie lands and woodlands I played in as a boy. I had them when I went to Scotland, the country of my mother's ancestors; I surely would have them if I went to Norway, homeland of my father's father. And I have them in every house I have ever called home, even if I only step into them for a moment.

Such memories, sparked by sight or scent, touch or some vague yet unmistakable awareness, may be relics of previous claims upon a piece of earth or stretch of water, as surely as our hair, appendix, or canine teeth tell us of other ways, other places, we once lived. They are all homes: the houses we inhabit if only for a while, the lands stepped onto however briefly, places inhabited or even imagined for a portion of our lives. That memory—is it something embossed in our genes, or the local elements of earth, air, and water we assimilate as we grow, so that they become incorporated into our blood and bones, skin and muscle? Or is it something that has seeped into our soul, having been car-

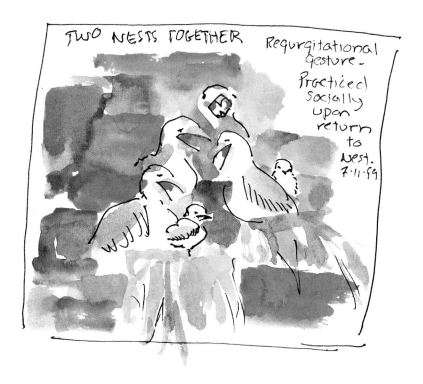

ried over great time and distances in the accumulated memories of our families and tribes, protected in our subconscious like a cherished heirloom?

Could it be the same impulse that stirs the salmon, alewife, or striped bass to move from salt to freshwater, swim up current to spawn and find its ancestral birthplace among the rocks or weeds of far distant waters? Or the same clues the bird uses to alight in the same tree after months away and having traveling thousands of miles from its wintering grounds? Or the same way the lost dog finds to trek for months over unknown ground to arrive on the doorstep of its master?

Home—for them, for us—may be a place of birth, or where we've lived all our life, or where we've stayed for only part of it. Or, it may be also where we've never been before, but feel we always have, through some most powerful yet mysterious inheritance.

JUNE

June 1 ('99). Bailey Pond on railroad bed, Marshfield, Vt. Hundreds of tiger swallowtail butterflies. Toads trilling, green and bullfrogs calling. Some small plants: bulb-bearing water hemlock, tiny sensitive fern just arising from the now-defunct gametophyte.

Later at another pond: moose feeding, bullfrogs going wild, thunder, bugs getting bad.

June 2 ('98). This is baby bird season. The young are blundering around and I get lots of calls from people who find them.

Back to North Branch Park in Montpelier to check on some mystery frog eggs which by now are gone. But we see a grackle nest, with 3 downy babies in it—not in an evergreen as at home, but in a nest in the mass of suckers growing from the trunk of a willow tree.

June 2 ('99). Lucy Bugbee Bog, Peacham, Vt. Blooming now everywhere:

- Stark, flat white—highbush cranberry
- Ivory white, also flat—nannyberry
- Smaller, off-white flattish poofs—alternate-leaved dogwood

And noted in the bog:

- Coral root—tiny leafless orchid with yellowish (pale) flowers
- Yellow lady's-slipper—leaves not furry, about to bloom

- Naked miterwort—tiny saxifrage in bloom
- Cleavers—like bedstraw, wet woods thickets

Nashville warbler nest. I flush out a tiny warbler as we leave the bog and spy eggs under the tuft of grass where she exited. She and mate chipping frantically from spruce, so we leave quickly.

Hubbard Park, Montpelier. Hear from Geoff Beyer that the baby barred owls are up in hemlocks now, can't fly but great hoppers/climbers (see May 31). No great horned owls in Clark's woods this year—where did they go? Scotch pine blooming.

June 3 ('99). Ewell Pond area, near Groton. Rare ram's-head lady-slipper.

Bog: red and black spruce, three-leaved Solomon's-seal, pale laurel, sedges, cranberry just starting to flower, pitcher plants in flower. Red-shouldered hawk sing/calling. Olive-sided flycatcher in dead trees, *Hick three beers!*

Hear a mourning warbler at Marshfield Pond. Home PM. Baltimore checkerspot caterpillars in several stages (instars) ½ to 1¼", eating joe-pye weed and turtlehead, and on many other plants—marsh fern, water avens, etc. They show up as little black lines when I scan the bog for them. This is NOT immediately apparent and needs time. Once seen, it's hard to think that I didn't see them at first. Baby woodchucks out and about, first rugosa roses bloom here.

June 4 ('99). Camel's Hump. Ferns (rusty woodsia, smooth woodsia), bog bilberry, mountain cranberry; bearberry willow, rattlesnake root (a lettuce), goldenrods (Rand's or Cutler's), mountain sandwort, Bigelow's sedge.

3,000'. Still some spring stuff blooming—clintonia (in bud), inflated sedge, and alpine rush.

Camel's Hump looking south. Bigelow's sedge, highland rush. Yellow-green pollen rings around puddles on summit, at 4,000+', above tree line. I guess pine pollen, flowering now in the valley, rising on air currents.

June 5 ('99). E. Montpelier, Vt. Blackberries blooming since a week ago. Hawthorn starting to drop petals. Foamflower in seed with some still blooming. Grasses and sedges blooming, some real beauties.

Trip to Southern Vermont (Putney): black locust blooming, roadside flowers have started (black-eyed susans, fleabanes, large yellow hawkweed), in the meadows bedstraw and chickweed, white shrubs—roses and mock-orange—blooming.

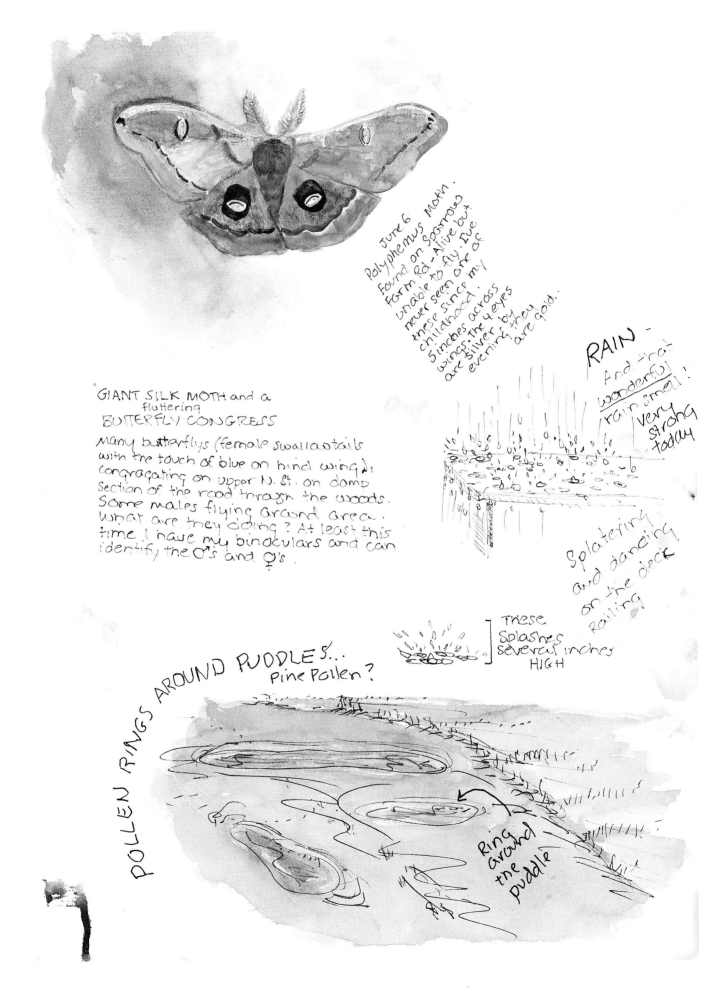

June 6
Polyphemus Moth.
Found on Sparrows
Farm Rd - Alive but
unable to fly. I've
never seen one or
these since my
childhood. The 4 eyes
5 inches across
wings. The 4 eyes
are silver: by
evening they
are gold.

RAIN -
And that
wonderful
rain smell!
Very
strong
today

Splatering
and dancing
on the deck
railing

These
Splashes
several inches
HIGH

GIANT SILK MOTH and a
 fluttering
BUTTERFLY CONGRESS

Many butterflys (female swallowtails
with the touch of blue on hind wing),
congregating on upper N. St. on damp
section of the road through the woods.
Some males flying around area.
what are they doing? At least this
time I have my binoculars and can
identify the ♂'s and ♀'s.

POLLEN RINGS AROUND PUDDLES...
 Pine Pollen?

Ring
Around
the
puddle

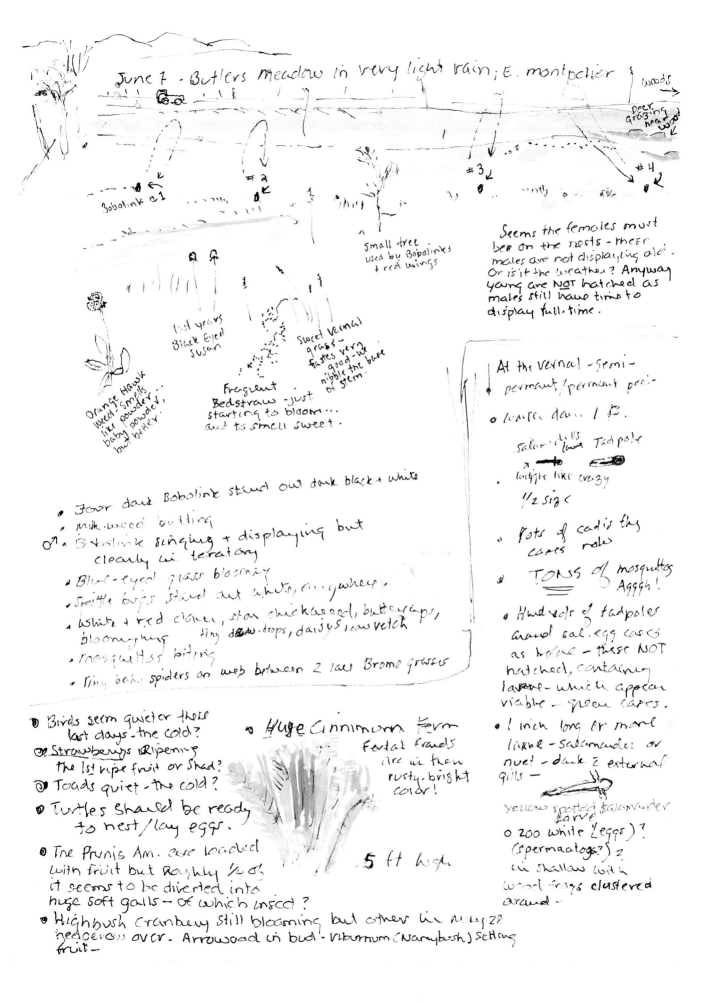

June 7 - Butlers meadow in very light rain; E. Montpelier

woods →

Deer grazing near woods ↓

#2

#3 ↓

#4 ↓

Bobolink #1

Small tree used by Bobolinks + red wings

Seems the females must be on the nests - these males are not displaying alot. Or is it the weather? Anyway young are NOT hatched as males still have time to display full time.

1st years Black Eyed Susan

Orange Hawk weed - smells like powder, baby powder, but better.

Fragrant Bedstraw - just starting to bloom... and to smell sweet.

Sweet Vernal grass - tastes very good - I nibble the base of stem.

At the vernal - semi- permant / permant pool

○ water down 1 ft.
Salamanders/larva Tadpole

• wriggle like crazy ½ size <

○ lots of caddis flys cases now

○ TONS of mosquttos Aggggh!

• Hundreds of tadpoles around sal. egg cases as before - these NOT hatched, containing larvae - which appear viable - green cases.

• 1 inch long or more larvae - salamander or newt - dark 2 external gills -

yellow spotted salamander larva

○ 200 white (eggs)? (spermaatogs?) 2 in shallow with wood frogs clustered around -

• Four dark Bobolink stand out dark black + white
• milkweed budding
♂ • Bobolink singing + displaying but clearly in teratory
• Blue-eyed grass blooming
• Spittle bugs stand out white, everywhere.
• white + red clover, star chickweed, buttercups, blooming, tiny dew drops, daisys, cow vetch
• mosquttos biting
• Tiny baby spiders on web between 2 low Brome grasses

○ Birds seem quieter these last days - the cold?
○ Strawberrys Ripening the 1st ripe fruit or Shed?
○ Toads quiet - the cold?
○ Turtles Should be ready to nest/lay eggs.
○ The Prunis Am. are loaded with fruit but Roughly ¼ of it seems to be diverted into huge soft galls - of which insect?
○ Highbush Cranberry still blooming but other in May 28 hedgerow over. Arrowood in bud - Viburnum (Nannybush) Setting fruit -

• Huge Cinnimon Fern Fertal fronds are in their rusty-bright color!

.5 ft high

June 6 ('98). Talk to AMC (Appalachian Mountain Club) at Pinkham Notch. 20 degrees in the White Mountains. 130 mph winds. Alpine bloom is all done—came in May this year, 2 weeks early, usually good about now through mid-June.

Home, to blooms: dame's rocket still brightens every wet area with pink/purple/white fragrant flowers for the last 2 weeks; roses in town, late lilacs (Canadian and dwarf) peaking; blackberries in full bright bloom everywhere ("knocking your eyes out," says Charles).

5:00 PM. 8-spotted forester in wood shed, a small black, white, and yellow moth. We see these often. Is the orange on legs pollen? No! Or minute "feathers" as its seems under the hand lens? Yes!

Tiny grouse about now; we're having cold, wet, almost frosty weather—bad for them, too?

June 8 ('98). Last day of rain and cool, warming up. Many wet areas in shade, river bottom woods especially, with ostrich fern and dame's rocket seemingly made for each other visually. This creates tangled wildflower gardens of extreme beauty and peacefulness.

1:45 PM. Beginning to clear. Hawkins field has not been mowed yet, and it's lively with both female and male bobolinks displaying (some swoop dives). My first good look at females from edge of field. Lots of circling females and about 6 or more males. Seems like 12 or more females. As I leave bobolinks settle way down.

June 8 ('99). Heat wave continues. 90s yesterday and today. Thunderstorms with scary lightning passing through, a couple a day. Downpours, then steamy heat/haze/sun. Reports of giant silk moths from all over.

Sudden bolt of grasses and flowering plants.

Shapely clouds whipping by, wind *shisshing* the leaves. More butterflies.

White pines releasing hazy clouds of pollen. Looks like a dreamy mist blowing off the trees every so often.

Buttercups and orange hawkweed blooming. Milkweed 18" high or more, with buds. Bedstraw in bloom but not yet with that heady fragrance.

Summer! But something missing. Grasshoppers. Not yet born? I find one, ½" long, Brazier flats.

Today the bobolinks are still on their nesting ground on Butlers' field, fortunately not usually cut till after most of the young fledge. The bluebirds at Flanders' still in residence and the bedstraw just starting to bloom.

June 9 ('98). E. Montpelier, Vt. First lovely day, with sun and warmth, in a week, no, since June 1 when cool weather blew in so hard.

Tree swallows have been absent from my hill for almost a month. Neither see nor hear them. Then today around 2:00, the wild pairing behavior, which never occurred here this spring at the bird box they have nested in for years, was suddenly going on, 3 or 4 birds, wild displays at, in, and around the box with perching on the new grape poles. I assumed I missed the pairing, but now I wonder if this is just the famous tree swallow disappearing mystery which I've read about and to some degree seen. By now—4:30—they are again gone, just as I come up with an hour to sketch them, here on the hill. Great view, though, of the newly sun-drenched world. So green and fresh.

Milkweed flowers budding—time for bud/blossoms on menu again.

New balsam needles all grown out and blended in, but the pale green tips of hemlock are quite beautiful now, on every single twig. A graceful tree by any standard, especially now.

Full moon tonight.

Brazier Rd flats. Everything starting to bloom. Buttercups and daisies, fleabanes and evening lychnis. Dandelions are all gone to seed, and the flat white flowers have mostly been ended by the recent winds and rains, except highbush cranberry and arrowwood, not yet bloomed.

What smells so lovely? A clean, fresh, raspberry-like scent coming and going, hard to pin down. Wild grape flowers! Some clusters fragrant, others not.

June 10 ('98). Clark's hill, AM. Sun, calm, warm; dry air. Strawberries ripe next to white rock. Are they better than domestic, or is the environment I eat them in better? I think both.

We flush baby grouse and female.

Returning to the house and yard, to the fragrance of spicy, sweet dame's rocket mixed with late lilacs.

A flock of 30 or 40 Canada geese fly over rather low but heading due north. Very late for geese here in central Vermont.

The new pond at Jennifer and Richard's has wood frog tadpoles around the edge, also toad tads, I expect, from toad eggs laid May 12. June 8 at DD's house toads were trilling and a few peepers calling still.

June 11 ('98). Colchester. Young ravens fledged out and croaking around the area, and other birds, including redstarts, still vocal.

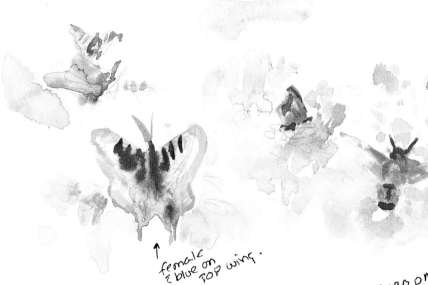

← A Hummingbird moth-like a large bee or a small hovering Hummer.

↑ female & blue on TOP wing.

BUTTERFLYS IN THE DAMES ROCKET

June 8. Heat wave continues. 90's both days, yesterday and today. Thunderstorm with scary lightning passing through, a couple a day. Downpours, then steamy heat/haze/sun.
Reports of Giant SILK MOTHS from every where — D.D, Levi + Brian, and others.

Sudden bolt of grasses and flowering plants.

RUGOSA

SHAPELY CLOUDS
WHIPPING BY.
WIND SHISSHING
THE LEAVES.
MORE BUTTERFLYS.
ROSES BLOOMING.
LATE LILACS BLOOM.
ING.

FLAT WHITE FLOWES
STILL AT IT:
　　High Bush Cranberry
　　nanny bush-ending
　　Hawthorn-ending
　　Alternate Leaved Dogwood
　　Red osier Dogwood
ONLY ONE. ARROWWOOD still in bud.

JUNE 7. 3:30 pm - Sun. Hot, Humid, some thunderheads building.
BUTTERFLYS + A DAY - FLYING MOTH (?) EVERY. WHERE IN THE WILD DAMES. ROCKET TANGLE BEHIND THE VEGETABLE GARDEN. Scores of Tiger Swallowtails and a red type of clear-wing, or HUMMING BIRD MOTH, and a small orange + black butter. fly. I watch for a half hour with binoculars + without. much chasing + spiraling by Swallowtails, but I often can't distinguish sexes, as its a large area + they are quickly fliting out of view and then returning breifly.

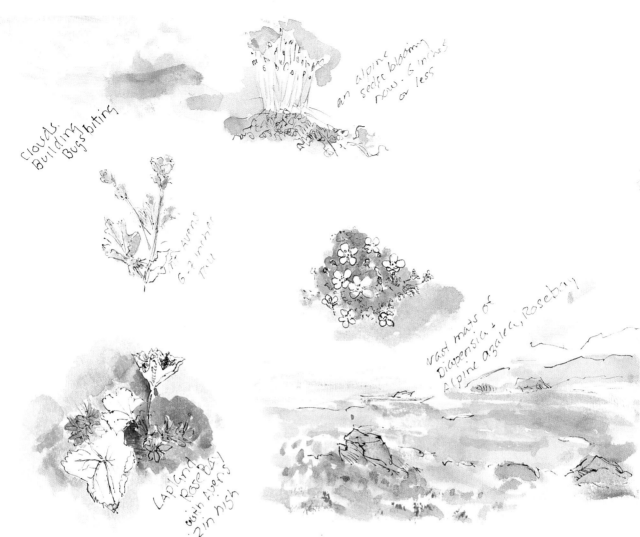

Clouds.
Building.
Bugs biting

an alpine sedge blooming now. 6 inches or less

Ft. Avens 6-8 inches Tall

vast mats of Diapensia + Alpine azalea, Rosebay

Lapland Rosebay with Avens 2 in high

Alpine Garden - Mt. Washington

6-13

Eyes gradually adjust to see these
prolific, ground-hugging bloomers.
Stopping invites black flies, but this is
a huge area + we amble, stop only
for these quick sketches.

On the way down by 3:30 pm. Mid-
elevations (Lions Head trail), three
white flowers blooming: star flower,
goldthread, shad... this blooming up
into the edge of tree line and just
above.

Driving home, lupine + nannybush still
blooming in the Northeast kingdom, N.
E. of St. Johnsbury on Rt. 2.

Home to a scrumptus dinner & wine
and an evening of fireflies.

Round-leaved dogwood blooming, more delicate structure than alternate-leaved dogwood.

See 3 new ferns: walking fern (5–8" long) on mossy lime cliffs; maidenhair spleenwort, tiny, about 2–3" long; and Braun's holly fern, hairy stem like Goldie's, shiny like cinnamon.

Smuggler's Notch, noon. Birdwatching at eye-level on 45 degree hill. I can look straight into the canopy, where I watch a red-eyed vireo and a black-throated blue, both with beaks so very wide during song.

2,000': White violets just ending, clintonia done and in fruit, purple trillium ("nose bleed") just finished, foamflower just ending. Mountain maple and mountain-ash blooming fresh new white together. 4th new fern: green spleenwort growing in crevices. Rare alpine plants on cliffs: white mountain-saxifrage, purple mountain-saxifrage (not blooming, leaves like tiny hens and chicks from distance), yellow mountain-saxifrage (also not blooming, looks like small, 5" sheep laurel. Over on the north cliffs is the area where the peregrine falcons are nesting. Right now they are quiet. High *squeely* begging noises from time to time.

June 12 ('98). Chickering Bog. Light rain. Blooming: pink moccasin flower on bog trail, in spite of all the talk of early bloom; red osier (later here); twinflower; Labrador tea; bunchberry.

Small, newly-shed garter snake nearby.

Blue flag iris blooming, also, two kinds of cotton grass, buckbean (bogbean), and water avens.

June 12 ('99). Butler's field. Insects flying now: common ringlets flip flopping, a bronze, medium butterfly (a satyr); lots of big eyed skippers; pearl crescents; still tiger swallowtails; white-tailed dragonflies out just this last week. Io moth (?) unfolding; Baltimore checkerspots in various instars.

June 13 ('98). Butternut Flats, wet meadow. Overcast again. Quiet, warm, and more rain due.

Birds singing. Waxwings here and at home in shad trees, though shads not fully ripe. White-throated and song sparrows, Canada and mourning warblers heard but not seen.

Ate a few ripe but not yet sweet strawberries. Need sun to do the finishing touches to flavor.

Saw 2 American toads today—a huge red one down here (female) and a smaller one (male) up in the woods by the mourning warbler. Song sparrow and

one or two small chanterelle "pre-fruiting" eruptions about ½ inch high. Sensitive fern here in 2 forms: brown, frosted (2 weeks ago, June 5) and new red fronds.

Pollywog Blowout. Dragonflies galore. Lots of whitetails, easy to see from a distance, with their abdomens a stark white—pairs in mating (?) chases high in the air. Also small blue damselflies mating lower over the water.

Wood sorrel and one-flowered wintergreen blooming in the forest. We find bulblet fern growing by the brook crossing (yellow orchid bog brook).

Horn of the Moon, E. Montpelier. Carley Koss reports a small snapping turtle (8") laid 26 eggs in ½ hour on the side of Sanders Circle road between Charles' and Burley's. They have placed a saw horse on side of road to protect nest. Mother turtle dug hole one back foot at a time, each egg tamped or placed with foot into back of nest at beginning, then just let them fall in. Covered them one foot-scoop full at a time from the 2 piles of dirt (one behind each foot), then brushed 2 feet off on each other, circled nest once in each direction and returned to the brook. Eggs take 3–4 months to hatch, in August and/or September. Sand—we've taken it from natural locations and put it on our roads, where turtles now come to deposit in high-risk nurseries!

Our large garter snake has shed its skin under the blueberry bushes.

June 13 ('99). Mt. Washington, Tuckerman Ravine Trail. Hazy, hot. Black flies. Revisiting spring on the climb up. Pretty little bunchberries, clintonia, this on the wooded section below the ravine. Swallowtails in the clintonia. White-winged crossbills as we get higher up, singing winter wren, blackpoll warblers.

3,700+', Lion's Head Trail. Pin cherry just ending as mountain-ash just starting. Everywhere there are blooming clintonia, tiger swallowtails, black flies.

Above tree line, 4,000' ±. Swarms of black flies—ahhagh! Banks of flowering Labrador tea. Snow still in Tuckerman's Ravine, one skier. Singing: white-throated sparrow, juncos, blackpoll warblers.

June 14 ('98). Rain. Pair (male and female) of harriers on Clark's field, second time in 10 days. Apparently fighting or mating? Bad lighting but one has ragged wings—the wet weather? We'll avoid this area in case of nesting.

Fireflies these wet nights when it's not actually raining. They seem to enjoy the damp night air.

June 14 ('99). Last of the large flat flowers (first around May 29) culminates with arrowwood. Set up chair in the back, near a clump of these viburnums to watch the pollinator show.

June 24 . Mt. Mansfield 4,000 (+~)
Heat Wave . Drought
A mere sprinkle
of rain in
early AM

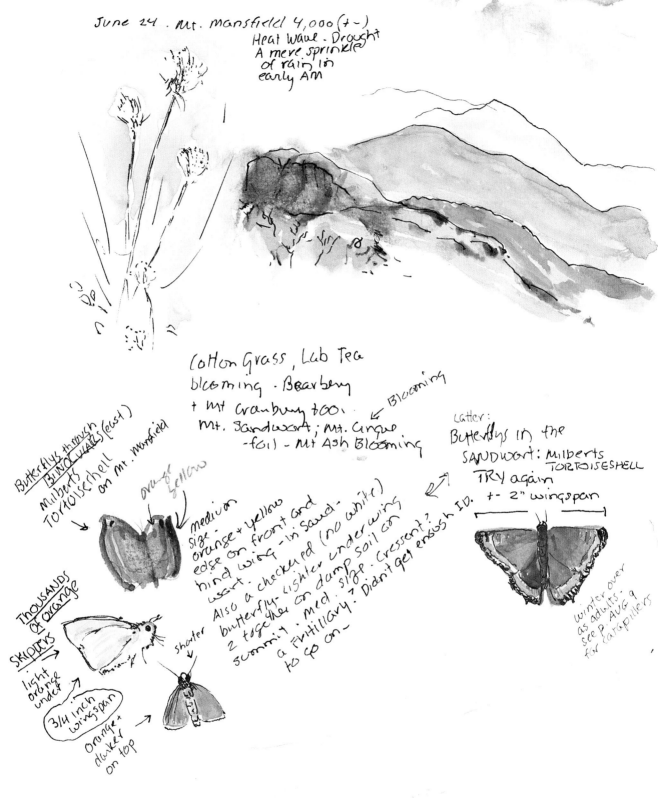

Cotton Grass, Lab Tea
blooming . Bearberry
+ Mt Cranberry too. ← Blooming
Mt. Sandwort ; Mt. Cinque
-foil - Mt Ash Blooming

Butterflys through
BINOCULARS (east)
Milberts
TORTOISESHELL
on Mt. Mansfield

orange
yellow

medium
size
orange + yellow
edge on front and
hind wing - in sand-
wort.
Also a checkered
butterfly - lighter underwing
2 together on damp soil on
summit . med. size . Cressent?
a Fritillary? Didn't get enough ID.
to go on -

Later:
Butterflys in the
SANDWORT: Milberts
TORTOISESHELL
TRY again
+- 2" wingspan

winter over
as adults ?
see p AUG 9
for caterpillars

THOUSANDS
of orange
SKIPPERS

light
orange
under

3/4 inch
wingspan

orange +
darker
on top

shorter

11

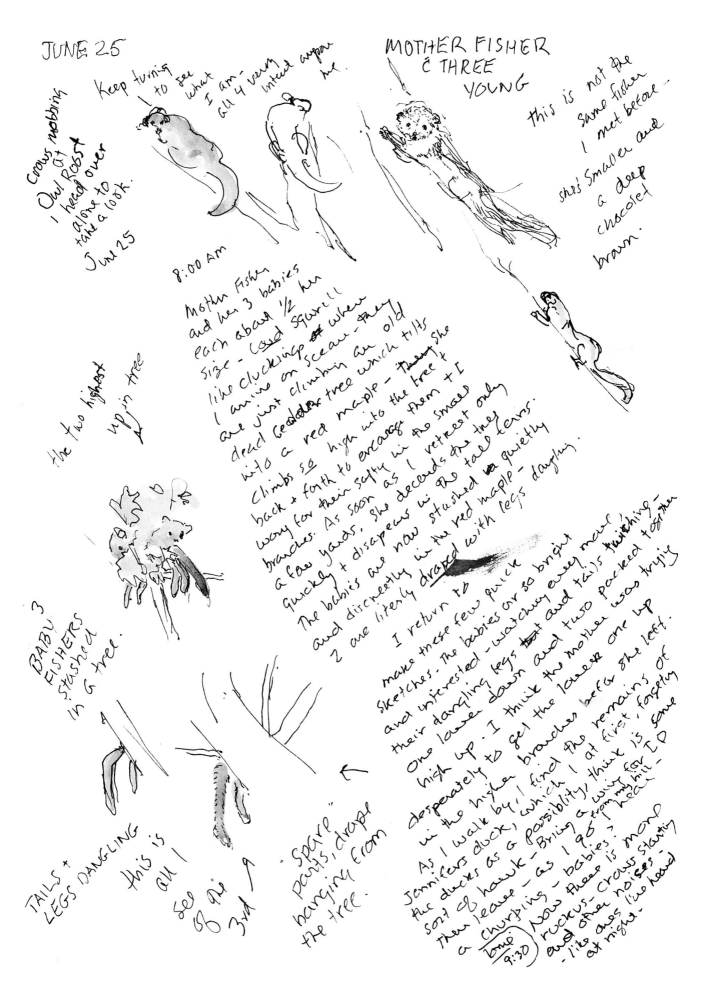

JUNE 25

Crows mobbing at Owl Roost. I head over alone to take a look. June 25

Keep turning to see what I am — all 4 views. Intend appear he.

MOTHER FISHER & THREE YOUNG

this is not the same fisher I met before — she's smaller and a deep chocolet brown.

8:00 AM

Mother Fisher and her 3 babies each about 1/2 her size — coud squirrel like clucking at when I arrive on scene — they are just climbing an old dead cedar tree which tilts into a red maple — they she climbs so high into the tree + back + forth to encourage them + I wory for their safty in the small branches. As soon as I retreat only a few yards, she decends the tree quickly + disapears in the tall ferns. The babies are now stashed quietly and discreetly in the red maple — dangling. 2 are literaly draped with legs dangling.

the two highest up in tree

BABY 3 FISHERS stashed in a tree.

TAILS + LEGS DANGLING this is all I see are 3rd 9

"spare" parts, drape hanging from the tree.

I return to make these few quick sketches. The babies are so bright and interested — watching every move, their dangling legs and tails twitching — One lauver down and two peeked together high up. I think the mother was trying desperately to get the lowest one up in the higher branches before she left. As I walk by I find the remains of Jennifers duck, which I at first, forgetting the ducks as a possibility, think for I.D. sort of hawk — Bring a wing from my hill — their leaven — as I go? heal — a churping — babies? Now there is more ruckus- crows starting and other noises - like ones I've heard at night.

tone 9:30

June 15 ('98). Toads trilling again here in E. Montpelier last night. Raining for days, all native shrub blossoms except arrowwood are washed away. Mock-orange blooming in the yards. Shad fruit getting plump—waxwings stepping up their visits. Dame's rocket still blooming, and all field flowers.

9:30 PM. Peepers again tonight, too.

June 16 ('99). Tadpoles in J & R's pond have tiny legs now. Heard first cuckoo, *cu! cu! cu!* in shrubby area up on Butler's field border early this week. Bedstraw fragrant and milkweed has started to bud. Most birds quiet, but a few continue their all-day singing. Sudden full flush of dragonflies and damselflies everywhere—a lovely black one, big, Clark's field. Still lots of great moths and butterflies on arrowwood.

June 17 ('98). A long spell of rain breaking up in the next 2 days. But today we expect another 1–2 inches in many downpours—has not rained yet. Meanwhile, mosquitoes, which generally don't even bite me, are out in droves and the slugs are 2 inches long. Can't get the garden really going—too wet and sluggy.

Scarlet tanager *chip burr . . . chip burr . . . chip burr* just off the deck. Perhaps the nest did survive all this rain and wind and the red squirrels, who are voracious nest predators, particularly when there are so many.

Brazier hedgerow, up top. Female turkey along fence row, probably with young. Been flushing grouse and young for 2 weeks now.

Red-shouldered hawk calling from same place as last Thursday, preening and *keeer keeer keeering* in Brazier's big easternmost field, on dead branch.

June 18 ('98). Brazier flats, 12:30. Bees' hum a part of the ambiance as they start to work the flowers, only a few honeybees and a bumblebee so far. The deer flies after me! A swallowtail arrives. Also a frenetic white admiral. And a very red and black lady bug on the dark green leaf.

Dock flowers by the roadside—these are said to make a good green in winter (the basal rosette). I've never tried it. At moment, there's no rosette.

12:50. Now some *quee quee quee* calls direct my attention to the sky again, S of the road where the female red-shouldered hawk has joined the male in low soaring together, two reddish forms as they turn. Beaked hazelnuts growing.

June 19 ('98). 7:30 AM. Overcast; been raining overnight. Last sunny day was June 9 and before that June 1. Only two sunny days so far this month.

Shads are red with ripening fruit. The leaves are greener and lusher than usual at this time—the rain must be responsible. 2 or 3 waxwings and a pair of

house finches in the shads. The finches are gorging, at least the male is, while the female sits by fluttering her wings and twittering softly.

Reed canary grass is flowering. Plumes of pollen drift off when brushed against.

3:30. On top of my hill to watch another storm come through. Swallows, thunder in distance, rain in spits—sheets of it in the west and north, the smell of it. Pick a handful of milkweed and run home before a downpour of hard, steady, thickly-pelting rain starts.

Milkweed buds with supper.

June 21 ('98). SUMMER SOLSTICE! First sunny day in ages. Today at salamander pond. Many, many of the large 2 in. salamanders swimming in the sunny patches. Reeds, rushes, grasses, sedges flowering or have set seed mostly.

Waxwings always at the shads now, much of the fruit is red—and they have waited for it. After feeding voraciously, pair sits quietly together, a foot apart, occasionally side-stepping and berry-passing, acrobatic moves to get berries on outlying branches.

June 21 ('99). Stowe, Vt. Summer solstice. The longest day, shorter and shorter from here on. Treefrogs singing, a couple of peepers, lightning bugs, three-quarters moon, full in a few days.

Black-berried elder in bud. Even narrow-leaved goldenrod is budding. Hundreds or more small orange butterflies with black edges in huge congress in Sugarbush area (on the Common Road), European skippers. They are everywhere.

June 22 ('98). Second sunny day. Several Baltimore caterpillars still in the fen. Saw an adult Baltimore butterfly.

Saw St. Johnswort blooming for first time yesterday on Butler's hill, leeks blooming in the woods.

Crows mobbing over by owl roost.

Saw a well-grown fawn today on the Canine Express. Also several half-grown baby grouse, with their mother.

June 23 ('99). Stowe, Vt. Big crowd of baby grasshoppers making 2" leaps in the moss and grass on picnic knoll at Trapp Family Lodge.

All afternoon the barn swallows work the meadow at Ten Acre Lodge, always on the wing, returning to feed three fledglings every few minutes. Sorrel giving red to grass. Common day lilies just blooming.

E. Montpelier. Our Baltimore butterfly (checkerspot type) has been in chrysalis since about June 5. Wiggles from time to time, from segmented portion. I hung it up by some silk it had made from the segmented end. Every time it rains I mist the inside, trying to cover chrysalis with a leaf, as would be the case in nature.

June 24 ('98). Walk over by U-32 High School with dogs, early. The bedstraw still blooming. Bottom of milkweed starting to bloom. Blackberry, raspberry in good fruit, set and growing. Strawberries for the picking though tiny . . . wild ones, sweet and good.

Wetland near DD's. Elderberries in bud and just starting to blossom. Waiting for snipe again. Hearing rail-like sounds from the wetland.

Sander's Circle. First milkweed blooming. Only one plant, the others in full bud. Still, it scents the air. Covered with small orange butterflies, wings-up kind (European skippers?), small striped bees and a couple of black wasps. Blue flag blooming in brook below, with buttercup and forget-me-nots. Daisies, clover (red and tiny yellow hop), fleabane (pink), bedstraw, tall white sweet clover.

Spirea—meadowsweet and steeplebush—just starting to bloom. Wild mint everywhere.

Back to DD's where I flush up a brown bittern in the little brook (full of minnows), just above our new town trail bridge.

June 25 ('98). 10:30 AM. Pile of baby fishers in tree, resting during day. The mother descends tree by way of cedar and disappears into ferns, making worried raccoon-like, chirp-like clucks. I find the remains of the missing neighborhood duck at the base of the cedar. Later, all 3 babies resting in the lower crotch, mother in large den tree area, 2 trees over. What a large litter for this apparently young mother. She is much smaller than the male I saw a few (2) years ago up Brazier Rd. She starts clucking and twitching tail—I retreat and leave.

All quiet.

Home 10:40. Crows again are mobbing half-heartedly. This is rather constant these days from that area of the woods where they are, about 200 yards from our house.

6:30 PM. Fishers and duck remains gone—crows cawing throughout day till late afternoon.

June 25 ('99). Heat wave and drought continue. Report of two bears swimming in the beaver pond over at Chickering's—to cool off? Bug control? Short dip of about 5 min.

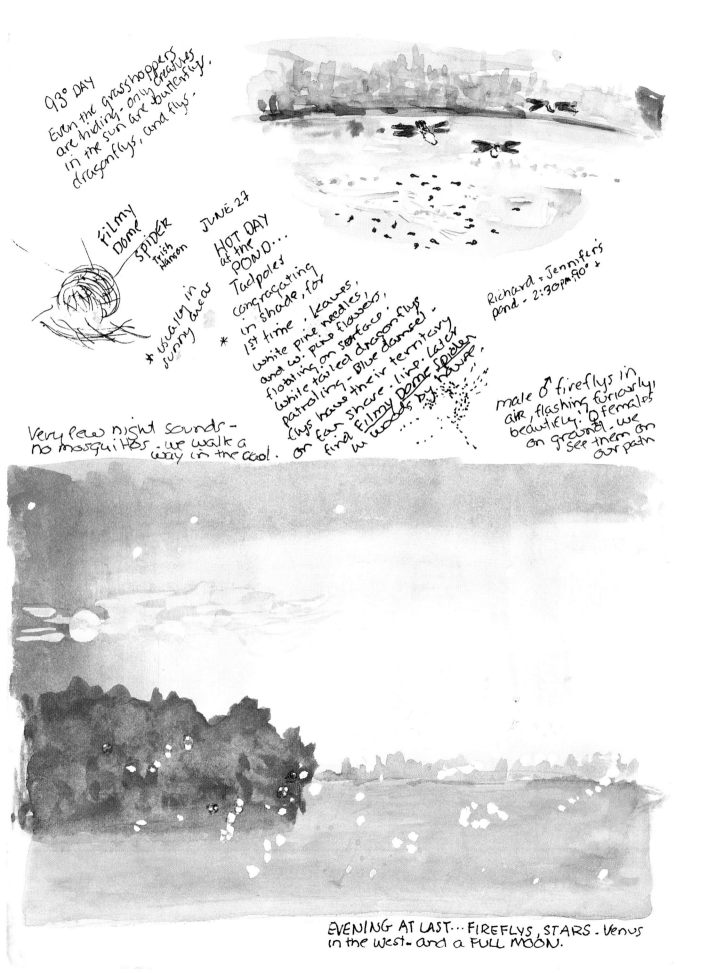

93° DAY
Even the grasshoppers
are hiding - only creatures
in the sun are butterflys,
dragonflys, and flys -

FILMY
Dome
SPIDER
Irish
Hanson
JUNE 27

* usually in
sunny area

HOT DAY
at the
POND...
Tadpoles
congregating
in shade, for
1st time. leaves,
white pine needles,
and w. pine flowers,
floating on surface.
white tailed dragonflys
patrolling - Blue damsel -
flys have their share . lily pads too -
or ferns share . linp. later
find FILMY DOME SPIDER
in woods by hawnet
............

Richard + Jennifer's
pond - 2:30pm 90° +

male ♂ fireflys in
air, flashing furiously,
beautifuly. ♀ females
on ground. we
see them on
our path

Very few night sounds -
no mosquitos . we walk a
way in the cool.

EVENING AT LAST... FIREFLYS, STARS. Venus
in the west - and a FULL MOON.

Orchids (showy lady's-slipper) blooming by hundreds in a local fen, some gone by. Usually 4th of July is final peak—early this year.

June 26 ('98). North Branch Park, Montpelier. Kingbirds about to fly. Parents feeding every few minutes, including green and red berries—shad? Also parents pulling off down feathers from nestings' heads, remove food from one "choking" bird and give it to another!

June 26 ('99). Paradise Brook, to cool off this hot, hot afternoon. Liverworts fruiting on rocks at brook. This in a crevice near the water which must get scoured by high water in spring.

PM. Almost full moon. Moths and many lightning bugs flying high and low in the air and grass. Fast sequences of flashes, stars fixed by comparison, especially luminous Venus in the west these last nights.

June 27 ('99). 90s today. More orange European skippers on wet garden path, just watered last night. Baltimore checkerspots in mating and territorial flights over turtlehead fen, spiral flutters up and dramatic dives down.

11:00. The compost bin is rotting away, smells bad. I'm sitting on a cool rock in shade.

Fledged swallows. Summer is holding its breath.

11:30. 82 degrees (shade). Field—constant twittering of swallows and buzzing of flies and other insects. The sky is pale blue with light, wispy clouds—temperature climbing. Swallows rounding up fledglings—"time to fly."

Earth dry and cracked on path. Fern "fruit" (spore) dots darkening, easier to read.

June 27 ('98). 9:30–10:30 AM. Kingbird nest in butternut over North Branch river. Two babies out of nest, in various precarious positions over the river, one left in nest.

Parents especially solicitous of bird remaining in nest.

Later. All 4 young kingbirds still in the tree—last bird just barely out of nest, on little twig ½" from nest. Distinct "personalities" emerge—a slow one, a sleepy one, one that is always on the go and never stays long on one branch, and the "middle" bird! The one on the go just "fed" the slow one, and it gave back a love peck to tail. Sleepy way off on a branch away, resting. No down left on his head. "Slow" still has down, as does one other—the middle or most active one. Slow has a dingy chest from being in nest so long. The others are whiter, females tail is ratty too, from the long incubation period. Both parents feeding Slow at once—feeding picked up a bit since yesterday.

7:15 PM. Big storms N of here up the valley. All four kingbirds close to nest on bare branches, over river. Lightning flashing about 5 miles away, thunder. Some chasing of parents by oldest baby bird. A lot of beautiful fly catching in mid-air, beautiful dives and swoops by parents. Sky getting darker.

On some signal (from parents?) the babies leave the area of the nest. Slow tries, but can't, and through binoculars I see he is caught by the foot with fishing line! He falls back into the nest flapping. He can't leave the nest and this terrible storm is coming. A calamity! Must act fast.

8:00. Rush to Geoff Byers' house to get help. Geoff grabs a ladder and starts down to river.

8:15. Speed home and get Charles. Together, Geoff and Charles place ladder in river and up to branch. Kingbird parents defending nest, the precarious ladder swaying. Charles steadies ladder from river below while Geoff slowly climbs to cut line and retrieve entwined baby bird just at dusk.

8:50. Geoff has bird in hand, on the ground. By flashlight, with scissors (on knife borrowed from a man who came to watch), he slowly, carefully cuts fishing line from the leg where it was tightly twisted. I unwind it and hold each loop. Foot is intact and functioning. Geoff places baby bird in same tree with siblings—Slow is able to perch! We're elated and, exhausted, all head home before storm hits.

June 30 ('98). All 4 baby kingbirds in the tree! Slow still has head fuzz. He's the most vocal and the least experienced flyer, but all alive and well. Parents busy feeding. Whew!

5:00. Butler's field. Still more rain storms coming through, especially Chittenden County and east. Bobolinks quiet—hear only one and see one or two late nesters, the others fledged and gone—3 or 4 females or young, but don't see the males in the 20 min. I sit.

To Burlington. Basswood blooming on way there, not here on my hill yet. Grasses and sedges in seed, ferns all in spore—is that how we say it?

More flooding, the wettest June on record. Salamander pool and woods—cool early AM, drizzle.

T. Clark reports a luna moth in Maine today. Mario, in Colchester, saw one yesterday.

Blooming tonight in Butler's woods: one-flowered wintergreen (to me this smells like citronella), pyrola or shinleaf (this one as sweet-smelling as lily of the valley), wood sorrel (delicate pink and white, and a night/rain closing leaf).

Chanterelles just up but under siege of slugs.

No obvious insects—must be hard for them to fly during such a prolonged rain. How do they? Or do they?

June 30 ('99). The roadsides and meadows with a show of black-eyed susans, clovers, daisies. In the garden delphiniums just starting.

7:00–10:00. Walk big loop to Winooski River through woods and Clark's field. Back by pond where scores of tiny wood frogs are hauling themselves up on the rocks, mud, and vegetation—they look like lumps of mud hopping. Size of small fingernail, hundreds of them, only ¼ inch long. So hard to see as they leave the water. Have to slow way down to catch their movement and notice them. Still, brown small tadpoles by hundreds in pond, some with legs, some not.

Black-billed cuckoo singing in brush on Clark's.

Timothy blooming, reed canary grass finished.

Little orange skippers still everywhere in the grass. Baby crickets too.

Harrier, brown female on Clark's lower field today.

Several days of rain showers at last, some relief from the drought.

The Next Generation

But far beneath this wondrous world upon the surface, another and still stranger world met our eyes as we gazed over the side. For, suspended in those watery vaults, floated the forms of the nursing mothers of the whales, and those that by their enormous girth seemed shortly to become mothers. The lake, as I have hinted, was to a considerable depth exceedingly transparent; and as human infants while suckling will calmly and fixedly gaze away from the breast, as if leading two different lives at the time; and while yet drawing mortal nourishment, be still spiritually feasting, upon some unearthly reminiscence;—even so did the young of these whales seem looking up towards us, but not at us, as if we were but a bit of Gulf-weed in their new-born sight, floating on their sides, the mothers also seemed quietly eyeing us.

—Herman Melville, *Moby Dick*

They come through us, our children, into an indifferent world. We try to make them feel welcome and at home. We tend and prepare them as we can. Then we let them go, to take a place we soon yield to them. Will, fortune, and, some believe, fate will decide the rest, and all our caring, once so vital, becomes as vaporous as their breath. Yet, like breathing, it is always part of them, a sustenance beneath the surface that stays with them through all their passage.

It is axiomatic that perpetuation of one's own kind is one of the strongest drives in all of life, whether protist, plant, or animal, something so tiny and brainless as a virus or an amoeba or so huge as an elephant or a whale. So strong among many, in fact, that self-sacrifice, even to the point of death, is the rule and not the exception. And for many animals, caring for and protecting the

young is equally axiomatic, a demonstration of primal duty—innate, impassioned, uncompromising, everlasting.

We humans see it best, or at least feel it most keenly, in ourselves. More is born than just a baby. The arrival of the new child elicits immediate tenderness in the awaiting parents, but one imbued with the fiercest, most enveloping, kind of love. Purpose and duty take on whole new meanings.

A parent will go to utmost measure of provision and protection for the child, reorder responsibilities, quite suddenly render "self" down and reconstitute it into a more precious "other." As we gaze at this new helpless infant, it dawns on us, perhaps for the first time, how terribly important we are, not for ourselves, but for what depends on us. We suddenly understand how inextricably fused and self-defining are strength and weakness, solidity and fragility. We see how courage is the mirage that floats above a bed of fear, immortality above mortality. We are powerful only because we feel our helplessness. We have placed ourselves at the mercy of our own making.

Becoming a parent also suddenly unites us with our neighbors and fellow travelers. We understand what Herman Melville is saying: in our kinship with other mothers and fathers, we feel compassion for undeniable expressions of the filial bond; we understand the same urgency to quell the hunger or calm the crying or soothe the pain. What is true in humans is true in whales—we know that not through what they say, but what they show. That language is beyond words, but the communication is the same.

The duration of parenting—and degree of devotion—usually depends on how long the children need this care before they can be on their own. Among many slowly developing mammals and birds, it may be a considerable time as the young gain size and strength, and learn the ways of survival in their world. A baby finback whale may spend up to three years in the company of a parent, usually the mother, a black bear one and a half years, a moose a year, a great horned owl five months, a common loon up to three months. (It is not so much a matter of how long the period is in any species, but what percentage that represents of an individual's life span. A warbler may spend only three weeks raising and caring for its nestling, but that counts for a big portion of a life that may last only a year or two.)

Among others where development is fast—usually those living in more exposed or open habitats, who need to be able to scurry for cover as soon as possible to escape predators—parenting may be fast and furious, and over quickly. As soon as baby killdeers hatch in meadows or graveled parking lots they are able to run for cover. Baby meadow voles are independent in the third week after birth.

Usually it is the mother who is the most attentive parent, but not always. Among birds especially, males participate in raising the young, some equally with the females. Among some, such as the spotted sandpiper, the male does the bulk of child rearing; it is the female that defends her territory from other females, and competes for males. Among cowbirds, neither parent cares for the young; the female deposits her eggs in the nests of others, abandoning them to the care of unwitting foster parents.

While tending to the young is most common among birds and mammals, other animals practice it too, to a greater or lesser degree. Among reptiles in New England, the female five-lined skink curls herself around her eggs and fiercely defends her newborn, as do mother garter snakes and timber rattle-snakes (the young are born from eggs hatched within the mother's own bellies). Redback salamanders protect the eggs they lay under forest-fallen logs, while dusky salamanders do likewise for theirs under moss or leaves at a stream's edge. In all these cases, however, the hatchlings are soon away and on their own.

Most fish simply lay eggs in roughed-out "nests" or deposit them on vege-tation or freely in the water, then leave them to their own devices. But there are many exceptions. In freshwater, sunfish, large- and smallmouth bass, bowfins (*amia*), bullheads, and some darters, sculpins, and sticklebacks all build some fashion of nest and guard their eggs and young to some degree. In saltwater, the rock bass and seahorse are examples of fish that parent. The latter lives among the shallow eelgrass beds along the ocean's edges; the female places her eggs in the marsupial-like pouch of the male, who in turn incubates them to hatching; the released young for a time will return to the father's pouch for protection when danger nears.

Even insects and other invertebrates behave as parents, whether the young have come from their own bodies or from the colony that is their home. The behavior may be aggressive guard-ing—who has not felt the sting of a bee, yellow jacket, or wasp, or the bite of an ant, defenders all of their broods within the nest? Or it may be more passive protection, such as the male giant water bug carrying the fertilized eggs glued to his back until they hatch.

We often gauge "parenting" by our human standard: having children, providing shelter, feeding them, giving what they need, protecting

thcm, teaching, ultimately weaning them slowly into the world. The concept implies willed, directed action on our part, an intention to provide as best we can for those dearest who are to follow. But other means of provision may be just as valid a form of caring, if not so closely equated with our own way.

Plants, too, provide for their young, devoting great amounts of time and energy to their seeds, once flowering is done, to give them the means to make their own way. The maple endows its seeds with wings to whirl into new territory, wraps the embryos within the preparatory food in cotyledons, and releases them to the fortunes of the wind. An apple tree conspires with animals and birds, wrapping its seeds in tasty pulp, offering a meal in return for the processing and dispersal of its seeds via their guts. Even those plants that do not go to such elaborate preparations, releasing instead enormous numbers of offspring only a small fraction of which will survive, have a certain design of caring, indicating commitment to a time not their own and to beings not themselves.

We really are not so different. Continuity unites us all in our own impermanence. Each of us at first a child, then each a parent to other children. I think the earth would see it so.

JULY

July 1 ('98). Slow (the kingbird) is still in the tree "next door" with his mom, doing his best to dodge drops from the leaves overhead. Can distinguish the female because of her worn tail—brooding eggs and young having soiled and battered the white tip until next molt.

July 1 ('99). 9:15 PM. Flying squirrel and dobsonfly (3" long, 2 pair of lacy, lacy wings) on window late at night.

July 2 ('98). PM. Vervain blooming now along the lanes and in the wet areas. Crickets; a single peeper in the wetland below—it's a cool, clear night tonight; the veerys are singing. Moon waxing.

July 3 ('98). North Branch Park. All with young: grackles, bluebirds, kingbirds, yellow warbler, kingfisher. Wild leek blooms in our woods, like thousands of small light bulbs.

July 4 ('98). Driving to Woods Hole, Mass. N of Boston by 15 miles. Oaks are again defoliated and some putting out new leaves. Saw this last year too. Gypsy moth? Frost? Other species-specific calamity? Elderberry setting seed here. A few blossoms left. Mullein blooming on top half of stem here. Butter-and-eggs blooming, in Boston cracks in pavement, at top of spire. Rugosa roses blooming freely along I-93. Sumac (staghorn), red and ready for sumac switchel (for recipe see p. 169).

S of Boston on Rt 3. Oaks OK here, and lots of pitch pine. No meadow

- As delphiniums are in last bloom and daylilies still going strong: many fruits maturing; shads drying up or gone; wet meadows are starting to bloom; raspberries (wild) are ready; basswood is finishing or over; milkweed flowers in all stages—buds, flowers, faded flowers, shriveled flowers, and setting pods.
- When goldenrods first bloom, wild blueberries are ripe.
- Mark DesMeules (Alna, Maine): "When the mackerel are running, the seals go nuts (July and August)."

flowers, compared to further north. Blueberries, etc., and grasses, an occasional rose in bloom.

July 6 ('98). Naushon Island, Mass. West End Cottage. Rose and honeysuckle fragrance everywhere in the air. Wake to a cooler but still fine day. Low tide.

Mockingbird song today includes song fragments of: cardinal, kestral, tufted titmouse, warbler-like composition, northern oriole rattle, crested flycatcher, phoebe. Where did he learn all these?

Take a 4-mile walk around West End Pond in AM—by Silver Beach and the Holly Rock. It's good to be among the huge old oaks and beeches, and in a place without roads or cars. Quiet swim alone at West End Pond and pick a few small chanterelles.

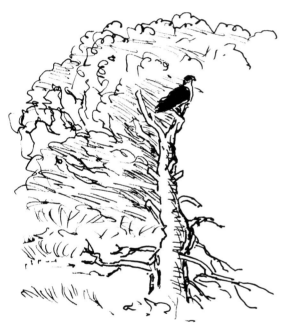

3:00 PM. Clear, hot, sunny. An osprey is suddenly on nest, peeping, flies off. Sparrow calls again: *stee stee te de deeeee da,* very high, very soft, very like an insect.

A 1" diameter, round, deep, perfectly perpendicular hole in the sand. A lycosa, or wolf spider? No sign of a nest or the silk lining or the female and her egg. Also it's only 6" deep. What has made these? We've seen several.

Blueberries in green fruit. Flowering shrubs typical of this area: sweet pepperbush just in bud, maleberry, dangleberry, staggerbush. Anywhere we walk on the island paths, two things are sure: ticks and fragrance! Every low wet place has the very sweet clammy azalea, or swamp honeysuckle, in bloom right now—the "warm" sweet tropical smelling fragrance carries hundreds of yards on the breeze and is reminiscent of all the previous years here at this season. It's so covered with blooms it's hard to draw. Also common honeysuckle. Little hudsonia growing on sandy ground, a heather-type or heath.

Rufous-side towhee near Holly Rock. Black gum swamp: yellow warbler, yellowthroat, veery.

1:30 PM. 3 American oystercatchers fly over—again it is the sound that alerts us, *weep! weep! weep! weep!*

Mockingbirds always here, quietly alternating location from one prominent spot to another.

A pair of sparrows in full mating or chase mode, all about the grasslands.

JULY 5·98 NAUSHON ISLAND -
West End Cottage - The Bragiers

Unaccustomed Quiet - No ospreys on
nest - But within minutes scores
of dragon flys in the yard - Eider
ducks and cormorants in the water
and a pair of mocking-birds and
king birds, also gold finches nesting
in the yard. The mocking bird's in the
Barberry bush - All three resting in the
late afternoon for 5 min quietly.

Walk along shore - these from memory at
5:30pm

3 Eider ducks
in the
little cove

Hills and
Every nook
filled with
Roses and
a viburnum
(white) is it
Black
Haw?

Ailanthus, Burr or
White Oak (?) and
Baburry

Actually,
the Black Haw
is visable from
long distances,
but is probably
really not
that plentiful

Osprey comes in very

carrying
fish

Quietly with fish;
lands in dead tree
next to empty nest.
What happened to
the nest this year?
stays for 45 min in tree.
Never a sound! How Odd!

a bit
too high
in the
water?

young Eider

Swimming
fast away,
against the
current

the horn Poppys, the rocks
the cormorants and the sea.
Sun shining - clouds in
the S.W but blue sky and
even bluer water
with golden highlights

Cormorant
and Eider
swimming
together

TICKS EVERYWHERE!
use
front
legs
like
antenae.

Eider
bathing +
preening
in the

I came out to try and finally see who makes the grasshopper-like trill. A grasshopper sparrow! The soft insect-like buzz trill stops shortly after I come into the field. It seems to come from everywhere, then stops.

5:00 PM. A harrier with something—then suddenly a squealing immature is following, begging for food. The parent DROPS the food and the young does a flip in the air and comes up to catch the item! A green heron is vocally disapproving of this.

7:30. Evening—supper at the picnic table—totally quiet as always around meal time. No boats in the bay or on the ocean side, or in the hole passing through. Mockingbird singing and has added yellowthroat, indigo bunting, barking dog sound, and flicker to his repertoire.

Charles saw a female turkey on the path from West Beach—she seemed quite tame . . . young nearby?

The dinners we've had so far all brought from outside or the farm on the East end. Tomorrow we hope to make a local quahog (clam) chowder. I'm hungry for local food and the weather is turning cooler and wetter.

Ollie says the rodents here have no predators since the undergrowth is so thick. He believes that is why the ticks are so bad. So he mows big swaths where the hawks can get a rodent meal—a plan to keep the ticks down.

July 7 ('98). 8:30 AM. To Wee Pecketts islands by boat, 15 min. from West End. Clear, light breeze. Bird nesting sanctuary. Bird sounds and smells from the water, reminiscent of the Bass Rock in Scotland but fainter in all respects. Black-backed gulls, herring gulls, cormorants.

5:30 PM. Cooper's hawk just flying through stirred up a pair of kingbirds by the stable.

Is weather really coming in or just hanging to our SE, as it has all afternoon? Tomorrow will tell. The big suspense issues here, with no contact, phone, etc., only the boats going by in the hole!

PM. Dark. A bank of backlit clouds east of the nearly full moon. Treefrogs singing from the marsh woodland behind the osprey nest platform. The endless daytime stream of motorboat traffic through Robinson's Hole has ceased for the night. Quiet except for the occasional jet, treefrogs, and the whine of mosquitoes, crickets, and the soft hiss/breathing of the gas refrigerator. Through the open back door we can see the fireflies. A black-crowned night heron flies by but we only hear his unmistakable *waake!* as he goes over. The mockingbirds seem to have gone to sleep.

July 8 ('98). Walking the paths along the shore, Naushon Island. Hear

more oyster catchers. Many areas offshore jammed with lobster traps. They are every 50 yards some places. Most boat traffic is people checking their traps. One morning at 6:45 guy blaring his radio, and here we are 10 miles down the island from any other habitation.

Low tide. Charles in the row boat going to get quahogs for our chowder. I'm very lazy, and listen to the mockingbird who has added swallows, killdeer, catbird, and robin alarm call to the series of clucks it makes. Now the song is flicker, finch, dog barking sound—Heydt's dog across the Hole?, and others.

3:30. Gather some periwinkles at low tide. Bring to a boil and eat with a pin. These I think are the sweetest of all shellfish. Does anyone else eat them?

4:50. Finally, a little rain—tiny, fine, sparse drops—falling this last few minutes, out of the south. Thunder east of us.

July 10 ('98). Naushon Island. 6:30 AM. Wake up to a very foggy day and light wind. The first day since we got here 6 days ago that the mockingbird has not sung once. The female is now constantly on her nest. Actually we have not seen the other bird (male) since yesterday morning, when he seemed to be hostile toward the mate. These are not birds we have in our part of Vermont, so I don't know their habits.

Heydt's (across on Pasque Island) clam chowder: open them raw, save any juice, rinse clams in it, sauté lightly after cutting up—use bacon too. Not tough this way, he says.

10 AM. Fog lifting. Clear sky. Male mockingbird gives us a quick and reassuring phrase, but stays out of sight. So he *is* around, just quiet and hiding. Female (and/or male) coming and going from nest.

10:30. Walk along w. shore beach to boat shell dune and a lovely milkweed, rose, and mint flower garden, with horn poppy and a few thistles. We see our first monarch butterfly and many, many bumblebees.

July 11 ('98). Naushon Island, West End Cottage. Sparrows: walking about, we often see the vesper sparrow with white outer tail feathers. Also savannah and song sparrow. Little savannah sparrow singing. I finally get to see one in the act. This bird being not at all shy—looks a bit like a song sparrow but with faint yellow above the eye and song unmistakable.

6:30. Saw a coastal variety of the common wood nymph butterfly—much larger than ours, 2× size.

8:00. Last order of mockingbird business—sitting together on fence, chasing kingbird off path and off fence . . . together.

8:30. She enters nest as sunset fades, he does a remove from the nest as

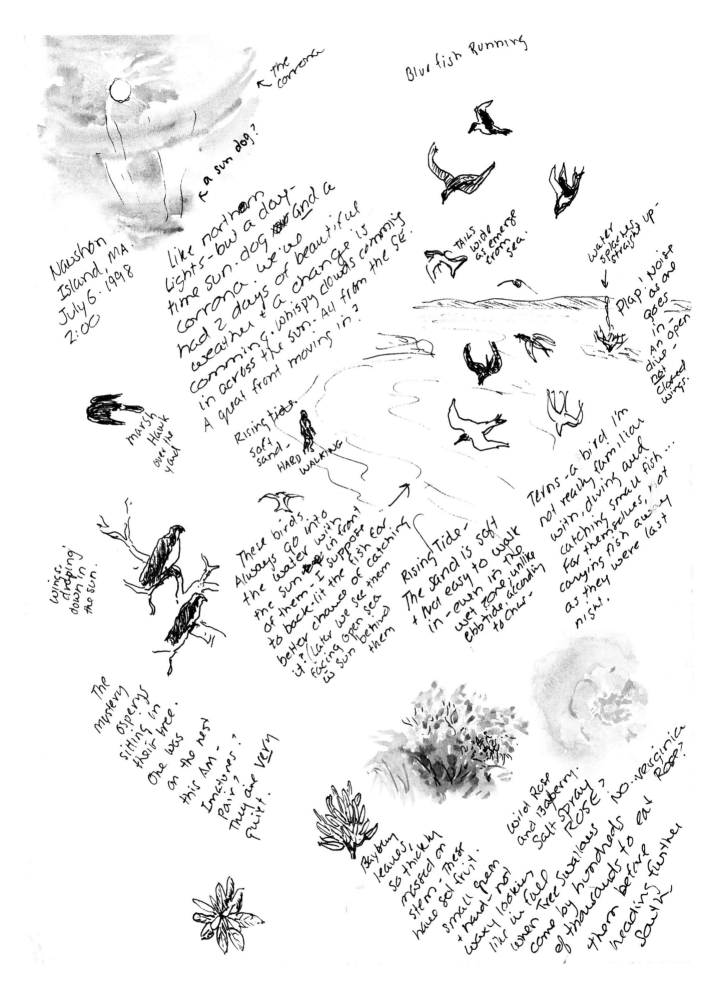

Bluefish Running

← the corrona

← a sun dog?

Nawshon Island, MA
July 5, 1998
2:00

Like northern lights—bw a day-time sun. dog xxx and a corrona. we've had 2 days of beautiful weather & a change is comming. whispy clouds comming in across the sun. All from the SE. A great front moving in.

TAILS wide as emerge from sea.

water splashes up-straight ↓ Plap! Noisy as are goes in — dive — not closed wings. An open

marsh Hawk over the yard

Rising Tide.
soft sand -
HARD is WALKING

Terns—a bird I'm not really familiar with, diving and catching small fish ... for themselves, not carrying fish away as they were last night.

wings drooping down in the sun.

These birds always go into the water with the sun in front of them—I suppose to back-lit the fish for a better chance of catching it? (Later we see them facing open sea w sun behind them

Rising Tide.
The sand is soft & not easy to walk in—even in the wet zone. unlike ebbtide. ascendin to char—

The mystery ospreys sitting in their tree. One was on the nest this AM— Inclones? Pair? They are very quiet.

Bayberry leaves, so thickly nested on stem—their small green + hard (not waxy looking) berries.

Wild Rose and Bayberry. Salt Spray ROSE? NO. verginica ROSE?

like in Fall Swallows come by hundreds to eat there before heading further south—
of thousands

Horse shoe crabs mating in the shallow water — heaping up the sand away from them — from the roops, they haul come at higher tide — the water is roilled + bubbled up. These are ancient creatures with moss + barnacles on their shells. July 9.98 6:30 pm

FULL MOON HIGH TIDE TONIGHT AT 9:30 we walk out to see the moon

lots of Bubbling + scraping bubbling noises.

pushing the sand into concentric mounds

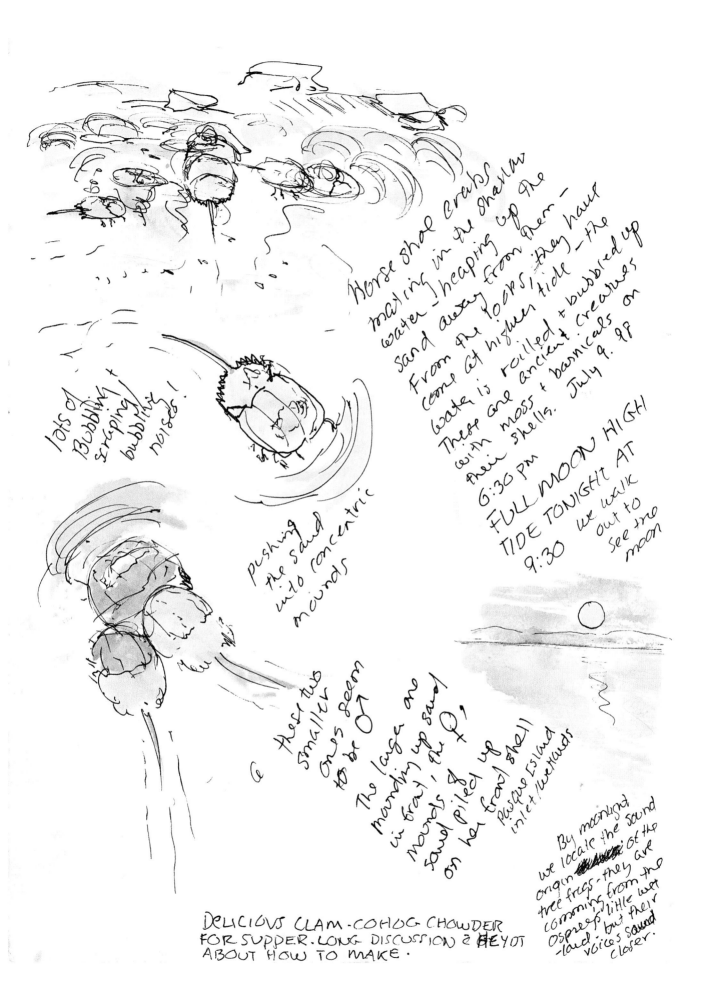

Pasque Island inlet/wetlands

these two smaller ones seem to be O'

The larger are mounding up sand in front, the O' sand piled up on her front shell

By moonlight we locate the sound origin of the tree frogs — they are coming from the ospreys' little wet -land, but their voices sound closer.

DELICIOUS CLAM · COHOG CHOWDER FOR SUPPER · LONG DISCUSSION 2 BEYOT ABOUT HOW TO MAKE.

soon as she's in it, then a flutter flight swooping to his roost over by the big hole where John used to stash whiskey in Prohibition, where he enters very low to the ground, into the thicket, near where singing this AM. The kingbird returns to fence and all is quiet.

July 13 ('98). Vermont. Cloudy, warm. The fragrance of Vermont when milkweed and basswood are blooming! Follow the bees! We find several Baltimore butterflies and a couple of fritillaries. Without binoculars we could never have identified them short of the old and to me completely unappealing "net" method of i.d.

I-89 roadsides with yellow king devil and small yellow clovers, Queen Anne's lace, chicory—very blue on this cloudy AM—gray ragweed adds a color grace note, not yet blooming.

July 14 ('98). Heat wave, 90. At home—some shadberries still left! Day lilies and delphiniums blooming since July 1 or so. Brazier Flats—a great place to smell basswood, because with corn fields on both sides of the hedgerow road there's no confusion with milkweed. The fragrance comes on the breeze in strips/wafts.

July 15 ('98). The remaining shadberries have shriveled up with the continuing heat wave. Apples becoming green balls on the trees. Pick chanterelles and raspberries on railroad bed at Marshfield cliffs.

July 16 ('98). Today for lunch: dandelion greens cooked, salad with dandelion greens and portulaca from garden. Snipping the dandelion greens off with scissors at the ground so they will grow back, tender. I think this method may work all summer.

I hear the crows over by the fisher area—should go take a look—it's noon and very hot. The heat; the feeling of everything holding its breath before the slide toward fall. Apples hanging like balls on the trees. Milkweed's lower flowers have shriveled—only one or possibly two holding their stem form— these destined to become pods. An apple falls and hits the ground nearby.

July 17 ('98). Joe-pye weed blooming. Rhythm of their opposite foliage on strong dark stems.

July 18 ('98). My top field, 8:00 PM. Mound ants' forestry practices. It seems each of the large ant mounds in the old field is surrounded by a good-sized (6' dia.) "lawn" of much shorter, weed-free grasses. Why?

Butter-and-eggs, hemp nettle, evening primrose, butterflies on milkweed that is in all stages.

Cedar waxwings in the raspberries. I'm surprised that they come to the shads at home at all, as they did yesterday, with such an abundance of raspberries. Shad must be a favorite.

July 19 ('98). Turtlehead fen, AM, sunny, 70s. A lovely time of summer in this wet meadow. Turtlehead, a favorite foliage plant of Baltimore checkerspots; just a few budding and one or two in bloom. Marsh fern's leafing rhythm. Joe-pye weed just starting to bloom. Boneset just budding. Wild mint, tall red stem and a small flowering one, flowering from leaf axis. Purple fringed orchis, in shade of willow clump near white quartz rock. Also vervain, heal-all, St. Johnswort.

July 22 ('98). Ant hills. Call to Ross Bell and Valerie Barnsbach. Our field mound ants—what kind? Why the clearing around mound? Valerie studies forest ants. Guesses the underlying structures (caverns, tunnels, etc.) cause the limited growth.

July 23 ('98). Monarchs here and there. Ash seeds under female trees. No katydids yet. Wild leeks have set seed. Tadpoles (toads?) still in pond. Thunderstorm. Fireflies are finished, snowy tree crickets started. Saw 2 huge colorful wasps today and yesterday.

Burlington today—yellow about to take over. Black-eyed susans already full, goldenrod poised. Queen Anne's lace is still the reigning roadside flower. Chicory with pink bouncing bet (soapwort) making a nice show. Also a new roadside weed, wild chervil, is thick in places.

9:15 PM. Storm has cleared, crickets singing, and a luminous ¾ full moon is filling the sky with light. The white nicotiana flowers in pots on deck by the bedroom window are pumping out their sweet evening fragrance.

July 23 ('99). Sun, hot, 80s. Monarch butterflies about. 7 Canada geese at fire station pond (2 adults, 5 juveniles). First time in memory breeding here.

"Trees heavy with leaves." (My mom).

Robins: 2nd or 3rd broods starting, 2 eggs in nest, 5½' off ground, maple next to driveway.

Fresh corn in at Hawkins farm!

Also: grackles in flocks, cruising neighborhood; troupes of swallows; delphiniums just ending; daylilies still blooming; berries everywhere—raspberries,

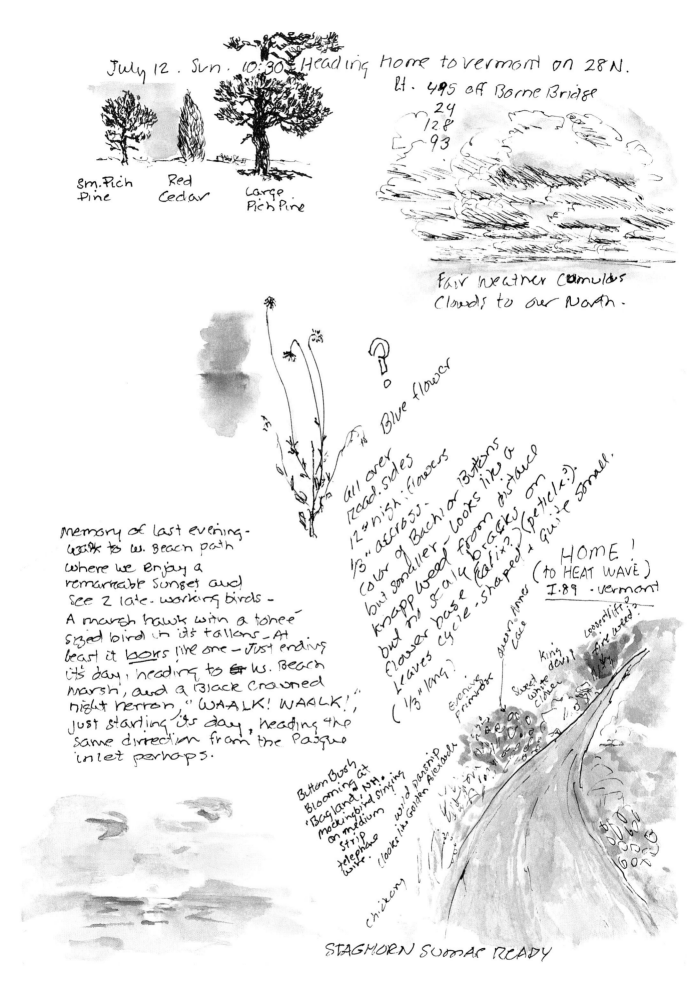

July 12. Sun. 10:30 Heading home to Vermont on 28 N.
Rt. 495 off Borne Bridge
24
128
93

sm. Pitch Pine Red Cedar Large Pitch Pine

Fair weather Cumulus Clouds to our North.

Blue flower

All over Road sides
12" high. flowers
1/3" across.
Color of Bachelor Buttons
but smaller - looks like a knapp weed from distance
but no scaly bracks on flower base (calix?). (petiole?)
leaves cycle - shaped + quite small.
(1/3" long)

Memory of last evening.
Walk to W. Beach path where we enjoy a remarkable Sunset and see 2 late - working birds -
A marsh hawk with a tohee - sized bird in its tallons - At least it looks like one - Just ending its day, heading to W. Beach marsh, and a Black crowned night herron, "WAALK! WAALK!", just starting its day, heading the same direction from the Pasque inlet perhaps.

HOME!
(to HEAT WAVE)
I·89 - Vermont

Loosestrift?
fire weed
King devil
Sweet white clover
Queen Anne's Lace
Evening Primrose
wild parsnip
looks like Golden Alexader
chikory

Button Bush Blooming at Bagland, NH.
mockingbird singing on medium strip telephone wire.

STAGHORN SUMAC READY

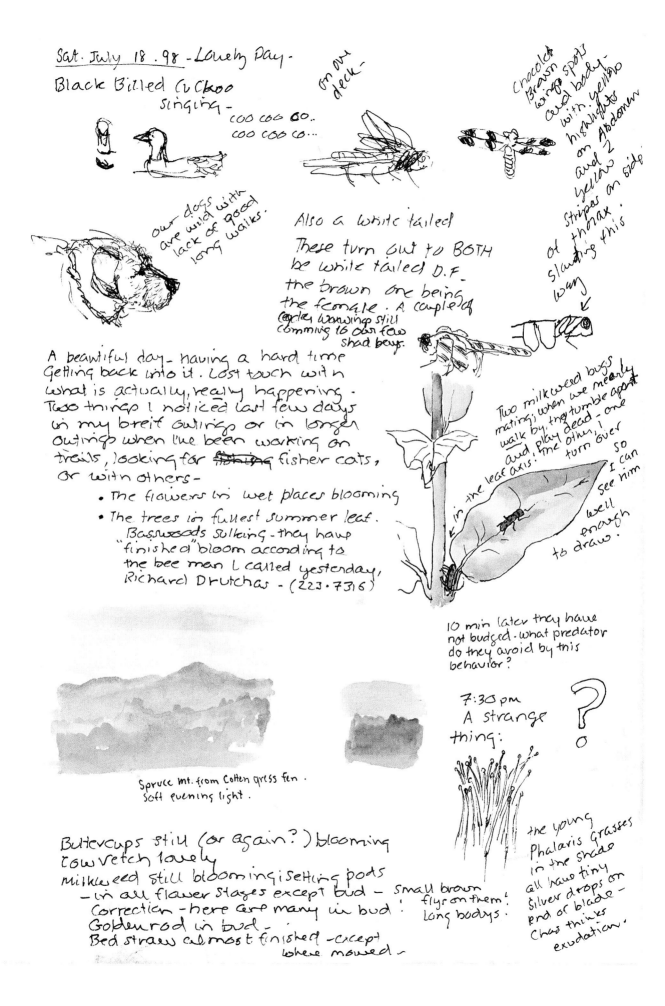

Sat. July 18. 98 - Lovely Day -

Black Billed Cuckoo
 singing -
 coo coo oo..
 coo coo co...

on our
deck -

Chocolet
Brown wing spots
and body -
with yellow
highlights
on Abdomen
and 2
yellow
Stripes on side
of thorax
slanting this
way

our dogs with
are wild with
lack of good
long walks.

Also a white tailed

These turn out to BOTH
be white tailed D.F.
 the brown one being
 the female. A couple of
Corleys warming still
comming to our few
 shad boys.

A beautiful day- having a hard time
Getting back into it. Lost touch with
what is actually, really happening.
Two things I noticed last few days
in my brief outings or in longer
outings when I've been working on
trails, looking for ~~fishing~~ fisher cats,
or with others -
 • The flowers in wet places blooming
 • The trees in fullest summer leaf.
 Basswoods sulking - they have
 "finished" bloom according to
 the bee man I called yesterday,
 Richard Drutchas - (223·7316)

Two milkweed bugs
mating; when we nearly
walk by they tumble apart
and play dead - one
in the leaf axis. the other, I
 turn over
 so
 I can
 see him
 well
 enough
 to draw.

10 min later they have
not budged. what predator
do they avoid by this
behavior?

7:30 pm
A strange
thing:

?
o

Spruce Mt. from Cotten grass fen.
Soft evening light.

the young
Phalaris grasses
in the shade
all have tiny
silver drops on
end of blade -
Chas thinks
exudation.

Buttercups still (or again?) blooming
Cow vetch lovely
milkweed still blooming; setting pods
 - in all flower stages except bud - small brown
 Correction - here are many in bud! flys on them!
 Goldenrod in bud - long bodys.
 Bed straw almost finished - except
 where mowed -

chokecherries just turning red, small green grapes, cranberries; beaked hazel-nut; milkweed at the black-frizzled flowers/small-newborn pods stage.

July 24 ('98). E. Montpelier. Fruits, berries, mushrooms, and the garden. Red osier dogwood greenish white, raspberries, blueberries, shads were still ripening on lower Densmore Mt. yesterday. Also some ripe blueberries on top. Blackberries still small and green. Basswood now has hard green, small "nuts."

A great crop of chanterelles.

My field: a concerned song sparrow behaving as if a nest nearby. Also these waxwings—I move to keep peace. I move and the song sparrow follows, scolding. One further attempt. What are these waxwings doing? A family group learning to hawk insects? Yes. They flutter about me making small forays out from a small copse of poplars near the path, never moving on the way wax-wings usually do.

July 25 ('98). Butler's field: New moth, like a ctenuchid but smaller, in the new-blooming goldenrod. Bumblebees in the goldenrod, their pollen baskets full of orange pollen. A hairstreak butterfly. Meadowsweet still blooming well. A lone red osier dogwood blooming. Black-eyed susans. Female white-tailed dragonfly. We encounter a flock of 30–50 grackles in the woods. No crops here of beechnuts. Buttercups are good this year. Burdock in flower and bur.

Chanterelle grounds, near old beaver pond. Chanterelles, several hun-dred. Like walking into a glade of gold plates scattered over the ground. We eat them, sell them, give them away, and freeze them. Always welcome; always delicious.

July 25 ('99). 8:30 AM. My field. Sitting on path. Sun again. Generally very quiet except the backdrop of crickets, the ones which have long sustained *churrrrs* with short breaks and blend into a gentle background hum.

New baby toads about. 1:00 PM. Size of my little fingernail. The narrow mowed path through the old field to Lucy and Bill's house is perfect for their hunting, and close to cover. Time to stop mowing it. So many different color phases, from dark to light to mottled. I lose count (50 or 60 between house and J & R's pond) before I reach the power line! Are they concentrated on the path? Do they have predators? A great many would be killed by mowing as they hide in the grass of the path, often at cut level.

July 26 ('99). Female or immature hummingbird has joined the male using our hummingbird feeder. And hummingbird wars have started!

July 27 ('99). Waitsfield, Vt. Staghorn sumac red and prime for switchel now (for recipe see p. 169). Spirea blooming in the meadows. Cattails brown since we returned from Scotland.

July 30 ('98). Bouncing bet, wild clematis, and black-eyed susans at height of bloom. Today the chicory has held all day. Joe-pye weed going strong, with accompanying butterflies. Butter-and-eggs and goldenrod. A few pockets of milkweed still left. I experience milkweed "fragrance withdrawal" and sniff around looking for good smells: some orange hawkweed re-blooming, also buttercup, some goldenrods are sweet . . . bees seem to think so.

Driving with car windows down we hear the voices of kingbirds every few miles, it seems. Much chattering back and forth as the young gain independence and the family groups enjoy their last few weeks before the long migration to the Amazon basin.

At mushroom grove, black-billed cuckoo sings loudly in scrubby area on Norma's property (old bee site). Pick lots of chanterelles.

July 31 ('98). Jamie Cope says, "Goldenrod and Queen Anne's lace bring in fall—it's a long gentle process."

7.22
The milkweed presents a shrivled flower mass, but looking carefully I see the 1 or 2 tiny or "nasent" I like that because they ARE new-born- PODS.

TODAY FEELS LIKE THE DAY THAT SUMMER TURNED!

The horizon, of course, is much lighter than this, and a warm tint.

grasses ripening, heading up. Second buttercups here + there; the fields taking on a new range of colour with the green. Things inside me quiet enough to be able to feel the small shift marking this day as special for me, special - a balancing point in summer just barely tipped toward fall.

7:23. Ant Hill #2, on mailbox path. Same ants, same behavior observed. The hill is soft + fluffy as I make a small shallow test hole - Again no ants come out until I breath on the hole gently from 10 inches away, and they all come running out! Again, as always hill is cleared of tall weeds or grass 4 ft. all around. Spent day walking up Densmore Mt. in a beautiful summer downpour! With Rita, Jean, Ann W. and Rachael W. Much moose browse and bare spots on ground just under ridge - some ice damage too! Stinging nettle/shad still red.

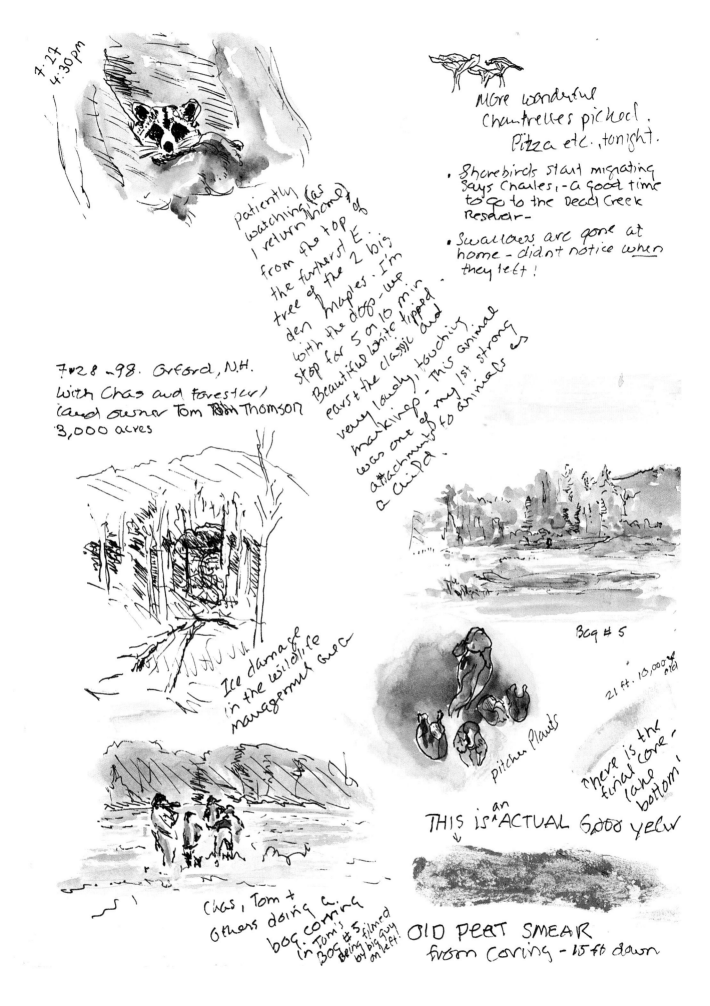

7.27
4:30pm

More wonderful
chanterelles picked.
Pizza etc., tonight.

- Shorebirds start migrating
Says Charles, - a good time
to go to the Dead Creek
Reservoir -

- Swallows are gone at
home - didn't notice when
they left!

patiently
watching (as
I return home)
from the top of
the furthest E.
tree of the 2 big
den maples. I'm
with the dog - we
step for 5 or 10 min.
Beautiful white tipped
ears + the classic and
very lovely, touching
markings - This animal
was one of my 1st strong
attachments to animals as
a child.

7·28 ~98. Greford, N.H.
With Chas and forester/
land owner Tom Tom Thomson
3,000 acres

Ice damage
in the wildlife
management area

Bog # 5

21 ft. 13,000 old

there is the
final core -
lake bottom!

Pitcher Plants

THIS IS an ACTUAL 5000 yr.
↓

OLD PEAT SMEAR
from coring - 15 ft. down

Chas, Tom +
Others doing a
bog coring
in Tom's
Bog # 5
Being filmed
by big guy
on left!

Expressions and Intentions
Communication

*I*n *spring I'm most aware of it,* mostly because of birds. My mornings are full of their announcements and activities: voices rich and lucid, gestures of ritualistic movement, other sounds their bodies make, their touching one another. The male cardinal sings to warn other males away from the place it hopes to bring a mate. The flash of red from the redwing's shoulders, aimed like a shield at other intruding competitors. The distant sputtering of a grouse's wings beaten furiously against the air. The goldeneye tossing its head back as it swims around a female. The new robe of feathers adorning the goldfinch. The peck of a raven's beak upon the neck of its mate.

We animals have many ways to let one another know how we feel or what we think, to reveal identity or intention, to get what we desire and shun what we don't, to keep our groups together. Sometimes it is with a voice or other sound production—a chirp, a buzz, a click, a scream, a booming drum. Sometimes it is with visual signals: colors, expressions on the face, gestures, posture of shoulders and stance. Sometimes it is by a scent or taste. Sometimes by merest touch or faint electrical impulse. Sometimes, perhaps, by means beyond ordinary perceptions or present understanding. Even the absence of any of these sends a message. There is meaning in silence and stillness.

For communication to happen there must be both a sender and a receiver of mutually understood signals. Further, some scientists add, the sender must have an intention in the sending that influences the behavior of the receiver (which raises the deeper question of how we ascertain, for sure, that any creature—sometimes even ourselves—intends anything).

The merest and most majestic of beings communicate, from microscopic protozoans to gigantic whales, for a variety of similar purposes.

One purpose may be to allow individuals to recognize their own kind, to bring them together when dispersed, wandering, or lost in a vast and confusing environment. The usually solitary single cell of a slime mold, that creature somewhere in the midst of evolution from plant to animal, will emit a chemical attractant to other cells, drawing them together in aggregations for reproduction. Immobile adult barnacles, their conical shells cemented to rocks or pilings, will send messages by chemical scent, or perhaps by clicking sounds, to free-swimming larval barnacles, attracting them to colonize the same locale. Schooling fish keep together by visual contact and possibly through commonly recognized chemicals. Flocking birds also depend on seeing one another to stay together, but, like geese and warblers migrating at night, also keep in contact by voice. Honeybees acquire the distinctive odor of their own hive; bees from another hive will not be accepted unless they first acquire the odor (this is demonstrated by placing the alien bee in a protective cage within the hive).

This function of keeping together may also occur between species that are mutually dependent. Aphid-tending ants, for example, with their forelegs continuously stroke their charges, an act that presumably not only stimulates the aphids to produce the desired honeydew but also keeps the "herds" together and more safely under their guardians' protection.

Rather than bringing or keeping individuals together, a communication might have the opposite effect, keeping them apart, ensuring spatial separation. Often this function is associated with a male of a species claiming, establishing, or defending territory against other males. This is accomplished in one of several ways, visually (ritualized fighting, aggressive displaying of feathers by birds, flashing of eyes by spiders, fanning of wings by butterflies, the belligerent postures or facial expressions of mammals), vocally (screeching, bellowing, buzzing), by olfaction (boundaries marked by scent, warning scents in the air), or sometimes even by feel (actual body contact in fighting).

Much communication has a social function—information passing within a group ultimately benefits the group as a whole. Sometimes it is an alarm of imminent danger. Bees will warn each other by increased agitation and loud buzzing. Ants will issue scents that alert others in the colony. Flocks of crows will surround an enemy owl and give raucous "mobbing" calls, while many songbirds will chip to one another when a predator is near. Fish produce an alarm chemical that warns members of their school. White-tailed deer flip their

tails up, showing others of their group the white rump patch. Moose walk stiff-legged when especially vigilant.

Sometimes the absence of a signal serves as alarm. Many insects, birds, and mammals will "freeze" to avoid detection, a visual clue readily picked up by others in the group. Grasshoppers normally give short clicks as they prepare to jump, which notifies others of their impending move; however, if a potential predator approaches, they will jump without clicking, thus passing information through this "negative" message. Some flocking birds have a similar system—short chuckles or clicks telling of their impending departure under normal circumstances, but none when leaving because of danger.

The alarm, more accurately called a warning, might go not to members of a group but to those who might threaten it or intrude from the outside. The result is perhaps the same: the social group remains intact, or individuals within it stay safe. The castanet-like rattle of the timber rattlesnake, the snarl and raised hackles of a coyote, the acrid scent of a skunk, the high whine of a wasp are all examples of active warnings. More passive are the spines of tussock moths and the brilliant orange of monarch butterflies, warning of poison to would-be predators.

When danger turns suddenly into actual attack or distress, the signals change accordingly; sounds become more strident or aggrieved, odors different or more pungent, displays more vigorous and dramatic.

Many animals inform one another of discovered food—turkey vultures and herring gulls will do it in the way they fly, crows by calls, coyotes by howls, ants by scent trails. But perhaps the most famous and fascinating is the "language" honeybees use to communicate such information, first interpreted by Nobel laureate Karl von Frisch. He found that a scout bee, upon returning from a food-finding mission, would inform her hive mates not only that she had indeed discovered food but the distance and direction from the hive, and its quality. These messages are all carried in the movements of the scout: up within the hive means toward the sun, down means away, and in between corresponds to angle; her walking straight means the source is less than 275 yards away, an

inscribed semicircle means between 275 and 1,000 yards; the vigor of abdomen wiggling corresponds to the quality of the nectar trove.

Much communication, of course, is about sex—finding, attracting, securing, and appropriating a mate, and the mating act itself. This accounts for much of the song, sound, color, scent, and movement of our New England springs and summers.

Finding a mate is the first necessity, so sounds of various kinds are often the most effective means, readily perceived over great distances, over and around intervening vegetation or topography. Most vocal, surely, are the birds, their songs coming from the canopies of trees, the grasses and shrubs of meadows, the waterways and wetlands. But insects by the score, mostly in summer, are a noisy lot too. Grasshoppers rub hind legs against wing covers to produce a rasping call, crickets and katydids their chirpy buzzes with just the wing covers, cicadas a thrumming whir as they rapidly vibrate large drumlike membranes (tymbals) on their bodies. The wings of female mosquitoes hum. Amphibians, too, add to the chorus in the nights of spring: the clucks and quacks of wood frogs, ringing peeps of spring peepers, trilling of toads and treefrogs.

Other sounds, too high, too low, too away, too submerged for our ears to detect unaided, are passing back and forth nonetheless. Stoneflies drum with their front feet, puffers and cod at the ocean bottom give a grinding grunt, porpoises and whales emit eerie booms, clicks, and other noises. (Perhaps the greatest long-distance communication is by baleen whales, literally across oceans. According to some experts, a finback can detect long-wave sounds of another finback 3,000 miles away!)

Chemical scents, produced by either males or females, are also effective over long distances, though they are generally less omnidirectional than sound, and more affected by wind and rain. Male moths, for example, can detect infinitesimally small amounts of pheromones issued by females miles away. Equally potent on a microscopic scale are the chemical attractants put forth by many protozoans. The musk of many mammals—males of deer, of canids and felids, of the weasel family, of shrews, and others—also serves this similar purpose, in addition to delineating territory, by its deposition on the ground, rocks, saplings, or other marking posts. Even spiders give their scent, either in the web itself or, for those species that do not spin webs, through strands of silk dragged across the ground.

Electricity can even play the role. In addition to using their other senses, certain fish will also stay in touch by weak electrical currents they send through water.

If distances between individuals are not a barrier, or where finding a mate

is not so difficult, or when the attention of that potential mate has been drawn, displays and other gestures designed to catch the eye are often the means of attracting the opposite sex and cementing the bond. Birds flit around, fan tails, raise crests, puff up, preen, toss back heads, dance, skitter over the water, bring gifts in their beaks, or show off dazzling plumage. Dragonflies hover and flash their iridescent wings at close range. Butterflies such as spring azures and mustard whites spiral up in the air, flair the wings, then slap them against the body. Or the displays might be more passive, inherent rather in the attractive colors of skin, fur, or feathers.

Even in the dark or near dark the visual signaling continues. Male fireflies blink their phosphorescent codes to flightless females waiting in the grass below, who give a coded responding signal. Strange and grotesque deep-ocean fish, living in the abyssal dark, carry lighted appendages, lanterns as it were, to beckon and guide their large-eyed prospective mates. Squids and octopuses, those mollusks with keen eyes, can change skin color and patterning with split-second rapidity.

Once together and bonded, the pair's attention then focuses on each other.

In preparation for conjugation, the communication between mates becomes more intimate, often conveyed by touching, though not always in what appears to us to be soothing manner. Insects stroke or bite, amphibians rub, mammals nuzzle or nudge, birds peck. These actions bring the pairs (or in some cases groups) to readiness at the same time, ensuring union of egg and sperm during copulation. Even organisms incapable of coming together for mating (such as marine mussels, tunicates, oysters, and others) often—if not always —have a mechanism for such synchronization. The eggs, if those are the first released, produce a chemical in the water that seems to trigger the release of sperm by the males. Or, conversely, if sperm are released first, they carry a chemical signal for the female to release her eggs.

Once mating is over, the communications turn more outward again,

toward caring for the vulnerable new generation, whether that involves brooding the eggs or tending the helpless young, protecting the progeny or the other tending parent, feeding or being fed, or instructing the growing young in the ways of survival. In situations where the young are more exposed and at some risk of discovery by predators, communication within the family group is quiet, somewhat secretive, as among many terrestrial, open-dwelling birds. However, where being obscure is not a possibility (oceanic colonial birds) and/or where there is safety in numbers (hornets and honeybees), the nurseries can be noisy places indeed, filled with the sounds of busy parents responding to demanding young.

But sometimes the absence of a signal—voice, movement, chemical, or other—carries important meaning. A baby bird lets the parent know it has had enough food when it no longer peeps or gapes. A fawn carries no scent of deer that would alert a predator to its presence; it will also freeze when so warned by its mother. A certain chemical, or chemicals, produced by the queen honeybee in the hive, abstractly called "queen substance," prevents development of ovaries in the workers. If the queen is removed, the queen substance goes with her, and some workers do develop ovaries, becoming potential replacement queens.

We clearly recognize communication in animals, for we notice the signals. But what about the other sharers of our earth? Does it take an eye to see, an ear to hear, a nose to smell, a nerve to feel, to call it all communication? There surely are other ways, other interpretations, of bringing beings together or keeping them apart. Even with the more exclusive definition of communication as "a signal given by one individual, received or incorporated by another, with both intention on the part of the sender and influencing the behavior of the receiver," I can imagine greater possibilities.

A flower blossoms and perfumes the air, drawing in bees, offering nectar; in return it receives its own pollination. Perhaps the flower in its petalled showiness and sweetening scent tells the bee something, and the bee responds, and then the flower responds in turn by ceasing. We could ascribe intention to both their actions.

Sugar maples all seem to know that one particular year, and none of the previous five or six, is the time to flood springtime hills with a yellow ocean of their flowers. Maybe the earth tells them something we don't know or can't interpret. Maybe the maples are answering.

The nettle and poison ivy might be warning us to be careful when ap-

proaching, and we have learned from our parents or by our own pain to leave them alone at certain times or in certain places.

And what about the trees that, when attacked by insects, produce a substance that lets neighboring trees know, who then in turn produce a repellent substance to protect themselves against those very insects?

To say in any of these cases that the plant's signaling and sensing functions are merely coded in the genes, or the plant is merely giving a mechanical response to a stimulus, is not enough of an explanation for me. The same could be said for all the organs and behaviors animals employ in their so-called communications.

I wonder. Could it be the earth guides a goose north in its migration or offers its scents of homeland to a lost dog? Could the earth itself have intention? If so, what benefit would it possibly get back from goose or dog?

Perhaps, I muse, just their presence. Perhaps it needs them as much as they it. For what would the tundra be without its caribou or snowy owl, the river without its trout or mussel, the forest without a bird? It might just be that the earth in all its ways is communicating, and we, partners in this experience, can decipher its messages with all our senses. Has the earth evolved its own language to bring along its creatures?

The heavy mustiness of estuary mud at low tide, the sight of Katahdin in moonlight, the mists between the branches of a fir on an April morning. These tell me something far beyond my own language, something deeper than my words portray. It is a kind of communication, but not necessarily one-way. Maybe the earth gets back from me in the way of love and affection or some necessary attention, as a flower does a butterfly or the butterfly a flower.

We listen, we watch, we speak, we touch. We pay attention. It's how we get along as a world.

AUGUST

Aug 1 ('97). Butler's field. Late-fledged bobolink flock moving about in the far corner, with a few redwing blackbirds.

Aug 1 ('99). 9:30 AM. (Yellow) spotted salamander pool is down a full 75%. Toad wogs and salamander larvae touching surface for air every few seconds. Still about 10" of water in pool. Salamanders 1½–2" long.

10:45. Pollywog Blowout: shorebirds passing through—a solitary sandpiper.

Pick chanterelles, a few not yet dried from the heat. See bear sign by old farm dump: a rotten stump clawed apart and rubbed against.

Colchester. Monarch butterfly on Trabulsy's meadow. Blackberries starting here. Still some raspberries. Not a lot of butterflies around—why? Elderberries (black) forming, some flowers remaining. Many swallows on the lines. The birds are molting—the chickadees and blue jays look frightful. Mallards have lost their color. Finding feathers—from the molt? Still a couple of milkweed flowers here and there—enjoy the staggering sweetness while it lasts. 4:00 PM, on way home see a white admiral.

Aug 2 ('98). Mansfield Trout Club, Moscow, Vt. Climb up the pointed mountain to the Green Mountain Trail. At around 2,000' looks like a gardener has been working the landscape for a few thousand years.

Mountain-ash berries (a favorite of thrushes in migration) are green but plentiful on tree which is down over trail. Don't see them up above as they are obscured and camouflaged by leaves.

Switchel: about 8 sumac heads bruised in a half gallon of cold water till the water turns rose-colored—use hands or potato masher; strain; sweeten to taste. Voilà, a high vitamin, local, environmentally sound alternative to lemonade and all those processed punches, juices, etc. We add mint to the jug or glasses. Available July–August. On the farms where many hands did the hot job of haying—always in the sun—switchel was popular and was sweetened with what was on hand—maple syrup, honey, or molasses. Later, sugar was used. But in earlier days lemons were of course not available, were expensive and/or not as good nor as pretty, according to my sources.

Aug 2. Cooler! Sunny. No Rain. This 2 inch wood frog jumps out of the green beans as I'm picking, and sits awhile — The color of females in spring — A lovely animal.

from
+ up

young phoebes have a more beautiful light on them always!

Even it's overcast. 8.4. Am. Deck.

this is a more accurate posture.

Seems to be a joint here.
Now! —

an especial mess - look and rolled and tumbled.

PM - Flock of Grackles in woods c̄ several fledged dependents.

9:00 pm - Call from Cathy Rico - Bear crossed road around noon along the same corridor as July 1. Cathy worried about her horses and grandchildren.

• The chickadees + nuthatches seem to be molting; the pileated woodpecker is back working in our woods + called once this am
• Coyotes calling from below the house last pm
• Evening primrose blooming since we returned from Scotland-

4:45 Aug 3. Walk for a couple hours without sketchbook or other stuff. Saw so many insects and berries and felt happy to be out in a different way. —

Golden Guide to spiders and their kin.

ARGIOPES?

Hanging this way

upside-down

front legs actually straight

some sort of striking pattern

Big tan spider in leaf hanging in web - colorful legs but can't recall how they were colored + ARANEUS?

Joe Pie Weed and monarchs

flying flying 2 competing for territory

classic web containing a fine ZIG-ZAG of silk

All from memory

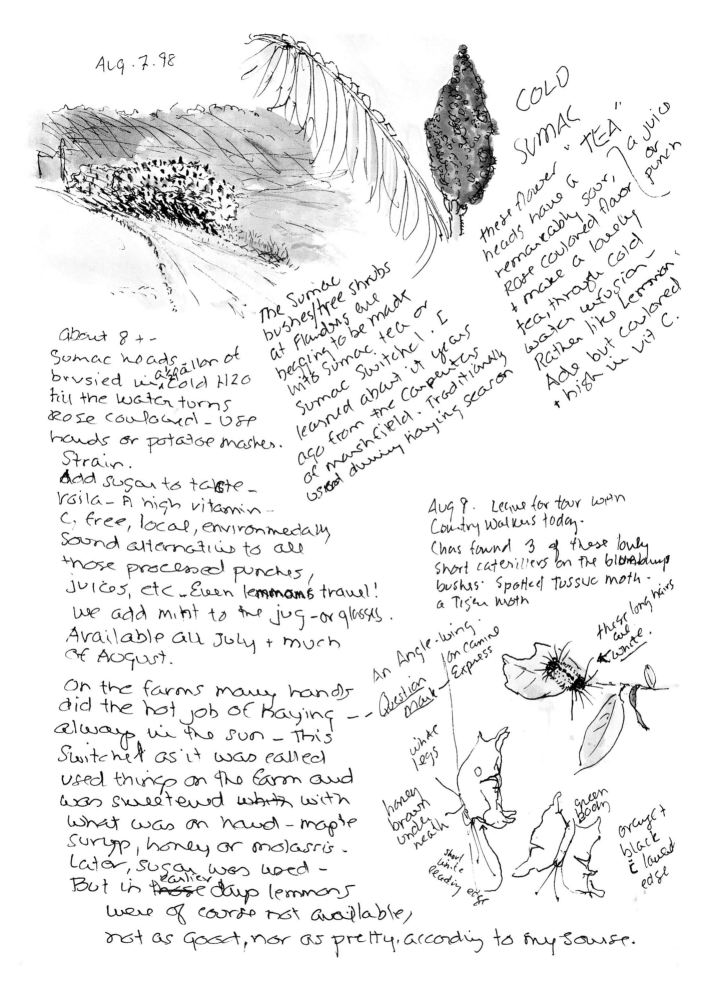

Aug. 7. 98

COLD
SUMAC

these flower "TEA"
heads have a
remarkably sour,
Rose coloured flavor
+ make a lovely
tea, through cold
water infusion —
Rather like Lemmon-
Ade but coloured
+ high in Vit C.

a juice
or
punch

The Sumac
bushes/tree shrubs
at Flanders are
begging to be made
into Sumac tea or
Sumac Switchel. I
learned about it years
ago from the Carpenters
of Marshfield. Traditionally
used during haying season

About 8 +-
Sumac heads
brusied in a½gallon of
Cold H2O
till the water turns
Rose coloured - use
hands or potatoe masher.
Strain.
Add sugar to taste -
Voila - A high vitamin -
C, free, local, environmedally
Sound alternatiue to all
those processed punches,
juices, etc. Even lemmons travel!
We add mint to the jug - or glasses.
Available all July + much
of August.

On the farms many hands
did the hot job of haying —
always in the sun — This
Switchel as it was called
used things on the farm and
was sweetend with with
what was on hand - maple
Surupp, honey or molassis.
Later, sugar was used -
But in earlier those days lemmons
were of course not available,
not as good, nor as pretty, according to my source.

Aug 8. Leave for tour with
Country Walkers today.
Chas found 3 of these lovely
short caterillers on the blueberry
bushes: Spotted Tussuc moth -
a Tiger moth

these long hairs
are white.

An Angle-wing:
Question mark or Comma
Express

white
legs

honey
brown
under
neath

short
white
Leading
edge

green
body

orange +
black
E laured
edge

Aug 4 ('98). 4–5:30 PM. Grouse, deer, coming in for the bumper crop of ripening apples. Deer in yard, grouse in apple tree at end of moss path. Flat-topped asters blooming this last week. Blackberries one-third ripe; two-thirds red—unripe. Blueberries for dessert tonight. Hermit thrush singing; black-throated green feeding noisy young. Find one of those 2–3 inch darker spotted puffballs.

Cicadas singing last 1 or 2 weeks on Canine. Baby black-throated greens still *churrp-trilling* for food.

So, so many goldenrods: the vase shaped ones; the finger shaped ones; the narrow-leaved, very fragrant, spicy leaved ones; the many that have not bloomed yet; the wand types in wet places; the zig-zag ones in my woods, blooming now.

In the wet meadow: rice cut-grass—"saw-grass" I call it—Ouch! 2–3' high in places, my legs are torn up by them if I don't wear long pants; as bad as stinging nettle, also now. Turtleheads blooming; the wet meadow is full of it and I pick a bouquet to take home. Joe-pye weed smells like honey, but fainter. Purple fringed orchis of July 19 just finishing the last of its bloom at the top of the spire. Crickets, 3 kinds: constant, low *churps,* high *churps.* The little mint still blooming, other big mint with red stems still growing. Boneset all in fist-like white buds. NOISE! Cars, lawn mowers, planes—all far away, but so noticeable. No butterflies about; where are the monarchs? One crazy red osier dogwood blooming late, in the shade.

Aug 5 ('98). To Berlin Pond. Looking for swallows. Many crickets. The interstate is LOUD. We head down the pond. Finally, on the south end, a flock of 50+ on the wires: some dusty throats (rough-winged) and a lot of barn swallows, a kingbird, but no tree swallows.

Aug 6 ('98). Male scarlet tanager in canopy singing still, in Butler's north end woods, by chanterelle spot. Bryan P. translates this song as "I really love this spot; it's mine and I'm coming back." The bird has probably molted up there to the winter plumage, but I can't see him.

Broad-winged hawk cry calling *pee-wee* from a stationary place on porcupine ridge.

Many earlier flowers; hawkweed, lychnis, buttercup are blooming a second time.

My meadow is full of flowers: sow-thistle all looking brightly to the morning sun, vetch, butter-and-eggs; yarrow has just yellowed up; handsome elecam-

pane blooming—looks like it has been for a week or so; spireas still blooming, etc. etc. and all the early goldenrods.

Aug 8 ('97). Dusk. At beaver pond in PM to watch beavers. A thunder storm comes up and no beavers but 2 young barred owls approach and sit with parents near, on the snags 20' away.

Aug 8 ('98). Sunny. Canine Express. Blackberries starting. Tiny bees and small possible pollinators on goldenrod. Thousands of turtlehead blooming in the fen, beneath the joe-pye weed. Still buds to go on the turtlehead. Joe-pye weed at peak. Blue thistle blooming this last week. Also wild cucumber in spires everywhere. Heal-all in the woods etc., here and there.

Baby barn swallows almost fledged out. 4 of them in this nest at the entrance of Sugarbush Inn, people coming and going. She removes a fecal sac at this last feeding.

Some silky dogwoods still blooming by the water at the pond below the Inn. Highbush cranberry turning red, most though are still orange.

Aug 9 ('97). Tonight beavers slapping and swimming, the owls *screeing* for food, parents nearby. Young flying and snapping their beaks as they follow parents and each other, and most noticeably, the two young endlessly bobbing and circling their heads dramatically while waiting, *screeeeeeing.*

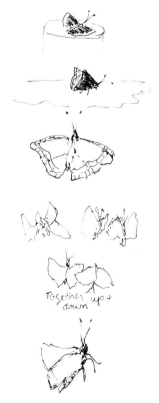

Together up + down

Aug 14 ('98). Home, top of Brazier Rd. Something black ahead causes me to stop—a bear! Bear stops, too, at the side of the class 3 road, only its nose sticking out of bushes. Then slowly onto dirt road. Turns to side and ambles. Ommie barks. Bear walks into hedgerow and disappears into corn field. Young 80 lbs or so.

Aug 15 ('98). Dead Creek Wildlife Refuge. Flowering rush, great blue herons (2), hickory nuts green and ripening, kingbirds, swallows (a few), basswood heavy with seed. Windy . . . leaves of oak silver underneath. Silky or gray dogwood in berry (white). New England aster just starting. Queen Anne's lace. New crops everywhere, of fragrant bedstraw, also yarrow and pinks. A thick carpet of barren strawberry in the south hickory grove, and a fine oak. Bur oak? No, swamp white oak, acorns ripening. These mostly unfamiliar species for me.

Butterflies: lots of coppers, fritillaries, sulphurs, and whites; a viceroy; sulphurs mating.

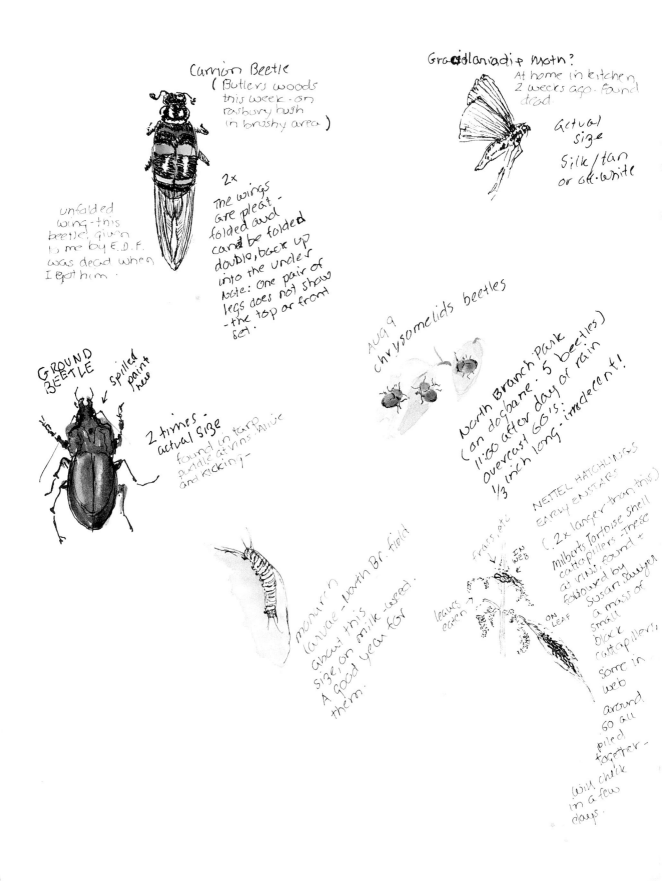

Carrion Beetle
(Butlers woods
this week - on
raxbury bush
(in brushy area)

2x
The wings
are pleat -
folded and
can be folded
double, back up
into the under
bate: one pair of
legs does not show
- the top or front
set.

unfolded
wing - this
beetle, given
to me by E.D.F.
was dead when
I got him.

Gracilariadie moth?
At home in kitchen
2 weeks ago. Found
dead.

actual
size
silk/tan
or off-white

GROUND
BEETLE spilled
 paint
 here

2 times -
actual size
found in tarp
puddle & rain - Alive
and kicking -

Aug 9
chrysomelids beetles

North Branch Park
(on dogbane - 5 beetles)
11:00 after day of rain
overcast 66's - indecent!
1/3 inch long -

monarch
larvae - North Br. field
About this
size, on milk-weed.
A good year for
them.

NETTLE HATCHLINGS
EARLY ENSTARS

(2x larger than this)
Milberts Tortoise Shell
catterpillers - Three
at vine, found +
followed by
Susan Sawyer
a mass of
small
black
catterpillers
some in
web

around
60 all
piled
together -

will check
in a few
days.

parasitic

EN
WEB

leaves
eaten

ON
LEAF

Aug 20
HAWKINS CORN STAND FINALLY GOES UP!

Our Tomatoes are ripe! This after a slow start this spring. Had the 1st one tonight!

Finally! great corn from next door →

Hot fresh Applesauce for desert

Oriole Migration Excitement — 8:00am

— ALL LOCAL DINNER —
Corn on the cob from Hawkins - squash and chard steamed from our garden - tomatoes from the garden and cheese from Cabots in a grilled sandwich on bread with local organic grains by manghis - Salade of dandelions lettuce, sorrel are.

Aug 21 Berlin pond wetland - no swallows left - Some still at Regional Public
8:00 AM Library — But 10-20 Northern Orioles singing, rattle-call + song, and
males chasing each other - females flitting more discreetly - flashing orange.
Migration staging ground ?? or stopover? The energy is very high here, in any case.

Fall webworms in the cherries.

Berries: dogwood—white green; grapes!; honeysuckle—red; prickly ash—tiny red on prickly stem; arrowwood—small green, not black yet; buckthorn—black, right on stem; red-osier dogwood—green to blue–deep Prussian blue green; buttonbush—in fruit, leaves in whorls of three.

Burs: burdock, wild licorice, motherwort.

New plants for me: fragrant sumac, seneca snakeroot.

Aug 16 ('98). E. Montpelier. Suddenly this AM we are surrounded by black-billed cuckoos—two birds singing east and west of us, only some yards away. I spend time trying to locate one in my side field—no luck. Their habits remain a secret, but we hope they have come to dine on the fall webworms, which are not terribly plentiful this year—perhaps the reason we didn't hear them much this summer. Charles hears one at 10 PM as we head to bed.

Feels like the last chance to enjoy the summer leaves—poplars frayed, rattling, a lovely green sound in the wind; on the ground, shifting light and shadows.

Aug 16 ('99). AM. Spider webs in field below Connor's "gone" within 15 min after fog lifts and sun dries dew on strands. Before that I check webs with Lucy P. and we find the yellow and black zig-zag garden spider and several other kinds.

12:00. View from Norma's deck, over fields. Monarchs and viceroys out on sunny day, crickets galore.

Cedar waxwings at edge of newly cut hayfield, foraging out to hawk insects and pick up tid-bits in the cut grass.

Aug 17 ('98). In early summer the red squirrels left the house and disappeared into the woods. We rarely see them now. At night, though, a flying squirrel comes down to the feeder. The chipmunks are a welcome change from the red squirrels constant fighting and scolding—they seem extremely compatible, even affectionate, with one another. We're always planning to quit feeding, otherwise the red squirrel population soars as it has under our past free-feed policy.

Zig-zag goldenrod at the top of its spire (blooms from top to bottom), as calico aster starts to bloom in my woods. Doll's-eyes (white baneberry) and red baneberry have set fruit. Arrowwood covered with dark blue berries. Colder, fall in the air.

Aug 17 ('99). With nesting over, our winter flock of chickadees have grad-

ually been assembling. Today they were behaving as a group, seven or so, with a lot of chickadee calling. The tame one that eats out of our hands being part of the flock. Last year's tame one, the very aggressive one, is apparently gone for good. How do these tame birds learn to eat out of the hand? We don't teach them, but there is always at least one that will—the others watch but judge it unsafe. The tame one is a vocal bird, decisive in its movements.

Aug 18 ('98). 8:30 AM. Several days now since the thrushes haven't sung here in the mornings. Six swallows fly over, very high, twittering, headed southwest. Nightshade berries red, asters blooming (purple-stemmed, calico, flat-topped, and others). Turtlehead and joe-pye weed slowing down; the display is less fresh. Turtlehead bloom almost finished, last flowers at top of spire. The fetid smell of stinkhorn this last 10 days on the damp path where we always smell it in August. One year found small red stinkhorns at the edge of the path here.

A fall feeling in the air, clear, but the sky a pale washed-out blue.

Aug 19 ('97). Husks from the nuts of beaked hazelnut shrubs on old log near stream bend E of Pollywog Blowout pond. Cleaned right out! I count the remains of 6 (double) nuts, or 12 filberts. On the ground a yard away, remains of several more scattered about.

2:00 PM. Dragonflies and damselflies. Small blue/clear (familiar bluet?) and large velvet red (ruby meadowhawk?)—spectacular, all sunning and mating. Complementary spots on leading edge of each wing.

3:00 PM. As the light fades they leave, but I see many in the sun over the pond.

Aug 22 ('97). 2 days of rain over. Last night and a week ago there were toads on the road—last night particularly there were many.

Aug 24 ('98). Sunny break midmorning after rain. Harvest in full swing. Everywhere, everything is ripening! Our garden is wild, full of food, every meal reflects it, even breakfast. The cold frame—our fall, spring, and early winter lettuce and spinach planted Aug 8—is packing the 3 × 6 space with tender young greens.

Crabapple (Dolgo) is loaded. We make apple sauce by adding them to the blander early apples, for color and flavor.

3:00 PM. A thunderstorm with wind and a downpour—first from the W, then N, finally E. Wind-driven drops of falling rain, water splashing and dancing on the table, etc., on deck—everywhere there is a solid horizontal surface.

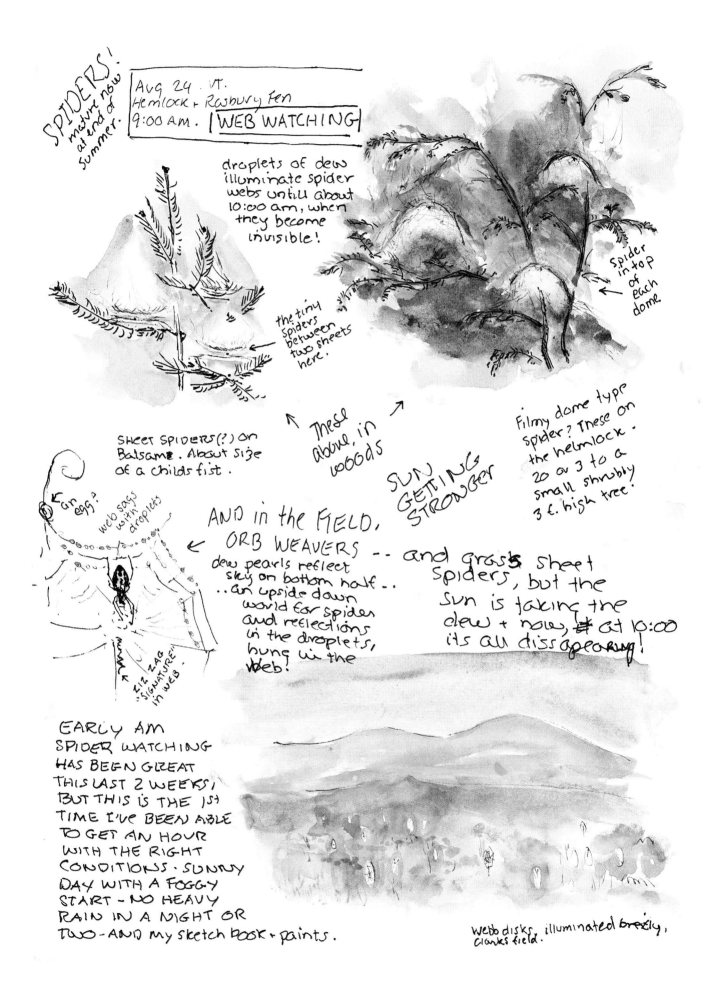

SPIDERS! mature now at end of summer.

Aug 24 · VT.
Hemlock + Roxbury Fen
9:00 AM. | WEB WATCHING |

droplets of dew illuminate spider webs until about 10:00 am, when they become invisible!

the tiny spiders between two sheets here.

spider in top of each dome

SHEET SPIDERS(?) on Balsam. About size of a childs fist.

← an egg?

web sags with droplets

These above, in woods →

Filmy dome type spider? These on the hemlock. 20 or 3 to a small shrubly 3 ft. high tree!

SUN GETTING STRONGER

AND in the FIELD, ORB WEAVERS -- dew pearls reflect sky on bottom half.. ..an upside down world for spider and reflections in the droplets, hung in the web!

"ZIG ZAG SIGNATURE" in web.

and grass sheet spiders, but the sun is taking the dew + now, at 10:00 its all disappearing!

EARLY AM SPIDER WATCHING HAS BEEN GREAT THIS LAST 2 WEEKS, BUT THIS IS THE 1st TIME I'VE BEEN ABLE TO GET AN HOUR WITH THE RIGHT CONDITIONS · SUNNY DAY WITH A FOGGY START - NO HEAVY RAIN IN A NIGHT OR TWO - AND MY sketch book + paints.

Webb disks, illuminated breezy, Clarkes field.

Aug 27

11:30 am

pee weeee!

The high distant call - finally I spot a broad wing - circling overhead. I'm late - this makes me about 10 minutes late -! Gtt -

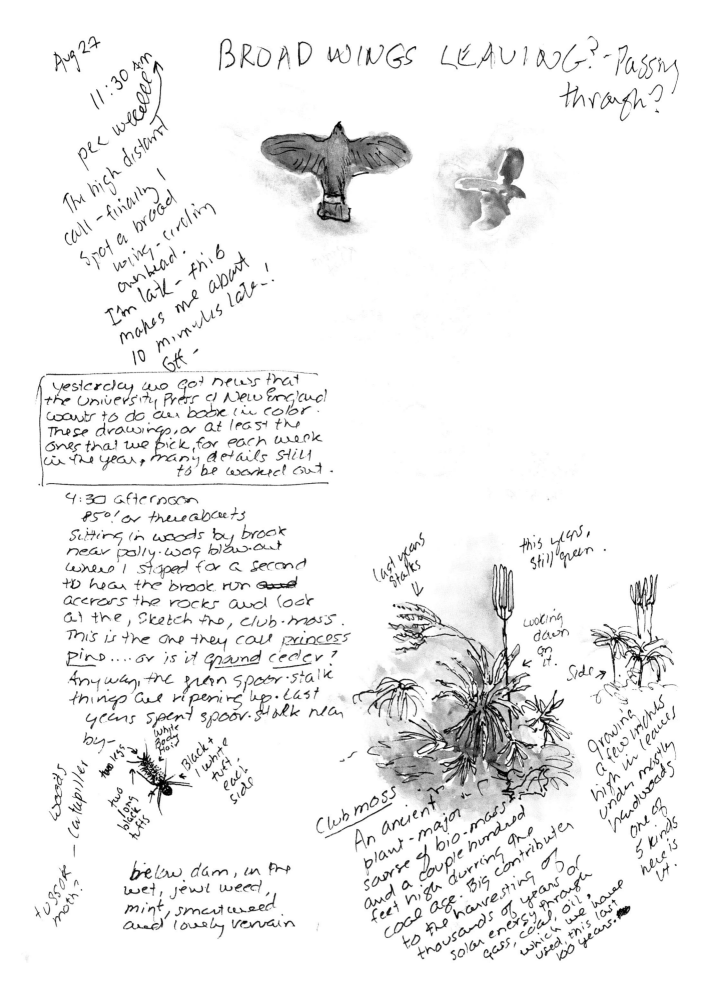

Yesterday we got news that the University Press of New England wants to do our book in color. These drawings, or at least the ones that we pick, for each week in the year, many details still to be worked out.

4:30 afternoon
85°! or thereabouts
Sitting in woods by brook near polly-wog blow-out where I stopped for a second to hear the brook run ~~and~~ accross the rocks and look at the, sketch the, club-moss. This is the one they call princess pine ... or is it ground cedar? Anyway, the green spoor-stalk things are ripening up. Last years spent spoor-stalk near by -

Tussock - Caterpillers
Woods
two legs
two long black tufts
White body hairs
Black + white tuft each side

below dam, in the wet, jewl weed, mint, smartweed and lovely vervain

Last years stalks

this years, still green.

looking down on it.

side

growing a few inches high in leaves under mostly hardwoods one of 5 kinds here is it.

Clubmoss

An ancient plant - major source of bio-mass and a couple hundred feet high durring the coal age. Big contributer to the harvesting of thousands of years of solar energy through gass, coal, oil, which we have used this last 100 years.

The drops are so large you can see them streaking down to the surfaces where small shimmering explosions an inch or two high mark each landing.

Aug 25 ('98). Berlin Pond, S end. Two broad-winged hawks riding thermals up for about 25 min. around the S end of pond and above the ridge. One behaves like a mate or young, interacting with the other in air, with near or actual contact, then out of sight. Are they leaving?

Heard: redwings, woodpeckers, catbird, *pee weeeee* (broad-winged hawk), lots of cedar waxwings, one peeper, mallards. Being a woodland person most of my life, ducks are exotic creatures to me, rather like drawing a rhino or a zebra at the zoo.

The ridge above the pond has been logged in a clear-cut or near clear-cut manner; about 90% or more of canopy gone, sticks left standing.

The wind is blowing, the trees all react differently to it. Quaking aspen leaves with shimmering surfaces, white underneath, the willows a quieter gray. Later in day, more storms and a double rainbow!

Grasshoppers and crickets everywhere. A dragonfly skims by.

The fields, except where recently mowed or grazed, are yellow. Bumble-bees still in the jewelweed. Tractors out turning over hay.

A pair of kestrels whirl in. They remind me somehow of bats this time.

Big clouds heaping up in the N. The sky is many colors of blue, top to bottom.

Aug 26 ('97). Flowering vines. Old man's beard (wild clematis) gone to seed heads on lower road. Wild cucumber still flowering in its upright spires all over the vine's green mantle.

Evening. Smells—apples!, dried grasses. After rains—moles cleaning out their tunnels, dirt heaped up on the mailbox path; mounds 1" high. Milkweed pods big (several inches long) and their leaves turning yellow. Some goldenrod past now, others in full bloom. Carpets of butter-and-eggs in my upper field. Flocks of robins (hundreds) over Montpelier this evening. A largish hawk in the field—Cooper's?—as I return home. Bull thistle and white lettuce gone to fuzzy white seed, with only a few flowers left. Goldenrod galls . . . the first I've seen. Last year's old galls still visible. Deep scarlet leaves here and there on the fire cherry. Tansy past full bloom—still some fresh heads opening. Tall flat-topped aster still blooming, creates a Victorian look wherever. Burdock seeds ripening. The sun has set, great clouds west and east especially, shades of gold, pinks, and oranges, also a warm soft white, thunderhead tops especially. Veery

sounding alarm call. Black-eyed susans, St. Johnswort, evening primrose pretty well gone.

Aug 27 ('98). 7:30 AM. Thick fog, warm, on deck. Hummingbirds fill the morning with the usual fall tiny bird battles, play and practice courting. After the quietest hummingbird summer here (20 years) and worry about why we had only one lone male, the yard is full of activity, squeaks, dives and all the familiar activities. A dominant male tries to keep young, female, and another mature male in order, and the immatures go wild with every hummingbird antic known to exist. They attack the dogs, us, other birds, etc.

Milkweed leaves just start to tinge yellow around the edges and apples are beginning to turn red.

Chanterelles are still coming up in the woods.

Occasional calls of warblers and other birds break the silence—migrating? young males? birds leaving? males expressing last territory statements? Redstart singing weakly and infrequently right now.

Chipmunks are bringing their "vacuum cleaners" (loading their cheek pouches) to the bird feeders!

Male porcupines start their nighttime competition vocal battles. Night before last Anna located two by flashlight right outside a window. We read in Stokes that they start fighting in association with mating Sept.–Dec. "Like fighting cat noise, but not the right sounds," Anna says.

Spider webs everywhere in AM. Charlottes' web type orb weavers hanging from grass stems and trees. Sheet webs covering the grass—when did this start? Seems like a couple of weeks ago or more.

Over on the coast, shorebird migration is on and the striped bass are starting to run.

But where are the monarchs?

Veery calling repeatedly out by the arrowwood. Last year they ate all the berries and we had the pleasure of seeing them close to the house.

A soft brown fall warbler alights near me in the jewelweed which is in full bloom, full of bees.

Aug 30 ('98). Fog each morning now, and the spider webs in the grass, on branches, even in the asparagus, illuminated by dew. By 11 AM they become almost invisible, except for the tiny spiders located in the center of a small dome (about the size of a child's fist) between the horizontal sheets.

Later, noon, a shower of seeds comes in on the wind—we don't recognize them at first, then wonder, balsam fir? Yes. A taste easily confirms it—

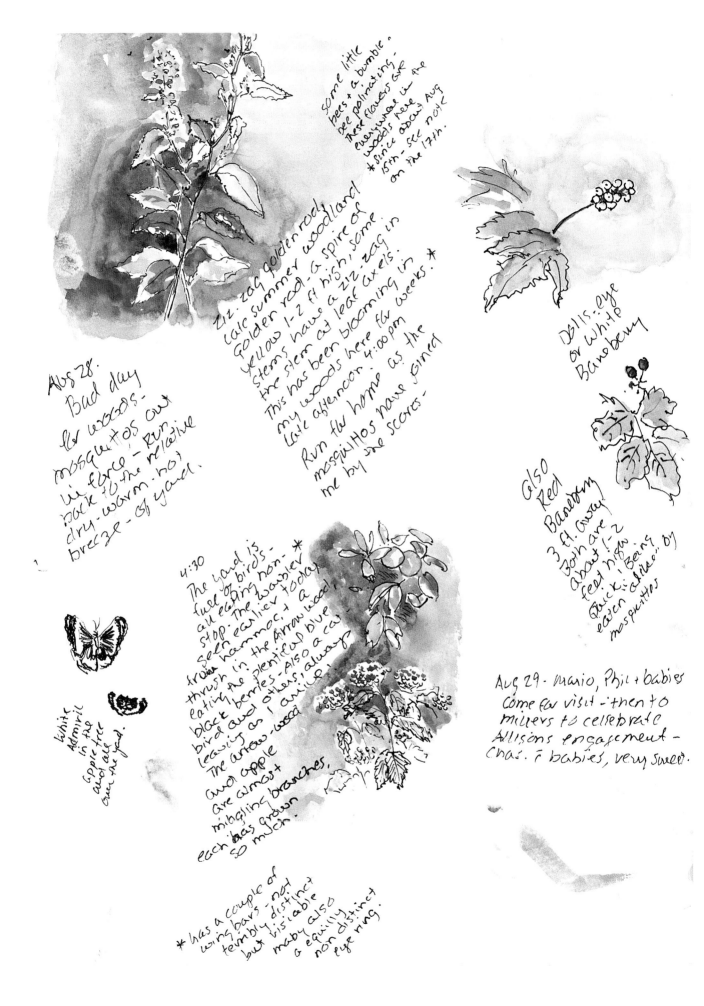

some little bees + a bumble-bee polinating. These flowers are everywhere in the woods here.
* since about Aug 15th - see mark on the 17th.

Zic-zag golden rod.
calc summer woodland Golden rod. a spire of yellow 1-2 ft high, some stems have a zig-zag in the stem at leaf axels.
This has been blooming in my woods here few weeks. *
Late afternoon 4:00pm

Run for home as the mosquitos have joined me by the scores -

Aug 28.
Bad day for woods -
mosquitos out in force - Run back to the relative dry - warm - hot breeze - of yard.

Doll's-eye or white Baneberry

Also Red Baneberry 3 ft away Both are about 1-2 feet high. Quick - being eaten alive by mosquittos

4:30
The yard is full of birds - all eating non-stop. The Warbler seen earlier today.
a Swainson's Thrush in the Arrow-wood, eating the plentiful blue-black berries - Also a cat-bird and others always leaving as I arrive.
The Arrow-wood and apple are almost mingling branches, each has grown so much.

White Admiral in the apple tree and all over the yard.

Aug 29 - Mario, Phil + babies come for visit - then to millers to celebrate Allisons engagement - Chas. + babies, very sweet.

* has a couple of wing bars - not terribly distinct but visiable maby also a equally non-distinct eye ring.

tangy, piney, Christmas blended with pine-nut taste, delicious! Some land on the front door, newly painted and still tacky. The balsam tops are thick with sienna-colored cones, from which small winged seeds continue spiralling down in showers through the afternoon.

3:30 PM. Question mark butterfly on door screen. It's backlit, and we can see where the fore and hind wings overlap—quick sketch using spit and fingers, as can't locate my brush fast enough before this creature flies off. Should mention that when Charles walked into the garden 14 feet away and below it, it suddenly closed its wings and remained so until he left the area. I feel sure they are very aware of us, and on guard. I now remember David Measures telling me this in Scotland.

10:00 PM. Ragweed—been blooming for ages, but I finally get close to giant ragweed at our local gas station. Actually past flowering and setting seed. This is the allergy culprit, not goldenrod—they just happen to bloom at the same time and ragweed is so inconspicuous from a floral point of view—the flowers, the whole plant is gray green—a tall (7') version here, and a 3' high variety seen along the roads.

Aug 31 ('98). Clear day, foggy start. Chipmunk in the arrowwood, harvesting ripe blue berries. Apples falling from the good-for-sauce wild tree behind the arrowwood.

Changes of Life
Metamorphosis

I remember as a child wondering at a chrysalis I found hanging under a leaf—the hard, dark nut within which the mysterious transformation of a caterpillar to butterfly was taking place. I wanted to know what was going on inside, was tempted to cut it open to see. Yet I also felt that I had no right to know, to invade the creature's opaque privacy; here, to me, was a magic act whose secret must be preserved. I wanted to bring it home to watch, in my habitat, what it would become; yet I also wanted to leave it where it was, in its own habitat, not transported to mine for my convenience. In the end, I left the chrysalis where it was, not tampered with.

It was a dilemma that has recurred in one form or another all my life: a curiosity that makes me want to pull things apart to find out the "how" of things, countered (most always) by a desire to leave things alone, unexplored and undisturbed, and let the question stay unanswered. It seems the more I search and find out, the more I want us not to know or not to understand. Mystery, however mild, is part of wonder, and wonder an essential ingredient to feeling.

But something special certainly was going on in there. I had watched the caterpillar prepare its own armored casing, or pupa, with its rigid surface folds (Linnaeus, the famous Swedish naturalist, named it "pupa," meaning "girl" in Latin, in reference to its appearing like a baby wrapped tight in swaddling clothes, as is done in some cultures). Over a period of weeks, immobile, out of sight, it would undergo miraculous change from the lumpy, hairy, and crawling tube into a butterfly that would take to the air on colorful, delicate wings. I have since

learned that the transformation is not simply a matter of the creature growing wings, or new legs, or some other appendage, but a complete rearrangement, both external and internal, of structure and function. Old organs disappear and entirely new ones emerge, some parts dissemble as others assemble. In effect, a different being is made by strange biologic alchemy, and the insect coming out might easily be considered a different species were we not able to see the direct connection.

Metamorphosis literally means "change of form" and can be applied to living things, or a geologic process of rock formation, or any number of other transformations. In the biological context, it more specifically denotes a rather distinct, dramatic, and predictable sequence of change in both form and lifestyle occurring in a creature's development from birth (or hatching) to adulthood.

Metamorphosis has its fullest expression and greatest diversity in insects. When it proceeds through four physically distinct stages—egg, larva, pupa, and adult—the process is called complete metamorphosis (in scientific parlance, "holometabolous development"). Also, the larva and adult of the species, the two feeding stages, live in completely different habitats and eat totally different foods, such as the caterpillar eating leaves of hardwoods in the forest while the butterfly drinks nectar from a field flower. Most people are somewhat familiar with the complete metamorphosis of butterflies and moths but may be less so with flies, mosquitoes, bees, wasps, and beetles, which also experience it. The larvae are called different names—"maggots" in flies, "wrigglers" in midges and mosquitoes, "grubs" in bees and beetles.

Incomplete metamorphosis ("hemimetabolous development") occurs in stoneflies, mayflies, dragonflies, and damselflies, where there are but three distinct stages and habitats: egg, aquatic larva (called "naiad"), and aerial adult. (Incidentally, mayflies are the only insects that molt in the winged, adult stage.)

Gradual metamorphosis ("paurometabolous development") is a process of slow transformation without strongly marked differences in stages along the way. The young, called nymphs, go through many molts (instars), gaining body characteristics as they go, a few at a time. The most striking change occurs in the last instar, when wings appear. Grasshoppers, crickets, locusts, cicadas, aphids, scale insects, whiteflies, and thrips all experience gradual metamorphosis, though with considerable variations on the rather simple theme described here.

(Some insects do not go through any of these changes—gradual, incomplete, or complete metamorphosis—but instead grow from hatching to adult without noticeable changes in structure, only size: from the earliest to the last, the instars are tiny versions of the adults. This is characteristic of the most

primitive insects, including fleas, bristletails, and springtails. The process is called "ametabolous development," analogous to what happens in most birds and mammals.)

While insects exhibit metamorphosis most fully and diversely, they are by no means the only living things that experience it. Other invertebrates certainly do. Rockbound barnacles along the coast spend the early part of their lives as free-swimming, shrimplike individuals, molt into a two-valve form that is still mobile, then finally settle on rocks, shed their legs, grow the conic shell, and spend the rest of their lives glued in place. Many bivalves—mussels, clams, scallops—though more or less sedentary as adults, have swimming larval stages, which in some species attach themselves to the gills of fish and hitch-hike to new regions.

Metamorphosis occurs in a few vertebrates, especially among amphibians. Frogs and toads have their tadpole stage, salamanders their gilled and tail-finned larvae, which may remain in that state for years. Even a few fish meta-morphose—American eels, for example, in their early years in the ocean are rather flat, transparent "glass eels," transforming after migration into rivers and lakes into the more serpentine, dark gray-green, tubular adults.

Even some plants experience what might pass for metamorphosis. Ferns, clubmosses, and horsetails have two separate and distinct life forms that appear to be entirely different species: the larger, more obvious sporophyte (spore-producing plant), and the tiny, altogether differently shaped gametophyte (gamete- [egg and sperm] producing plant). The sporophyte, as the name implies, produces spores, which disperse from the parent and grow into the gametophyte, which, in its turn, produces egg and sperm that unite (from sepa-rate plants) to form another sporophyte.

But consider a greater meaning of metamorphosis, letting it expand be-yond the frame we have squeezed it into. Then it might be more than one being's change of form or structure. Then it might well include that which we can't see so readily, or which takes longer than a generation to complete, or which happens among groups rather than just to individuals.

For example, it might include that which takes place inside a bird's egg or a mammalian womb, after egg and sperm unite—the being metamorphoses through stages that look like fish, then amphibians, then reptiles, until it takes on the form we recognize.

The process of evolution could be a form of it, during which over great stretches of time new species emerge from the old. Or it could be what hap-pens within me, or you, over our lifetimes, not so much the physical changes as those of spirit and perception we experience between birth and death. It

possibly could also be the incremental changes that happen collectively to societies, over many lifetimes. Take ours, for example.

Sometimes it seems to me that we are floundering ever more helplessly in all our technological complexities, losing the nourishing, direct connection to environment and community. Our society no longer seems defined by what it is, but by what is disappearing. Instead of traditions preserved and passed down through generations, we lose them overnight, and celebrate our inventiveness. The land we cherish is bulldozed before our eyes, its skin scraped raw and pushed aside into piles. We sanction loss as progress. We have even come to expect losses: of childhood places, of families, of neighborhoods, of nature itself.

But then, at other times I look with a different eye, in another way. I even have a vague, strange hope, sensed rather than seen, that maybe, just maybe, all this turmoil is leading somewhere, to something better. After all, over decades of writhing, we seem to have become a more humane society in many ways, or at least more aware of the problems we have caused: to others of different color or belief, to women, to children, to nature and the earth's less imperious residents.

We seem to be trying, even if poorly, haltingly, or ponderously at times, to right the wrongs created or inherited. We are appalled by the self-destruction of war, condemn its glorification that blinds us into marching rigidly, without a sideways glance of doubt, into leering, coaxing conflicts. We reflect with horror on the grotesque slaughter of bison, whales, seals, passenger pigeons. Isn't our society, for all its ills and with all its open, festering wounds, more honest than the one of our boyhoods and girlhoods and cloudy remembrances?

So, are we in the throes of ultimate degeneration, or a death-and-rebirth? Are losses just losses, or could they be a stage in our essential metamorphosis?

SEPTEMBER

Sept 2 ('98). Treefrogs in S. Burlington singing in the willows in a heavily residential area. Stokes claims breeding season through August in the north. But where is the water there? Even temporary water will attract them. How old do they live—could these be from before the house was built next door, 10 years? Is this an explanation for the trilling of these frogs in suburbs? Using swimming pools where there had once been small puddles, pools, etc.

Also today, Ellen reports seeing three monarch caterpillars crossing Brazier Road. This in last two weeks or so. She asks why there are so many small, late red efts.

Sept 3 ('98). Cornfield, Brazier Road. Foggy AM again, but no little birds —crows, blue jays. Crickets singing all around us; songs change slightly as sun breaks through. Field cricket a few feet away stops singing. The churp churp ones, the continuous ones, and the background buzz ones keep going, then field cricket starts up again. Chickadees calling. Another beautiful late summer/ early fall day. Apples, mushrooms, wild plums, beans to harvest; wildflowers to enjoy, moments between summer and fall to savor.

2:00, Berlin Pond. *Pink! Pink!* Stop car and watch 2 kingbirds feeding, fattening up on dogwood berries hanging thick and heavy. The berries are beautiful, tinged with green but turning a deeply complex green-blue with wedgewood blue overtones and red stems.

Sept 7 ('98). Rain, 10:30 PM. Thunder and lightning in distance. Flying squirrel in small window feeder. Such large ears and eyes! Allows me to come

up close, even though light is on. Stays for the duration of the storm, eating and sheltering in the feeder on the bedroom window. Its fur is wet, and I remember the baby flying squirrel I raised when I was 12, how soft she was and her coming in the window during storms to sleep in my bed, wet little creature but soon warm and dry next to me.

Sept 9 ('99). Sadly, the old Brazier Road hedgerow was massacred by the road crew in its efforts to prepare for winter—this has never been done in 20 years I've lived here. Not the first time, and it will grow back if left alone.

Home woods. 2:30 PM. Maple-dependent insects:

- Maple leafcutters, sketched on Sept 6.
- Maple trumpet skeletonizer, responsible for the frizzled leaves I've seen. According to Trish at Dept. of Forest & Parks, this critter is in "epidemic proportions" right now. A small moth. Damage is late season, not harming health of tree though to look at them now, just as fall colors are about to start, they seem to be simply dying or hard hit by an early frost—which has not yet happened.

Late today, flocks of phoebes on Brazier Road during my walk. Rain pelting down.

Sept 11 ('98). E. Montpelier, Vt. Top of hill. 4:30 PM. Early fall day. Three waxwings watching me and the rest of the area. High calls. A dove flies by, making the rapid high *whee whee whee whee* sound of the wings.

Hillside colors begin to show the locations of red maple (also bird or fire cherry and sometimes Virginia creeper). Long grass on hills is buff colored; mowed sections green. Many trees now begin to present a transparent look of fragility. The poplar leaves more brittle perhaps, their movement less, color less, with the late afternoon sun giving the look, the smell even, of a whole range of "fall." I'm noticing a floral scent here in the field. It's one of the goldenrods, always a surprise how very sweet and "spring like" it smells . . . but only up rather close. Bumblebees working these flowers.

10:15 PM. 60s. Outside for a few minutes, last night before leaving on my tour tomorrow. Glow worms in the grass, little birds chipping from overhead (migrating birds?). A couple of isolated peepers calling plaintively from the woods. And so to bed.

Sept 11 ('97). Naushon Island, Mass. 2:30 PM. On a walk on path to the

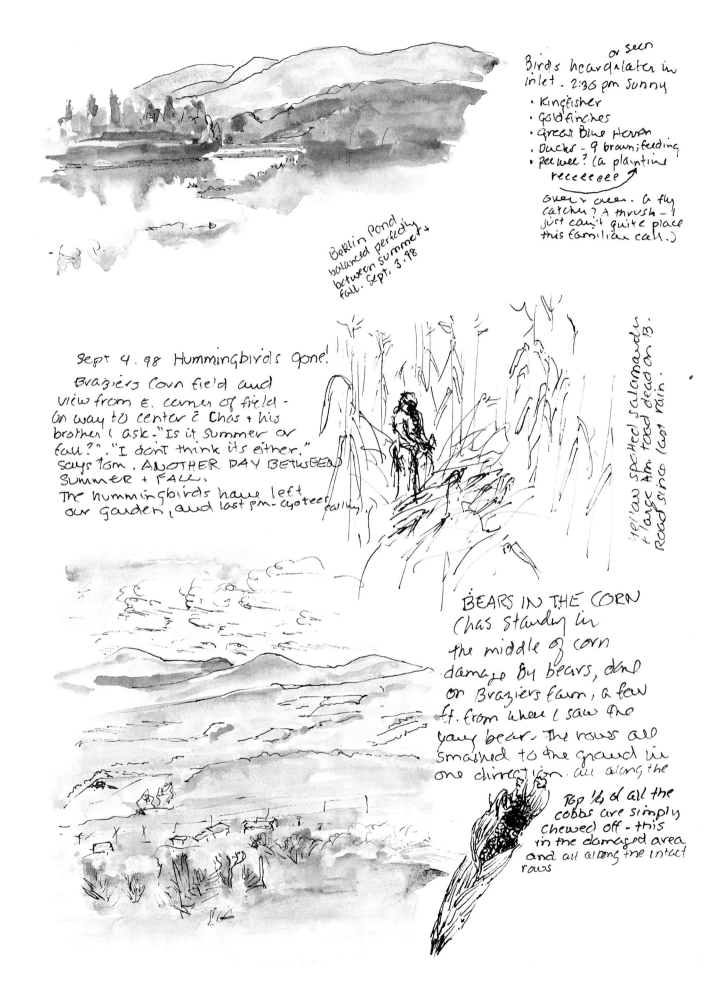

Berlin Pond
balanced perfectly
between summer +
fall. Sept. 3.98

or seen
Birds heard alater in
Inlet. 2:30 pm sunny
· Kingfisher
· Goldfinches
· Great Blue Heron
· Ducks - 9 brown; feeding
· Peewee? (a plaintive
 reeeeeeee →

Over + over. A fly
catcher? A thrush - I
just can't quite place
this familiar call.)

Sept 4. 98 Hummingbirds gone!

Braziers Corn field and
view from E. corner of field -
On way to center 2 Chas + his
brother I ask - "Is it summer or
fall?" . "I don't think it's either."
says Tom. ANOTHER DAY BETWEEN
SUMMER + FALL.
The hummingbirds have left
our garden, and last pm - coyotes calling.)

Yellow spotted salamander
+ large Am. toad dead on 13.
Road since last rain.

BEARS IN THE CORN
Chas standing in
the middle of corn
damage by bears, down
on Braziers farm, a few
ft. from where I saw the
gang bear. The rows all
smashed to the ground in
one direction. all along the

Top 1/3 of all the
cobbs are simply
chewed off - this
in the damaged area
and all along the intact
rows

Sept 5. Cold air came in overnight and suddenly it feels like fall - looks like fall. One of the big maples just E. of the house is friggeling its leaves - no color, just crumpling + drying. Why? The roses (Rugosa) are launching a second bloom these last 10 days - just recent days have reduced the Japanese Beetles;

Asters rule the fields + roadsides - white and purple, with the last goldenrods providing a solid yellow bloom. In a week I start my last 3 weeks of walking tours -- dispersing plums (seed) from back road, this last few days.

MANY ORCHIDS - sm WHITE seen at Sand pit
(sm White) RICKER BASIN HISTORY WALK

Sept 6 Sunny Clear start - a warm day ahead. walk to Brazier farm early. Doves flocking. Touch-me-nots still blooming in the wet spot. Take a picnic breakfast + coffee now being consumed in the cornfield behind the hedgerow. I look around cautiously at unexplained sounds because of the bears. Having Buddy the dog is a worry - alone I would be OK. But would he attack a bear. Maybe. Not a good idea. I hear the Red Shouldered hawk but don't see him/her. Same area - up on top of Brazier - one or 2 calls - Some tiny warbler + finch calls overhead; A peeper peeping. Crickets - 2 kinds. Walking up here, The Highbush Cranberry is in full display.

Two pretty little hover-bees on my leg + around me - very shy of movement; stay right together. One has brown eyes.

MAPLE LEAF CUTTERS
· On the road, I find these under the maples. Actual size.

· Here's the leaf - or a leaf. They are all in stages of being used as an over-wintering (egg? Larva?) structure by these leaf cutter guys. I don't feel like even opening one to look - Another day, I always say. Anyway they are kind of touching to me and on some days in the maple woods the rain down in showers you can see + hear if you tune into small things.

The Cedar Trees - A bright warm orange - mimics turning needles but is actually orange seed pods AND needles changing colors -

Fresh Green Top side (maple leaf circle)
Brown underside (older leaf)
Side view

came from here
came from here - then it moves this piece to upper location gives both together + somehow cuts loose second, greener circle, the whole disk then falling to the forest floor to spend the winter! AMAZING

AND HERE is one JUST STARTING;

little beach we scare up a harrier, where earlier this AM was boiling with tree swallows.

The sky has cleared and neither here, nor on Pasque, nor over the water, is a single swallow. They have gone. And in their place, blue sky, sun, etc. Good fishing weather!

The beach is empty save for a lone snowy egret fishing at the creek outlet/inlet.

Sept 12 ('97). Naushon Island, Mass. 1:00 PM. Tree swallow migration. Another flock of thousands resting in bayberries. Suddenly they are off, circling. They land again, covering every available shrub or branch. No branches show, only birds! Trees are blue and gray or white.

They are here to feed en route south — all east coast tree swallows funnel though this area, so we hear.

2:20 PM. The subtle but distinct sound of the snapping of hundreds of swallow beaks as the birds fly about me feeding on insects. Tails down and spread a bit. Some swooping in air, some feeding by hover-flight at the tops of short grasses. Then on signal (but what?) they are all up! But higher this time and they are off somewhere.

Walking to West Beach we come across a "smallish" flock of 1,000 swallows, with 2,000 or more roosting, resting, not feeding, in the bushes and on the rocks, covering the surfaces. As we approach we see that the entire valley is filled with them! Many thousands. We sit and watch as they land and chitter around us.

Sept 13 ('98). Sugarbush, Vt. Beautiful clear, cool day. Beaver pond behind Sugarbush Inn. 5:40 PM. (Newly active) lodge, small clams along the tiny outlet brook. A quiet mossy spot. Yellow birch leaves turning. Crickets, blue jays. Sound of beaver chewing and once a short *wooo,* a beaver moan. Bunchberries red, an orchid pod (moccasin flower) green and setting seed.

Sarsaparilla changing color to salmon. Silky dogwood leaves a deep maroon — the berries mixed blue-black with a touch of light blue-green. Cattails turning yellow on ends of leaf. Witch hazel just starting to bloom on Mad River path, last year's seed pod set to explode. Little birds flocking/migrating.

Saw a monarch today, flying over the grass at von Trapp farm, my first in Vermont this year. Many, many sulphurs.

Sept 14 ('98). Sugarbush. Sun breaking through mists. 8:00 AM. The maples beside the beaver pond are alive with various warblers. The yellow sunlight

catches their active, incautious feeding, their short chasing flights in the branches. I see this as the first sun hits—have they just come down (from a night of migrating) to feed and rest for the day?

Sept 15–17 ('98). Stowe–Mt. Mansfield area. Some nice chanterelles still on Stowe Spring Rd. Colors blazing with red maple at mid-levels around 1,000 feet? Asters, closed gentian, in full bloom. A few monarchs here and there. Cooper's hawk, peregrine falcon, kestrel. At top of Mt. Mansfield (4393') bilberries, blueberries all reddish-purple. A few of the tiny white ladies' tresses orchids blooming still on Hedgehog Hill at Little River State Park. Also gentian. And ripe black cherries splatter the Stowe Spring Rd.

Sept 18 ('98). Home again. Goldenrod almost finished, mostly dried. Asters! Berlin Pond:

- Sweet gale turning rose-yellow.
- Aquatic smartweed still blooming pink in water.
- Dogwood leaves maroon, berries still turning deep blue from green.
- Winterberry berries huge and light orange red, bright light green leaves on female plant; dark green, no berries of course on male nearby.
- Nannyberries way back in tangle just now turning from red to blue! At home all berries are *long* gone.

Home to red and white admirals on driveway and deck.

Brazier flats. Trees just starting to turn. Late golden sun, maples red and green. Leaves rustling. Flutterings, quiet white-throated sparrow song fragments and chips. A flock of these birds moving mostly through the trees and underbrush. Sat awhile and finally picked up their tiny movements and sounds.

Later in the cedar swamp behind Braziers' I watch a winter wren for 5 minutes.

Back at the woods' edge, so many energetic little birds preparing to leave, fly—warblers and sparrows. They seem excited—flocking or en route? It's stirring to see them for these last times before next spring. I'm saying my farewells—may they travel safely and return to mate and raise successful broods.

Brazier field, 6:00 PM. Crickets, long evening shadows, maples red along road. Corn is burnt sienna in background.

Basswood still very green, leaves in great sulk. A barred owl flies over, big round head, quietly flapping and soaring.

The most beautiful time of day outside. Supper time! A crime against nature to be indoors.

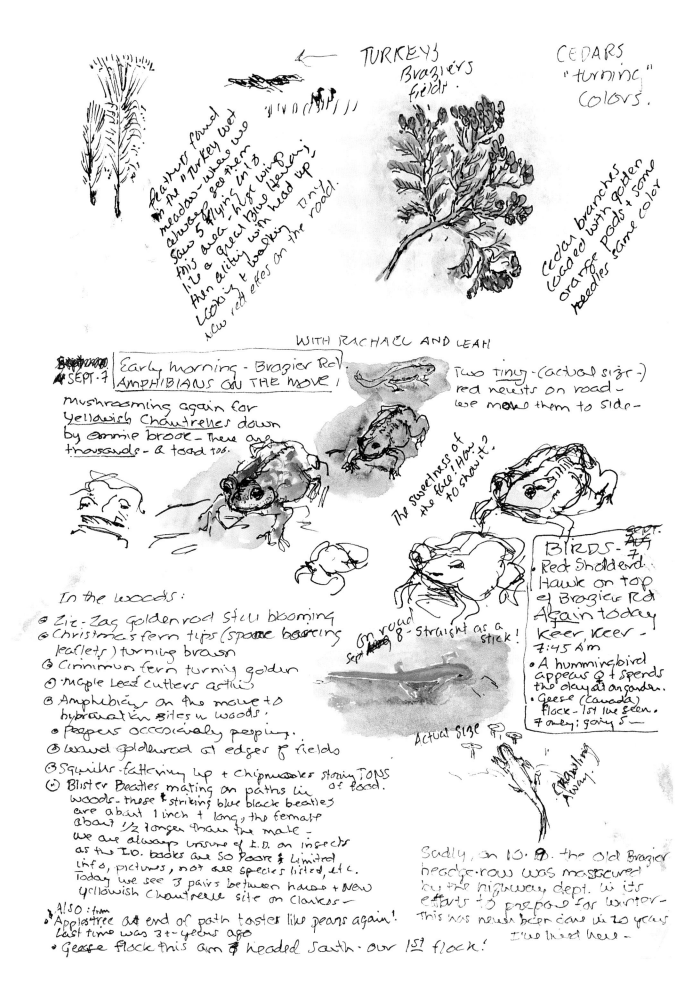

TURKEYS
Braziers
Field.

CEDARS
"turning"
Colors.

Feathers found in the "Turkey wet meadow - where we always see them - between see them - Saw 5 flying in B this area - high wings, like a Great Blue Heron, then lifting with head up. Looking & walking on the road. Tiny.
New red eyes on the road.

Cedar branches loaded with golden orange pods + some needles same color

WITH RACHAEL AND LEAH

SEPT. 7 Early morning - Brazier Rd.
AMPHIBIANS ON THE MOVE!

mushrooming again for Yellowish Chantrelles down by ammie brook - There are thousands - a toad too.

Two tiny - (actual size -) red newts on road - we move them to side -

The sweetness of the face! How to show it?

In the woods:
- Zig-zag Goldenrod still blooming
- Christmas fern tips (spore bearing leaflets) turning brown
- Cinnamon fern turning golden
- Maple leaf cutters active
- Amphibians on the move to hybrenation sites in woods.
- Peepers occasionally peeping.
- broad Goldenrod at edges of fields
- Squirrels fattening up + chipmunks storing TONS of food.
- Blister Beetles mating on paths in woods - these striking blue black beetles are about 1 inch + long, the female about 1/2 longer than the male - we are always unsure of I.D. on insects as the I.D. books are so poor & limited info, pictures, not all species listed, etc. Today we see 3 pairs between house + new yellowish Chantrelle site on Clarkes -

On road Sept 8 - straight as a stick!

Actual size

Crawling away.

BIRDS - SEPT. 7
- Red Sholderd Hawk on top of Brazier Rd. Again today. Keer, Keer - 7:45 AM
- A hummingbird appears & spends the day at our garden.
- Geese (Canada) Flock - 1st I've seen. 7 one; going S -

ALSO: from
- Apple tree at end of path tastes like pears again! Last time was 3+ years ago
- Geese flock this am & headed south - our 1st flock!

Sadly, on 10.9. the old Brazier hedge-row was massacured by the highway dept. in its efforts to prepare for winter - This was never been done in 25 years I've lived here -

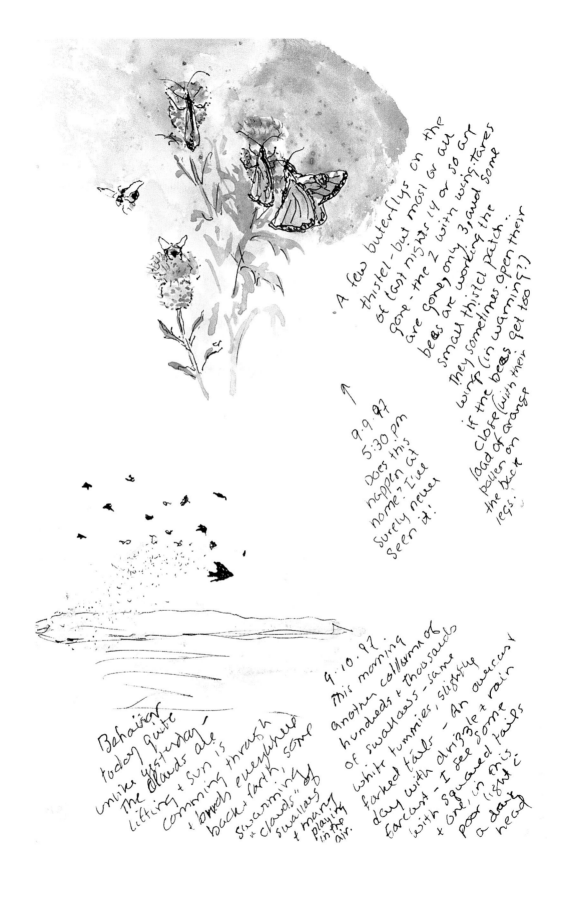

A few buterflys on the thistel - but most or all of last nights 14 or so are gone - the 2 with wing tares are gone; only 3, and some bees are working the small thistcl patch. They sometimes open their wirp (in warming?) if the bees get too close (with their load of orange pollen on the back legs.

9.9.97
5:30 pm
Does this happen at home? I've surely never seen it.

Behaivor today quite unlike yesterday, The clouds are lifting + sun is comming through + brings everywhere back forth, some swarming "clouds" of swallows + many playing in the air.

9.10.97
This morning another collum of hundreds + thousands of swallows - same white tummies, slightly forked tails - An overcast day with drizzle + rain forecast - I see some with squared tails + one in this poor light c a dark head

Sept 21 ('98). By my scheme of an early, a mid, and a late foliage season, it is now EARLY PEAK!

- Asters and some other flowers remaining.
- Cinnamon ferns russet-orange.
- Milkweed a pale bright yellow.
- Ashes just starting to turn salmon.
- Red maples crimson—sugar maples still green.
- The earlier flowers—joe-pye weed, vervain—dried and dark accents.
- White pine and cedar dropping orange and yellow needles.
- Virginia creeper red.

End of day on Brae Loch, Colchester. Many monarch butterflies in the lower meadow just before dark.

Tom's fish

Chas & Tom
meanwhile have
gone out where
the Striped Bass are
"running" and
have brought back
2. A Three & five
pounder - beautiful
animals which l
get a quick sketch
of before they are
filleted. I save
the heads + bones
for a soup - hope
its as good as they
are lovely - sept. 11

Migrations

Homecoming or Homegoing?

*N*ow and then I think about the great auk, the large, flightless and penguin-ish bird that used to swim some 3,000 miles up the East Coast from the Caribbean Sea to breed in the North Atlantic, then back again for winter. A migration of 6,000 miles each year, often struggling against storms and monumental seas, passing through extremes of temperature, eluding predators from above, below, and the side, all the while trying to find food and rest of its own. It seems to me remarkable that the species could have survived even one of those odysseys, and nothing but incredible that it could have done so 10 million times over the long history of its existence. To the dreaming mind, such journeys over such expanses of time can take on mythic proportions, transform facts into miracles.

But now, here in the middle of May as I watch the birds—warblers flitting through trees in search of newly hatched insects, hummingbirds hovering at flowers, hawks circling overhead—I see all arrivals as wondrous, all migrations as improbable miracles. The hummingbird, restoring itself with the nectar of

these few flowers in central Vermont, came perhaps from a patch of Costa Rican rainforest weeks before; the Nashville warbler in the balsam fir, from the heart of the Amazon Basin; the broad-winged hawk, riding the thermals, rising in circles here as it did earlier over the Lesser Antilles.

These regular, predictable arrivals are not just of birds, either.

In early spring, even before the snow has left completely, many amphibians make annual treks from hibernating locations in the ground or under logs to ancestral waters and wetlands to breed. Some we hear in the evening at night as they announce their territories or sing for mates: wood frogs, spring peepers, American toads. Others, not vocal—notably the subterranean mole salamanders—we can see only if we are willing to go out on certain nights when the combination of season, temperature, and rain is just right. On such nights the spotted salamanders emerge from underground and move over land to temporary pools in forests, where they congregate for breeding, sometimes by the hundreds; following mating and egg laying, they will go underground again, leaving their eggs to develop into larvae, then from larvae to terrestrial adults by the time the ponds dry up.

In summer come butterflies, many of which have sailed and skipped north to visit summer flowers; they will work their way back south as the blossoms wane. Red admirals, painted ladies, question marks, and buckeyes, among others, from the southern United States, Mexico, Central America, and the West Indies. Monarchs, most famous of the butterfly migrants, travel north from an isolated 50-acre forest stand in central Mexico, breeding and fanning out as they come, until they occupy milkweed-bearing meadows across the eastern United States and Canada. The last of these northernmost broods will be the ones to retrace their progenitors' flight down to Mexico.

Bat migrations may take two different paths. Some (such as the hoary and silver-haired bat) come north from southern regions, like warblers and vireos keeping pace with the emergence of flying insects, their source of food. Others (e.g., the little brown, the big brown, and Keene's bat) move into New England caves and attics for winter hibernation, then disperse again come spring.

Fish migrate, too. Atlantic salmon and American shad swim from the ocean up rivers and streams to spawn in shallow headwaters, while American eels do just the opposite. Rainbow trout in the spring and brown trout in the fall move upstream to spawn in the rocky beds of streams.

Whales, porpoises, and seals of many species migrate in the ocean, some over the great distances between arctic and equatorial waters.

The movement is not all horizontal, either—there is vertical, as well. As winter approaches, crows move down from the mountains into the lowlands, while moose do the reverse, shifting to the spruce-fir forests of higher elevations, both going to where their food is more available. Lobsters go deeper offshore in the ocean, where they take refuge in the more insulated, warmer zones. The larvae of many insects (e.g., cicadas, junebugs, Japanese beetles, maple leafcutters) live in the ground—sometimes, like cicadas, for many

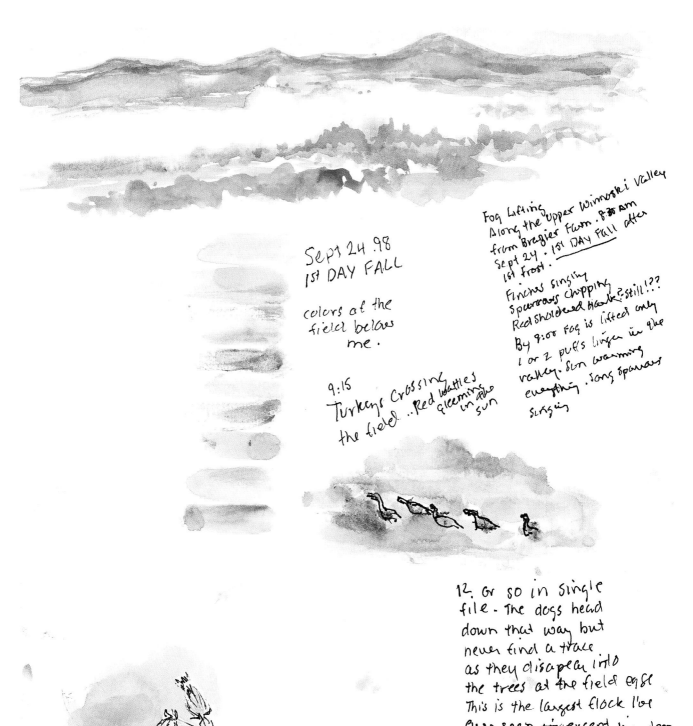

Sept 24. 98
1st DAY FALL

colors at the
field below
me.

9:15
Turkeys crossing
the field ..Red wattles
gleeming in the
sun

Fog Lifting
Along the Upper Wimoski Valley
from Bregier Farm . 8:30 am
Sept 24 . 1st DAY FALL after
1st Frost.

Finches singing
Sparrows chipping
Red shouldered Hawk ? still !??
By 9:00 Fog is lifted only
1 or 2 puffs linger in the
valley. Sun warming
everything. Song Sparrows
singing

12. or so in single
file. The dogs head
down that way but
never find a trace
as they disapear into
the trees at the field east
This is the largest flock I've
ever seen to except in deep
winter, when the stay
close to Bragier's barn
and manure pile for
warmth and seed.

Evening
Lichnich still
blooming
after last nights
frosts—here a
there a bee works
the few golden rod
left. A flock of 20+
Grackles fly over.
Haven't seen any
for 2 weeks.

years—while their winged adult stage is spent in trees or other aboveground vegetation.

Vertical migrations may be daily, too. Zooplankton often spend the day in the depths of lakes or oceans, presumably to avoid potentially lethal doses of sunlight, then rise to the surface at night for feeding. The adults of some fireflies (especially males) fly at night but spend the day in the grass or other low vegetation. Snow fleas may work their way up through the snowpack on warm winter days, to reach and remain on the surface during the day, then move down again under the insulating blanket for the colder night.

Even if we limit the definition of migration as the periodic (usually annual), predictable, and habitual return of an animal to a specific area, particularly for feeding or breeding, the concept is not a simple one to apply. If, for example, we regard the monarch as migratory, even though the individual making the trip either way is not the same one that did it the year before, then why not also for dragonflies or mosquitoes, born and living as aquatic larvae in ponds, emerging to flight as winged adults, then returning to deposit their eggs in the same ponds? Consider also map, painted, and snapping turtles, which come out of water at the same place year after year to lay eggs in the warm sand. Or timber rattlesnakes returning from woods and fields to the crevices of their rocky cliffs for winter birthing and hibernation. What about the many insects that spend one life stage—egg, larva, pupa, or adult—in one environment and the rest in another? What about the tiny snow flea that treks through the spaces between crystals of ice and snow, up to the surface when the days are mild, down at night or when it's colder?

Do we humans perform anything that might resemble migration, even in our modern lives? Many if not most of us get into cars (or some other conveyance) in the morning, drive from home to work, then back again in the evening. We call it a commute, but it could just as well be regarded as a daily migration for sustenance and family (feeding and breeding).

And then there are trees and other plants that have shifted their ranges in response to climate changes over their long history on the continent, north as it warms, south when it cools.

These all are migrants of sorts, of one kind or another, and thus our vision becomes even broader, and more encompassing.

When birds come back in spring to nest, I think of them as returning home, somewhat as if they had been children away from home awhile, testing their wings, growing up, ready now to be parents. But for someone living in the tropics, those same birds have merely left home for a time, to return when their job of raising young is done. In fall, the birds leave us, return to them.

What we call each segment, coming or going, leaving or returning, is of course a matter of our perspective. But from the bird's, home is not so clearly or sharply defined. It needs both areas equally, and the distances between are vital, unbroken bridges in time and space. Neither place, nor any along the way, can call it a stranger.

In my own life from time to time I have recognized such polarities, translated into feelings: the yearning to go back to where I was born and raised, reconnecting to the comfortable familiarities and freedoms of childhood; but also the desire to be somewhere else of my own choosing, a new, exciting place staked out on my own as a grown person. These places are not the same, yet both are homes, both desirable. If only in memory sometimes, I make the journey between them regularly. When I do, I always hope the trip is not too difficult, and I hope each place is still there when I arrive.

The hazards of migration, however great and insurmountable they may seem, have been factored into the biology and continuity of bird, butterfly, fish, frog, salamander, turtle, or mammal. The very presence of beings for so long on Earth surely is testimony enough to a wisdom far beyond our comprehension or explanation. Most perilous and calamitous, however, have not been the environmental challenges they always faced but the human degradation of their habitats at either end of their treks, and the obstacles thrown in their paths along the way.

For three hundred years sailors plundered great auk eggs on breeding grounds, hunters shot and netted the birds as they swam, and scientists sought both for their collections, until the bird was driven to extinction in 1845, when the last female was killed as it brooded its last egg, and the egg smashed into oblivion on the rocks of Eldey Island near Iceland.

Whalers of generations past pursued their giant quarry worldwide, intercepting whales in this region as they moved through the Gulf of Maine on their way between summer arctic waters and their winter Caribbean breeding and calving grounds. They harpooned several species to near extinction, all for oil to light our lamps, to extend our days into nights a little longer.

In our own era, the unbridled use of DDT caused such thinning of eggshells that incubating bald eagles and peregrine falcons crushed their own next generations before they could be hatched. Hydroelectric dams barred Atlantic salmon and shad from entry into the Connecticut, Merrimack, Kennebec, Piscataqua, and other major rivers for spawning, while lake sturgeons, the largest and one of the most ancient of freshwater fish on Earth, could no longer go up tributaries of Lake Champlain to lay eggs. Oceanside development and recre-

ation on beaches, meanwhile, eliminated breeding sites for many shorebirds, gulls, and terns.

Threats to migrants continue in disturbing ways today. Inroads into and outright losses of tropical as well as temperate forests, due to heavy cutting, encroachment by development, and conversion to other uses (e.g., agriculture), have severely reduced the numbers of many migratory birds that depend on both types of forest. The small sanctuary of monarchs in the mountains of Mexico is under siege from human neighbors who also need the forest—for the fuel it provides. Vandals have swatted and torched bats off their roosts in caves. Ever more cars on more roads squash untold numbers of crossing amphibians and turtles, while countless millions, perhaps billions, of migrating butterflies end up splashed on windshields and grills. Night-migrating birds collide with towers and city skyscrapers in numbers that stagger the imagination. (I once picked up 3,000 dead birds—warblers, vireos, finches, grebes, catbirds, a whole sickening gallery of migratory species—that had struck the guy wires of three radio towers on just one foggy night in fall.)

For the great auk, concern came too little, too late. Its presence now is only a fading wake of memory and regret. But we hope we have learned a lesson from such tragedies, no matter how bitter: that we must never again treat our fellow travelers this way.

We have done some good, certainly, curtailing whaling, outlawing the killing of nongame migratory birds, and setting seasons and limits on the others. We have constructed fishways around dams for salmon, shad, and sturgeons; we keep sunbathers and swimmers away when barrier-beach birds raise their families. We urge conservation of forests, grasslands, and wildlands. We close newly installed gates at cave entrances during bat hibernation, and work with architects, builders, and office workers to make tall buildings safer for passing birds. We even—in Massachusetts and Australia, for example—put up signs and make road underpasses for migrating salamanders, provisions unthinkable, laughable, a generation ago.

So, in some respects we have come a long way. Now we do these things not in penitence or atonement but because we should, because we must. We are not done, of course. We will never be done, so long as there are some to make the journeys, however near, however distant, trying to reach their homes.

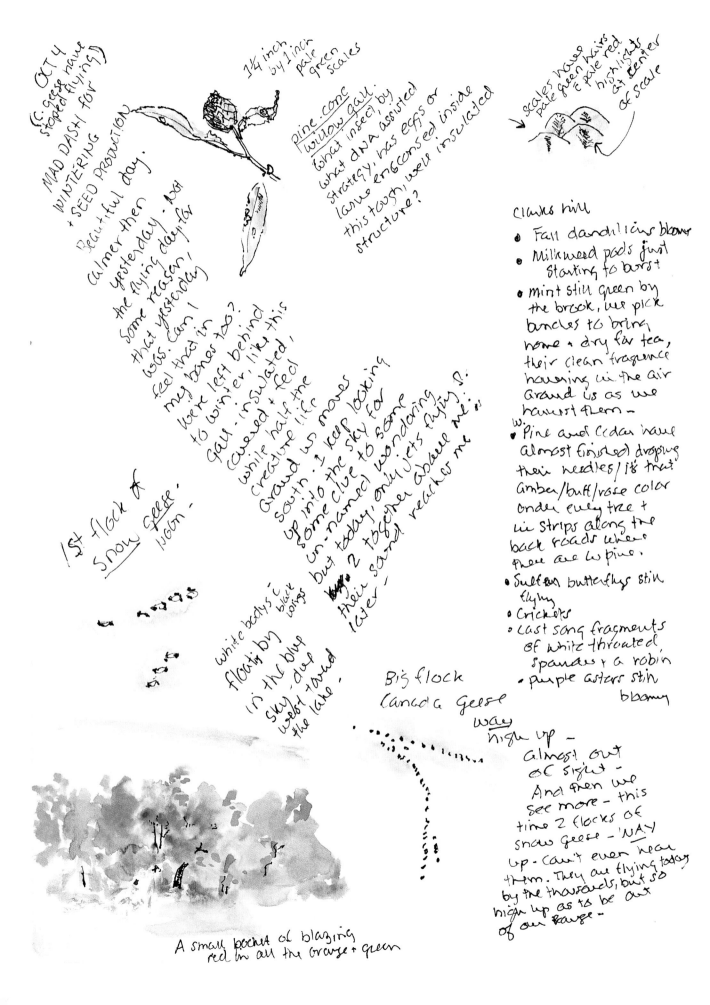

OCT 4
(C. geese have stopped flying)
MAD DASH FOR
WINTERING
+ SEED PRODUCTION.

1¼ inch by 1inch pale green scales

Beautiful day. Calmer then yesterday - not the flying day for some reason that yesterday was. Can I feel that in my bones too? We're left behind to winter, like this gall-insulated creature like Ground up moves South. I keep looking up into the sky for some clue to some un-named wondering. But today, only jets flying 2 together above me, their sound reaches me later.

pine cone willow gall.
What insect by what DNA assisted strategy, has eggs or larvae ensconced inside this tough, well insulated structure?

scales have pale green hairs & pale red highlights at center of scale

1st flock of
snow geese.
noon -

white bodys c black wings floating by in the blue sky, due west toward the lake.

Big flock Canada Geese
way
high up -

Clarks Hill
• Fall dandilions bloom
• Milkweed pods just starting to burst
• mint still green by the brook, we pick bunches to bring home & dry for tea, their clean fragrance hovering in the air around us as we harvest them -
• Pine and Cedar have almost finished dropping their needles/ it's that amber/buff/rose color under every tree & in strips along the back roads where there are lupine.
• Sulfur butterflys still flying
• Crickets
• Last song fragments of white throated sparrows & a robin
• Purple asters still blooming

Almost out of sight - And then we see more - this time 2 flocks of snow geese - 'WAY up - can't even hear them. They are flying today by the thousands, but so high up as to be out of our range -

A small pocket of blazing red in all the orange & green

OCTOBER

Oct 2 ('98). E. Montpelier. Cold high pressure over us. Flocks of Canada geese flying over. Colors early peak, some sugar maples still green, leaves starting to fall from red maples. Hills toward Groton State Forest red-orange.

Big turkey flock on Brazier's field, flying into woods from field. Count about 20, only a glimpse. Primitive looking as they fly, like pterodactyls. As I sit later, I hear some various turkey noises. A kind of cry and a bunch of *cheep cheep cheeps!* No gobbles.

Oct 3 ('98). E. Montpelier. AM. 2 flocks of geese last ½ hour. 2 more flocks at 7:30 AM, these very high.

Colchester, Vt. Cold, clear. Sugar maples still green, red maples crimson. Zig-zag goldenrod going to seed at the top.

And a huge association of several flocks of snow geese at 3:15 PM, with a hawk soaring behind them.

PM. Back in E. Montpelier, to bed at 10:30. ¾ moon. Geese still flying over, flock after flock, by moonlight.

Oct 4 ('98). Beautiful day, calmer than yesterday. Mad dash for wintering and seed production. Canada geese have stopped flying. Not the flying day, for some reason, that yesterday was. Can I feel that in my bones too? I keep looking into the sky for a clue to this unnamed wondering. We're left behind to winter, like a gall—insulated, covered, and fed while half the creature life around us moves south.

- Mid-peak! The brightest color.
- Red maple leaves may start falling as sugar maple colors brighten.
- "Scuffling season" starts as the leaves pile up, and it smells like fall.
- When the robins flock and the geese fly south, woodcock are migrating.

Clark's Hill:

- Fall dandelions blooming.
- Milkweed pods just starting to burst.
- Mint still green by the brook, we pick bunches to bring home and dry for tea, the clean fragrance hovering in the air around us as we harvest them.
- White pine and cedar have almost finished dropping their needles—it's that amber/buff/rose color under every tree and in strips along the back roads.
- Sulphur butterflies still flying.
- Crickets.
- Last song fragments of white-throated sparrows and a robin.
- Purple asters still blooming.

Brazier Rd hedgerow. PM. Buckthorns overrun with grape vines create a mass of black fruit (buckthorn) and blue-black fruit (grapes), all in clusters so dense and interconnected it's hard to differentiate between them.

Great red hawthorn fruit next to this, several times the size of the grapes and buckthorn fruit.

A flock of redwing blackbirds, with many (more than half?) speckled young, alights in a bare black cherry in the sun, mostly all facing the sun. Their wing patches are hard to see; a dull orange and only a very few adult males in the flock, but their voices alert me that they are here. The first flock I've seen since they left this area back in the summer after they had raised their broods. These must be from further north?

Call notes of migrating songbirds overhead in the night, nearly full moon.

Oct 8 ('98). I'm out on tour again. Days of soft mist, light rains, falling leaves and vibrant colors—some maples in Stowe valley still totally green. See water pipits on Mt. Mansfield, in fog. Cooper's hawk chasing crow in a swoop, down by cornfields.

Fall colors somber this year from a distance, but bright at particular locations.

Oct 11 ('98). E. Montpelier. Back home. Overcast since Oct 6. Land bird

migrations. Warm. Small insect-eaters—the round olive-gray ruby-crowned kinglet, with eye ring and two wing bars, foraging in hedge row. Also the kinglet's rattle call, similar to the oriole's. Surely the orioles have all gone through back in Aug/Sept. Grapes still good. Robins and redwings still here in flocks. 70 redwings in a yellow aspen. Almost NO green in maples now—many falling leaves of all sorts.

Last gray day before high pressure. Brazier Rd. hedgerow, just as corn is being cut: redwing flock moving from tree to tree; robins and sparrows too; one flock of Canada geese heard but not seen.

Colchester, Vt. 8:30 AM. Clearing and geese flying again, flock after flock, in single file flocks of 20–25.

Oct 13 ('98). I-89, Vt. YELLOW EXPLOSION! The yellows are gathering strength as many late-to-turn maples show a decidedly ocher cast and the birches, elms, beech, and poplars are turning without waiting for the maples to fall. A great wave of yellows overtaking us unexpectedly after a somber start. One monarch in Huntington—after all these frosts and rain.

Poplars a delicate pattern of lacy yellow, a soft texture next to the maples and ash.

We're on way to Dead Creek Wildlife Management Area in Addison County, to see migrating waterfowl.

Oct 17 ('98). E. Montpelier, Butler woods. Noon, 50s or 60s. Leaves 85% down. Beech woods ablaze with yellows and russets. Mushroom/dried leaves smell. Crows calling. Flocks of juncos have arrived from the North.

Ferns still green or standing: cinnamon—lovely pale yellow/gold; New York—some yellow ones; spinulose woodfern—bright green; maidenhair—both green and yellow ones; Goldie's—spores spent, green in protected areas; marginal woodfern—green on rock ridges.

Brown ferns: sensitive, lady, ostrich, some New York and maidenhair.

Clubmosses, some producing spores now: ground cedar—long done; bristly and tree—not spored; wolf-claw—green spore caps.

Oxalis all frosted in the bog to a peachy-pale, like bits of silk sprinkled over the hummocks of moss.

Lovely pillows of red sphagnum 5' across and carpeting vegetation.

Bazzania (a moss-shaped liverwort) in huge mat at S end of yellow orchid bog. Crows screaming!

Other liverworts, by thousands, their spent sporophytes like tiny brown flowers.

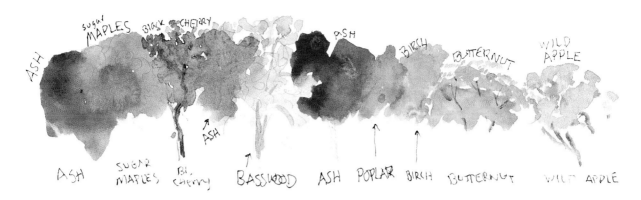

ASH SUGAR MAPLES BLACK CHERRY ASH ASH BIRCH BUTTERNUT WILD APPLE

ASH SUGAR MAPLES Bl. Cherry BASSWOOD ASH POPLAR BIRCH BUTTERNUT WILD APPLE

COLORS HERE AS OF TODAY, OCT 5. (over-story only)
very few leaves on ground - some red maples - etc

Oct 6. Cold wet days, and the yards (+
surrounding lanes and fields) are full of
flocks of smaller birds. Today especially
juncos. Hundreds flitting excitedly in the
underbrush, mostly out of sight, in groups
of 50 or so. Up on Brazier Rd, hundreds
of robins. all excited as a short-lived gale
sweeps in with gusts, flying colored leaves
and a rain, sleety mixture. This morning
the sun came through for 45 min and the
song fragments started up - white T. sparrow -
During all this cold wet week, not an insect
to be seen anywhere, except a bedragled +
benumbed wolf spider who had made it's way
into the bedroom last night + was cowering in a
corner, untill I captured it and shooed it the
door.

Oct 8. sun, warm - 60's finally get outside at 4:00.
Bees trying to get inside at Elementary school at noon,
through open door - Yellow jacki's - Also flys. 1st insects
we've seen all week. Hard frosts the last two nights. Yesterday,
a gale of leaves came down
in the early afternoon as I
was walking on Brazier Rd.

This would be called peak - but not by
my system, in which there's an early, mid
and late peak - Early - red maples only -
mid - sugar maples - (now) late yellows
and most leaves down - good smells +
sruffling through leaves etc - Still though
many sugar maples still green - so more is
ahead.

KINGLETS comming
through.

Milkweed pods
have popped down
in Turtlehead Fern.

Oct 9. sun + clouds; 60's
noon. wind. Walk long
way around to Polly wog
Blow-out pond. Kinglets (ruby
crowned) comming through,
the rattle call, scolding alerts
me - also see them in the shads
around the kitchen window alot.
At p.w. pond turtles are out sunning
and dragonflys (darners) out here
and there - Clouts just roaring out of
the N.W, but down here the breeze shifts
around from one place to another.

Oct 9. Wasps swarming on the S. side of house.
Supposedly, they are mating, but to watch,
it looks like breif ferretic and indiscriminate
attacks upon one another. 1:00° after 3:00 pm

Flock of juncos eating the
weed seeds in the garden —
the most delicate small sounds
in the background as scores
of them work in the weed
patches + scrubby areas —

A lone spring peeper peeping,
bird-like!

Wasps in
mating in
prep for over-
wintering of
egg-bearing queens,
on hot side of
house in sun.
Just saw a coupl?
of attacks on
① Lady bug on
side of house
② fly sunning
on same.
These, if truly
mating skirmishes,
must not involve
stinging . ???

attracted to
knot holes in
wood + to each
other. many
air skirmishes
—breif
sometimes
2

tumble
down
through
10 feet
of air
before
separating

?
0

SCUFFELING SEASON · Oct 9

Has started — Leaves
are piling up in the
woods. The bright Red
maples lead the way +
now the others, including
sugar maples, follow, some
lagging way behind, who knows
why. And some Ashes are bare now,
others still with leaves — This all
right along the side of the back-
yard — edge of woods. See comparison
Oct 5, same trees — after a cold, wet,
windy week.

Good fall
leaf smells
start

ASH SUGAR BLACK ASH BASSWOOD ASH— POPLAR BIRCH BUTTERNUT WILD APPLE
 MAPLES CHERRY (many (leaves droop- leaves (Not a leaf with some
 (still branch ing.) dry + left on it) SUGAR MAPLES
 Green) bare) falling Late maples BEHIND, JUST IN
 behind bare tree. PEAK COLOR NOW

MANY LEAVES DOWN as of OCT, 9,

woods filling up with leaves
Their smells + sounds are a big
part of walking now. Easy to
trip, hard to find paths. Feels
like fall compared to last week
when it only looked like fall.

Oct 11 Last of the ruby meadow Hawks mating at Chapples pond, last of
Monarch's down in Turtlehead fen, and in the evening Eastern
Sky, the Pleides are well up — When did they appear about
the horizon? Coopers hawk 2× — yesterday and today, near our
house. And geese, both snow and canada, passing over in small
flocks.

Yellow-footed and trumpet chanterelles, which survive many frosts. We eat the trumpet but not the yellow-footed.

Two small red meadowhawks mating in air and on landing sites here and there. A darner 2× the size visiting the area, over the pond edge.

Oct 18 ('98). Home woods. Warm—70s, wind expected from S but not here yet at 2:30. Sun. Leaves all down except a few poplars, cherry, and birch—all yellow. Lilacs still green. Summer apple still green/yellow. Marginal wood-fern green. The woods are full of fallen leaves and sun here . . . like in spring before they bud out. Here and there a large green basswood leaf has fallen and looks so fresh and untouched by frost. The bare bones of this woodland floor are exposed again—many old fallen tree trunks in various stages of bleaching out, drying, gradually decaying and becoming porous, moist beds for mosses and fungi, and finally rich organic matter. Zig-zag goldenrod still green with fuzzed seeds, some heads broken off halfway.

Sounds:

- crackling leaves—settling?
- occasional breeze stirring brings down more leaves . . . scritch-scratch sounds above as leaves fall through almost bare canopy.
- leaves blowing about slightly during breeze—these sounds on forest floor—the deep cover of leaves shifting.
- 20 or more crows mobbing—probably the fisher family from that area.
- cars on our road—and way down in the Winooski valley on Route 2.
- no lawn mowers!
- occasional twitterings—ruby-crowned kinglets were here this morning, their rattle-call like a quieter version of the oriole's.

Also scents: balsams are now dropping some of their old needles, very fragrant along with poplar and apple leaves.

A few weeks ago bare, dark ground showed in places in the woods where plants had become dormant. Now totally obscured by a deep blanket of leaves.

Blue cohosh berries, stalks about 18" to 2' high. Blueberry bushes and arrowwood in color, the former is scarlet red and the latter just turning a deep russet.

Oct 21 ('97). Watching crows, hundreds near two deer kills. A basswood and cherry, both with rhythms of "S's," both still holding leaves.

Oct 21 ('98). Colchester, Vt. Still in glory of golden maples and oaks here

by the lake—cool, breezy, no geese flying—leaf noise still up in the trees. Enough leaves on the ground for what Karen Kitzmiller calls "scuffling season," which is in full swing at home, our woods being "full up" with leaves.

On I-89 all is gray-brown, pink with yellow showing through in slanting sunlight to reveal the yellow beech leaves understory in places. A kind of hologram of leaf color.

But most arresting here and there on the mountains are one or two stunning gold trees: big-toothed aspen (?), the last to leaf-out in spring, late to display in fall. At home, great fall smells; underfoot, great scuffling.

Still making apple sauce by the gallon, our little wild apple trees contributing to the mix. The fragrance in the house while it's cooling anchors us to the season.

Chard still green and tender. Kale lies in wait under wire fence hoop "tents," protected from the deer, getting sweeter with each frost—when the chard is finally brown we'll start eating the kale.

Apples, and sauce by the pot full, the last batches going into the freezer. Northern spy, small sweet-tart wild apples, and some of the "pear" apples (by now, off the trees). The best sauce is always a mix of apples, old varieties from unnamed and untended trees. And, of course, it's organic. We freeze what we don't give away.

Oct 29 ('99). Sunny, calm. 10:00 AM, Clark's. For at least a week the milkweed pods and their curious seeds have been catching my eye. Their moods and conditions: puffs of dazzling light at the end of the day, bedraggled and sodden

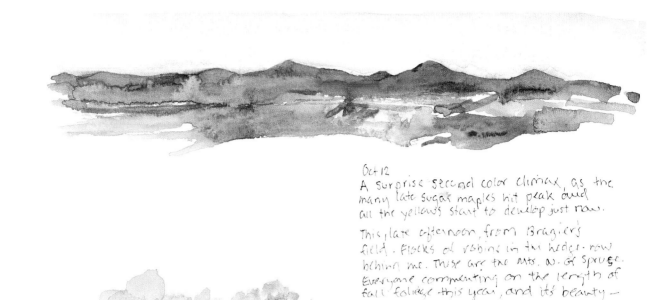

Oct 12
A surprise second color climax, as the many late sugar maples hit peak and all the yellows start to develop just now.

This late afternoon, from Bragier's field. Flocks of robins in the hedge-row behind me. These are the mts. w. of Spruce. Everyone commenting on the length of fall foliage this year, and its beauty — Black cherry just paling + yellowing up here on the ridge.

1:30 pm
Oct 19. Maples still yellow/golden in many spots with many leaves on ground. Poplars yellow now and

LATE PEAK falling — a special poplar leaf smell — this is especially on warm days — Birch golden — a rich deep gold — now combining with the remaining sugar maples & — the

Clarke's fields + weeds

YELLOW EXPLOSION is going on — Oaks at peak this last few days. Especially in Champlain Valley. Low bush blueberry blazing a bright/blue-red — alternate leaved Dogwood salmon peach — and the soft grey of bare trees now too — Still Peak of color in Champlain Valley — Mid-Peak I call it — Mist today intensifies the color.

Robin flock of 30-60 go over in ribbons of 15 or so together until 30 or 60 have passed — then a long break, then another staggered flock — This for the last many weeks — as happens here when the mountain Ash crop ~~on the ridge~~ above 1500+ feet is poor. Ground still thawed —

On Oct 17 winterberry, with red berrys + green leaves in Colchester near marshes

milkweed. only a few seeds

winter apple

the milkweed pod pirated of its seeds by mice — sometimes of its "fuzz"; leaving the seed; sometimes a neat hole gnawed in to the pod.

Nanny bush Viburnum shrub — still holding fruit — The robins must have alternative food sources (worms, etc.)?

wads after a rain, today they are drying again and the seeds are here and there lifted into the air and carried off. This plant gives pleasure at every season, and for the mice who seem to suddenly be gathering seeds, both food and nesting material.

Oct 30 ('99). Colchester, Vt. Winterberry leaves have dropped. Cut branches of red berries and oak twigs for DD's Halloween birthday celebration/harvest dinner tomorrow night. Find some yellow maple leaves too—still in color here.

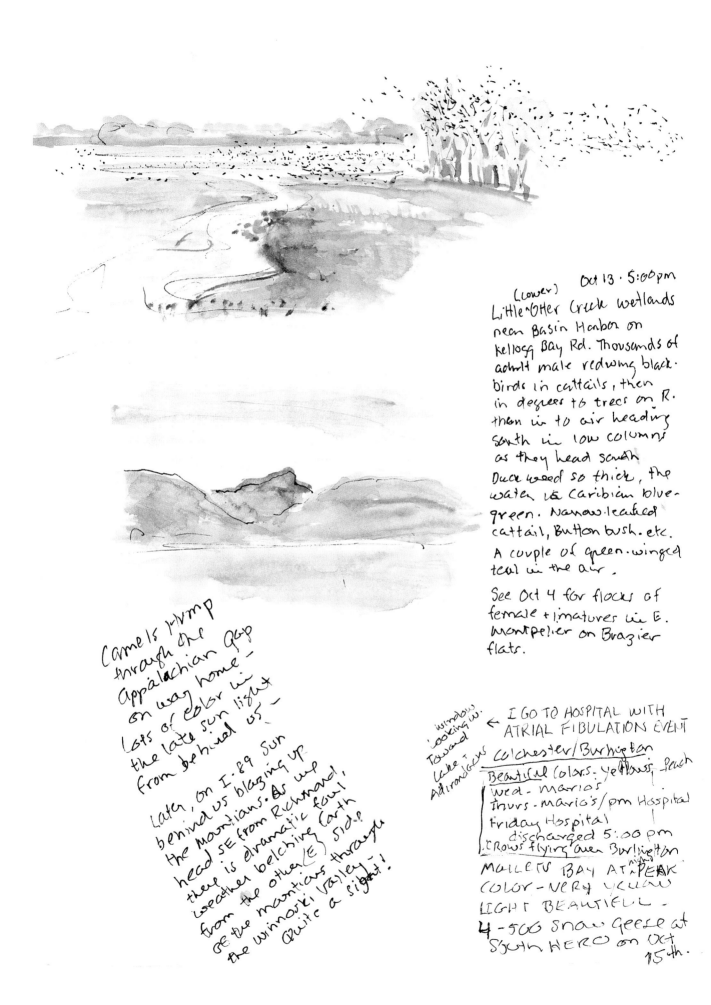

Oct 13 · 5:00pm
(lower)
Little^Otter Creek wetlands
near Basin Harbor on
Kellogg Bay Rd. Thousands of
adult male redwing black-
birds in cattails, then
in degrees to trees on R.
then in to air heading
south in low columns
as they head south
Duck weed so thick, the
water is Caribian blue-
green. Narrow-leafed
cattail, Button bush. etc.
A couple of green-winged
teal in the air.

See Oct 4 for flocks of
female + imatures in E.
Montpelier on Brazier
flats.

Camels Hump
through the
Appalachian Gap
on way home—
Lots of color in
the late sun light
from behind us—

Later, on I-89 Sun
behind us blazing up
the mountians. As we
head SE from Richmond,
there is dramatic (arth
weather belching (arth
from the other (E) side
of the mountians through
the Winooski Valley—
Quite a sight—!

windows
looking W.
Toward
Lake &
Adirondacs

← I GO TO HOSPITAL WITH
ATRIAL FIBULATION EVENT
Colchester/Burlington
Beautiful colors- Yellows, Peach
Wed - Marios
Thurs - Marios/pm Hospital
Friday Hospital
discharged 5:00 pm
Crows flying over Burlington
MALLETS BAY AT PEAK
COLOR - VERY YELLOW
LIGHT BEAUTIFUL -
4 - 500 SNOW GEESE at
S'JOUTH HERO on Oct
15th.

Oct 19 · 98 · E. Montpelier. Vt.
A great wind, in the night
and today, take all the
rest of the leaves. Our 3
season view of Spruce Mt.
appears - the hardwood
stands on its flanks no
longer orange but that
pale purple pink - of the
bare branches in a certain
light,

The thin stand of
maples in the foreground
seem to disappear and
Spruce Mt. Looks close.

Brazier Rd. Flats - Tom B.
is chopping corn today.
Views from the Road seen
again to the East. Leaves
down except elm, poplar +
cherry smatterings of wind-
blown yellow. Can prob -
head home.
LATE PEAK STARTS
...on Rt. 2 today, saw
that the Tamerack is just
turning Orange -

Oct 20 - Still breezy
and much cooler -
unexpected sun this
morning - the sky and
clouds in a new,
bluer mood - A good
laundry day before
my trip on the 23rd,
to Colorado + New Mexico.

Suddenly notice
the crickets are
no longer singing.
The drying grasses
make a rubbing, fall Sound in the breeze.

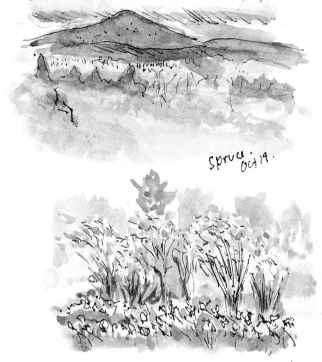

Spruce. Oct 19.

Oct 20
Touchetts
tiny wetland.
and Alder
Thicket
11:05 Am

dried Golden.
rod, for.ground;
Alder thicket,
background.

Tamerack and alder in
glory from near Touchettes.
Alot of the tameracks,
though, have not
yet come into
their yellow
peak yet -
still greenish

In Our Nature

*I*t *seems more than a little silly,* sitting inside this cabin and writing about nature when there it is, all around outside. I'm sure most, probably all, nature writers wonder at this same strange activity (or lack of it). Annie Dillard certainly does:

> It should surprise no one that the life of the writer—such as it is—is colorless to the point of sensory deprivation. Many writers do little else but sit in small rooms recalling the real world. This explains why so many books describe the author's childhood. A writer's childhood may well have been the occasion of his only firsthand experience. Writers read literary biography, and surround themselves with other writers, deliberately to enforce in themselves the ludicrous notion that a reasonable option for occupying yourself on the planet until your life span plays itself out is sitting in a small room for the duration, in the company of pieces of paper. [*The Writing Life*]

A hunter doesn't hunt indoors, nor a logger cut a tree there, nor a farmer plow the land. A sailor doesn't sail without a sea. So why write at all, if it's nature that's our subject? What is it I'm after? Do I suppose nature needs my embellishment to convey something that others haven't seen, or thought, or felt? Or that some enlightenment, a magic alchemy, will occur with the mixing of that outside world and what's inside me? Or am I simply trying to say how inextricable and essential is that connection we have?

I worry that I cannot be outside without a reason, to wander without mission, letting a bird go by unnamed or a plant not classified. To be alive appar-

ently is not enough; it is some elusive purpose I am after, or some unresolved meaning. I sense that nature hides them both deep within its treasury. My writing, I tell myself, will help dig up the gold.

But, like an owl after digesting its prey, this rumination yields up a hard, indigestible pellet: the stark realization of my separation from the natural world, no matter how much I think I am in it. I am outside nature, looking in. I make an object of nature, something to study and try to understand, something to tease out, explore, make use of. Even my writing externalizes it and turns it into tidy organized thought, rather than liberating experience and participation.

I am both inheritor and consignor of my traditions and perceptions. I have come from a legacy of dominion, one that assigns nature to a place in our lives, makes it a component of our lives, partitioned outside ourselves. Even our dictionary definition (nature = "the outside world") subtly reinforces that view. Nature is a place we go when we're not working, a landscape we admire, a hike we take to the mountains, a picnic by the lake, a stroll to watch the birds, a binocular hunt for whales. We sell it as a commodity, experience, or, like medicine, an elixir for better health.

We corral it into classrooms or disciplined field trips as "environmental education," offering it up in periods measured by clocks and buzzers, apportioning it a space equal to that of math or history or English literature. In so doing, we can teach concepts, names of things, but we cannot teach intimacy born of close association, nor love that comes from personal relationship and familiarity. We feed the intellect, but not the entire body of our soul.

We gain identity more by our jobs, our education—our many kinds of separation from one another—than by our commonality with the world. Even "naturalist" is a profession!

I remember an old man I once saw in a supermarket. He looked like a Turkish shepherd: swarthy, bearded, dressed in woolen vest and pants, a faded cotton shirt, old boots. He shuffled down the glossy aisles of the supermarket, passed row upon row of foods whose scents and textures were locked away inside tin, glass, or plastic. In this place he looked like a bum, alone, a ragged homeless wanderer in this stainless steel warehouse. But on the hills of another place and time, he would seem at home, grown from the land and like the creatures of his tending. He would be a revered elder of his culture. He would belong.

It is easy to underestimate the power of a long-term association with the land, not just with a specific spot but with the span of it in memory and imagination, how it fills, for example, one's dreams. For some people, what they are is not finished at the skin, but continues with the reach of the

senses out into the land. If the land is summarily disfigured or reorganized, it causes them psychological pain. Again, such people are attached to the land as if by luminous fibers; and they live in a kind of time that is not of the moment but, in concert with memory, extensive, measured by a lifetime. To cut these fibers causes not only pain but a sense of dislocation. [Barry Lopez, *Arctic Dreams*]

There have been times and societies not so removed or dissociated from the natural world—in our area Native American and Inuit, especially—when people learned its ways directly and adopted its identity as their own. Within nature's seasons, sometimes in fear, sometimes in fierceness, they held their ceremonies, living within its rules that were also theirs, honoring its gods who were also theirs. Their temples were outside, made of trees, mountains, ocean, and sky. That is where they, too, simply belonged.

But to some substantial degree we have moved away from that relationship, progressively relegating nature to ever more apportioned slots and narrowing spaces in our lives.

Yet we are still of nature, however layered our relationship may have become by artifact and edifice, however thin and invisible the connecting strand may have been stretched. Our natural lives and experiences are not done yet, nor have we archived them all away in personal or collective memory. We still are born, eat, live, and die. Air made by plants still passes through our lungs, blood of Earth's elements still pumps through our veins. Its water is our water. We still clock our time by days and nights. We are subject as we ever were to a much greater mercy.

Children, without prompting or cajoling, have unabashed attraction to nature, an on-your-hands-and-knees curiosity about what grows and crawls and

hops across their path. At least they do before we take them by the hand, lead them inside, shut the door, and teach them the mental things we think they'll need later as adults. They grow to love computers more than beetles, simply because they spend more time with them. Their hands get dirty only at play-time, then the soil is washed away, down the drain.

I look back at my own childhood, at the unstructured hours upon hours I spent outside. Nose to grass, then turning over to watch clouds take forms of animals and birds, then drift, changing, across my sky, away. Or playing among the streamers of brown seaweed washing in the tidal currents between rocks, or hearing the katydids in a warm August evening, rasping away the final stage of my summer. Those are the hours and days and years I cherish most, not in any flash of recollection, but in the way I have come to view the world, and myself within it.

Even as adults we retain the roots of our association. Nature is still that which is within us, as well as that beyond, pointing back as well as ahead.

How could it be otherwise? The brain evolved into its present form over a period of about two million years, from the time of *Homo habilis* to the late stone age of *Homo sapiens,* during which people existed in hunter-gatherer bands in intimate contact with the natural environment. Snakes mattered. The smell of water, the hum of a bee, the directional bend of a plant stalk mattered. The naturalist's trance was adaptive: the glimpse of one small animal hidden in the grass could make the difference between eating and going hungry in the evening. And a sweet sense of horror, the shivery fasci-nation with monsters and creeping forms that so delights us even today in the sterile hearts of the cities, could see you through to the next morning. Organisms are the natural stuff of metaphor and ritual. Although the evi-dence is far from all in, the brain appears to have kept its old capacities, its channeled quickness. We stay alert and alive in the vanished forests of the world. [E. O. Wilson, *Biophilia*]

We bear evidence of even earlier forma-tive connections as vestiges in our bodies: the sparse hair that as denser fur protected against the cold; the pointed canine teeth that allowed tearing the flesh of prey; the withered appen-dix that once helped digest a rougher diet of twigs and leaves; the whorl of fingerprints

that allowed a surer grip of what we held. So surely our feelings—joys, fears, pleasures, tears—coming from this same being are just as valid remnants of a much closer connection. We go for a walk in the woods, for that is where we have always hunted for our food or sought remedies for our sicknesses or found solace in the quiet. We sit by the ocean, not just for views, but because we always went there for its fish and crabs, or to gaze beyond the known horizons. We have always tracked the sun across our sky and seasons, always looked up at stars for their direction. We have always danced to rhythms coming out of the earth, let songs go into the air like birds. And we have always sat by fires in the night, to keep warm and tell our stories.

So that is why I'm alone in this cabin, writing about nature. In repetition, like prayer, to confirm what is dearest to me and most important, as if I might be lost without it. To touch myself all over, as I might wash my body with the sea, just to feel that I'm still here and part of something bigger. To find out who I am, really, this being behind the skin, within the bones, through the eye of my seeing. To tell my stories to the children who might listen someday, wanting to hear a bit of what I have seen and learned.

I also write to discover a truth, not just about how the world is put together and works its way through all its seasons, but about who I am because of it. I think sometimes I should be satisfied with always searching outside and cataloging, content with little discoveries, but I have found that is not enough for me. I need to search inside as well, and find where these worlds converge, and how they touch and mix. I need to recall the feel of sea sway upon the rocks even when I'm inside, or see the grasses billow like waves across my remembered prairies.

We will never be able to say why, really, a flower is beautiful to us, or a bird miraculous, or why we pick up a rock and bring it home, or gaze at the moon, or care so much for a tree. We can't say for sure, any more than we can define love or even life precisely. Nor should we have to, or even want to. But we will keep trying, in our walks, in our talks, in what we write or sing. We do these things not for any material reward. We do them for all our selves. We do them because it's in our nature.

NOVEMBER

Nov 4 ('98). Back from New Mexico. Clouds; flurries. A season away from when I left. Apples still on the trees, but all the leaves are on the ground except blackberry, honeysuckle, rose, dogwood (shrub), and of course beech and oak. Tamaracks still yellow.

Nov 5 ('98). Tamaracks: yellow on ground at base of trees, with fine short golden needles; also many still remaining on trees. Winter working its way down the Winooski valley. The tamaracks in Richmond just coming into peak in a day or so, still some green. 4 hawks on way to Colchester. On way back see one woodcock at dusk, flying over the car, 15 feet high.

Nov 6 ('98). Clouds, flurries. Cate Farm for our next few months' vegetable supply. Box of potatoes, 25 lbs carrots, 25 lbs beets, celeriac, 15 lbs parsnips, couple burdock roots, box of winter squash, 5 pumpkins for pies and soup etc. Into cooler mud room, after door closed and window opened to adjust temperature.

Nov 7 ('98). Sun! Chipmunk out gathering sunflower seeds. Nov 4 I gathered a bouquet—balsam, milkweed, and blackberry leaves which are still red. It remains pretty today, though the leaves have dried.

Reports from several friends in town of crows after dark making a huge outcry.

1:00 PM. IRISH Hill, Berlin. Northwest wind at about 10 mph. Overcast. Came up to look for the big hawks as they pass through from Canada. Not one

- Late peak! Mountains are that soft lavender, and the tamaracks and poplars brighten to gold.
- Fox sparrows are passing through.
- Many types of "hunter" moths are flying in the woods, both day and night.

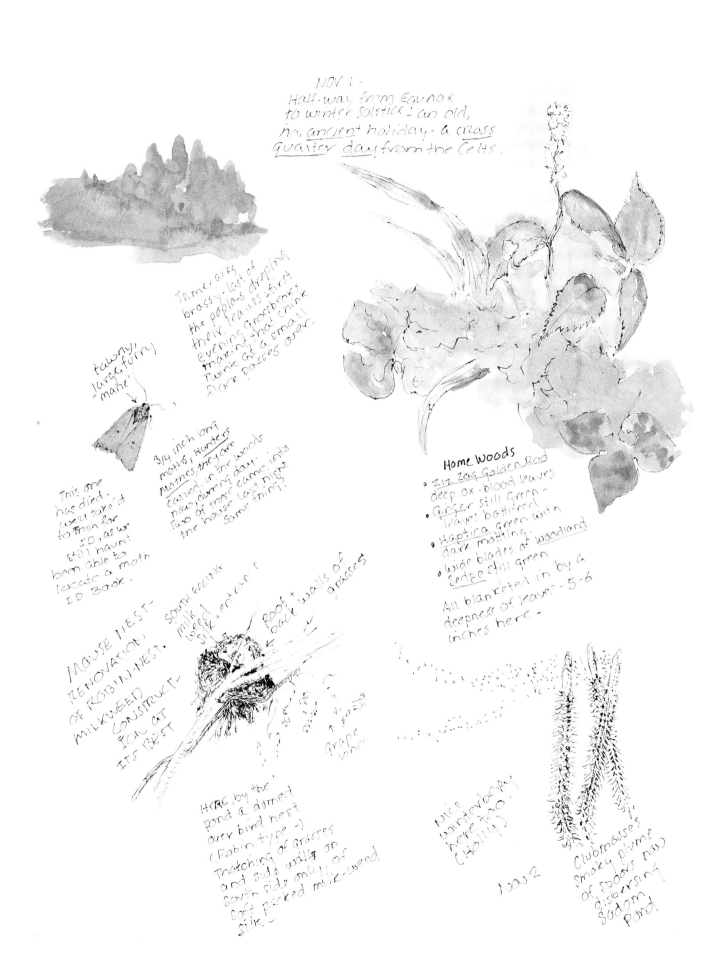

NOV 1.
Half-way from Equnox
to winter Solstice - an old,
hm, ancient holiday - a cross
Quarter day from the Celts.

Tamaracks
brassy - last of
the poplars dropping
their leaves. First
Evening Grosbeaks
making that chink
Twink as a small
flock passes over.

tawny/
large furry
"mane"

This one
has died -
we'll take it
to finish for
ID, as we
still haven't
been able to
locate a moth
ID Book.

3/4 inch long
moths; Hunters
moths, they are
called, in the woods
this coming day -
two of these came into
the house last night -
same thing?

Home Woods
• Zig Zag Golden Rod
 deep ox - blood leaves
• Ginger still Green -
 leaves battered
• Haptica Green with
 dark mottling
• wide blades of woodland
 Sedge still green

All blanketed in by a
deepness of leaves - 5-6
inches here -

MOUSE NEST -
RENOVATION. SOUTH FACING
OF ROBIN-NEST. milk
MILKWEED weed
CONSTRUCT- silk entrance
ION AT
ITS BEST

Roof + walls of
ball grasses

Grape
vine

HERE by the
pond a domed
over bird nest
(Robin type -)
Thatching of grasses
and side walls on
south side only of
soft packed milkweed
silk -

Nice
winterberry
here too.
(holly)

Nov 2

Clubmosses
smoky plume
of spoors now
dispersing
Sodom
pond

for short 'ened

a green aphid, crossing page

I'm able to get close to this one before it moves on

This is 1/2" (each side or wing)

fringe on outer wing

"Hunter Moths"

This one is flying today - Then alighting upon grasses or stems where it rests with wings making a "tent". The posture on the twig a bit more parallel with twig than shown here.

NOV. 10 · MILD! 55°, CALM, OVERCAST
'99 (home woods)

wings 1/2" long

(from underneath) The underwing is lighter.

KINGLETS CLAIM WOODS -

o Yellow-Crowned (Golden Crowned) Kinglets, kinglets, kinglets every where in the softwoods. Hard to see but easy to hear - a high thin see see see see!, as I hear it. Especially in a spruce grove -

o The Blackberrys are finally loosing their deep russet, or actually dark red leaves, after weeks of under-story color - GOOD TIME TO SCOUT FOR NEXT SUMMERS PICKING BEFORE THEY FALL, DURING LATE OCT. early NOV.

PM - BY NIGHT THEY ARE FLYING EVERYWHERE, IN SPITE OF A LIGHT DRIZZLE - SEVERAL ON THE WINDOW + DOORS

I'VE SMEARED RIPE BANANAS ON SEVERAL TREES IN THE WOODS NEXT TO THE HOUSE - BY FLASHLIGHT, CHECK:

5:45 pm 3 large (3/4"L) Tan moths, as seen on NOV 1 on or near the "bait", and one crane fly.!!

8:30 pm A large 1" + orangish moth drops to the ground as we shine flashlights. Seen at other (Nov. 1) moths. Called possibly a Bicolored Swallow - this. according to Trish.

seen in the hour's walk up the hill, to within 100 yards of the tower, and return. Last 45 minutes walking in clear-cut.

Noted:

- 3 clubmosses are giving off spores: ground cedar, princess pine, and shining.
- 1 appears finished: wolf-claw.
- hop hornbeam seeds down here and there.
- birch trees black with seed capsules, below the clear-cut.

Nov 9 ('98). Gray last 2 days. A cold blanket repressing the spirits. Balsam has long ago sent most seeds down (see Aug. 30) in little whirly-gig showers. The larger balsam cone scales have followed them and are all over ground here. How many seeds have been launched—millions. COLD! Still about freezing but bone-chilling if I am still too long.

11:30. Still green in mossy area in great horned owl bog: speedwell, mosses, strawberry, goldthread, ferns, partridgeberry, clubmoss. These have center stage as ground turns brown. Outdoor to-do:

- check crows in Montpelier (Nov 7).
- wintergreen from Owl's Head for tea.
- clubmoss—spores spent up by Pollywog Blowout?
- mice eating milkweed seeds in pod—any action up on my corner?
- pick last mint for tea.
- complain to Bryan Pfeiffer about no hawks.

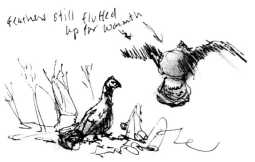

feathers still fluffed up for warmth

Apples in trees, highbush cranberry; nests everywhere.

There is dense dark fur against the den hole tree on Butternut Flats—looks like the soft side and stomach of a big old porcupine. A newly-trod path to the hemlocks from the trees also suggests porky.

Rugosa roses in yellow foliage, tamaracks still yellow, mint still green. Pick a bouquet of weeds for kitchen.

Nov 10 ('98). Weak sun out by 9:00. Brazier Hill looking east. The corn is all down, giving great views to the east. No turkeys warming in the sun today. No red-shouldered hawks calling. But a lone robin flying south towards Towne Hill Road along the hedgerows, stopping in the treetops. Crows here and there, and a cardinal singing. Lots of blue jays. Gloves on but hands still cold.

Thousands of seeds everywhere I look closely. Old man's beard, milkweed, and myriad of composites. All drying, waiting, ready for the right conditions. Corn kernels, too, left from the harvest.

Nov 11 ('98). 11:00. Brazier Hill. Red-shouldered hawk woods. Strong winds, heavy rains in the night and early AM. Clearing now with the SUN! Mild, in the 50s. Many insects out today, besides the moths. The light tan moths are everywhere—about 3 per acre or more. They fly along at 5 feet, covering ground fast.

And kinglets, but they elude me!

Find the red-shouldered hawk nest about halfway into the woods and just east of the sugaring road. These same hawks had nested where a house now sits. The nest there still a reminder of their long-tenancy about ⅛ mile from here, or less—200 yards or so—the house is 2 years old.

Another nest, older, disused—about 40 ft high and 50 paces NE of the first nest. Great nest discoveries at this time of year. Some, like the red-shouldered hawk, expected; others like the two by the driveway and in the apple tree completely unexpected until the leaves fall and there they are!

Nov 12 ('98). Sun! Indoors all day till 2:00. Up by Pollywog Blowout. The ground cedar is definitely in plumes of smoky spores; when tapped the plumes show me the wind is out of the SW.

It's warm outside after I re-dress. My body opposed to chill at this time of year. Feels good to break through the chill barrier and get out—my sitting pad and down jacket save the day.

Some spruce cones down, many still up in trees.

Flushing grouse everywhere, from a tree snag, from under an overgrown apple. An explosion of wings always makes me jump unless, as now happens more often, I see the bird or birds before they go up. Recently, 4 or 5 walking through a thicket before taking off.

The mosses and dried flowers or seeded flowers—vervain and a poof of willow-herb at the edge of the pond. I hear the water running out of the dam —no longer kept tight by resident beavers.

11:00 PM. Insects seeking shelter as temperature gets ready to drop. After a warmish day in the 50s, the wind rises, temperatures fall to 30s and 40s and a pelting of icy rain and snow comes down sporadically. By evening the front light is on for Charles, and it attracts scores of insects, many of which seem to

in a sugar maple, just where the crown starts. about 66 ft high.

Nov 16. 98 The apples on the wild tree,
late in the afternoon before the
first snow fall - WATER COLOR
Pencils for use when temps
are below freezing.

New seeds under maples
at stone wall on way
to Marilees/Patti...
All over the path.
On the wet mat of
maple + Buckthorn
leaves. An annual?
No time to spend more
than 5 min looking
around - no ideas yet.
Its not Queen Annes Lace

↑ about 1/3 larger
than actual

Night of the
begining of the
LEONID
 METEOR
 SHOWERS

Snow tonight,
but we may
see some tomorrow,
after skys clear
on Nov 17th
These will appear
in the south.

Clearly visable
Sun rise today.
35 days
till SOLSTIS

Today's sun
position

Solstis
position
from my
window

11:00 pm.

Light snow falling.
no stars. but a
flock of snow geese
fly over low. Calling
their ragged broken
cry - weather. But of
the West has turned
them E. to alight, perhaps
in one of our fields for
the night - they are headed
toward Fairmont Farms —

Last flocks
of snow
geese
pushed
by snow.

11:40 pm.
Snowing harder.
Another flock
goes by. the
snow is pushing
them! these are
the 1st geese we're
had going over in
a few weeks!

Nov 17. 98. Many more snow geese flying over low in the
night! With the window open just an inch,
we would wake for a moment with each
flock's calling. Two or three inches of snow
on the ground by this morning. Our 1st accumulation.
A flock of 20 robins is in the balsam sheltering,
or passing through, looking for fruit. our crabapple
is bare, and they don't seem interested in our bigger
apples! BRING OUT THE SOLAR SIPPY! And order
a new one —

NOV 24. WIND! The Old Anglo-Saxons called this wind month.

To the East;
9:00 am

Overhead

To the West

9:15 East

9:15 overhead

West

9:30 East

Overhead

West

Wind from the West — There goes our blue sky!
But, at this rate, anything could happen. A partially
sunny day is forecast. I'm painting with gloves
on but no problem with the paint freezing.

Spinach Red Lettuce Oak Leaf

The Cold Frame
Still producing,
but the 20° nights
have slowed things
down and there
are fewer and
fewer leaves to
pick. The lettuce
will die, but the
spinach plants
will be producing
again in March
or April. Planted
Aug. 1, or thereabouts.
This usually takes
us through Thanks-
Giving, only 2 days
away.

Sounds: Crows, chickadees, finches, and the wind
 in the trees. an occasional car, and
 the dogs, chewing long + hard on various
 bones - the wind fall of hunting season
 refuse, which hunters leave on the road
 below. This is surely our dog's favorite
 time of year.
 Nuthatches + red squirrels. Suddenly, at 10:30 - the sky is
 BLUE.
NOTE: By 12:15 A GALE IS ROARING THROUGH! Spits of snow.

whoosh in on the warm air offered every time the door opens—spiders too, and some caddisfly types of various sizes. I keep taking them out. A wasp is batting against the windows. I take out a big brown spider.

Nov 13 ('98). Cold morning with ice everywhere it was wet last night. The sun is out and warms everything by 9:00, into the mid 30s. At Pollywog Blowout pond there are 2 ducks on the water, up and out before I can get a good look, but I don't hear the mallard wing noise. There is a skim of ice in the shallows at side of pond. A couple of the light tan moth are flitting about in the hardwoods east of the pond. "Hunter" moths they are called, all these tan species at this season.

Find a wolf-claw clubmoss that is sporing.

And up by ski-bog trail the dogs rampage off on a scent, giving call as they go—high excited yips. I lie under a small balsam tree and pretty soon a fine big coyote, dark tail and back, and going fast, heads N about 30 feet away. I get a good look as it goes by. The dogs give chase, crying all the time, passing by me occasionally—no response to my calls. Very excited. A few minutes later, when they are spent, the coyote gives a deep long call from the hill above us. I thought when I saw him/her "more like a wolf—too big for a coyote." (Never saw me, or didn't care.) We hear this pack—there must be others here—at night. He or she calls, to regroup—then Bud is off again, but this soon ends as he is out of gas.

Stragglers—two lone flock birds—a grackle pair, are with us today. Most went through weeks ago. Won't see them again till spring. Feeding decorously here on the lawn and feeder.

Nov 14 ('98). Rifle season for deer starts.

Nov 16 ('98). Monday. Sun! 40s. First snowstorm coming tonight. Wild apples still hanging on the tree. By afternoon the clouds are coming in. A big hawk heading SW in front of the snow—making use of warm rising air to tack its way up almost out of sight—soars up in spirals, then glides. A buteo, but which one? Too high for field i.d. Clears the Northfield Mountains before I lose sight of it.

Nov 17 ('98). Foggy, snowy, drizzly. Great gray blankets of low pressure sit on us, slide over us, from Canada or up the coast or from out west—we are the "must visit" for every low pressure touring the continent this year. It begins to

feel cozy. The color spectrum stops down to limited colors and tones. Do our rods and cones gradually expand capacity to distinguish and appreciate the subtle shades at this time of year? The snow and gray light (mist) close the spectrum still further today. I especially enjoyed the remaining willow leaves on the way to Burlington—these flecked with snow, their yellow pigments a shock of color. The tamaracks, too, are yellow: veiled with a light scrim of snow, they are still arresting yellow. Arrive at Mario's where the children have just come in from sledding. Maddie: "I love this snow, it's just like rain, only cold!"

6:00 AM. Up before dawn—no meteors in the clear sky.

Nov 18 ('98). 8:30. Cold front came in last night. 20s, clear, snow, sun. Miniature snow-fields repose on every available horizontal plane. The goldenrods and Queen Anne's lace and grasses balance white loads of snow. Sunlight glancing off the whites in dazzling exuberance. Shadows lingering, slug-a-bed, in frosty under-lairs. The air starts to warm.

Gray birch seeds on the snow. Look like tan birds on a white sky. Small round seeds, each with "wings."

As the sun drops, so does the temperature. Snow still underfoot and plastered to W side of trees in my home woods. Big melt of snow today from most small plants—still on evergreens and tree limbs. The cold chases me up the hill where the sun is still shining.

Tracks. Two small entrances to 1" underground hole, about 14" apart— shrew came out for air (?) on left, but did not leave hole, came out on right, 14" away, soiled slightly and hopped around, leaving "sit" marks.

Several small tidy nests now visible by the road. Highbush cranberries a stunning scarlet red, a couple still snow-capped.

Blackberry and even raspberry leaves still with some color. Russet, the stems a lovely red-brown.

Nov 19 ('98). Home woods. Sun; clouds in long wisps. Rain had been forecast. Snow, both on ground and in trees, since 3 nights ago. Moths still about— fall cankerworm, Bruce spanworm, hemlock looper. Zig-zag goldenrod still green and reddish, beech leaves a rosy tawny. Very cold hands!

Cate Farm to get veggies. Hawks still coming through—an osprey (this late?), red-tailed and an apparent rough-legged before noon near Cate Farm on Winooski/Kingsbury Branch. Also robin at the farm.

Cedar Seeds!

Nov 20 ('98). Overcast, warmer. Hatch of small clear flies (⅓ in. long) by parking lot at Hubbard Park. Hemlock seeds in bowl on table where I left a

Nov 29

Hawk off the porch -
- large - not seen clearly.
Red shouldered hawk call
as it leaves, but this could
be the blue jay - who gives
this call, and is in the area
when this happens - R.S. Hawks
left the area a while ago - Sept.
or Oct - early Oct.

HUNTING SEASON IS
OVER - At least with rifle
SEASON OVER, ITS SAFE TO GO
WALKING IN THE WOODS - WE
* TRADITIONALLY USE HUBBARD PARK
AND TOWN WALKS - MOST TOWNS
HAVE WALKING TOURS AND THIS IS
THE TIME OF YEAR TO TAKE THEM.
BURLINGTON HAS A INTERVALE WALK
WHICH LOOPS THROUGH TOWN. PROB.
7 miles?

DURING HUNTING SEASON

Dec 1 - Colchester
Warm - Record breaking?
Still no snow as our last
cold snap's snow cover is long
gone - Brayloc windy and
overcast until later in day
Abe learns to make blowing/
whistling when wind or his
paper bird mobile are pointed
out. He notices everything. @ Wim
says "Hi Nena" when I pay attention
to Abe to get my attention back -
We most feel the loss of unintrupted
regard as Abe gets more of it.
CLARKS HILL ? DEC 2
And outdoors - A (reflective) time of
not knowing what's happening.
The "2 year old brain" does not
remember winter, knows something
is different but can't say what
it is - I notice.

• The grass colors
have gone weird -
either a fake crazy
green (around S. side
of over house + cold
frame) or half
dead / half green
(fields + woods.)
• The cedars
look so yellow;

• The trees are stripped
down to their bare bones.
• Crows tell us where
every deer carcus within
2 miles is. Where do
they roost? (see Jan 2·99)
• If I look a certain way
- sort of half dreaming
into the sun, I might see
lots of tiny insects flying
or the spider webs of yesterday.

Dec. 2 Blue Blue Blue! warm
enough for a Summer Blue at
the horizon - that blue green
Cerulean Blue with a
Tawny Indian Fall (because
it feels like fall, not Dec 1)
world underneath.

Sort of
winter blue.

Sort of
Summer blue

cherry,
Basswood
Elm + young
Poplars in
the hedge -
Row
Over story.

(greatly
enlarged!
some white
on abdomen)

Clarks hill - Is it fall or
winter? a spider crosses my
page along the left edge -
Dear god, the tiny creature
is spinning a webb over
me and my book, especially
now, on the right side, around
the spirea's, lifting off into the
wind, then comming back in
and hiding behind black spiral.
Then in a gust which
suddenly flips the page - gone!

* this size,
no, half this
size!

Here on the
Rock pile, where
I'm sitting, 2
daddy long-legs
and other small
spiders are
going about
their lives -
or just basking
in the sun -
I loose a brush
down into the rock cracks

hemlock cone. Hemlock seeds taste rich and mild though, for me, tiny. Cedar seeds have a pungent resinous taste, not unlike, in same class as, balsam seeds and juniper berries.

Sandy W. told me the deer are about to rut—have not yet—and that bear are still about at deer camp.

Nov 22 ('98). 8:30–9:00 5–8,000 snow geese at Dead Creek, coming in and taking off in flocks, calling. Later PM, also blue phase lesser snow goose and some Canada geese.

Button Bay with Lori and Bryan. A yearling snow goose shot 2 miles away has swum all the way down the lake to Button Bay point, where we find it in its death throes. Rusty stains on breast from the red soils on the tundra where this young goose was fledged.

We watch a sole female snow bunting on the gravel parking lot, eating seed, perhaps injured, else why alone and why so reluctant or unable to fly?

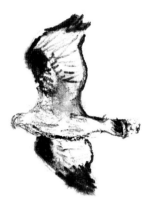

Nov 23 ('98). Sun till tonight—chipmunk out today on seed shelf, along with the chickadees.

Saw goldeneyes at lake yesterday, stark black and white males flying over by water treatment plant near Button Bay. A huge heap of zebra mussels next to plant. We see them in the water, too—thick. Also a last garter snake sunning on the path to Button Bay.

Wintering hawks everywhere. A rough-legged with dihedral in flight; also saw this species "kiting" over a field in Plainfield and in the Champlain valley.

Nov 29 ('98). Sun—insects about. Snow melting, grass in patches. Tiny insects mating in an up-and-down dance, 3–5 feet off the ground in the sun. 2 types: one, mosquito-like, with long legs hanging down, the others tiny winged light tan round sort of flying creature—all sharing the space with us here in the backyard in a warm spot.

Over in the garden by the kale and broccoli—still being harvested—there are new spider webs on the pea supports—but a search finds everything so small, so delicate, so ephemeral, that the idea of a spider spinning webs this late in the year evaporates with the warmth, as sun slips behind the balsam fir to our west. It's suddenly cold and time to gather up and go inside.

Then out with large-mouth ball jar to catch one of the still active larger flies—into fridge—in about 15 minutes, quiet enough to look with hand lens through jar and here's what we see . . . from memory, as we right away took it back for release before nightfall.

Winter Solstice

Going from fall into winter is an imaginative, sensory time for me. In the midst of a physical slowing down and pulling in, I experience a curious opening up of my feeling—as opposed to thinking—side. So, in that spirit, I offer a poem here instead of an essay.

<div align="right">

—C.W.J.

</div>

The longest night,
the shortest day,
the bitter cold,
our farthest tilt away from
the sun in our orbit of the year.
The calendars call it
the beginning of astronomical winter;
we may know it another way,
symbolic winter, the darkest time
in our souls.

But winters do not start
so suddenly;
they creep down and
weigh upon us
like glaciers.

Last month, even the month before,
the snows barely brushed by
at night, faded by day.
Then the searing snap
of tall, leafless trees
gave a sharper warning.
Now, this night, it is so deadly cold,
the blackness honed icy sharp.

I step outside for wood,
no coat, no gloves, no hat,
improper shoes,
and feel my heat rush
outward, skyward, almost sucked up
by the vacuum of night.
The stars stab at me.
My breath rises thinly,
curling into itself and
hanging a crystal veil
around the moon.

Seconds, ticked by shivers,
clock my urgent trip
from kitchen door to woodpile.

As I hurry I glance into the woods
and just catch the shape of deer,
huddled statues,
awaiting the more frigid hours
yet to come.
They too are freezing,
seeking warmth from each other,
under ragged tents of conifers.

I grab some chunks of maple
and go back, through the door,
footing it closed behind me,
easing into the glowing, heated room,

behind windows curtained against
a view either out or in.

The deer are out, I am in.

Our separate winters began
some time ago,
but we will come around again,
in time,
tilting toward the light
of our common spring.

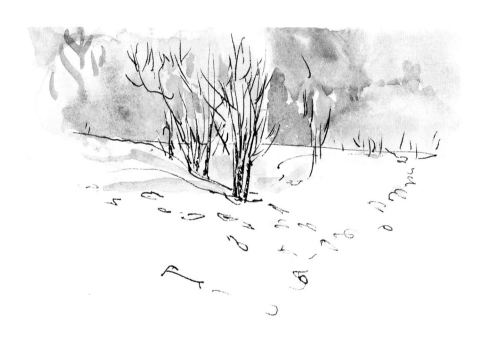

DECEMBER

As the days get shorter and shorter:

- Winter solstice.
- The darkest month.

- Ducks still passing south—stopping on inland waters—coots, mallards, and mergansers.
- Sea ducks and diving ducks on the coast—great time to see them with binoculars or scope.
- Seals migrating south to wintering locations along the coast—weekly seal cruises start from the Cape.
- Red winterberry brightening up wet areas.
- Great horned owls begin to case out potential territory towards the end of the month.
- Empty bird nests for the viewing.
- Last moths and other insects on warmer days early in month.
- Low sun all day creates a sunset-like atmosphere and light, particularly beautiful on snow.
- Time to pick bouquets of various evergreens and berries.
- Also, dried weeds or oak leaves for identification or to enjoy.
- Start of winter tracking season in snow belt.

Dec 3 ('98). Gray, warm, windy too, later. Moths, flies, other insects. The blue jay has perfected his red-shouldered hawk call, *Keer! Keer! Keer!* In the evening either a raccoon or fisher is *chur-r-r-rr-ing* loudly below the house.

Dec 4 ('98). En route to Maine coast to see waterfowl. 60 degrees, sunny,

strong south wind. A great laundry-drying day. Small puff-wisp clouds evaporating as they sail overhead. The small ones are gone by the time they travel to the horizon. Bare hills soft grays and warm neutrals. White Mountains snow-covered.

Dec 5 ('98). Dodge Point Natural Area, Damariscotta, Maine. 30 degrees, sun and clouds, light wind. Tidal river—black ducks, hunters on the point. Meet a man at 8:30 AM with two bags of soft-shelled clams, small black and tan.

A pair of goldeneyes (whistlers) settle in, just off shore. Hunters launch their boat, and the ducks lift off as a female red-breasted merganser flies back towards shore.

Black ducks and goldeneyes are flying high, buffleheads lower. Both buffleheads and whistlers come closer to shore when the tide comes in, out when it goes out.

Suddenly ducks are up everywhere in response to some shots from the point. Then quiet.

Black ducks, goldeneyes, buffleheads, a merganser (female), and one loon —here in winter, on this tidal river.

On the way back, the old farm road is frequently bordered by mats of trailing arbutus. Trees—red oak, planted red and scotch pine—understory full of beaked hazelnut.

Hockamock Reserve. Noon. Puffins here in summer, on the islands at Egg Rock. Later a black guillemot in winter plumage—very light with black wing patches—a small auk. Four oldsquaws with scoters. The *ow-outtle-ow!* we've been hearing could be these. *Ow-ow-it! Ow-ow-it* and *yelp!* A musical yodel in from the ocean.

Dec 7 ('98). Vermont. 60s, overcast, very windy. Cold front with snow coming in from the WNW. Berlin Pond south end. Just under 40 coots and a number of mallards, also some mergansers. Gloves necessary for sketching as temperature seems to have dropped already.

The coots are black, very round bodies and head, and extremely active in the water. They stay together. Through the binoculars I can see a largish light beak; even from a great distance this shows up, like a facial headlight. Some are standing on a small shrubby spit of land. It's getting sharply colder.

Mallards quacking loudly, sailing sedately by comparison. Larger than the coots. Mallards now mingling with them. Too cold to stay.

Lovely, small, tightly constructed nest of spider webs and delicate plant fibers, 4' high over water in a winterberry shrub. Many of the branches have been cut for the red berries.

Dec 8 ('98). Colchester. Mixed sun and clouds AM. Snow comes in from NW by afternoon. 2 buffleheads out in the cove. Grey, wind-swept, cold. Call from Anna about crows mobbing/calling—its carrion time! For all the animals a feast of findings as many hunters return deer hides and cleaned carcasses to the woods along back roads. First time skiing—wet, sticky, but good!

Dec 9 ('98). Snow. E. Montpelier wakes up to a fluffy 2". A fox or coyote has perfect-stepped alone along the Canine Express. Tracks everywhere—porcupine, etc. still about in mild weather. White pine laden with snow.

Later, the acrid smell of fox, on a stump where he/she walked over the stump before end of snow, and urinated (more like a male, but unclear).

Melting fast, must be about 33 degrees, with sun popping in and out of the clouds.

Pick evergreens for the kitchen table (scotch pine, white pine, cedar, hemlock), add highbush cranberry berries and some red osier twigs.

Dec 10 ('98). Sun and clouds, around the 30s. See rough-legged hawk again on fencerow tree and in air.

Dec 11 ('98). A sticky snow covers everything. I ski out to Clark's. All patterns transformed into their essential forms, sometimes in surprising ways. The short "double standard" days are here:

- from inside, or from the car, too windy, too gray, too dark.
- but from the outside, fresh, lovely muted colors, comfort, beauty, joy.

"Snow snakes" form as temps rise; goldenrod with hanging glacier; puffs of snow relaxing on the wild plum tangle; woodferns transformed.

And colors, rays of sun on a dark afternoon:

- light warms the edges of the trees.
- sun catches the beech leaves.
- a small yellow meadow blazes with light. I can just see parts of it through the trees.
- wild apples are gold and crimson, with snow caps and puffs.

- ALTERNATING GREEN + PALE RUST FERNS

These colors in the woods on a hill where Hay-sented and (spinulose) wood fern alternate. The sun is spilling down the slope and backlighting the Haysented - dried a ~~rouge~~ subtle dusty rose, and the wild green of the (spinulose) wood fern —

CHECK LATER) Ferns growing in brownish rose areas:

Ferns growing in green swaths:

NESTS EVERYWHERE

Dec 2. 98
Two small nests found near home -
The light one, I know was a song sparrow or chipping sparrow
The dark one, I'm guessing a yellowthroat (warbler) *
because the area where the nest was would be a good spot for a hearing "witchity witchity witch", in summer!
But now to check our nest field guide - which never seems to have the right pictures or information to help -

SIDE VIEW OF FLAT CEDAR "NEEDLES"

How did cedar evolve to have such FLAT scale-like needle-leaves? Impossible to draw in a quick sketch.

SAME COLORS IN A PIECE OF CEDAR BRANCH LYING ON THE PATH - must have fallen off during the wind last night.

this curved

½ size

actual size

cedar seeds - taste strongly of the tree. see Nov 29.

STRONG TASTE OF CEDAR SEED NOV 29.

Seeds have been on ground now for weeks - I first noticed them on Nov. 4th, the day back from New Mexico. Also drew pods on Sept. 6 this year.

2" inside
1" deep inside;
1¾" deep outside

Fine dark plant fibers held together by strong solid (spider web?) RIGID THIN CONSTRUCTION
3x2½" oval -

⅓ actual size

4 x 3" oval
2" deep outside
1¼" deep inside
1¾" inside diam.

Song Sparrow -
This one full of soft white downy plant (milkweed etc.) fibers and delicate reddish white pine needles.

Both of these were disturbed - the song sparrows actually knocked to the ground from a 6-8 ft high maple, the young gone - the other found today, sideways in a spirea bush, about 2 feet or less, high, in a moist, shrubby edge.

Peterson Field Guide to Nests:

yellowthroat - small dark nest not right - yellowthroat's is, according to Peterson, bulky, large for a small bird of coarse grasses

Song Sparrow - grasses, leaves, etc sounds all wrong, but can find no nest in this book to match these! As so often the case with nest identification - best perhaps to just enjoy the few that do come my way.
the beauty of

Dec 11. A snow *sticky* covers everything. I ski out to Clark's.
All patterns transformed into
their essential forms, sometimes in surprising ways.
The short "double standard" days are
here:

Golden rod
with hanging
glacier

from inside,
from on the car...too
cold, too windy,
to grey. too dark.

but from outside...
fresh, lovely muted colors,
comfort, beauty, joy!

Snow snakes, as temps
rises.

puffs of snow relaxing on
the wild plum tangle —

wood ferns
transformed.
A stray
moment of sun
finds us in the
woods.
3:30 pm

Dec 12 ('98). 20 degrees, sun. 2nd day skiing on our "rock" skis, old enough that we feel OK about clomping over bare spots. More snow shapes: woodland sedges, mosses a bed of white rounded tufts, grasses flying frost flags.

Dec 18 ('98). Sun and snow. A dry 20 degrees. Clark's hill. AM. Wave patterns from snow blown out of the W, creating a compass. Wave patterns still being formed in the fine dry snow—I sit and wait for a "sand storm" effect. It comes with a burst of wind, the snow moving, piling up in ridges running N–S.

MORE SNOW SHAPES

mosses a bed of white rounded tufts

Grasses flying frost flags.

Dec 21 ('98). Warms to above freezing at dusk. We set the candle lanterns, bring out the food and eggnog, invite in friends and family, and light the bonfire. The longest night! Late in the evening as we head to bed, a light rain. Length of day 9 hours, 4 minutes.

Dec 22 ('98). A cold front races in from the NW with high winds. The temperature drops from the 40s at noon to the teens by evening. Length of day 9 hours, 4 minutes, but it's not really light before 8 AM and it starts getting dark at 3 PM.

Dec 23 ('98). Sun again, rising in the clump of hardwoods just south of the first white pine. Cold, windy, but you can find warm places in the sun, out of the wind. Out 20 minutes before I warm up and begin to see things. The poor tracking snow still has ample record of the thaw of Dec. 21. Ruffed grouse, a big fisher—the mother of this summer? Raccoon and many deer, rodents; also scales and seed of conifers again on the snow. Hemlock cones coming down and in the scotch pine woods a new seed, like balsam but a much wider, more golden wing. This from memory as I was too cold to stop then. AND am getting cold now and must move again, but it's good being out.

Dec 24 ('98). Length of day every day the same, 9 hours, 4 minutes. But tomorrow will be the first day of increased length. From the perspective of watching day by day, now is the time we stop our tilt away from the sun, before we start tilting back. I watch this process carefully every year, noting the length of days and nights, as if I had some personal part in the sun's return.

Dec 25 ('98). Christmas dinner with family. It's warm enough to sit in the sun on the porch at the Trabulsy's, drinking tea.

Dec 30 ('98). Snow, but only ¾". Temperature dropping to "normal" for

this time from a balmy week in the 30s. Crows passing over and visiting briefly. A great din of the entire flock at dawn the last few mornings. Where are they and what are they mobbing, carrion or predators? An owl setting up territory or a dead deer? There is a frost on everything today which lasts into early afternoon. I ski to Clark's but don't make much progress, as I stop to admire the frosted landscape many times.

Dec 31 ('98). Go back to see if the Cooper's hawk (from Dec 29 drawing) is still around. Some warm creature has been here—the snow is gone from branch. Snow is a wonderful revealer of what was here recently.

Cold, 5 degrees, light wind. Sun. We ski to Clark's again around 1:00. Always staying out of wind except for last dash down trail on way home. It's warm and lovely in the sun on sheltered Butternut Flats.

New Year's bonfire at my sister DD's. Very cold. Stuffy's bonfire starts with the sky clear and stars shining. Small flakes of frozen moisture condensing out of the clear sky (like dew in summer), while the sparks from the fire shoot up into the sky. By 9:30 or 10:00 as it dies down, a squall has moved in, bringing 2 inches of snow in a short time.

Dec 31 ('99). The bonfire has died down. We're all quiet, listening for the stroke of midnight in towns around us. Then a great pealing of bells from near and far announces the new millennium.

Dec. 13. En route to Burlington,
sunny, 30's NO WIND. Frost
On trees + Grasses. Last night
a crescent moon waning.
The earth tilted almost as
far away (for the N half
of earth!) from the sun,
As it will get. Sun rising
way S. now. no new snow
but a good 2·3 inches
still on the ground..

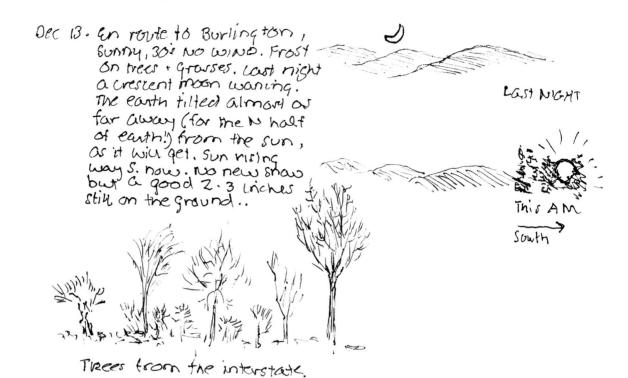

LAST NIGHT

This AM

South →

Trees from the interstate.

Dec. 15. Town Trail-Lodge Rd - Kinglets heard - Sun (400) - snow in patches.
Finally locate the town's big crow flock, over on Fairmont Farms.
From the town trail they are visable across the field and in the
woods. I watch awhile with the binoculars. About 200 birds
rest quietly in tree tops between forays to the field for feeding (?)
and re-locating themselves periodically. Alot of questions about
crows from montpelier people since fall/winter flocking;
and recent flock feeding at sites of deer-kill.

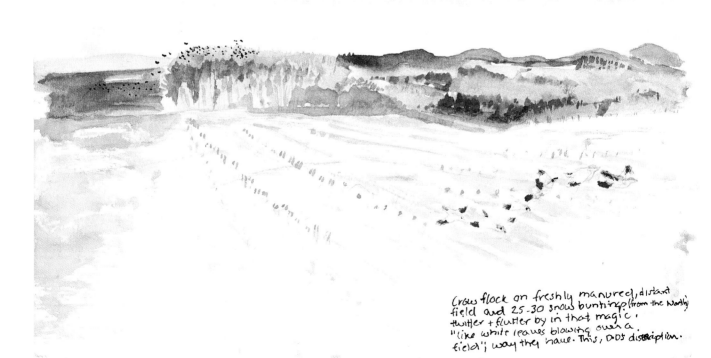

Crow flock on freshly manured, distant
field and 25-30 snow buntings (from the North)
twitter + flutter by in that magic.
"like white leaves blowing over a
field", way they have. This, DD's description.

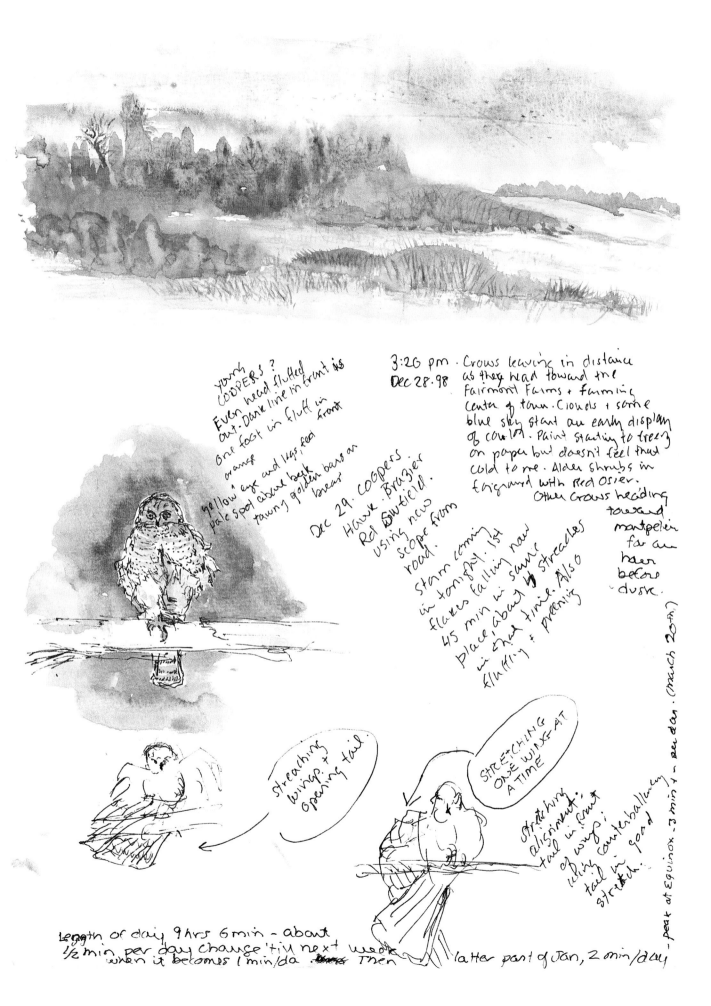

young?
COOPERS?
Even head fluffed
out. Dark line in front is
one foot in fluff in
front
orange
Yellow eye and legs feel
pale spot above beak
tawny golden bars on
breast

Dec 29. COOPERS
Hawk. Brazier
Rd Burfield.
using new
scope from
road.

storm coming
in tonight. 1st
flakes falling now
45 min in same
place. about ½ streables
in that time. Also
fluffing + preening

3:20 pm · Crows leaving in distance
Dec 28·98 as they head toward the
Fairmont Farms + Farming
center of town. Clouds + some
blue sky start an early display
of color. Paint starting to freeze
on paper but doesn't feel that
cold to me. Alder shrubs in
foreground with Red Osier.
 Other Crows heading
 toward
 montpelier
 far an
 hour
 before
 dusk.

streching
wings +
opening tail.

STRETCHING
ONE WING AT
A TIME

stretching
alignment.
of wing;
tail in front

wing counterbalancing
tail in good
stretch.

peak at Equinox. 3 min. per day. (March 20th)

length of day 9 hrs 6 min - about
½ min per day change 'till next week
when it becomes 1 min/da. Then latter part of Jan, 2 min/day

Appendixes

Natural Communities of New England

For its relatively small size, New England (coincidentally, about the same as that of Old England) is a place of extraordinary diversity of geology, topography, climate, and biology. From 6,000-foot peaks to the Atlantic Ocean, from forests to wetlands to sandy barrens, from rivers to lakes, it has rich visual texture, and an equally rich ecological one. To characterize this landscape (and seascape) in a way that captures the mix and vitality, and yet not overwhelm with volume or detail, is a challenge.

However, we have attempted to strike a middle ground, describing rather general, easily recognizable, yet ecologically organized "natural communities," drawing on and modifying other classification categories. Within the larger groupings, the communities are listed as they generally, but not strictly, occur from the tops of mountains down to the ocean and/or north to south.

Broadly, natural communities fall into the following categories:

UPLANDS: Moderately to well-drained areas on mineral (nonsaturated, nonorganic) soils. Some are coastal, adjacent to the ocean and affected by saltwater, either by regular tidal inundation or periodically by spray.

BARRENS: Areas with tree canopy cover less than 25%. In other words, they are very open, with trees (if present) spaced well apart.

WOODLANDS: Areas with tree canopy cover of 25–60%.

FORESTS: Areas with tree canopy cover greater than 60%.

WETLANDS: Areas where water is above, at, or near the ground surface long enough to promote formation of hydric (waterlogged and oxygen-poor) soils and growth of hydrophytic (water-loving) plants. Soils are always saturated, though water levels in some may fluctuate considerably over the year. Includes water bodies such as ponds and lakes.

For each natural community some "notable seasonal events" are listed, as

they occur at an approximate mid-latitude, mid-elevation, inland range of locations in New England, coarsely demarcated as:

SPRING: March–May
SUMMER: June–August
FALL: September–November
WINTER: December–February

Each season is further divided into early (first month), middle (second month), and late (last month).

Of course, exact timing of events—flowering, return of migrating birds, peak of fall colors, and so forth—depends on latitude, altitude, topography, proximity to large water bodies, unusual environmental conditions (excessive heat or cold, wet or dry, etc.), and other influences. For example: New England's spring, if gauged by flowering and bud break, generally progresses north about 100 miles a week, occurs sooner at lower elevations, on warm south-facing sites, adjacent to large lakes, in warm weather, and so forth.

That we single out certain events as "notable" is not to imply that the countless others, big or small, are not. Rather, our purpose is to whet the appetite for observing all kinds of natural events in natural places, through some of the more dramatic examples. This is much the same approach as gaining support for lesser-known, even obscure endangered species such as Jesup's milk-vetch or dwarf wedgemussel through the well-recognized and striking, like the bald eagle or eastern mountain lion. Our hope is that people, by whatever means, will come to notice the subtle as well as the spectacular, the plain as well as the flashy, and see them all as essential elements of an entire picture.

Uplands

ALPINE TUNDRA

Description: Mountainous lands above tree line (approximately 4,000 feet and higher) with a very short growing season, severe weather, and thin organic soils, with arctic-type plants such as alpine bilberry, Bigelow's sedge, mountain sandwort, diapensia, and three-toothed cinquefoil. Different kinds of alpine-arctic plant communities exist on high, steep cliff faces of many northern mountains.

Distribution in New England: Occupies the higher ridgelines and peaks in Maine, New Hampshire, and Vermont (most extensive on New Hampshire's

White Mountains and Maine's Mount Katahdin, least on Vermont's Green Mountains).

Notable Seasonal Events: Alpine wildflower bloom on tundra (late spring–early summer); peregrine falcon nesting in cliffs (spring–summer); hawk migrations along ridges (fall); fall colors of heaths, such as bilberry, blueberries, and huckleberries (fall).

BOREAL (SPRUCE-FIR) FOREST

Description: The evergreen forest of the north country, dominated by red spruce and balsam fir, with a sparse understory due to dense shade, and with poor (organic layer is very thin), acidic soils. Home of moose, lynx, snowshoe hare, spruce grouse, and black-backed woodpeckers.

Distribution in New England: Red spruce and balsam fir occur as unbroken forest in much of the higher elevations of the mountains, usually about 2,800 feet to tree line, which is about 4,000 feet (higher as one goes south). White spruce boreal forests grow on the rocky coast and islands of Maine, while those of black spruce do so along the ridges of the Mahoosuc Range in Maine and New Hampshire. Black spruce and tamarack grow in association with many bogs throughout the region.

Notable Seasonal Events: Early breeding or northern boreal birds (late winter–spring); warbler migration (spring, fall); moose on the move (spring, fall); mushroom emergence (late summer–early fall).

NORTHERN HARDWOOD FORESTS

Description: Forests of hardwood (deciduous) species, dominated by sugar maple, beech, yellow birch, and a softwood component, hemlock. Much regional variation in composition. They often have several "layers" (canopy, sub-canopy, sapling, seedling), several sizes and ages of trees, and considerable shrub and herbaceous ground layers.

Distribution in New England: Throughout the region, especially in central–northern portions, up to moderate elevations, and on fair to good soils. There

are various "associations" (different assemblages and percentages of species), depending on geographical location, site characteristics, soils, land use history, and other variables.

Notable Seasonal Events: Maple sugaring (late winter–early spring); woodcock displays in clearings (early spring); songbird arrivals (early spring); mole salamander migration and wood frog mating (see Ponds and Lakes); early woodland butterfly flights, such as mourning cloak, spring azure (spring); woodland spring wildflower bloom (spring); warbler migration (spring); mushroom emergence (late summer–early fall); fall colors (early–midfall); owl breeding (midwinter–early spring).

TRANSITION HARDWOOD FORESTS

Description: They are called "transition" hardwoods because they are intermediate in composition between northern hardwoods and the oak-hickory hardwoods of the southern Appalachian Mountains (see Central Hardwood Forests). Species composition is variable, depending upon climate and site characteristics—generally, northern hardwood species predominate in cooler, moister areas, while central hardwood species do so in warmer, drier ones. The trees are generally wider spaced and understories scantier than those of northern hardwoods, giving these forests a more open feel, with more sunlight penetrating to and drying the soils.

Distribution in New England: In the relatively warmer and somewhat drier regions of New England, either in valley lowlands or, especially, on the lower slopes of the Taconic, Berkshire, and southern Green Mountains. They are rarer as one proceeds north, becoming more restricted to warmer south-facing slopes until they disappear completely.

Notable Seasonal Events: Timber rattlesnake dispersal from winter dens (mid–late spring); male gypsy moth flights and female egg-laying (summer); see also Northern Hardwood Forests.

CENTRAL HARDWOOD FORESTS

Description: The central hardwoods have their main distribution well south of New England, into Georgia along the Appalachian Mountains. However, they

do extend into southern New England, though usually as isolated (disjunct) stands. They grow on many types of terrain, from lowlands to relatively steep hillsides. Oaks and hickories predominate, with regular appearances of tulip poplar, sassafras, flowering dogwood, and others.

Distribution in New England: Sporadic occurrence from mid-Connecticut and Rhode Island south, but also rarely in isolated pockets in Massachusetts, extreme southern Vermont, and the southern coastal plain of New Hampshire.

Notable Seasonal Events: Flowering dogwood blooming (early spring); see also Transition Hardwood Forests and Northern Hardwood Forests.

PITCH PINE SCRUB OAK BARRENS

Description: Barrens with some tree cover. Primarily occur on the coastal plain in New England, with thin, nutrient-poor, and acidic soils atop deep sand deposits. Trees, mostly pitch pine and scrub oak, are widely spaced, stunted, and contorted, especially near the coast. The understory is dominated by heath shrubs such as black huckleberry, bearberry, and lowbush blueberry. Variations of the barrens, occupying more isolated areas in the interior, are associated with sand deltas of postglacial lakes such as Lake Vermont (larger precursor of Lake Champlain) and Lake Hitchcock (precursor of the Connecticut River).

Distribution in New England: Barrens along the coastal plain from mid-Maine south; woodlands spotty inland. Due to their desirable locations and soil quality for housing, they have been much reduced, fragmented, and altered.

Notable Seasonal Events: Vocal breeding birds (warblers, whippoorwill, night-hawk, towhee, etc.) (spring–summer); heath bloom (spring); butterfly flights (summer); blueberry ripening (summer).

SANDY COASTS (BARRIER BEACHES AND DUNES)

Description: Barrier beaches are built of immense quantities of sand, which currents paralleling the coast ("longshore" currents) have carried and de-posited over long stretches of time. Tides and currents constantly smooth and rework the beaches, while wind and storm waves mound the sand into dunes

behind them. The continual erosion and deposition constantly reshapes the coast—the outer, eastern flank of Cape Cod, for example, has eroded westward several hundred feet since colonial days. The barrier beach has two zones: the intertidal, between mean high and low tides, and the wrack, where dead sea weed collects in thatched rows between mean high and the highest ("spring") tides. The dunes may also have distinct areas, such as swales, salt ponds (isolated former salt marsh), and protected pockets of maritime forest in contact with fresh groundwater. Each zone has its distinctive plant and animal communities.

Distribution in New England: From mid-Maine south through Massachusetts, Connecticut, and Rhode Island. Most extensive and unbroken, for miles in places (except for tidal flats and rocky headlands), along the outer coast of Cape Cod.

Notable Seasonal Events: Oystercatchers active (spring–summer); piping plover and terns (least, roseate, arctic, common) nesting (spring–early summer); migratory shorebirds (late summer); migratory songbirds in maritime forests (early spring, late summer–early fall); tree swallow migrations (late summer–early fall); eastern spadefoot toad breeding (summer); migrating bats (early–midfall).

COASTAL HEATHLANDS

Description: These are shrub lands along in the coastal plain inland from the barrier beaches and tidal estuaries, grading into the pitch pine–scrub oak barrens farther inland. Often they occupy the knolls of sandy bluffs and the dales behind them. They are regularly exposed to high winds and airborne salt, and the vegetation is dominated by scrubby heath shrubs, false heather, bayberry, grasses, and lichens. Trees, if present, are stunted and gnarled.

Distribution in New England: In localized areas along the coast from Maine south, especially Cape Cod and its islands. They have been lost or damaged by human activity, especially development, roads, and conversion to other uses.

Notable Seasonal Events: Heath bloom (spring); bayberries ripe (mid–late summer); butterfly flights (summer); tree swallow migration (late summer–early fall); heath fall colors (early–midfall).

Description: Where ancient bedrock stands against the sea. These are tough places for living things, exposed directly to the pounding of storm-driven waves, drying sun and wind, and biting cold. There are several zones, depending on the frequency and duration of flooding. (The zone between high and low tides is called the "littoral.") Highest is the spray zone, with crusty lichens and, in cracks where a bit of soil has accumulated, a few flowering plants such as seaside goldenrod or beach pea. Next lower and submerged only at high tides is the black zone of cyanobacteria (dark, seaweed-like in appearance). Below that is the periwinkle-barnacle zone experiencing about equal times of inundation and drying, followed by the brown seaweed zone (two species commonly called wrack or rockweed) exposed at low tide, and the Irish moss zone exposed only during the lowest monthly spring tides. Lastly, the kelp zone is submerged most of the year, except during the extreme low tides of the two equinoxes.

Distribution in New England: Virtually unbroken in Maine, extending from the Canadian border south below Portland. From there it appears in occasional stretches along the rest of the New England coast (e.g., Cape Ann).

Notable Seasonal Events: Harlequin ducks, purple sandpipers feeding (winter); snow buntings visit (winter); tide pools active (all year, especially in spring–fall).

HUMAN-CULTURED AREAS

Description: Yards, agricultural fields, roadsides, and even woodland parks have highly modified or essentially replaced the natural communities once there, bringing with them—intentionally or otherwise—a high percentage of nonnative species more suited to the newly created, usually more open, conditions. It is estimated that a third or more of all plants in many such areas are nonnative species.

Distribution in New England: Anywhere humans settle will demonstrate such changes. Obviously, the most severe transformations happen in the most densely settled areas. Proliferation of roads has also greatly affected natural communities, often cutting through them and literally providing avenues for nonnative species to enter and colonize.

Notable Seasonal Events: Woodcock displays (early spring); snow and Canada geese feeding in croplands, fields (early spring, fall); field wildflower blooms (spring–fall); bobolink, meadowlarks breeding (summer); butterfly flights in fields and shrubby areas (spring–summer); raptors hunting in open fields, such as kestrels, red-tailed hawk (spring–fall): bats feeding at night (sum-

mer); berry and apple picking (summer–early fall); land bird migration (early fall); insects (crickets, tree crickets, grasshoppers, katydids, cicadas) singing (summer–early fall); monarch butterfly migration (late summer–early fall); northern raptors visit, such as snowy owl, hawk owl, gyrfalcon, rough-legged hawk, etc. (winter).

Wetlands (Including Aquatic Areas)

STREAMS AND RIVERS

Description: Surface waters flowing in clearly defined channels. Streams, being smaller and higher in the uplands, generally flow or enlarge into rivers (or other water bodies). Mountain streams have a high gradient and their waters rush and tumble downhill, carrying sands, silts, clays, and organic matter with them; the heavier gravels and boulders remain as the bottom. The wider, slower rivers accumulate some of these materials. They are also warmer in summer, due to the greater sun exposure (slower flow and the tree canopies not arching completely over). Streams and rivers at lower elevations move quite slowly, accumulate considerable muck, and may meander over the terrain. Vegetation instream is usually scant, not being able to withstand the rushing waters, but riverside—and occasionally within river—vegetation can be distinctive and diverse. Aquatic insects, aquatic stages of terrestrial insects, amphibians, and fish are especially abundant and noteworthy members of these communities. The associated land and cover ("riparian" areas) is also important to many terrestrial animals; they can move, feed, drink, and rest there in the security of waterside vegetation.

Distribution in New England: Throughout the region, from countless, small upland streams in the mountainous areas to those winding from coastal ponds to marine estuaries in the coastal plain to major tributaries of larger lakes and the ocean.

Notable Seasonal Events: Black fly and stonefly emergence from streams (early spring); fish spawning runs, such as shad, Atlantic salmon, alewife, smelt, steelhead, walleye, etc. (early–midspring); mayfly and other aquatic insect hatching (spring); dragonfly flights (summer–fall); migratory shorebirds (late summer–early fall); bald eagle visits (large rivers, winter).

PONDS AND LAKES

Description: Water bodies in basins of various dimensions, where water is impounded behind a topographical constriction, beaver dam, sand and gravel outwash, or some other natural barrier. Ponds are shallow and the water is not stratified into layers, with vegetation growing across the entire bottom. Lakes are deeper, stratified into two zones that mix only during spring and fall "overturn," and have rooted vegetation only to a certain depth along the margins (littoral zone). Vernal pools are small, shallow, isolated woodland "ponds" that fill in spring with snowmelt, then slowly dry out in summer. Despite their ephemeral nature and small size, they are home to aquatic invertebrates and are critical breeding areas for amphibians, especially wood frogs and

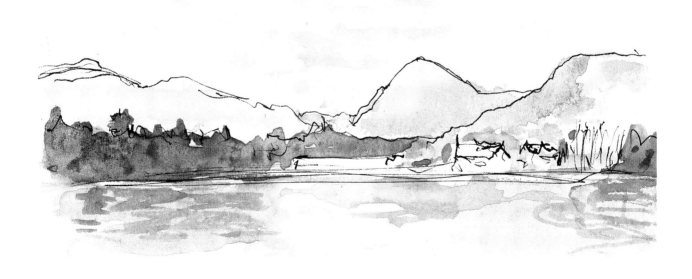

the subterranean mole salamanders that in spring emerge and migrate overland to their ancestral sites.

Distribution in New England: Throughout the region.

Notable Seasonal Events: Mole salamander breeding in vernal pools (early spring); hawks migrating along larger lakes (early spring); frogs singing (early spring–early summer); loons breeding (spring–early summer); dragonfly and damselfly flights (summer–fall); waterfowl (all year, especially abundant in migration in fall); bald eagles in migration along larger lakes (winter–early spring).

PEATLANDS (BOGS AND FENS)

Description: Wetlands with plants growing on partially decomposed organic soil (peat) accumulating in very wet, poorly drained environments, such as kettles or shallow, isolated bays of lakes. (In very cold or moist maritime environments, peatlands may build beyond the basin, into raised or blanket bogs and/ or patterned fens.) "Bogs" receive water and nutrients only from precipitation. They are highly acidic, mineral-poor, and oxygen-poor. "Fens" are less so since they have contact with enriching ground or surface waters. Bog indicators are such species as sphagnum mosses, dwarfed heath shrubs (leatherleaf, Labrador tea, etc.), black spruce, and others, while fens are more diverse, with sedges, orchids, carnivorous plants, northern white cedar, and others.

Distribution in New England: In more southern and inland locales peatlands are small and restricted to basins. Maine, with the most and largest peatlands in New England, has raised and blanket bogs and patterned fens in northern and north-maritime ("down east") regions.

Notable Seasonal Events: Heath bloom (early–midspring); orchid and pitcher plant bloom (late spring–early summer); dragonfly flights (summer–fall); fall colors—heaths, tamarack, sedges, bog goldenrod, etc.; open fens with boneset, joe-pye weed, turtlehead, etc. (late summer–fall); cranberry ripening (fall).

FLOODPLAIN FORESTS

Description: These are forested wetlands, usually occurring as linear river terraces, where regular (usually spring) flooding from snowmelt in the uplands

deposits clay, silt, sand, and organic matter. As wetlands, they fall somewhere between upland and swamp in wetness, since they may dry considerably after floodwaters recede and remain dry all summer. Common species are red maple, silver maple, black willow, and box elder. The understory is often dense and lush with ferns, other herbaceous plants, and shrubs.

Distribution in New England: Regionwide south of the spruce-fir zone. Their former extent has been much reduced due to conversion to agriculture and development along rivers.

Notable Seasonal Events: Ostrich fern fiddleheads, wild leeks emerge (early–midspring); wood ducks, mergansers in migration (early spring); tree canopy songbirds active (spring–early summer); herons breeding in rookeries (early spring–summer); fall colors, red maple, silver maple, willows, etc. (fall).

FRESHWATER MARSHES

Description: Marshes are wetlands dominated by herbaceous vegetation— cattails, sedges, water lilies, and the like—rooted in the soil and growing up through the water, either as floating-leaved or emergent plants. They often form along ponds, in shallow bays of lakes, and in oxbows of slower rivers, and are among the most biologically productive natural communities. The density and diversity of plants here offer homes, hiding places, and feeding areas for many animals, from invertebrates to mammals.

Distribution in New England: Throughout the region. As much as 50% or more of New England's freshwater wetlands have been lost or severely altered by dredging, draining, and filling for development and agriculture. Many, but not all, states now have wetlands protection programs.

Notable Seasonal Events: Shorebird migration (spring, late summer–early fall); waterfowl migration (early spring, fall); frogs and toads calling (early spring–early summer); fish spawning, pike, pickerel, etc. (early spring).

SWAMPS

Description: Wetlands dominated by shrubs, trees, or both, rooted in the saturated ground, and their trunks rising through the standing water (when it's

there), their crowns fully in the air. They often have thick understories of ferns and shrubs growing on hummocks, and are important breeding, nesting, and nursery areas for many animals.

Distribution in New England: Red maple swamps are the most common, throughout the entire region. Silver maple–swamp white oak–green ash swamps are most frequent in the Champlain Valley of Vermont, but extend southward along major river valleys in Connecticut, Rhode Island, and Massachusetts. Northern white cedar swamps are in limestone areas in the northern parts of the region. Red spruce–balsam fir–tamarack swamps are more restricted to the north. Black spruce swamps are mostly in northern, wet, acidic, cold areas within spruce-fir forests. Hemlock swamps occupy cool, moist lowlands or ravines. Atlantic white cedar swamps are coastal, from mid-Maine down.

Notable Seasonal Events: Cavity-nesting ducks (wood duck, mergansers, goldeneyes) begin nesting (early spring); songbirds active (spring); red maple swamps in color (early spring, early–midfall); bald eagle nesting (later winter–early spring).

SALT MARSHES

Description: Wetlands along low-gradient, relatively flat expanses of sandy shoreline between high and low tides. The classic salt marsh has three zones related to frequency of tidal inundation and salinity: inundated twice a day at high tide is the "low marsh," dominated by saltmarsh cordgrass; farther inland and flooded only during the highest (spring) tides is the "high marsh," dominated by the shorter saltmeadow cordgrass (also called salt hay for the awry appearance of its tufts); farthest up, away from normal tidal influence but regularly subjected to salt spray, is a narrower zone of several salt-tolerant plants such as common reed, freshwater cordgrass, and marsh elder. In reality, the salt marsh often is not so neatly arrayed, but is a convoluted, dynamic network of shallow pools, mudflats, sandbars, and winding tidal creeks, especially noticeable at low tide. This meeting ground of sea and land is one of the most biologically rich ecosystems on Earth, where countless species live for all or part of their lives. It is a nursery for innumerable invertebrates and young fish, which in turn become food for other fish, birds, and mammals of the ocean and bordering land.

Distribution in New England: Along the coast throughout, spottily in the rocky northern coast of Maine, more frequently in the sandy shores of southern New England. Many salt marshes have been destroyed, altered, or otherwise damaged by development and other human activities.

Notable Seasonal Events: Horseshoe crab breeding (midspring–early summer); coastal birds active, such as black ducks, bitterns, Canada goose, brants, raptors, shorebirds (all year, especially abundant in spring and fall); tree swallows migrating (late summer–early fall).

OCEAN (COASTAL)

Description: Marine waters of the continental shelf between the limit of low tide and the profundal (deep ocean) zone. The ocean waters are generally cold in the north, somewhat warmer south of Cape Cod where the Gulf Stream swings close as it moves northeast. They are subject to powerful storms, which can create turbulent, tempestuous seas. Tides vary greatly along the coast: nearly 30 vertical feet against the headlands of northern Maine and as little as 2–4 feet along the sloping coastal plain of southern New England. Many animals visit or live permanently in the coastal ocean, from microscopic zooplankton to fish to seals to gigantic whales, from clams buried in the substrate to jellyfish floating in the currents to seabirds riding the high waves and plunging for fish to eat. The shallower "banks" (e.g., Grand Banks off Maine, Georges Bank off Massachusetts) are especially important biological oases within the deeper waters.

Distribution in New England: Off the entire coast (Gulf of Maine, including around Cape Cod and through Long Island Sound), from the northeastern tip of Maine to western corner of Connecticut.

Notable Seasonal Events: Fish runs, such as bluefish, striped bass (spring, fall); whales migrating (mid-May–October, mostly summer); bioluminescent plankton (summer); harbor seals (all year, mostly winter); marine turtles cold-stunned, stranded (late fall–winter); pelagic birds, such as gannets, storm petrels, razorbill, etc. (all year, mostly summer); gray seal pupping (midwinter); seabirds active close to shore, such as scoters, red-throated loon, eiders, old-squaw, canvasback, etc. (winter).

For Further Information

The subject matter of this book is so wide-ranging—from journal keeping and sketching of daily events to many natural history topics—that it would be overwhelming to present a comprehensive directory of relevant books, magazine and journal articles, and information on the Internet. Instead, we give here just a few references we use most consistently and other sources we found especially useful.

In addition, many local, state, and regional nature centers, environmental education organizations, and public conservation agencies publish notes, calendars, and checklists, give workshops, and sponsor field trips around seasonal events. Knowledgeable individuals, libraries, and the Internet can help those wishing more in-depth information or guidance on any particular topic. Finally, whether city or country, the land, water, and seasons themselves are the ultimate resources, whatever your region or setting.

New England Natural History (General)

Several books (some a bit dated) provide a basic picture of the "natural history" of the New England region: its geologic origins and foundation, ecological changes, human interaction with the landscape, and present natural composition. The broadest regional perspectives are Betty Thomson's *Changing Face of New England* (Houghton Mifflin, 1977), Neil Jorgensen's *Guide to New England's Landscape* (Pequot Press, 1977), and Dean Bennett's *Forgotten Nature of New England* (Down East Books, 1996). The more state-focused works include Charles W. Johnson's *Nature of Vermont: Introduction and Guide to a New England Environment* (2nd ed., University Press of New England, 1998) and the Massachusetts Audubon Society's *Nature of Massachusetts* (Addison-Wesley Publishing, 1996). *New England Wildlife: Habitat, Natural History, and Distribution,* by Richard DeGraaf and Mariko Yamasaki (University Press of New England, 2000), is an excellent and easily referenced compendium on the subjects of its title.

There are also many technical and semitechnical references on the states'

and region's natural history, including wildlife inventories, critical species lists, and ecological classifications (e.g., those of The Nature Conservancy and the U.S. Forest Service.)

Seasonal Activities/Events in Nature

The many field guidebooks available primarily for identification of various plants and animals all usually give some information on seasonal activities of the organisms in question. Of them, the Stokes Nature Guides series (Little, Brown) are most focused on seasonally associated behavior of groups of animals.

A few books, such as Scott Weisensaul's *Seasonal Guide to the Natural Year* (Fulcrum Publishing, 1993) and the *National Audubon Society Field Guide to New England* (Alfred A. Knopf, 1998), not only describe important (albeit the more dramatic) seasonal events in New England, but also give places to go to see them taking place.

Though not restricted to New England, Peter Marchand's *Life in the Cold: An Introduction to Winter Ecology* (3rd ed., University Press of New England, 1996) and *Autumn: A Season of Change* (University Press of New England, 2000) give more scientific, yet very readable, explorations of these two particular phases of the year. Gilbert Waldbauer's *Insects through the Seasons* (Harvard University Press, 1998) is an engaging presentation about the many fascinating ways members of this one huge and varied group live their lives.

Humans are part of the natural world, too. *Penobscot Man* by Frank Spec (University of Maine Press, reprinted 1998) tells of many of the seasonal activities and lore of the native people of this region. *Changes in the Land: Indians, Colonists, and the Ecology of New England,* by William Cronon (Hill and Wang, 1983), is a "historical treatment of early New England ecology," exploring the impacts of Native Americans and later-arriving Europeans on the landscape here. Henning Cohen and Tristram Coffin (eds.) in *Folklore of American Holidays* (Gale Research, 1987) trace the often nature-rooted origins of our more current celebrations. On a similar theme, *The Ancient Celtic Festivals and How We Celebrate Them Today* by Clare Walker Leslie and Frank Gerace (Inner Traditions, 2000) is written for children but is of general interest. It is illustrated by Leslie.

Field Art and Journal Keeping

Many splendid naturalists also are splendid artists, recording their observations by pencil, pen, watercolor, oil, or other media. Some also are fine writers,

adding their thoughts and notes to the illustrations, by way of journals or more formal presentations.

Clare Walker Leslie has numerous books on the illustrated nature journal. They are comprehensive how-tos, with generous illustration. She is the artist-writer-teacher who perhaps is most responsible for bringing this form to the attention of Americans. Her works include *The Art of Field Sketching* (Kendall/Hunt, 1994 [republished]) and *Keeping a Nature Journal*, with Charles E. Roth (Storey Books, 1998.)

Hannah Hinchman (*A Life in Hand: Creating the Illuminated Journal* [Gibbs Smith, 1991] and *A Trail Through Leaves: The Journal as a Path to Place* [W. W. Norton & Company, 1997]) describes and explores the process of seeing, writing, and creating the illuminated journal. She is an accomplished, original artist and writer.

The British have a long and distinguished tradition of illustrated nature writing. John Busby is considered an artist who has influenced a generation of wildlife artists internationally. He is a master of field drawing and painting, capturing birds in flight and action. His many books include *Drawing Birds* (Royal Society for the Protection of Birds, 1986) and *Nature Drawing* (Arlequin Press, 1993). Janet Marsh (*Nature Diary* [Gallery Books, 1979]) writes about and paints exquisite color illustrations and delicate drawings of an area she loves in her homeland. David Measures is our favorite outdoor journal watercolorist. We go back to his works (*Butterfly Season, 1984* [Arlequin Press, 1996]; *Bright Wings of Summer* [Prentice-Hall, 1976]) again and again for his spontaneity of color, composition, and writing.

Of course, some of the older classics still have power and freshness. In his journals, Henry David Thoreau recorded simple, immediate, daily observations of familiar surroundings, which are always interesting and still stand out after 150 years. The drawings of Michelangelo, Leonardo da Vinci, and Rembrandt are gold standards of economic use of line and form.

Index

An asterisk (*) indicates an illustration

Beaver (*continued*)

16; gestation period, 95; lodges, 40, 120, 192; ponds, 80, 112, 255; sounds, 192

Bedrock, 7, 9, 11, 12, 253

Bedstraw(s), 107, 125, 128, 136, 138, 157; fragrant, 127*, 173

Bee(s): bumble-, *see* Bumblebee(s); carpenter, 68, 99; communication, 163, 164; defenses, 49; drawing, 103; hives, 120, 121; honey-, *see* Honeybee(s); metamorphosis, 185; mimics, 49; as pollinators, 99, 103, 113, 154, 167, 173; solitary, 103*; in winter, 36, 208

Beech drops, 48

Beech, American: fall leaf color, 207, 211, 221, 229; forests, 13, 15, 148, 249; leaf-off, 62, 91, 237; leaf-on, 100; nuts, 40, 158

Beetle(s): bark, 120; blister, 194; carrion, 45, 174*; dogbane (*chrysomelid*), 174*; dung, 48; ground, 45*, 174*; Japanese, 199; June, 115; ladybird, 109*, 136; metamorphosis, 185

Bellflower(s), 82

Beltane, 100

Berkshire Mountains (Mass.), 9, 10, 250

Big Dipper, 55, 60

Bilberry, bog (alpine), 125, 134, 193, 248, 249

Billingsgate Shoals (Mass.), 74*

Birch: colors, 208*, 209*, 212*; gray, 229; paper (white), 13; yellow, 13, 30*, 92, 102, 103, 249

Bird(s): adaptability, 50; biological clocks, 69, 73; breeding seasons, 249, 251, 257; colonial, 167; communication, 97, 163, 164, 165, 166–67; defenses, 49; effect of deforestation on, 16; evolution, 10; feeding, 33, 45, 259; food of Native Americans, 13; heat production and conservation, 33–34, 36; homes, 119, 121, 123; mating, 95, 96, 99, 166, 249; migration, *see* Migration, bird; molting, 147, 169, 170; nests, 120; parasitism of, 45; parenting, 145; pelagic, 67, 260; as pollinators, 98; in post-glacial environment, 13; as predators, 33, 45, 66; in salt marshes, 89; as seed dispersers, 146; shore, *see* Shorebirds; spring chorus, 59, 162; threats to, 203. *See also by species of bird*

Bittern, American, 138, 259

Bivalves, 186. *See also* Mollusks

Blackberry/blackberries, 106, 138, 221, 223, 229

Blackbird(s): redwing (breeding season, 103, 169; display, 97, 106, 111, 162; flocks, 55, 77, 164*, 206*, 207, 214*; migration, 39, 57, 58, 60, 75; song, 56, 58*, 60, 84, 180); rusty, 111

Black-eyed susan: bloom, 125, 127*, 158, 159, 181; roadside, 142, 155

Bladderwort(s), 48

Block Island (R.I.), 11

Bloodroot: bloom, 81, 87, 91; leaves, 83, 102

Blueberry/blueberries: flowers, 113, 148, 251*; fruit, 147, 148, 158, 172, 251; leaf color, 193, 210, 212, 249; lowbush, 212, 251

Bluebird, eastern: breeding season, 147; migration, 83, 91, 108; nesting, 80, 88, 91, 128; song, 80; wintering grounds, 39

Bluefish, 1, 48, 152, 260

Bluets, 111, 177

Bobcat, 45

Bobolink, 108, 127*

Bobwhite, northern, 89

Bog(s): Cape Cod, 88, 89; carnivorous plants, 48, 118; coring, 161*; described, 256; development, 11, 13; Maine, 14, 112; New England, 249, 256; New Hampshire, 111, 161*; orchids, 99; seasonal events, 256; types of, 256; Vermont, 124–25, 132, 207, 224

Bogbean. *See* Buckbean

Boneset, 155, 172

Botfly, 117

Boulders, 11, 12, 18, 254

Bouncing bet (soapwort), 155, 159

Bowfin (*amia*), 145

Box-elder (ash-leaved maple), 85, 87*, 100, 257

Brainworm, 117

Brant, 89, 259

Brewster (Mass.), 79

Bristletails, 186

Buckbean (bogbean), 132

Buckthorn, common, 39, 40, 176, 206, 226

Bufflehead, 39, 57, 84, 236, 237

Bug(s): giant water, 145; June, *see* Beetle, June; lady-, *see* Beetle, ladybird; milkweed, 157*; spittle-, *see* Spittlebug. *See also* Insects

Bullhead, brown, 145

Bumblebee(s): adaptations, 66; energy conservation, 66; nests, 91; as pollinators, 36*, 113, 136, 151, 158, 180, 189; in winter, 36, 88

Bunchberry, 115, 132, 133

Bunting(s): indigo, 106, 108*, 150; snow, 33, 231, 242*, 253

Burdock, 106, 136, 158, 176, 180, 221

Buteos, 228. *See also by species of buteo*

Butter-and-eggs, 147, 155, 159

Buttercup(s): bloom, 128, 129, 138, 158, 159, 172; swamp, 112

Butterfly/butterflies: anglewing, 171*; Baltimore checkerspot (caterpillars, 125, 132, 137, 155; chrysalis, 138; habitat, 53, 103, 137; hatching, 103, 116; mating, 140; as pollinators, 154); barrens, 251; buckeye, 199; camouflage, 49; coastal heathlands, 252; common ringlet, 132; common wood nymph, 151; congresses, 116, 126, 137; coppers, 173; energy conservation, 66; fritillaries, 154, 173; hairstreaks, 49, 158; human-cultured areas, 254; metamorphosis, 184, 185; migration, 199, 200; mimicry, 50; monarch (avoiding predation, 49, 164; caterpillars, 174*, 188; habitat, 155, 169, 172, 176, 181, 196; illustrated, 170*; in human-cultured areas, 254; migration, 151, 192, 194–95, 199, 201, 254; mimicry of, 50; threats to, 203); Milbert's tortoise shell, 134*, 174*; mourning cloak, 35, 74, 77, 173*, 250; mustard white, 103, 114, 166; painted lady, 199; pearl crescent, 132; pollinators, 114, 136, 155, 159, 169; question mark, 171*, 183, 199; red admiral, 193, 199; satyrs, 132; skippers, 115, 132, 134*, 138, 140, 142; spring azure, 103, 111, 166, 250; sulphur, 97, 114, 204; territorial defense, 163, 166; threats to, 203; tiger swallowtail (activity, 112, 124, 126, 132, 133, 138*; habitat, 110, 112, 115, 130*, 133; mating flights, 111); viceroy, 50, 173, 176; white admiral, 136, 169, 182, 193; whites, 173

Butternut, 208*, 209*

Button Bay (Vt.), 55

Buttonbush, 156, 176, 214

Caddisflies, 92, 102, 119, 127

Calla, wild, 111

Camel's Hump (Vt.), 47*, 214*

Camouflage, 49

Canada, 199

Cape Cod: alewife migration, 88; barrier beaches, 251–52; geologic formation, 11, 12; Gulf Stream, 259; ocean, 260; seals, 74*; in spring, 89; in winter, 39, 74

Carbon dioxide, 70, 71

Cardinal, northern, 84, 148, 162, 224

Caribbean Sea, 8, 79, 88, 198, 202

Caribou, 13, 15, 18, 34, 168

Carnivores, 45, 50

Carrion flower, 99

Catbird, gray, 151, 180

Caterpillars, 49, 103, 119, 125, 137, 188. See also Butterfly/butterflies

Cattail: common, 92, 107, 113, 214, 257; narrow-leaved, 214

Cedar: Atlantic white, 258; northern white (cones, 194*; needle-drop, 204; in peat-lands, 256; seeds, 191*, 229*, 238*; in swamps, 258); red, 156*

Celandine, 112

Central America, 199

Champlain Sea, 12

Champlain Valley, 212, 258

Chanterelle(s): edible (on Cape Cod, 148; early season, 133, 141; late season, 181, 193; mid-season, 154, 158, 159, 161*, 169); trumpet, 210; yellow-footed, 210; yellowish, 194

Char, arctic, 13

Cherry/cherries: black (bloom, 110; colors, 208*, 209*, 212, 215; in fall, 208, 209, 210, 212, 215; shapes, 230*); bloom, 88, 89, 110; bud break, 91; choke, 107, 110, 158; fall leaves, 210; fall webworm on, 173; pin (bird, fire), 105*, 110, 113, 116*,133; sand, 89

Chervil, wild, 155

Chestnut, American, 14

Chestnuts, 15

Chickadee, black-capped: cavity-nesting, 92; in fall, 170, 176, 177, 188, 227, 231; molting, 169, 170; in spring, 77, 84, 86, 91, 92; in winter, 24, 25, 33, 34

Chickweed(s), 125, 127

Chicory, 154, 155, 159

Chipmunk, eastern: in fall, 176, 194; fecundity, 96; food storing, 34, 181, 183, 221, 231; in spring, 52, 60, 61; underground, 91, 119; in winter, 35

Chokeberry, black, 111, 112

Chrysalis, 35, 138, 184

Cicada(s), 98, 165, 172, 185, 199, 254

Cinquefoil, three-toothed, 134, 248

Civil War, 16

Clam(s), 67, 151, 186, 192, 236, 259. See also Mussel(s); Quahog

Claws, 48

Clay, 254, 257

Cleavers, 125

Clematis, wild. See Old man's beard

Climate: changes in, 7, 13, 18; and forests, 250; global change, 70–73; hypsithermal interval, 14; and life cycles, 66; Little Ice Age, 14; micro-, 92; New England, 247; and plants, 13, 201; during Pleistocene, 10, 11; post-glacial, 13

Clintonia (blue-bead lily), 110, 111, 115, 125, 132, 133

Clocks, biological, 64–73

Clover(s), 127, 138, 142, 154, 156*

Clubmoss(es): bristly, 207, 222*; ground cedar, 207, 224, 225; princess pine, 224; shining, 224; sporing, 179*, 222*, 224*; tree, 207; wolf-claw, 207, 224, 228

Coal, 16

Coasts, sandy, 251

Cocoons, 119, 120

Cod, Atlantic, 165

Cohosh, blue, 81, 84, 91, 210

Commensalism, 45

Communication, 117, 144, 162–68

Communities, natural, 5, 247–60

Conifers. See Forests, coniferous

Connecticut: Algonquian name, 15; forests, 249–51; fossil dinosaurs in, 10; and Lake Hitchcock, 11; and ocean, 259; sandy coasts, 252; swamps, 258

Connecticut River: Algonquian name, 15; dams on, 202; log drives, 17; as post-glacial lake, 251; southern species along, 14; valley, 9, 11

Conservation, 17, 203, 261

Coot, 235, 236

Coral root, 124

Cordgrass: freshwater, 258; salt marsh, 258; saltmeadow, 258

Cormorant, double-crested, 149*, 150

Corona, 52*

Cotton grass, 111, 132, 134*, 157, 256*

Cottontail, eastern, 45. See also Hare; Rabbit(s)

Courtship, 97–99, 162

Cowbird, brown-headed, 77, 81, 145

Coyote: adaptability, 50; calls, 29, 52, 228; communication, 164; gestation, 95; illustrated, 228*; mating, 29; predation, 24, 44; scavenging, 33; sightings, 228; in snow, 52; tracks, 25, 57, 60, 237; warning, 164

Crab(s): biological clocks in, 67, 69; fiddler, 68–69, 70; green, 33; hermit, 119; homes, 120; horseshoe (ancestry, 64; biological clocks, 69, 72; ecology, 67; egg-laying, 64–65; mating, 2, 64*, 98, 153*, 259); Limulus polyphemus, 64; in salt marshes, 258

Crabapples, 177

Cranberry/cranberries: in bogs, 89; high-bush (berries, 30*, 173, 191, 224, 237; bloom, 110, 113, 127, 129, 130; flowers, 124; food for birds, 40; hedgerow, 116*); mountain, 125; wild (small and large), 125, 256

Craneflies, 115

Creeper: brown, 33, 77, 82, 85, 88; Virginia, 113, 189, 196

Cricket(s): baby, 106, 142; cave, 69; fall, 188, 192, 193, 206, 215; field, 188; in human-cultured areas, 253; mating songs, 165, 204; metamorphosis, 185; in spring, 106; in summer, 147, 150, 155, 158, 172, 176

Crocus, 77

Crossbill, white-winged, 133

Crow, American: calls, 102, 106, 138, 154, 207; communication, 64; in fall, 188, 199, 206, 221, 224; flocks, 242*, 243*; flying to roost, 20*, 22*; mobbing, 86*, 137, 138, 163, 210, 237; "murder," 91; pairing, 38*, 42; scavenging, 33, 210; schedule, 24; in spring, 53, 60, 80, 84, 91, 93; in winter, 21, 24, 25, 28, 39, 241

Crust, oceanic, 9

Crustaceans, 68, 69

Cuckoo, black-billed, 136, 142, 157, 159, 176

Cucumber, wild, 173

Curlews, 65*

Currents, longshore, 251

Cyanobacteria, 253

Daffodils, 75, 87, 88, 91, 100

Daisy, ox-eye, 1, 127, 129, 138, 142

Fleabane, common, 111, 125, 129, 138

Flicker, northern, 103, 150, 151

Flounders, 49

Flukes, 117

Fly/flies: black (abundance, 112; emergence from streams, 199, 255; hatching, 92, 100, 106; on mountains, 131, 133); carrion flower, 99; deer, 136; fall, 229, 231; hover, 191*; maggots, 185; metamorphosis, 185; as pollinators, 99, 103, 113; *sarcophaga*, 121; in spring, 77; syrphid, 49; in winter, 208, 235

Flycatcher(s): great crested, 148; migration, 45; olive-sided, 125; as predator, 45. *See also by other species of flycatcher*

Foamflower, 82, 102, 111, 125, 132

Forestry, 17, 154

Forests: boreal (spruce-fir) (defined, 249; distribution, 249, 257; moose in, 199; pre-European contact, 15; seasonal events, 249; swamps in, 258; warblers, 112; white spruce in, 249); central hardwood, 250; changes in New England, 16, 17; coniferous, 15, 16, 17 (*see also* Forests, boreal); conservation, 17, 203; defined, 247; disjunct, 251; floodplain, 115, 256; and global climate change, 44; and humans, 219; and land-clearing, 16, 17, 44, 203; maritime, 252; mixed, 15, 104, 112; monarch butterfly wintering ground, 199, 203; and Native Americans, 14; northern hardwood, 13, 14, 15, 249, 250, 251; old growth, 18, 91; pre-European contact, 15, 18; present composition, 18; rain–, 7, 198; reclamation of old fields, 16; transition hardwood, 15, 250, 251; values to wildlife, 16, 119, 168, 199

Forget-me-not, 109, 138

Fossil(s): brachiopods, 8; cephalopods, 8; corals, 8; crinoids, 8; dinosaurs, 10; in Lake Champlain, 8; tree ferns, 10; trilobites, 8, 64

Fox, red: courtship, 97; dens, 28, 93, 120; food of, 45, 60; gestation period, 95; illustrated, 93*; mating, 21; as predator, 29; as scavenger, 45, 60; scent marking, 237; tracks, 21, 25, 26*, 28, 29, 57; in winter, 21, 29

Frisch, Karl von, 164

Frog(s): bull, 115, 124; dormancy, 35; floodplain forests, 257; green, 93, 112; metamorphosis, 186; of ponds and lakes, 256; as prey, 44; wood (eggs, 78*, 91, 100, 102; communication, 165; illustrated, 170*; mating, 80, 84, 85, 165, 199, 250; migration, 199; tadpoles, 92, 102, 111, 115, 136, 142; in vernal pools, 127, 255)

Froghoppers, 120

Fungus/fungi, 45, 48, 117, 118, 210. *See also* Mushrooms; *by species of fungi*

Gale, sweet, 89, 193

Gall(s): goldenrod, 25, 28, 119*, 180; pine cone willow, 204*

Gametes, 186

Gametophyte, 124, 186

Gannet, northern, 45, 98, 99*, 120, 260

Gaspé Peninsula, 9

Gastropods, 69. *See also by species of gastropod*

Gentian, closed, 193

Georges Bank, 12, 259

Ginger, wild, 28, 82, 84, 87*, 222*

Glacier(s)/glacial/glaciation: action, 11–12; evidence, 11–12, 18–19; melting, 11, 12, 70–71; related to Native Americans, 13, 18; in New England, 7, 10, 71; outwash, 255; plant recolonization after, 18; rebound, 11, 12; retreat of, 11, 12; and sea level, 11

Gland, pineal, 69

Glow worms, 78*, 189. *See also* Firefly/fireflies

Glycol, 35, 66

Goldeneye, common (whistler), 57, 231, 236, 258

Goldenrod(s): allergies, 183; alpine, 125; bloom, 147, 155, 159, 180, 191, 193; bog, 256; budding, 137; dried, 215*; galls, 25, 28, 119*, 180; narrow-leaved, 137, 172; pollination, 158, 159, 173, 189; as scavenger, 48; scent, 189; seaside, 253; in snow, 229, 237; variety, 172, 173; wandlike, 194; zig-zag (bloom, 176, 182*, 194; in fall, 222*, 229; habitat, 172; seeds, 205, 210)

Goldfinch: in fall, 190; food of, 23, 33, 97; mating, 97, 162; nests, 97; in spring, 57, 80

Goldthread, 111, 131, 224

Goose/geese: Canada (breeding, 155; on Cape Cod, 74*, 89; at Dead Creek [Vt.], 231; feeding areas, 254*; illustrated, 204*; on Lake Champlain, 57; migration [fall], 62*, 204*, 205, 207, 209; migration [spring], 129; in salt marshes, 89, 259); communication, 163; mating, 96; migration, 62*, 163, 194, 205, 207; snow (Dead Creek [Vt.], 231; feeding areas, 254; on Lake Champlain, 214, 231; migration [fall], 204*, 205, 209, 226; migration [spring], 62)

Grackle, common: in fall, 228; flight, 110; flocks, 155, 170*; mating, 81; nest, 124; return, 55, 58; in spring, 57, 60, 61, 75, 77; in summer, 155; young, 115, 124, 147

Grand Banks, 12, 259

Granite, 9, 10, 11, 111

Granite Hills (Vt.), 10

Grapes, wild, 113, 129*, 206

Grass(es): bloom, 125, 137, 148; blue-eyed, 127; bobolinks in, 97; coastal heathlands, 252; cotton, *see* Cotton grass; fireflies in, 48, 107, 140, 166, 189, 201; food, 44; nests, 96; reed canary (*phalaris*), 137, 142, 157*; rice cut-, 172; scent, 115, 180; seeds, 141; in snow, 229, 240; sparrows, 148; spiders in, 181; sweet vernal, 115, 127*; timothy, 142

Grasshopper(s): birth, 114, 128; communication, 164; in human-cultured areas, 253; immature, 137; metamorphosis, 185; in summer, 139, 180

Grass-pink, 99

Gravel, 7, 11, 12, 231, 254, 255

Grebe(s): horned, 57; killed, 203

Green Mountains (Vt.), 9, 10, 11, 12, 249, 250

Grenville Mountains, 8–9

Grosbeak: evening, 33, 222; pine, 28, 30, 40; rose-breasted, 82, 107

Groundhog Day, 38

Grouse: ruffed (partridge) (camouflaged, 92, 225; coverts, 117; defenses, 49; drumming, 75, 80, 102, 112, 162; flying, 224*; food of, 172; immature, 128, 129, 136, 137; nests, 120; sign, 76; tracks, 25*, 29, 240; winter, 25); spruce, 249

Grubs, 120, 185

Guillemot, black, 120, 236

Gulf of Maine, 202, 259

Gulf Stream, 259

Gull(s): breeding sites, 203; greater black-backed, 150; herring, 33, 79, 150, 164; illustrated, 253*; ringbill, 57